Vito Acconci//Theodor Adorno//Alexander Alberro//
Rasheed Araeen//Art & Language//Jay Bernstein//
Benjamin H.D. Buchloh//T.J.
Diarmuid Costello//John Cur
Jacques Derrida//Anna Dezeuze//Martin Donougho//
Marcel Duchamp//Thierry de Duve//James Elkins//
Leo Fitzmaurice//Fredric Jameson//Jason Gaiger//
Leon Golub//Christoph Grunenberg//Dave Hickey//
Kathleen Marie Higgins//Suzanne Perling Hudson//
Mark Hutchinson//Caroline A. Jones//Alex Katz//
Rosalind Krauss//Agnes Martin//Saul Ostrow//Simon
O'Sullivan//Griselda Pollock//David Raskin//Gerhard
Richter//John Roberts//Rudolf Sagmeister//Elaine
Scarry//Robert Smithson//Nancy Spero//Wendy
Steiner//Andy Warhol//Dominic Willsdon//Paul
Wood//Richard Woodfield

Beauty

Whitechapel Gallery
London
The MIT Press
Cambridge, Massachusetts

Edited by Dave Beech

BEAUTY

Documents of Contemporary Art

Co-published by Whitechapel Gallery and
The MIT Press

First published 2009
© 2009 Whitechapel Gallery Ventures Limited
All texts © the authors or the estates of the authors,
unless otherwise stated

Whitechapel Gallery is the imprint of Whitechapel
Gallery Ventures Limited

ISBN 978-0-85488-163-5 (Whitechapel Gallery)
ISBN 978-0-262-51238-1 (The MIT Press)

A catalogue record for this book is available from
the British Library

Library of Congress Cataloging-in-Publication Data

Beauty / edited by Dave Beech.
 p. cm. — (Whitechapel, documents of
contemporary art)
 Includes bibliographical references and index.
 ISBN 978-0-262-51238-1 (pbk. : alk. paper)
 1. Art—Philosophy. 2. Aesthetics, Modern—
20th century. I. Beech, Dave.
 N66.B39 2009
 701'.17—dc22
 2008036627

10 9 8 7 6 5 4 3

Series Editor: Iwona Blazwick
Commissioning Editor: Ian Farr
Project Editor: Sarah Auld
Design by SMITH
Justine Schuster
Printed in China

Cover: John Currin, *Twenty-three Years Ago* (1995)
© John Currin. Courtesy of Gagosian Gallery.

Whitechapel Gallery Ventures Limited
77-82 Whitechapel High Street
London E1 7QX
whitechapelgallery.org
To order (UK and Europe) call +44 (0)207 522 7888
or email MailOrder@whitechapelgallery.org
Distributed to the book trade (UK and Europe only)
by Central Books
www.centralbooks.com

The MIT Press
55 Hayward Street
Cambridge, MA 02142
MIT Press books may be purchased at special
quantity discounts for business or sales
promotional use. For information, please email
special_sales@mitpress.mit.edu or write to Special
Sales Department, The MIT Press, 55 Hayward
Street, Cambridge, MA 02142

Whitechapel Gallery

Documents of Contemporary Art

In recent decades artists have progressively expanded the boundaries of art as they have sought to engage with an increasingly pluralistic environment. Teaching, curating and understanding of art and visual culture are likewise no longer grounded in traditional aesthetics but centred on significant ideas, topics and themes ranging from the everyday to the uncanny, the psychoanalytical to the political.

The Documents of Contemporary Art series emerges from this context. Each volume focuses on a specific subject or body of writing that has been of key influence in contemporary art internationally. Edited and introduced by a scholar, artist, critic or curator, each of these source books provides access to a plurality of voices and perspectives defining a significant theme or tendency.

For over a century the Whitechapel Gallery has offered a public platform for art and ideas. In the same spirit, each guest editor represents a distinct yet diverse approach – rather than one institutional position or school of thought – and has conceived each volume to address not only a professional audience but all interested readers.

Series Editor: Iwona Blazwick; Commissioning Editor: Ian Farr; Project Editor: Sarah Auld; Editorial Advisory Board: Achim Borchardt-Hume, Roger Conover, Neil Cummings, Mark Francis, David Jenkins, Kirsty Ogg, Gilane Tawadros

Everybody protests that artists are irresponsible, but artists are not concerned with the material world. I would advise them to turn away from this world and go on a picnic or something. Go into the forest and feel the difference.

Agnes Martin, Interview with Irving Sandler, 1993

IF YOU'RE IN THE
SHIT
UP TO YOUR
NECK
THE ONLY THING YOU CAN DO IS
SING

Samuel Beckett, quoted by Mel Ramsden, in Art & Language, 'On Painting', 2004

Dave Beech
Introduction//Art and the Politics of Beauty

Beauty and art were once thought of as belonging together, with beauty as among art's principal aims and art as beauty's highest calling. However, neither beauty nor art have come through avantgardist rebellion and modern social disruption unscathed. Their special relationship has, as a result, become estranged and tense.

It is not that babies, flowers and diamonds have stopped looking good. The critique of beauty is never a critique of beautiful objects but always of ideas, ideologies, social practices and cultural hierarchies. When objects of beauty are contested they always stand in for objectionable conceptual frameworks: the feminist critique of beauty is typically a critique of how the social status of women is codified in and maintained by beauty; the argument stemming from Theodor Adorno for the 'crisis of beauty' focuses on how commodity exchange has abolished beauty's seemingly neutral and universal value; and so on. This is how to read Marcel Duchamp's avowed visual indifference in the selection of his readymades: if you take away beauty and the visual from the definition of art then – so one tradition of Duchampian thinking has it – the dominant forces within culture are denied their privilege. This is how to read a contemporary artist Rasheed Araeen's questioning of the western conventions of beauty imposed on the east: beauty is attacked because it has been colonized by and shaped to the needs and pleasures of the west. Both Duchamp and Araeen deliberately set out to contest beauty *as such* (i.e., beauty as universal, natural, given or singular) by reframing the beautiful as always in fact local and partial.

Beauty is often said to be impossible to define on account of the subjective nature of judgements of pleasure and taste. Simply put, if I say something is true then that claim implies that it is true for everyone, but if I say that something is beautiful I am merely stating what is beautiful to me. The subjective condition of judgements about beauty has not changed, but something has been added to make the problem of beauty's definition more difficult still. Modern thinking introduces a new twist to the problem of beauty: after Marx, Freud and Nietszche develop what the philosopher Paul Ricoeur calls the 'hermeneutics of suspicion', which I will describe below, beauty becomes not only subjective but controversial. In other words, modernism introduces a politics of beauty.

This collection has been put together with the politics of beauty in mind. It is not, therefore, devoted solely to beauty, as if beauty could be isolated like a botanical specimen from the social and political world, but rather an exploration

of beauty's full relationship to the legacies of modernism and avantgardism, the rejection of beauty and the subsequent recent disavowal of that rejection. The first section, *The Revival of Beauty*, begins with the inaugural text on these questions in the 1990s: Dave Hickey's 'Enter the Dragon: On the Vernacular of Beauty' (1993). This marks a turning point in thinking about beauty. It is not that Hickey's argument is taken up by subsequent writers on the revival of beauty; rather, Hickey seems to open up the possibility of affirmations of beauty that exceed his framework. The scholar of language and ethics Elaine Scarry, for instance, argues that beauty is etymologically and conceptually linked to kindness and justice, while the philosopher and art critic Arthur Danto attempts to restore beauty as a legitimate, if no longer central, concern for art as well as a 'necessary condition for life as we would want to live it'.

The first section also includes a number of early confrontations with the revival of beauty (Kathleen Marie Higgins, Suzanne Perling Hudson, Alexander Alberro). The key historical and theoretical writings, from Adorno onwards, that inform a wider confrontation with beauty are collected in the second section, *Concepts and Contexts*. Here we see an expansion of the conceptual parameters for thinking about beauty (Adorno, Derrida, Bernstein, Gaiger) and the critique of beauty from a range of perspectives: from feminist interrogation of 'woman as sign' in representations of female beauty (Griselda Pollock) to the analysis of beauty as skewed by late capitalism (Fredric Jameson) and the questioning of beauty in terms of the critical values of the avantgarde (John Roberts). Other texts explore and revalue beauty's relation to ugliness, vulgarity, the sublime and practices outside established definitions and conventions of art (Mark Cousins, Mark Hutchinson, T.J. Clark, Caroline Jones, Simon O'Sullivan).

The final section, *Positions*, focuses on artists. Including several interviews as well as polemics, catalogue essays and lectures, it intends to highlight beauty as a contested category. Artists such as Robert Smithson and Rasheed Araeen seemingly kill beauty off while others, such as Agnes Martin and Alex Katz, value it immensely. Such evident differences of opinion put us in a position to make a choice about beauty, one which the revivalists think is quite straightforward: Beauty, they say, is a no-brainer; we must have gone some way off target as a culture if we do not prefer beauty to ugliness, vulgarity and bad taste. Scarry, for instance, complains that it is as if 'we should be obligated to give up the pleasure of looking at one another'. This argument is tempting because it gives us what we want; however, the modern history of thinking about beauty in art calls for hesitation here.

The revivalists read beauty's politicization as a loss that can and should be made good. Another way of looking at this is to say that the current politics of

beauty includes the attempt to undo or unthink its existing politics. Let's remind ourselves of what is at stake. Avant-gardism, both in the early twentieth-century avant-garde movements such as Dada and Surrealism and the neo-avant-garde such as Minimalism and Conceptualism, recast beauty as ideologically complicit with political power, while simultaneously cultivating a sensitivity to the repressed value of ugliness, philistinism, shock or abjection. On the face of it, then, the controversy about beauty appears to boil down to rival tastes, with traditionalists preferring order and beauty, while avant-gardists prefer disorder and shock. But under the surface there is another controversy about the very nature of beauty as a category of experience.

There are two contradictory conceptions of beauty: one is the conviction that it is a purely private, subjective experience; and the other is the notion that it is always, inevitably socially inscribed. To understand this rift in approaches we need to take a detour into the history of the emergence of this modern conception of socially inscribed behaviour. It is charted by Michael Rosen in his book *On Voluntary Servitude* (1996) where he argues that after the eighteenth century society is seen for the first time as an active, behaviour-forming system or machine in which individual belief and conduct is explained as functional for, or produced by, society. What is characteristic of premodern thinking is the conviction that society is simply the aggregate of individual choices and actions. Adam Smith's 'invisible hand' and Hegel's 'cunning of reason' initiated a new conception of how individual actions were inextricably tied up with a greater whole. However, these were faint promises of what was to come – a fully-fledged theory of the ways in which society infiltrates the thoughts, feelings and actions of individuals in even the most private and subjective experiences.

Ricoeur calls this modern interpretation of the relationship between the individual and society the 'hermeneutics of suspicion', inaugurated by the works of Marx, Freud and Nietzsche. Ideology, the unconscious and the Will-to-Power share a vital theoretical commitment to structures beyond the individual which decisively shape subjectivity itself. As a result, statements made by individuals about their intentions, beliefs and conduct cannot be accepted uncritically. Rather, the suspicion is that individuals are inevitably prey to forces that they cannot control – forces of which they are often entirely unaware. By calling the unmediated sovereign individual into question, the hermeneutics of suspicion does not thereby merely replace talk about individuals with talk about society (a hermeneutics of social certainties). Rather, it draws out the *tension* between individual experience and the social structure. We'll come back to this.

At the same time that the individual was seen by the hermeneutics of suspicion as inserted into the social structure, the individual itself was radically reconfigured by the conditions of modern society. Modernity is characterized, in

the sociologist Max Weber's terms, by disenchantment, rationalization and bureaucracy. Standardization, efficiency, methodicalness and hard work combine in modernity to produce what Weber called the 'specific and peculiar rationalism of Western culture'. Within modern enterprises and institutions, according to Weber, individuals do not just happen to act instrumentally, they are obliged to do so. The key social relations of modern life – buyers and sellers, managers and workers, experts and clients, and so on – bring individuals together through anonymous processes of organization, mediated by forms of rationality. Which is why Weber describes the fate of the modern individual as constrained by the rationality of economic acquisition, as if by an 'iron cage', which Adorno later rechristened the 'totally administered society'. In this way, rational calculation structures the actions, events and things in the modern world, ultimately including the consciousness, feelings and pleasures of those who live in it.

It is important for our thinking about beauty that we register the fact that ancient, classical, mediaeval, Renaissance and Enlightenment thinkers did not in any significant way concern themselves about how society weaves its way through our intimate experiences of beauty. The philosophy of beauty from Plato to Kant may have been ethically charged but it did not theorize how individual pleasures, choices and tastes are always unwittingly charged with social content. To see beauty as politically loaded is to brand private, subjective likes and dislikes as unintentionally but inextricably caught up with social codes and social divisions. Sociology and cultural studies are adept at reading individual and private judgements in exactly this way. Social inscription is common currency in critical thinking, but it is, according to Rosen, a specifically modern idea. Kant's thinking on beauty stands uncomfortably at the cusp of this modern world. No longer able to presume the individual subject's asocial sovereignty, Kant labours to regulate a space for uncorrupted subjectivity by identifying all the major threats to it and then systematically eliminating them from aesthetic judgement properly conducted. This tension between the subjective and the social has become characteristic of modern disputes about beauty.

The controversy around beauty is rooted in the contested intersection between social facts and subjective experience. Stripped of traditional relations and forms of community, the bulk of modern sociality is markedly asocial. Competition, rivalry, antagonism, instrumentality and exploitation are characteristic of the salient structural relations of contemporary society. Subjectivity not only adapts to such conditions but is itself turned into an object of instrumental reason. The point, therefore, is not to take sides with the individual or the social analysis of beauty, for this would trap us within the terms of this fissure. As social relations take on an anonymous, mechanized and abstract

manner, beauty itself becomes subject to rationality, commodity exchange and calculation. Hence beauty gets tied up with design, style and marketing.

Losing its innocence in this way, beauty comes to feel saccharine or even violent. This is why, for instance, modernism either eliminated (as in Cubism, Expressionism, Dada and Surrealism) or streamlined (as in Constructivism, Purism, Minimalism). These were strategies that either countered beauty altogether or offered a counter-beauty in order to subvert hegemonic beauty, inherited beauty and premodern beauty. With modernism, then, we have a new category of experience, the suspiciously beautiful. And even when modernism and avant-gardism offer their own counter-beauty, beauty has no more to recommend it than the chaotic, the accidental, the philistine, the primitive, the ruined or the overlooked.

We can see the current of cultural values turn against beauty in several key moments within modernism, avantgardism and postmodernism. Modernist art's use of what T.J. Clark has called 'practices of negation' – for instance, deliberate acts of incompetence, the use of accident, and so forth – can be seen not only as the means by which 'a previously established set of skills or frame of reference ... are deliberately avoided or travestied' but also as a means to counter the privileges and pleasures of a peculiar historical version of beauty. The avantgarde penchant for 'shock' simply could not have taken place if it did not at the same time subvert existing views of the beautiful. The Dada, Surrealist or Constructivist gesture could not cause discomfort for the cultural and social elites if it presented its radicalism according to the taste of those very elites. This is why the Futurists presented the motor car as a rival model of beauty to that which was universalized by the museum. And the postmodernists take up this mantle when critics such as Craig Owens argue in favour of the hybrid, the marginal and the low, to locate contemporary art deliberately and conscientiously *in the wake of* high art's dominance of culture.

We continue to see beauty around us but this can no longer be the kind of elevated experience that it once was. Beauty might seem like something that we know when we see it, but the hermeneutics of suspicion refers such experiences to hidden motives, unintended consequences, structural conditions and spurious rationalizations. When avantgardism took up the hermeneutics of suspicion in its diverse forms of cultural dissent, the resistance to beauty was part and parcel of the resistance to bourgeois culture generally. 'Except in struggle, there is no more beauty', wrote Marinetti in the 1905 Futurist Manifesto. Art after avantgardism tended to preserve the avantgarde's suspicion of beauty even when its politicization had been cooled. Clement Greenberg, for instance, preferred to describe work of the New York School as 'good' or 'successful' rather than 'beautiful'. After that, Pop was vulgar, Minimalism was

literal, Conceptualism was opposed to the visual and postmodernism was either more interested in the sublime or regarded beauty as one of art's institutionalized discourses. Beauty has become utterly contentious.

Against this, the revival of beauty typically wants to place the individual in an unmediated, untroubled and de-cluttered relationship to the beautiful object. Thus, the controversy over beauty reasserts the modern dilemma that pits the individual against society by assuming (or insisting on) the individual's autonomy. It therefore fails to see how the forces of modern alienation have transformed beauty *immanently*. To imagine that we can make judgements without unintended consequences, or take pleasure without risking structural and ideological complicity and culpability, is to conjure up a hermeneutics without suspicion. At the same time, the reduction of the individual to the social does not adequately register the modern tension between individual and society. Beauty is political not despite the fact that it feels subjective but precisely because it is, in fact, subjective. Beauty enters us into a world of dispute, contention and conflict at the very moment when we feel to be removed from the social world.

Maybe this seems like bad news for beauty, as if such ideas threaten to spoil the pleasure promised by it. However, pleasure is not cancelled by modern structures of subjectivity. For one thing they are released from the old hierarchies of social and cultural hegemony. As a result, though, it is more difficult – if not impossible – to universalize pleasure or beauty. Subjective certainties and regimes of taste can no longer be bracketed off from the economies of beauty. The result is not the rejection of beauty or the death of taste but the need to learn to love beauty without the kind of social endorsement or cultural authority that it once enjoyed and wielded. What would that be like?

Following Ricoeur, we might begin to develop what we could call an aesthetics of suspicion. This is a counter-intuitive proposal. Aesthetics, we normally think, is not the sort of experience that tolerates suspicion. But we have a model of what that might be like in Judith Butler's performative theory of gender: a very intimate world subject to suspicion. Gender identity, she says, is performatively constituted. For Butler gender should be seen as a fluid variable rather than a fixed attribute. In this sense, she argues, gender is always an achievement. Butler argues that certain cultural configurations of gender have come to seem natural by virtue simply of their hegemonic power. In response to this, Butler calls for subversive action with the mobilization, confusion and proliferation of genders.

Various ambitious contemporary artists have taken pleasure and critical purchase from the confusion and collapse of the distinction between beauty and

a vast range of its antonyms, such as ugliness, the banal, ideology, chaos, and so on. In addition to those whose writing is included in this anthology one should also mention here several of the other significant artists in this realm, such as Tomoko Takahashi, Liam Gillick, Jeff Koons and Pipilotti Rist. Takahashi, for instance, immerses herself in waste, reclaiming unwanted and rejected items that have left circulation, and converts disorder into order and ugliness into beauty. Gillick links the question of beauty to that of living well, not limiting beauty to the visual but drawing attention to the beauty of endeavour, struggle, social change and political action. Gillick uses modernist design with all its cool appeal to pursue a double-edged enquiry into the more general 'unfinished project of modernity', as Habermas puts it. Koons has consistently highlighted banality, pop, indulgence, advertising, commodity culture, sexual desire and guilty pleasures, presenting these 'low' amusements as often outstripping the delights of a more high-minded nature. Beauty, for Koons, has to be less accountable, less sober and less privileged if it is going to capture us. And Rist, too, 'risks vulgarity' – to use a phrase from T.J. Clark in reference to Abstract Expressionism – in her determinedly unconventional version of beauty. An aesthetics of suspicion is played out in Rist's work by discovering itself performatively in the act of finding things beautiful or finding ways of presenting things as beautiful.

It would be wrong therefore to suggest that the contemporary politics of beauty leads towards drab or clumsy art. Beauty is raised as an issue by these artists without the question of beauty being posed merely as a theoretical enquiry. Beauty, in other words, is not obliterated by the aesthetics of suspicion but is expanded, twisted, shifted and split. Beauty, then, need not be naturalized as purely subjective nor reduced to the social relations to which certain dominant cultural configurations are attached. If aesthetics is performed in the way that gender is, then beauty exists at the tense intersection of the individual and society, with the individual neither fully subsumed nor fully free from social norms and cultural hierarchies. There is pleasure and play in that gap as well as critique, suspicion and subversion. An aesthetics of suspicion, then, would be one in which beauty is no longer reducible to the individual, the subjective and the authentic, nor to the social, the political and the imposed. Individuals can play out social inscriptions while retaining a pleasurable and critical relation to them. Beauty – like masculine, feminine or queer positions – is not something given but something that we do and something that we change.

What all this means, as an introduction to a selection of writings on beauty, is that each text is to be seen as occupying a specific place and taking a specific position within the politics of beauty, including the aestheticist resistance to the politics of beauty. If it is true, as I've suggested, that the controversy of beauty is

rooted in the tension between individual and society that is endemic to modern capitalism, then we can read these texts also as caught up within forces beyond their control. In other words, we cannot expect the positions and arguments to resolve the situations to which they respond. Instead, these texts are documents of the struggle for nothing less than universal human flourishing, albeit conducted for the most part in terms of very local disputes over paintings, photographs, objects and events. These details count. If universal human flourishing is to mean anything it has to be embedded in the very fabric of existence, in the minutiae of life, not just the grand idea. This is why beauty – and the politics of beauty – is never to be taken lightly.

Once we got
married,
a kind of
neutrality
descended on me.
I really
just wanted to
make things
beautiful.
I had no interest
in constructing
a painting out
of its references
or its ideas
or out of
its grudges.

John Currin, Interview with Robert Rosenblum, 2000

Dave Hickey
Enter the Dragon: On the Vernacular of Beauty//1993

It would be nice if sometime a man would come up to me on the street and say, 'Hello, I'm the information man, and you have not said the word *yours* for thirteen minutes. You have not said the word *praise* for eighteen days, three hours and nineteen minutes.'
– Edward Ruscha, *Information Man*

I was drifting, daydreaming really, through the waning moments of a panel discussion on the subject of 'What's Happening Now', drawing cartoon daggers on a yellow pad and vaguely formulating strategies for avoiding punch and cookies, when I realized that I was being addressed from the audience. A lanky graduate student had risen to his feet and was soliciting my opinion as to what 'the issue of the nineties' would be. Snatched from my reverie, I said, 'Beauty', and then, more firmly, 'The issue of the nineties will be beauty' – a total improvisatory goof – an off-the-wall, jump-start, free association that rose unbidden to my lips from God knows where. Or perhaps I was being ironic, wishing it so but not believing it likely? I don't know, but the total, uncomprehending silence that greeted this modest proposal lent it immediate credence for me. My interlocutor plopped back into his seat, exuding dismay, and, out of sheer perversity, I resolved to follow beauty where it led into the silence. Improvising, I began updating Walter Pater; I insisted that beauty is not a *thing* – 'the beautiful' is a thing. In images, I intoned, beauty is the agency that causes visual pleasure in the beholder; and any theory of images that is not grounded in the pleasure of the beholder begs the question of their efficacy and dooms itself to inconsequence. This sounded provocative to me, but the audience continued to sit there, unprovoked, and *beauty* just hovered there as well, a word without a language, quiet, amazing and alien in that sleek, institutional space – like a pre-Raphaelite dragon aloft on its leather wings.

'If images don't *do* anything in this culture', I said, plunging on, 'if they haven't *done* anything, then why are we sitting here in the twilight of the twentieth century talking about them? And if they only do things after we have talked about them, then *they* aren't doing them, *we* are. Therefore, if our criticism aspires to anything beyond soft-science, the efficacy of images must be the cause of criticism, and not its consequence – the subject of criticism and not its object. And this', I concluded rather grandly, 'is why I direct your attention to the language of visual affect – to the rhetoric of how things look – to the iconography of desire – in a word, to *beauty*!'

I made a *voilà* gesture for punctuation, but to no avail. People were quietly filing out. My fellow panellists gazed into the dark reaches of the balcony or examined their cuticles. I was genuinely surprised. Admittedly, it was a goof. Beauty? Pleasure? Efficacy? Issues of the nineties? Admittedly outrageous. But it was an outrage worthy of a rejoinder – of a question or two, a nod, or at least a giggle. I had wandered into this *dead zone,* this silent abyss. I wasn't ready to leave it at that, but the moderator of our panel tapped on her microphone and said, 'Well, I guess that's it, kids.' So I never got off my parting shot. As we began breaking up, shuffling papers and patting our pockets, I felt a little sulky. (Swallowing a pithy allusion to Roland Barthes can do that.) And yet, I had no sooner walked out of the building and into the autumn evening than I was overcome by this strange Sherlock Holmesian elation. The game was afoot.

I had discovered something; or rather, I had put out my hand and discovered nothing – this vacancy that I needed to understand. I had assumed that from the beginning of the sixteenth century until just last week artists had been persistently and effectively employing the rough vernacular of pleasure and beauty to interrogate our totalizing concepts 'the good' and 'the beautiful'; and now this was over? Evidently. At any rate, its critical vocabulary seemed to have evaporated overnight, and I found myself muttering detective questions like: Who wins? Who loses? *Qui bono?* – although I thought I knew the answer. Even so, for the next year or so, I assiduously trotted out 'beauty' wherever I happened to be, with whomever I happened to be speaking. I canvassed artists and students, critics and curators, in public and in private – just to see what they would say. The results were disturbingly consistent, and not at all what I would have liked.

Simply put, if you broached the issue of beauty in the American art world of 1988, you could not incite a conversation about rhetoric – or efficacy, or pleasure, or politics, or even Bellini. You ignited a conversation about the market. That, at the time was the 'signified' of beauty. If you said 'beauty', they would say, 'The corruption of the market', and I would say, 'The corruption of the *market*?!'. After thirty years of frenetic empowerment, during which the venues for contemporary art in the United States had evolved from a tiny network of private galleries in New York into this vast, transcontinental sprawl of publicly funded, postmodern iceboxes? During which time the ranks of 'art professionals' had swollen from a handful of dilettantes on the East Side of Manhattan into this massive civil service of Ph.Ds and MFAs who administered a monolithic system of interlocking patronage, which, in its constituents, resembled nothing so much as that of France in the early nineteenth century? While powerful corporate, governmental, cultural and academic constituencies vied for power and tax-free dollars, each with its own self-perpetuating agenda and none with any vested interest in the subversive potential of visual pleasure? Under *these* cultural

conditions, artists across this nation were obsessing about the market? – fretting about a handful of picture merchants nibbling canapés on the Concorde? – blaming them for any work of art that did not incorporate raw plywood?

Under these cultural conditions, I would suggest, saying that 'the market is corrupt' is like saying that the cancer patient has a hangnail. Yet the manifestations of this pervasive *idée fixe* remain everywhere present today, not least of all in the sudden evanescence of the market itself after thirty years of scorn for the intimacy of its transactions, but also in the radical discontinuity between serious criticism of contemporary art and that of historical art. At a time when easily 60 per cent of historical criticism concerns itself with the influence of taste, patronage and the canons of acceptability upon the images that a culture produces, the bulk of contemporary criticism, in a miasma of hallucinatory denial, resolutely ignores the possibility that every form of refuge has its price, and satisfies itself with grousing about 'the corruption of the market'. The transactions of value enacted under the patronage of our new 'non-profit' institutions are exempted from this cultural critique, presumed to be untainted, redemptive, disinterested, taste free, and politically benign. Yeah, right.

During my informal canvass, I discovered that the 'reasoning' behind this presumption is that art dealers 'only care about how it looks', while the art professionals employed by our new institutions 'really care about what it means'. Which is easy enough to say. And yet, if this is, indeed, the case (and I think it is), I can't imagine any but the most demented naïf giddily abandoning an autocrat who monitors appearances for a bureaucrat who monitors desire. Nor can Michel Foucault, who makes a variation of this point in *Surveiller et punir*, and poses for us the choice that is really at issue here, between bureaucratic surveillance and autocratic punishment. Foucault opens his book with a grisly, antique text describing the lengthy public torture and ultimate execution of Damiens, the regicide; he then juxtaposes this cautionary spectacle of royal justice with the theory of reformative incarceration propounded by Jeremy Bentham in his 'Panopticon'.

Bentham's agenda, in contrast to the king's public savagery, is ostensibly benign. It reifies the benevolent passion for secret control that informs Chardin's pictorial practice, and, like Chardin, Bentham *cares*. He has no wish to punish the offender, merely to reconstitute the offender's desire under the sheltering discipline of perpetual, covert, societal surveillance in the paternal hope that, like a child, the offender will ultimately internalize that surveillance as a 'conscience' and start controlling himself as a good citizen should. However, regardless of Bentham's ostensible benignity (and, in fact, because of it), Foucault argues that the king's cruel justice is ultimately more just – because the king does not care what we *mean*. The king demands from us the appearance of

loyalty, the rituals of fealty, and, if these are not forthcoming, he destroys our bodies, leaving us our convictions to die with. Bentham's warden, on the other hand, demands our *souls*, and on the off chance that they are not forthcoming, or *cannot* come forth into social normality, he knows that we will punish ourselves, that we will have internalized his relentless surveillance in the form of self-destructive guilt.

These are the options that Foucault presents to us; and I would suggest that, within the art community, the weight of the culture is so heavily on Bentham's side that we are unable to see them as equally tainted. We are, I think, such obedient children of the Panopticon, so devoted to care, and surveillance, and the irredeemable *souls* of things, that we have translated this complex, contemporary option between the king's savage justice and Bentham's bureaucratic discipline into a progressive, utopian choice between the 'corrupt old market' and the 'brave new institution'. Thus beauty has become associated with the 'corrupt old market' because art dealers, like Foucault's king, traffic in objects and appearances. They value images that promise pleasure and excitement. Those that keep their promise are admitted into the presence of the court; those that fail are subject to the 'king's justice', which can be very cruel and autocratic indeed. But there is another side to this coin, since art dealers are also like Foucault's king in that they do not care 'what it means'. Thus radical content has traditionally flourished under the auspices of this profound disinterest.

The liberal institution, however, is not so cavalier about appearances as the market is about meaning. Like Jeremy Bentham's benevolent warden, the institution's curators hold a public trust. They must look carefully and genuinely care about what artists 'really' mean – and therefore they must, almost of necessity, distrust appearances – distrust the very idea of appearances, and distrust most of all the appearance of images that, by virtue of the pleasure they give, are efficacious in their own right. The appeal of these images amounts to a kind of ingratitude, since the entire project of the new institution has been to lift the cruel burden of efficacy from the work of art and make it possible for artists to practise that 'plain honesty' of which no great artist has yet been capable, nor ever wished to be. Yet, if we would expose the inner soul of things to extended public scrutiny, 'sincere' appearance is everything, and beauty is the *bête noire* of this agenda, the snake in the garden. It steals the institution's power, seduces its congregation, and, in every case, elicits the dismay of artists who have committed themselves to plain honesty and the efficacy of the institution.

The arguments these artists mount to the detraction of beauty come down to one simple gripe: *Beauty sells*, and although their complaints usually are couched in the language of academic radicalism, they do not differ greatly from my grandmother's *haut bourgeois* prejudices against people 'in trade' who get

their names 'in the newspaper'. Beautiful art *sells*. If it sells itself, it is an idolatrous commodity; if it sells anything else, it is a seductive advertisement. Art is not idolatry, they say, nor is it advertising, and I would agree – with the caveat that idolatry and advertising are, indeed, art, and that the greatest works of art are always and inevitably a bit of both.

Finally, there are issues worth advancing in images worth admiring; and the truth is never 'plain', nor appearances ever 'sincere'. To try to make them so is to neutralize the primary, gorgeous eccentricity of imagery in Western culture since the Reformation: the fact that it cannot be trusted, that imagery is always presumed to be proposing something contestable and controversial. This is the sheer, ebullient, slithering, dangerous fun of it. No image is presumed inviolable in our dance hall of visual politics, and all images are potentially powerful. Bad graphics topple good governments and occlude good ideas; good graphics sustain bad ones. The fluid nuancing of pleasure, power and beauty is a serious, ongoing business in this culture and has been since the sixteenth century, when the dazzling rhetorical innovations of Renaissance picture making enabled artists to make speculative images of such authority that power might be successfully bestowed upon them, privately, by their beholders, rather than (or at least prior to) its being assigned by the institutions of church and state.

At this point, for the first time in history, the power of priestly and governmental bureaucracies to assign meaning to images began to erode, and the private encounter between the image and its beholder took on the potential of changing the public character of institutions. Images became mobile at this point, and irrevocably political – and henceforth, for more than four centuries subsequent to the rise of easel painting, images *argued*, for things – for doctrines, rights, privileges, ideologies, territories and reputations. For the duration of this period, a loose, protean collection of tropes and figures signifying 'beauty' functioned as the *pathos* that recommended the *logos* and *ethos* of visual argumentation to our attention. It provided the image's single claim to being looked at – and to being believed. The task of these figures of beauty was to enfranchise the audience and acknowledge its power – to designate a territory of shared values between the image and its beholder and, then, in this territory, to argue the argument by valorizing the picture's problematic content. Without the urgent intention of reconstructing the beholder's view of things, the image had no reason to exist, nor any reason to be beautiful. Thus, the comfort of the familiar always bore with it the frisson of the exotic, and the effect of this conflation, ideally, was persuasive excitement – visual pleasure. As Baudelaire says, 'the beautiful is always strange', by which he means, of course, that it is always strangely familiar.

Thus Caravaggio, at the behest of his masters, would deploy the exquisite

hieratic drama of the *Madonna of the Rosary* to lend visual appeal and corporeal authority to the embattled concept of the intercession of the priesthood – and would demonstrably succeed, not only in pleading his masters' case, but in imposing the urbane glamour of his own argument onto that doctrine. So today, as we stand before the *Madonna of the Rosary* in Vienna, we pay homage to a spectacular souvenir of successful visual litigation – an old warhorse put out to pasture – in this case, a thoroughbred. The image is quiet now; its argumentative frisson has been neutralized, and the issue itself drained of ideological urgency, leaving only the cosmetic superstructure of that antique argument just visible enough to be worshipped under the frayed pennants of 'humane realism' and 'transcendent formal values' by the proponents of visual repose.

Before we genuflect, however, we must ask ourselves if Caravaggio's 'realism' would have been so trenchant, or his formal accomplishment so delicately spectacular, had his contemporary political agenda, under the critical pressure of a rival church, not seemed so urgent? And we must ask ourselves further if the painting would have even survived until Rubens bought it, had it not somehow expedited that agenda? I doubt it. We are a litigious civilization and we do not like losers. The history of beauty, like all history, tells the winner's tale; and that tale is told in the great mausoleums where images like Caravaggio's, having done their work in the world, are entombed – and where, even hanging in state, they provide us with a ravishing and poignant visual experience. One wonders, however, whether our standards for the pleasures of art are well founded in the glamorous *tristesse* we feel in the presence of these institutionalized warhorses, and whether contemporary images are really enhanced by being institutionalized in their infancy, whether there might be work in the world for them to do, as well.

For more than four centuries, the idea of 'making it beautiful' has been the keystone of our cultural vemacular – the lover's machine gun and the prisoner's joy – the last redoubt of the disenfranchised and the single direct route from the image to the individual without a detour through church or state. Now, it seems, that lost generosity, like Banquo's ghost, is doomed to haunt our discourse about contemporary art – no longer required to recommend images to our attention or to insinuate them into the vernacular, and no longer even welcome to try. The route from the image to the beholder now detours through an alternate institution ostensibly distinct from church and state. Even so, it is not hard to detect the aroma of Caravaggio's priests as one treads its grey wool carpets or cools one's heels in its arctic waiting rooms. One must suspect, I think, that we are being denied any direct appeal to beauty, for much the same reason that Caravaggio's supplicants were denied appeal to the Virgin: to sustain the jobs of bureaucrats. Caravaggio, at least, *shows* us the Virgin, in all her gorgeous

autonomy, before instructing us not to look at her and redirecting our guilty eyes to that string of wooden beads hanging from the priest's fingers. The priests of the new church are not so generous. Beauty, in their domain, is altogether elsewhere, and we are left counting the beads and muttering the texts of academic sincerity.

As luck would have it, while I was in the midst of my informal survey, the noisy controversy over exhibiting Robert Mapplethorpe's erotic photographs in public venues provided me with a set-piece demonstration of the issues – and, at first, I was optimistic, even enthusiastic. This uproar seemed to be one of those magic occasions when the private visual litigation that good art conducts might expand into the more efficacious litigation of public politics – and challenge some of the statutory restrictions on the conduct that Mapplethorpe's images celebrate. I was wrong. The American art community, at the apogee of its power and privilege, chose to play the ravaged virgin, to fling itself prostrate across the front pages of America and fairly dare the fascist heel to crush its outraged innocence.

Moreover, this community chose to ignore the specific issues raised by Mapplethorpe's photographs in favour of the 'higher politics'. It came out strenuously in defence of the status quo and all the perks and privileges it had acquired over the last thirty years, and did so under the tattered banner of 'free expression' – a catchphrase that I presumed to have been largely discredited (and rightly so) by the feminist critique of images. After all, once a community acquiesces in the assumption that *some* images are certifiably toxic, this, more or less, 'opens the door', as they say in the land of litigation.

And finally, hardly anyone considered for a moment what an incredible rhetorical *triumph* the entire affair signified. A single artist with a single group of images had somehow managed to overcome the aura of moral isolation, gentrification and mystification that surrounds the practice of contemporary art in this nation and directly threaten those in actual power with his celebration of marginality. It was a fine moment, I thought, and all the more so because it was the *celebration* and not the marginality that made these images dangerous. Simply, it was their rhetorical acuity, their direct enfranchisement of the secular beholder. It was, exactly, their beauty that had lit the charge – and, in this area, I think, you have to credit Senator Jesse Helms, who, in his antediluvian innocence, at least saw what was there, understood what Mapplethorpe was proposing, and took it, correctly, as a direct challenge to everything he believed in. The senator may not know anything about art, but rhetoric is his business, and he did not hesitate to respond to the challenge. As, one would hope, he had a right to. Art is either a democratic political instrument, or it is not.

So, it was not that men were making it in Mapplethorpe's images. At that

time they were regularly portrayed doing so on the walls of private galleries and publicly funded 'alternative' spaces all over the country. On account of the cult of plain honesty and sincere appearance, however, they were not portrayed as doing it so *persuasively*. It was not that men were making it, then, but that Mapplethorpe was 'making it beautiful'. More precisely, he was appropriating a baroque vernacular of beauty that predated and, clearly, outperformed the puritanical canon of visual appeal espoused by the therapeutic institution. This canon presumes that we will look at art, however banal, because looking at art is, somehow, 'good' for us, regardless and, ultimately, in spite of whatever specific 'good' the individual work or artist might urgently propose to us.

This habit of subordinating the artist's 'good' to the 'higher politics of expression' of course, makes perfect sense in the mausoleums of antiquity, where it was born, and where we can hardly do otherwise – where it is, perhaps, 'good' for us to look at the *Madonna of the Rosary* without blanching at its Counter-Reformation politics, because those politics are dead – and where it may be 'good' for us, as well, to look at a Sir Thomas Lawrence portrait and 'understand' his identification of romantic heroism with landed aristocracy. It is insane and morally ignorant, however, to confront the work or a living (and, at that time, dying) artist as we would the artefacts of lost Atlantis, with forgiving connoisseurship – to 'appreciate' his passionate, partisan and political celebrations of the American margin – and in so doing, refuse to engage their 'content' or argue the arguments that deal so intimately with trust, pain, love and the giving up of the self.

Yet this is exactly what was expected and desired, not by the government, but by the art establishment. It was a matter of 'free expression', and thus, the defence of the museum director prosecuted for exhibiting the images was conducted almost completely in terms of the redemptive nature of formal beauty and the critical nature of surveillance. The 'sophisticated' beholder, the jury was told, responded to the elegance of the form regardless of the subject matter. Yet this beholder must be 'brave' enough to look at 'reality' and 'understand' the sources of that formal beauty in the artist's tortured private pathology. If this sounds like the old patriarchal do-dah about transcendent formal values and humane realism, it is, with the additional fillip that, in the courts of Ohio, the sources of beauty are now taken to be, not the corruption of the market, but the corruption of the artist. So, clearly, all this litigation to establish Robert Mapplethorpe's 'corruption' would have been unnecessary had his images somehow *acknowledged* that corruption, and thus qualified him for our forgiveness. But they did not.

There is no better proof of this, I think, than the fact that, while the Mapplethorpe controversy was raging, Francis Bacon's retrospective was

packing them in at the Los Angeles County Museum of Art, and Joel-Peter Witkin was exhibiting in institutional serenity – because Bacon's and Witkin's images speak a language of symptoms that is profoundly tolerable to the status quo. They mystify Mapplethorpe's content, aestheticize it, personalize it, and ultimately further marginalize it as 'artistic behaviour', with signifiers that denote angst, guilt and despair. It is not portrayal that destabilizes, it is *praise*. Nor is it criticism of centrality that changes the world. Critique of the mainstream ennobles the therapeutic institution's ostensible role as shadow government and disguises its unacknowledged mandate to neutralize dissent by first ghettoizing it, and then mystifying it. Confronted by images like Mapplethorpe's that, by virtue of their direct appeal to the beholder, disdain its umbrella of 'care', the therapeutic institution is immediately disclosed for what it is: the moral junkyard of a pluralistic civilization.

Yet the vernacular of beauty, in its democratic appeal, remains a potent instrument for change in this civilization. Mapplethorpe uses it, as does Warhol, as does Ruscha, to engage individuals within and without the cultural ghetto in arguments about what is good and what is beautiful. And they do so without benefit of clergy, out in the street, out on the margin, where we might, if we are lucky, confront that information man with his reminder that we have not used the word *praise* for eighteen days, three hours, and nineteen minutes.

Dave Hickey, 'Enter the Dragon: On the Vernacular of Beauty', in *The Invisible Dragon: Four Essays on Beauty* (Los Angeles: Art Issues Press, 1993) 15–24.

Kathleen Marie Higgins
Whatever Happened to Beauty?
A Response to Danto//1996

Whatever happened to beauty? In 'Beauty and Morality' (1994),[1] Arthur C. Danto meditates on the relative scarcity of beauty in recent art. He seeks the explanation in our attitudes about the appropriate use of beauty. Following Kant to a point, he contends that beauty casts a universalized light upon a phenomenon, reminding us that what is presented beautifully is an inherent part of human experience. Beauty is appropriate as a means of marking the loss of a loved one, for it reminds us that the pain of loss is a universal human experience. 'It is as though beauty were a kind of catalyst, transforming raw grief into tranquil sadness', Danto observes (page 364).

Appropriate as beauty's healing influence seems when one is faced with personal loss, it seems far from apt in the face of political defeat for a cause that is a matter of moral urgency. Beauty seems wrong in such cases, 'wrong because one is called upon to act ... and not to philosophize' (365). Danto elaborates this point by considering the category of artworks that display what he calls 'internal beauty'. Beauty is internal to a work of art when it is 'internally connected with the reference and the mood' (366). For such a work, beauty is part of the work's content. Accordingly, Danto contends, 'it can be a criticism of a work that it is beautiful when it is inappropriate for it to be so' (370).

Judgements that beauty is inappropriate underlie the decision to forego beauty in much contemporary art. 'Ours ... is an age of moral indignation', Danto reminds us (374). He seems to concur with artistic abstinence from beauty in many instances. To find beauty in images of suffering, to seek aesthetic satisfaction where injustice prevails is, in his view, a moral failing. Our societal aversion to beauty, accordingly, has to do with our heightened moral sensitivity. We cannot in good conscience close our eyes and ears to the troubles of our world, but beauty threatens to conceal them.

Yet Danto takes a mixed view of the activist art that has largely supplanted art that is beautiful. Too often, he contends, political activists have failed in their efforts to 'enlist art as an ally in their campaign' (374). The problem, as he sees it, is that when art designed to inspire moral response fails *as art*, it also 'fails morally, extenuated only by the good intentions of the artist' (375). He concludes that 'the lesson is that art has its limits as a moral arm. There are things it can do and things it cannot. It can do what philosophy can do, and what beauty can do. But that may mean that philosophy too has its limits as a moral arm' (374). Our age has yet to learn this lesson, however. Moral indignation continues to hold

sway among artists. 'Beauty', he predicts, 'may be in for a rather long exile' (375).

Is this a fair assessment of our time's relation to beauty? I think this must depend on what we take beauty to be – and this is scarcely a matter of agreement. Interestingly, most instances that Danto cites are elegies – beautiful commemorations of those who have died. Danto suggests that beauty, in these cases, renders us philosophical, attuned to the universal 'meaning of what it is to be human'. Our inner state is converted to the dispassionate stance of 'disinterestedness', which Kant saw as essential to experience of the beautiful.

An alternative account might, however, focus on other traditional features of beauty besides Kantian disinterestedness. When beauty transforms raw emotion in times of loss, does it necessarily make us more 'philosophical', in the colloquial sense of more stoical, more distanced from the wound we have suffered? Loss, besides provoking pangs of anger, regret and sadness, has a deadening influence on the person engulfed by it. Loss is depressing. The bereaved often doubt that they can continue in a world devoid of a loved one.

Enter beauty. Beauty makes the world seem worthwhile again. Plato described our stance towards beauty as erotic. We are drawn to beauty. Beauty incites ardour. It is the bridge to a sense that reality is lovable. Plato, as much as Kant, would say that beauty makes us philosophical. But for Plato this means that beauty makes us fall in love with what is perfect. I want to suggest that beauty typically, perhaps especially in times of loss, urges not stillness but renewed love of life. Beautiful elegies reflect our sense that the only fitting remembrance for one who lived is to renew life, and that our own march forward into dying is itself an affirmation that life, in its basic character, is good.

Beauty's power to arouse rapture with life is indeed at odds with some of our moral intuitions, as Danto observes. Milan Kundera makes a similar point when he describes kitsch as reflecting 'a categorical agreement with being.'[2] Kundera, too, like Danto, believes that this is a faith which we have lost. Indeed, this loss is both the key *moral* insight and the key *religious* insight of our era. After the World Wars and the Holocaust, after the many wars and atrocities since, we cannot, like God in Genesis, pronounce the world entirely good. To the extent that beauty says otherwise, we see beauty as kitsch. Beauty shamefully screens off whatever is morally offensive in our lives.

I am convinced, however, that other motives are also at work in the modern avoidance of beauty, overdetermining our tendency to think ill of it. For instance, the traditional conception of beauty understands it as involving harmonious agreement among elements. Beauty renders disparate materials into a coherent whole, with the elements as interdependent as an organic body. The beautiful object is virtually alive. Nature, accordingly, provides the paradigm of beauty. Art is beautiful to the extent that it resembles the order of nature.

This model suggests one of our motives for shunning the beautiful in art. One traditional basis for art-making is meditation on human beings' relation to nature. Currently, however, this relationship is in shambles. The traditional notion that human beings enhance the natural order of things is alien to us. The products of human making have sullied our world in the first place. In so far as we see art as the product of human creation, it seems intrinsically contrary to the natural order. Our creations are the products of a Faustian pact, which signs away paradise for power.

The style of our activity is also contrary to the traditional ideal of beauty. Kant describes beauty as involving a direct 'feeling of life's being furthered'.[3] Beauty appears to be attuned to our senses, and thereby facilitates a sense of repose in our contemplation of it. By contrast, in our era, we do not have time for beauty or repose. Our frenzy for getting ahead of the game by means of efficient juggling and corner-cutting does not jibe easily with the aesthetic model of beauty, the organically, perfectly constructed whole. Culturally, we count as success not the gradual ripening of well-ordered projects, but efficient time management.

Traditionally and colloquially, beauty is ascribed to human beings. A third reason for our avoidance of beauty is that we consider contemporary human beings as poor candidates for beauty. If someone appears to shine brightly as a torch, as Romeo says of Juliet,[4] we all know that we are seeing make-up and acting at work. We are jaded by 'special effects'. American culture is cynical, captivated with Freud's sinister reports on what people are really like. Few of us share Plato's sense that eros is an ennobling spiritual ardour incited by beauty. Freud has convinced us that sex is murky business but the key to what fulfils or traumatizes our lives – and glamour is enough to provoke sexual impulse. Beauty seems inessential for satisfying our basic aims, which themselves are seen as paradigmatically unbeautiful.

In such a context, we are more likely to resent beauty than to love it. Beauty too easily becomes identified with a more perfect time, the imaginary point from which things have gone downhill. We would like to glow and flourish ourselves, and to see the same in those around us. But we despair of genuine flourishing. Thus, the sensitive among us, both artists and others, find beauty irrelevant, a reproach, or a distraction from the business of our lives.

Which returns us to Danto's point. Who can deny that the sensitive these days absorb disturbance more than beauty from their world? This, I think, is bound to be the case; and it is natural that art made by such individuals will reflect their sense that the world is troubled. They may employ beauty, as Motherwell does in his elegies, but beauty cannot strike us or them as the naïve truth about our lives.

Beauty, where it exists at all, must be contextualized and its propriety always

subject to question. Knowing, as we do, that the sublime splendour of the mushroom cloud accompanies moral evil, that aesthetic appeals congealed Hitler's rallies, that beautifully embellished clothes and jewelry currently motivate teenagers to murder; knowing these things, we cannot see beauty as innocent or its comforts as necessarily ennobling. At times we can see artistic beauty as thoroughly inappropriate, as Danto suggests. [...]

The overly determined avoidance of beauty by contemporary artists seems an understandable response to our recent history and living conditions, but an overly simplistic response to the gap between the real and our ideals. It may be insensitive, at times, to luxuriate in aesthetic comfort while human misery abounds. But the mesmerizing impact of beauty may, even in miserable conditions, rekindle our sensitivity.

Beauty seems at odds with political activism because it is not a directly practical response to the world. It inspires contemplation, not storm and fury. But politically motivated artists, I submit, have much to gain from beauty. Beauty encourages a perspective from which our ordinary priorities are up for grabs. True, our political commitments are among these priorities. But the condition of contemplating beauty is essential to the total economy of political 'engagement'.

In the first place, contemplation of beauty provides the receptive condition in which we can recognize our own moral insights. Beauty creates a space for spiritual openness. Political activism, taken by itself, does not.

Second, our political commitments are suspect if they cannot survive confrontation with beauty. Political commitment does not a sensitive person make. If one's political commitments are not themselves submitted to reflective reconsideration, they may come to function as fixed ideas, guiding action, but unresponsive to changing circumstances.

Third, beauty allows moral insight to develop further. As Danto notes, a certain sugar-coating encourages people to look at sights from which they would otherwise turn. His point was that such cases may reveal a prurient, sadistic appetite. But more often, I think, beauty provides the comforting background against which one can think the uncomfortable. An unfiltered awareness of the ailments of the world would nullify action. Indeed, no one's sanity could survive it. Beauty, however, assures us that something real is lovable. With that awareness, we are capable of the courage to face what is not.

Fourth, beauty teaches the possibility of degrees. Because beauty allows us to appreciate in a still, contemplative way, it develops our capacity for nuance. The response of moral outrage typically does not. Moral outrage speaks an extreme vocabulary. This may seem heroic in the case of certain demonstrations against the Vietnam War, or the more recent student demonstrations in Tiananmen Square; but lynch-groups and vigilantes are also motivated by moral

indignation. Without a sense of degrees, moral indignation is stupid and dangerous. Beauty may indeed have limits as a moral arm, but it is indispensable to reflective and responsible moral outrage.

Fifth and finally, political activism requires not only commitment and courage, but faith in the improvability of things and in the fundamental soundness of what is to be improved. The big threat to effective political action is not beauty, but despair. Nietzsche's insight into the courage necessary for revolutionary change makes this point: 'Place little good perfect things around you ...! Their golden ripeness heals the heart. What is perfect teaches hope.'[5] [...]

Perhaps the modern avoidance of beauty reflects our deepest fears about ourselves. Perhaps we doubt that we really do have enough of a heart to appreciate and transform at the same time. Obsessively aware of what is unbeautiful, we can only find beauty a threatening challenge. But the other side of this threat is a promise. Beauty promises, in Danto's phrase, to 'transfigure the commonplace' of our everyday reality. Its re-emergence could transfigure contemporary art as well.

1 Arthur C. Danto, 'Beauty and Morality', in *Embodied Meanings: Critical Essays and Aesthetic Meditations* (New York: Farrar, Straus & Giroux, 1994) 363–75.

2 Milan Kundera, *The Unbearable Lightness of Being* (New York: Harper & Row, 1984) 248.

3 Immanuel Kant, *Critique of Judgement,* trans. Werner S. Pluhar (Indianapolis: Hackett Publishing Company, 1987) 98, §23.

4 Shakespeare, 'Romeo and Juliet', act I, scene 5, lines 46–9.

5 [footnote 6 in source] Friedrich Nietzsche, *Thus Spoke Zarathustra,* in *The Portable Nietzsche,* ed. and trans. Walter Kaufmann (New York: Viking, 1968) 405.

Kathleen Marie Higgins, extract from 'Whatever Happened to Beauty? A Response to Danto', *The Journal of Aesthetics and Art Criticism*, vol. 54, no. 3 (Summer 1996) 281–4.

Elaine Scarry
On Beauty and Being Just//1999

The banishing of beauty from the humanities in the last two decades has been carried out by a set of political complaints against it. But, as I will try to suggest, these political complaints against beauty are themselves incoherent. Beauty is, at the very least, innocent of the charges against it, and it may even be the case that far from damaging our capacity to attend to problems of injustice, it instead intensifies the pressure we feel to repair existing injuries. I will try to set forth a sketch of the way aesthetic attributes exert this pressure on us.

When I say that beauty has been banished, I do not mean that beautiful things have themselves been banished, for the humanities are made up of beautiful poems, stories, paintings, sketches, sculpture, film, essays, debates, and it is this that every day draws us to them. I mean something much more modest: that conversation about the beauty of these things has been banished, so that we co-inhabit the space of these objects (even putting them inside us, learning them by heart, carrying one wedged at all times between the upper arm and the breast, placing as many as possible into our book bags) yet speak about their beauty only in whispers. [...]

The political arguments against beauty are incoherent
The political critique of beauty is composed of two distinct arguments. The first urges that beauty, by preoccupying our attention, distracts attention from wrong social arrangements. It makes us inattentive, and therefore eventually indifferent, to the project of bringing about arrangements that are just. The second argument holds that when we stare at something beautiful, make it an object of sustained regard, our act is destructive to the object. This argument is most often prompted when the gaze is directed towards a human face or form, but the case presumably applies equally when the beautiful thing is a mourning dove, or a trellis spilling over with sweet pea, or a book whose pages are being folded back for the first time. The complaint has given rise to a generalized discrediting of the act of 'looking', which is charged with 'reifying' the very object that appears to be the subject of admiration.

Whatever merit either of these arguments has in and of itself, it is clear at the outset that they are unlikely both to be true since they fundamentally contradict one another. The first assumes that if our 'gaze' could just be coaxed over in one direction and made to latch onto a specific object (an injustice in need of remedy or repair), that object would benefit from our generous attention. The second

assumes that generous attention is inconceivable, and that any object receiving sustained attention will somehow suffer from the act of human regard. Because the two complaints so fundamentally contradict one another, evidence that can be brought forward on behalf of the first tends to call into question the accuracy of the second; and conversely, evidence that can be summoned up on behalf of the second works to undermine the first.

If, for example, an opponent of beauty eventually persuades us that a human face or form or a bird or a trellis of sweet pea normally suffers from being looked at, then when the second opponent of beauty complains that beauty has caused us to turn away from social injustice, we will have to feel relieved that whatever harm the principals are now suffering is at least not being compounded by our scrutiny of them. If instead we are persuaded that beauty has distracted us from suffering, and that our attention to that suffering will help reduce the harm, we will have to assume that human perception, far from poisoning each object it turns towards, is instead fully capable of being benign. [...]

It is the argument of [this essay] that beauty, far from contributing to social injustice in either of the two ways it stands accused, or even remaining neutral to injustice as an innocent bystander, actually assists us in the work of addressing injustice, not only by requiring of us constant perceptual acuity – high dives of seeing, hearing, touching – but by the more direct forms of instruction. [...]

People spend so much time noticing one another that the practice will no doubt continue regardless of the conclusions we arrive at about beauty. But many arguments can be made to credit the pleasure people take in one another's countenance. Staring, as we earlier saw, is a version of the wish to create; it is directly connected to acts of drawing, describing, composing, lovemaking. It is odd that contemporary accounts of 'staring' or 'gazing' place exclusive emphasis on the risks suffered by the person being looked at, for the vulnerability of the perceiver seems equal to, or greater than, the vulnerability of the person being perceived. In accounts of beauty from earlier centuries, it is precisely the perceiver who is imperiled, overpowered, by crossing paths with someone beautiful. Plato gives the most detailed account of this destabilization in the *Phaedrus*. A man beholds a beautiful boy: suddenly he is spinning around in all directions. Publicly unacceptable things happen to his body. First he shudders and shivers. Then sweat pours from him. He is up, down, up, down, adopting postures of worship, even beginning to make sacrifices to the boy, restrained only by his embarrassment at carrying out so foolish an activity in front of us. Now he feels an unaccountable pain. Feathers are beginning to emerge out of his back, appearing all along the edges of his shoulder blades. Because this plumage begins to lift him off the ground a few inches, he catches glimpses of the immortal realm. Nonetheless, it cannot be denied that the discomfort he feels on the inside is matched by how

ridiculous he looks on the outside. The beholder in Dante's *Vita nuova* is equally at risk. Coming face-to-face with Beatrice, Dante undergoes a violent trembling. All his senses go into a huddle, alarmed at the peril to which he has exposed them. Soon he is so immobilized he might be mistaken for 'a heavy inanimate object'.

It is hard – no matter how dedicated one is to the principle of 'historical difference' – to account for the discrepancy between the aura of radical vulnerability beholders were assigned in the past and the aura of complete immunity they are assigned today. Someone committed to historicism might shrug and say, 'We just no longer see beauty in the same way.' But how can that be an acceptable answer if – as an outcome of this newly acquired, wretched immunity – people are asking us to give up beauty altogether? A better answer might be to say not that we see the beauty of persons differently but that we do not see it at all. Perhaps only if one spins momentarily out of control, or grows feathers, or begins to write a sonnet, can one be said to have seen the beauty of another person. The essentialist who believes beauty remains constant over the centuries and the historicist or social constructionist who believes that even the deepest structures of the soul are susceptible to cultural shaping have no need, when confronting the present puzzle, to quarrel with one another. For either our responses to beauty endure unaltered over centuries, or our responses to beauty are alterable, culturally shaped. And if they are subject to our wilful alteration, then we are at liberty to make of beauty what we wish. And surely what we should wish is a world where the vulnerability of the beholder is equal to or greater than that of the person beheld, a world where the pleasure-filled tumult of staring is a prelude to acts that will add to the beauty already in the world – acts like making a poem, or a philosophic dialogue, or a divine comedy; or acts like repairing an injury or a social injustice. Either beauty already requires that we do these things (the essentialist view) or we are at liberty to make of beauty the best that can be made – a beauty that will require that we do these things. [...]

It is important to contemplate the way beauty works not only with respect to someone one loves, but also with respect to the large array of beautiful persons walking through the public sphere. As we will eventually see, the fact that we look at beautiful persons and things without wishing to be ourselves beautiful is one of the key ways in which – according to philosophers like Simone Weil and Iris Murdoch – beauty prepares us for justice. It is then more useful simply to ask the nature of the relation between the person who pursues beauty and the beauty that is pursued. [...]

The structure of perceiving beauty appears to have a two-part scaffolding: first, one's attention is involuntarily given to the beautiful person or thing; then, this quality of heightened attention is voluntarily extended out to other persons or things. It is as though beautiful things have been placed here and there

throughout the world to serve as small wake-up calls to perception, spurring lapsed alertness back to its most acute level. Through its beauty, the world continually recommits us to a rigorous standard of perceptual care: if we do not search it out, it comes and finds us. The problem of lateral disregard is not, then, evidence of a weakness but of a strength: the moment we are enlisted into the first event, we have already become eligible to carry out the second. [...]

One final matter will enable us to move forward to the positive claims that can be spoken on behalf of beauty. We saw that the two political arguments are starkly incompatible with one another; and we also saw along the way that if we move into the intricacy of any one argument and one site – such as the site of persons – the objections on this more minute level are also wildly contradictory. If we were to move not into the intricate interior but outside to the overarching framework – if we were, in other words, to move outside the political arguments and contemplate their relation to the non-political arguments used to assault beauty – we would come face-to-face with the same incoherence.

A case in point is the demotion of beauty that has come about as a result of its juxtaposition with the sublime. It is not the sublime that is incoherent, nor even the way in which the sublime systematically demotes beauty that is incoherent. What is incoherent is the relation between the kinds of claims that are made by this demotion and the political arguments looked at earlier.

The sublime has been a fertile aesthetic category in the last twenty years and has been written about with such intricacy that I will sketch its claims only in the briefest form, so that those unfamiliar with it will know what the aesthetic is. At the end of the eighteenth century, writers such as Kant and Burke subdivided the aesthetic realm (which had previously been inclusively called beauty) into two realms, the sublime and the beautiful. [...]

The sublime occasioned the demotion of the beautiful because it ensured that the meadow flowers, rather than being perceived in their continuity with the august silence of ancient groves (as they had when the two co-inhabited the inclusive realm of beauty), were now seen instead as a counterpoint to that grove. Formerly capable of charming or astonishing, now beauty was the not-astonishing; as it was also the not-male, the not-mountainous, the not-righteous, the not-night. Each attribute or illustration of the beautiful became one member of an oppositional pair, and because it was almost always the diminutive member, it was also the dismissible member.

Furthermore, the path to something beyond both meadow flower and mighty tree, something detachable from their concrete surfaces – one might call it, as Kant did, eternity; or one might instead describe it as the mental realm where, with or without a god's help, the principles of justice and goodness hold sway – suddenly ceased to be a path of free movement and became instead a path lined

with obstructions. In its earlier continuity with the meadow flower, the magnificent tree had itself assisted, or at least not interrupted, the passage from blossom to the sphere of just principles; now the magnificent tree served as a giant boulder, a locked gate, a border guard, jealously barring access to the realm that had been reconceived as adjacent to itself and thus as only its own to own. The sublime now prohibited, or at least interrupted, the easy converse between the diminutive and the distributive.

One can see how oddly, yet effectively, the demotion from the sublime and the political demotion work together, even while deeply inconsistent with one another. The sublime (an aesthetic of power) rejects beauty on the grounds that it is diminutive, dismissible, not powerful enough. The political rejects beauty on the grounds that it is too powerful, a power expressed both in its ability to visit harm on objects looked at and also in its capacity to so overwhelm our attention that we cannot free our eyes from it long enough to look at injustice. Berated for its power, beauty is simultaneously belittled for its powerlessness.

The multiple, opposing assaults on beauty have worked in a second way. The sublime – by which I mean the outcomes that followed from dividing a formerly unitary realm into the sublime and the beautiful – cut beauty off from the metaphysical, permitting it to inhabit only the ground of the real. Then the political critique – along with a closely related moral critique and a critique from realism – come forward to assert that beauty (forever discomforting mortals with its idealized conceptions) has no place on the ground of the real. Permitted to inhabit neither the realm of the ideal nor the realm of the real, to be neither aspiration nor companion, beauty comes to us like a fugitive bird unable to fly, unable to land.

Beauty assists us in our attention to justice

The positive case that can be made on behalf of beauty has already begun to emerge into view and will stand forth more clearly if we place before ourselves the question of the relation between the beholder and the object beheld. The question can best be posed if we, for a moment, imagine that we are speaking not about the person who comes upon beauty accidentally, or the person who – after valiantly resisting beauty for all the reasons one should be warned against it – at last succumbs, but instead about a person who actively seeks it out.

What is it that such a person seeks? What precisely does one hope to bring about in oneself when one opens oneself to, or even actively pursues, beauty? When the same question is asked about other enduring objects of aspiration – goodness, truth, justice – the answer seems straightforward. If one pursues goodness, one hopes in doing so to make oneself good. If one pursues justice, one surely hopes to be able one day to count oneself among the just. If one pursues

truth, one wishes to make oneself knowledgeable. There is, in other words, a continuity between the thing pursued and the pursuer's own attributes. Although in each case there has been an enhancement of the self, the undertaking and the outcome are in a very deep sense unself-interested since in each case the benefits to others are folded into the nature of my being good, bearing knowledge, or acting fairly. [...]

But this continuity does not seem to hold in the case of beauty. It does not appear to be the case that one who pursues beauty becomes beautiful. It may even be accurate to suppose that most people who pursue beauty have no interest in becoming themselves beautiful. It would be hard to make the same description of someone pursuing the other objects of aspiration: could one pursue truth if one had no interest in becoming knowledgeable? This would seem like quite a feat. How exactly would one go about that? Would there be a way to approach goodness while keeping oneself free of becoming good? Again, a path for doing so does not immediately suggest itself. And the same difficulties await us if we try to come up with a way of furthering the goals of justice while remaining ourselves outside its reach.

Now there are at least three ways in which one might wish to say that the same kind of continuity between beauty and its beholder exists. The beholder, in response to seeing beauty, often seeks to bring new beauty into the world and may be successful in this endeavour. But those dedicated to goodness or truth or justice were also seeking to carry out acts that further the position of these things in the world; the particular alteration of self they underwent (the thing for which we are seeking a parallel) is something additional to the fact that they supplemented the world. A second answer is to say that beholders of beautiful things themselves become beautiful in their interior lives: if the contents of consciousness are full of the calls of birds, mental pictures of the way dancers move, fragments of jazz pieces for piano and flute, remembered glimpses of ravishing faces, a sentence of incredible tact and delicacy spoken by a friend, then we have been made intensely beautiful. Still, this cannot be a wholly satisfying reply since, though the beautiful object may, like the beholder, have internal beauty, it also has external features; this externality has long been held to be crucial to what beauty is, and even to its particular way of turning us towards justice. But there is a third answer that seems more convincing. [...]

The thing perceived, the beautiful object, has conferred on it by the beholder a surfeit of aliveness: even if it is inanimate, it comes to be accorded a fragility and consequent level of protection normally reserved for the animate; if inanimate, like a poem, it may, by being memorized or read aloud to others, thereby be lent the aliveness of the person's own consciousness. If what is beheld is instead a person, he or she may sponsor – literally – the coming into the world of a

newborn, so that the person now stands companioned by additional life; the more general manifestation of this same phenomenon is visible in the way one's daily unmindfulness of the aliveness of others is temporarily interrupted in the presence of a beautiful person, alerting us to the requirements placed on us by the aliveness of all persons, and the same may take place in the presence of a beautiful bird, mammal, fish, plant. What has been raised is not the level of aliveness, which is already absolute, but one's own access to the already existing level of aliveness, bringing about, if not a perfect match, at least a less inadequate match between the actual aliveness of others and the level with which we daily credit them. Beauty seems to place requirements on us for attending to the aliveness or (in the case of objects) quasi-aliveness of our world, and for entering into its protection.

Beauty is, then, a compact, or contract between the beautiful being (a person or thing) and the perceiver. As the beautiful being confers on the perceiver the gift of life, so the perceiver confers on the beautiful being the gift of life. [...]

The notion of a pact here again comes into play. A single word, 'fairness', is used both in referring to loveliness of countenance and in referring to the ethical requirement for 'being fair', 'playing fair' and 'fair distribution'. One might suppose that 'fairness' as an ethical principle had come not from the adjective for comely beauty but instead from the wholly distinct noun for the yearly agricultural fair, the 'periodical gathering of buyers and sellers'. But it instead, as scholars of etymology have shown, travels from a cluster of roots in European languages (Old English, Old Norse, Gothic), as well as cognates in both Eastern European and Sanskrit, that express the aesthetic use of 'fair' to mean 'beautiful' or 'fit' – fit both in the sense of 'pleasing to the eye' and in the sense of 'firmly placed', as when something matches or exists in accord with another thing's shape or size. [...]

Fairness as 'a symmetry of everyone's relation to one another'

[...] At the moment we see something beautiful, we undergo a radical decentring. Beauty, according to Simone Weil, requires us 'to give up our imaginary position as the centre. ... A transformation then takes place at the very roots of our sensibility, in our immediate reception of sense impressions and psychological impressions.' Weil speaks matter-of-factly, often without illustration, implicitly requiring readers to test the truth of her assertion against their own experience. Her account is always deeply somatic: what happens, happens to our bodies. When we come upon beautiful things – the tiny mauve-orange-blue moth on the brick, Augustine's cake, a sentence about innocence in Hampshire – they act like small tears in the surface of the world that pull us through to some vaster space; or they form 'ladders reaching toward the beauty of the world', or they lift us (as though by air currents of someone else's sweeping), letting the ground rotate beneath us several inches, so that when we land, we find we are standing in a

different relation to the world than we were a moment before. It is not that we cease to stand at the centre of the world, for we never stood there. It is that we cease to stand even at the centre of our own world. We willingly cede our ground to the thing that stands before us. [...]

It is as though one has ceased to be the hero or heroine in one's own story and has become what in a folktale is called the 'lateral figure' or 'donor figure'. It may sound not as though one's participation in a state of overall equality has been brought about, but as though one has just suffered a demotion. But at moments when we believe we are conducting ourselves with equality, we are usually instead conducting ourselves as the central figure in our own private story; and when we feel ourselves to be merely adjacent, or lateral (or even subordinate), we are probably more closely approaching a state of equality. In any event, it is precisely due to the ethical alchemy of beauty that what might in another context seem like a demotion is no longer recognizable as such: this is one of the cluster of feelings that have disappeared.

Radical decentring might also be called an opiated adjacency. A beautiful thing is not the only thing in the world that can make us feel adjacent; nor is it the only thing in the world that brings a state of acute pleasure. But it appears to be one of the few phenomena in the world that brings about both simultaneously: it permits us to be adjacent while also permitting us to experience extreme pleasure, thereby creating the sense that it is our own adjacency that is pleasure-bearing. This seems a gift in its own right, and a gift as a prelude to or precondition of enjoying fair relations with others. It is clear that an ethical fairness which requires 'a symmetry of everyone's relation' will be greatly assisted by an aesthetic fairness that creates in all participants a state of delight in their own lateralness. [...]

Beauty may be either natural or artefactual; justice is always artefactual and is therefore assisted by any perceptual event that so effortlessly incites in us the wish to create. Because beauty repeatedly brings us face-to-face with our own powers to create, we know where and how to locate those powers when a situation of injustice calls on us to create without itself guiding us, through pleasure, to our destination. The two distinguishable forms of creating beauty – perpetuating beauty that already exists; originating beauty that does not yet exist – have equivalents within the realm of justice, as one can hear in John Rawls' formulation of what, since the time of Socrates, has been known as the 'duty to justice' argument: we have a duty, says Rawls, 'to support' just arrangements where they already exist and to help bring them into being where they are 'not yet established'. [...]

But what if now the deliberation turned to objects and events, instead of being evenly distributed across the world, were emphatically non-distributional. 'Shall

there be here and there an astonishingly beautiful underground cave whose passageways extend several miles, opening into crystal-lined grottos and large galleries of mineral latticework, in other galleries their mute walls painted by people who visited thousands of years earlier?' Those from whom we are seeking counsel cannot assume that they are likely to live near it, for they have been openly informed that the caves about which they are being asked to vote exist in only two places on earth. Nor can they even assume that if fate places them near one of the caves, they will be able to enter its deep interior, for climbing down into the galleries requires levels of physical agility and confidence beyond what are widely distributed among any population. But here is the question: isn't there every reason to suppose that the population will – even in the face of full knowledge that the cave is likely to be forever unavailable to them – request that such a cave be kept in existence, that it be protected and spared harm? Isn't it possible, even likely, that the population will respond in exactly the same way towards objects that are non-distributional as to those that are shared across the surface of the earth, that they will – as though they were thinking of skies and flowers – affirm the existence of remote caves and esoteric pieces of music (harder to enter even than the cave) and paintings that for many generations are held by private collectors and seen by almost no one's eyes?

People seem to wish there to be beauty even when their own self-interest is not served by it; or perhaps more accurately, people seem to intuit that their own self-interest is served by distant peoples' having the benefit of beauty. For although this was written as though it were a thought experiment, there is nothing speculative about it: the vote on blossoms has already been taken (people over many centuries have nurtured and carried the flowers from place to place, supplementing what was there); the vote on the sky has been taken (the recent environmental movement); and the vote on the caves has innumerable times been taken – otherwise it is inexplicable why people get so upset when they learn that a Vermeer painting has been stolen from the Gardner Museum without any assurance that its surface is being protected; why people get upset about the disappearance of kelp forests they had never even heard of until the moment they were informed of the loss; why museums, schools, universities take such care that beautiful artefacts from people long in the past be safely carried forward to people in the future. We are not guessing: the evidence is in.

Elaine Scarry, extracts from Part Two, 'On Beauty and Being Fair', *On Beauty and Being Just* (Princeton, New Jersey: Princeton University Press, 1999) 57–67; 71–8; 81–97; 107–15; 122–4 [footnotes not included].

Wendy Steiner
Venus in Exile: The Rejection of Beauty in Twentieth-Century Art//2001

[...] Beauty is certainly a magnet for the cultural anxieties of our day: the readjustment of gender roles that has been in the works since the Enlightenment, the commodification of the body in consumer culture, the genetic and evolutionary discoveries changing our understanding of human nature. In the eyes of the geneticist, for example, female beauty is a competitive packaging that increases a woman's chances of perpetuating her genes; for the beauty industry, this packaging perpetuates multinational profits. One way or the other, female freedom and self-realization would seem to require resistance to such an aesthetics. But eschewing beauty comes at a high price if it closes off passion and procreation and self-understanding. For many women, beauty appears to set freedom and pleasure at odds.

Indeed, this is true for men as well. The Enlightenment may have celebrated beauty as an experience of freedom from contingency, but in our day beauty seems anything but a liberation, bearing witness, instead, to our socialization or biology. Are we taught to identify certain traits – in people, nature, art – as beautiful, or do we come into the world wired to admire? If the response to beauty is learned, then how should we react to the fact of this acculturation? Beauty in a multi-ethnic society, for example, would seem suspect unless every race can lay equal claim to being beautiful, and that is still far from the case in many countries. But perhaps, on the contrary, our aesthetic socialization is a good thing, every touch with beauty amounting to an all too rare experience of community and shared values. [...]

The history of twentieth-century elite art is in many respects a history of resistance to the female subject as a symbol of beauty. This resistance, in its turn, is related to real-world struggles during the past century – the past two centuries, in fact – as society learned (and continues to learn) to consider women fully human. In general, the avant-garde stood contemptuously aloof from this struggle, disdainful of woman in either her traditional or emerging meanings. Modernists vilified aesthetic pleasure, defining the sublime aspirations of art as unrelated or antipathetic to the pleasures of feminine allure, charm, comfort. At the same time, they treated the 'new woman' and the goal of female self-realization as equally irrelevant to the laboratory of the modern. Though we might deplore their failure to inspirit women during this crucial period of history, the avant-garde inadvertently aided the women's movement in treating 'the weaker sex' with so little sympathy. Their motives, of course, were utterly different:

modernist misogyny is something to behold! Nevertheless, their violent break from an aesthetics of passive allure now frees us, paradoxically, to contemplate new possibilities in beauty and its female symbolism. For both feminist and modernist reasons, it is impossible to return to the old stereotypes of woman in the arts. The task that awaits us is nothing less than the reimagination of the female subject as an equal partner in aesthetic pleasure. [...]

Far from a God-given virtue, beauty now appears an impossible ideal set by voracious financial and sexual interests. Even women who survive this oppression do not emerge unscathed. Naomi Wolf, for example, tells of her bouts with anorexia and low self-image in the best-selling *Beauty Myth*, but puts her attractive image on the cover. As a result, her story of victimization by men and the media ends up looking a lot like self-advertising. Women cannot win as long as beauty is seen as exclusive and controlling, regardless of whether they exert this power themselves or others exert it upon them. The problem is how to imagine female beauty, in art or outside it, without invoking stories of dominance, victimization and false consciousness.

For a start, I think, we must stop treating beauty as a thing or quality, and see it instead as a kind of communication. We often speak as if beauty were a property of objects: Some people or artworks 'have' it and some do not. But *pace* Kant and Burke, the judgement of beauty in a person or artwork varies enormously from one person to the next, and in the course of time, even within the same person. These shifts and differences are meaningful and valid, and not 'fallings away' from some 'truth' or 'higher taste'. Beauty is an unstable property because it is not a property at all. It is the name of a particular interaction between two beings, a 'self' and an 'Other': 'I find an Other beautiful'. This act of discovery, we shall see, has profound implications.

It might appear that some form of inequality is already invoked here, before we have gone beyond the first step in our discussion. The 'self' judging the beauty of art, for example, is a perceiver and hence a conscious subject, whereas the 'Other' is merely the object of this perception. If the Other is an artwork, it is inanimate by definition; many people would argue that the perception of a woman (or man or child) as beautiful reduces her to the status of a thing as well. Indeed, in the perennial symbolism surrounding beauty, the perceiver (the self) is active and 'hence' male, and the artwork or woman (the Other) is passive (to-be-seen) and 'therefore' female.

However, dominant as the perceiver may appear in the act of judgement, the aesthetic object turns out to be no shrinking violet. In the course of aesthetic experience, the perceiver may be overwhelmed by this 'mere object', overcome with emotion, altered to the very roots of his being. [...] The experience of beauty involves an exchange of power, and as such, it is often disorienting, a mix of

humility and exaltation, subjugation and liberation, awe and mystified pleasure. Even if we invoke the traditional model of a self that is gendered 'male' and an artwork that is gendered 'female', they would resemble Shakespeare's Benedick and Beatrice, with Beatrice giving out as good as she got. Many people, fearing a pleasure they cannot control, have vilified beauty as a siren or a whore. Since at one time or another though, everyone answers to 'her' call, it would be well if we could recognize the meaning of our succumbing as a valuable response, an opportunity for self-revelation rather than a defeat.

Unfortunately, modernism has trained us against such an understanding. The avant-garde operated with a one-way model of power, attempting to limit the artwork to the status of a thing – a form, a machine, an ethnographic fetish, the merest hint of an idea, a nought. The perceiver, perplexed and ungratified by such a work, had no choice but to see the artist as the real centre of attention. A wizard hiding behind the curtain perhaps, the artist was the prime and only 'mover'. If perceivers experienced any pleasure or transport in contemplating such cerebral, alienating works, they could credit the artist's genius, or perhaps his uncompromising honesty in presenting this minimal pleasure as all that modern life could afford. So much for pleasured beauty!

In this way, twentieth-century modernism perpetrated a cultural deprivation from which we are only now recovering. It involved a double dehumanization: art reduced to thing; audience reduced to stereotype – the caricature of the bourgeois philistine incapable of appreciating beauty. Our emergence from these avant-garde assumptions reflects much more, however, than a renewed desire for the gratification of beauty. It entails a flexibility and empathy toward 'Others' in general and the capacity to see ourselves as both active and passive without fearing that we will be diminished in the process. […]

In the hope of contributing to this process, I would offer a twenty-first-century myth of beauty, freely adapted from the Hellenistic past: the story of Psyche and Cupid. In this tale, the mortal Psyche (the Soul) is married to the divine Cupid (Love), but does not know his identity or even what he looks like. He visits her only in darkness and disappears with the dawn. Psyche's sisters, however, jealous of the riches he has showered upon her, claim that he must be a monster and urge her to investigate. So one night, Psyche lights a candle and gazes on her sleeping husband. She finds the opposite of a monster and is so overcome with his beauty that her hand trembles and a drop of burning wax falls on the god's still form, awakening him. Seeing her disobedient, unworthy gaze (she is awed, burning), Cupid deserts her, flying up towards the heavens. Psyche grabs on to his leg and is carried up briefly, but she soon falls to earth, for she is a mere mortal. Yearning to be reunited with Cupid's heavenly beauty, she performs a series of superhuman tasks that earn her immortality. She then

dwells in heaven as Cupid's equal, and the offspring of their union is a divine child. Pleasure.

This myth is a little allegory of aesthetic pleasure, as the soul, moved by beauty, becomes worthy of love and its delights. It might be seen as a friendly amendment to Romanticism as well. Exactly two hundred years ago, William Wordsworth wrote, 'We have no sympathy but what is propagated by pleasure'. The Psyche myth rewrites that maxim: We have no pleasure but what is propagated by sympathy. Sympathy is the product of the interaction that we call beauty, an interaction in which both parties become aligned in value and, in the process, become in some sense equal. [...]

Value is thus always central to the meaning of beauty. We often say that something or someone is beautiful, in fact, when what we mean is that they have value for us. Parents find their infants inexpressibly beautiful for this reason – because so much of what they care about is focused in this tiny creature. Even when we use the term in a purely artistic context, a beautiful object is something we value, and we value it because it touches our dearest concerns. In our gratitude towards what moves us so, we attribute to it the property of beauty, but what we are actually experiencing is a special relation between it and ourselves. We discover it as valuable, meaningful, pleasurable to us. [...]

This attribution, though, is only the beginning of the experience of beauty. Psyche discovers Cupid's beauty as a thrilling, overpowering force that is at the same time unavailable to her. Beauty may provoke awe, admiration and fear, but much more valuable are the insight, understanding and empathy to which it may lead. Just as Psyche earns her right to Pleasure by surpassing her previous limits, finding something or someone beautiful entails becoming worthy of it, in effect, becoming beautiful, too, and recognizing oneself as such. The experience of beauty involves a challenge to achieve the value or beauty of the Other. This elevation requires effort, interpretation, openness, but once achieved, however fleetingly or vicariously, the result is a pleasure different in kind from normal experience.

Thus, the judgement of beauty is not a one-way street. One discovers a valuable Other, and rises to recognize oneself in it. In doing so, one 'participates' in beauty. This gratifying self-expansion produces profound generosity towards the beautiful Other. The person or artwork claims nothing but receives all; the lover or critic is validated but credits the Other. This is a win-win situation if ever there was one, and occasions great pleasure. It also occasions utter confusion as to the direction of agency involved, for the object or person who can elicit the perceiver's pleasure through its passivity does not seem passive at all. The 'power of beauty' is a mystification of the perceiver's magnanimity, but how grateful we are to a force that can show us ourselves so great in spirit.

Little of this pleasurable and complex reciprocity occurs in the experience of

the Kantian sublime, which was the aesthetic model for high modernism. In the sublime, as we shall see, aesthetic experience is specifically the non-recognition of the self in the Other, for the Other is chaotic, annihilating, though paradoxically our limited nature manages to conceive its limitlessness. Awe, admiration and fear are the cardinal emotions of the sublime, seen as ends in themselves or else proof of the perceiver's heroic ability to persist amid such forces. Here, the Soul does not even try to hold on to the god in his upward flight, for it knows it is not his equal. Its value lies in its ability to grasp the immensity of this gap, leaving the Other untouched and unrecognized except as Other. The self in this interchange may be sublimely unfettered, but it is also unfastened, unconnected to the object of its awe.

Compared to this thrilling detachment, sometimes called 'freedom', the experience of beauty appeared to modern artists to involve unreasonable and constricting demands; solicitations for admiration, involvement, reciprocity, empathy. So did the main symbol of such beauty, the female subject. The avant-garde were utterly hostile toward the 'feminine aesthetics' of charm, sentiment, and melodramatic excess, which they associated with female and bourgeois philistinism. Their lack of sympathy with the Other rendered the experience of artistic (and often human) beauty an experience of alienation. [...]

At the same time that the avant-garde declared its contempt for the 'soft aesthetics' of the past, feminists were campaigning against a view of woman as passive and inferior. In such a climate, the female subject was too symbolically fraught to initiate anything like the generous mutuality achieved through Psyche's experience of beauty. This is a pity, not because we should want to return to the unliberated days before feminism, but because the mutuality implied in the female analogy is an immensely valuable possibility in art. So was the train of thought about art and women that modernism suspended. The entailment of beauty and woman will not go away simply by avant-garde or feminist fiat. And neither can artists proceed much longer ignoring their audience's desire for pleasure. The time has come for a change, and the sudden, widespread fascination with beauty in our day indicates a cultural readiness to move on.

It is the task of contemporary art and criticism to imagine beauty as an experience of empathy and equality. If we can discover the bonds between value and mutuality forged in aesthetic response, the female subject of art (and ultimately the male subject, too) will be available once again to symbolize a beauty that moves us to pleasure. And that pleasure will be seen as life-enhancing rather than exclusive or oppressive. [...]

Wendy Steiner, extract from 'Proem', *Venus in Exile: The Rejection of Beauty in Twentieth-Century Art* (Chicago: The University of Chicago Press, 2001) xviii-xxv. [footnotes not included].

Suzanne Perling Hudson
Beauty and the Status of Contemporary Criticism//2003

Beauty is a power we should reinvest with our own purpose.
– Felix Gonzalez-Torres, 1994

In December 1994, the veteran *New Yorker* dance critic Arlene Croce published a polemical piece of criticism that assumed the form of a non-review, an essay-length argument marked by a spectrally present – if otherwise unilaterally refused – object of enquiry at its core. In her 'Discussing the Undiscussable', Croce details her refusal to attend the recent work of the black, gay, HIV-positive choreographer Bill T. Jones on the grounds that his *Still/Here* (performed at the Brooklyn Academy of Music on 2 December 1994) was in fact little more than an instance of the rapidly proliferating 'victim art' – replete, as it was, with video and audiotapes of 'real' terminally ill cancer and AIDS patients juxtaposed with live performance by other sick dancers.[1] The dance's invocation of a kind of unmediated experience of death and suffering thus rendered questions of theatre and form essentially moot for Croce, while the dance itself was decried as 'beyond criticism'. The dancers, here described as 'dissed blacks, abused women or disenfranchised homosexuals', clearly fared no better than the context in which their inauspicious performances were articulated, as they too remained resolutely beyond the pale for Croce, and thereby outside the discursive framework she motivates.

Pathology is certainly at issue here, although to no greater extent than the status of criticism per se, put under pressure, as it is, in the wake of multiculturalism and identity politics, not to mention the AIDS crisis and the 'culture wars' promulgated in response to the funding decisions proffered by the National Endowment for the Arts. The problem thus becomes one of criticism's – or the critic's – agency and viability, or to put the matter slightly differently, its triviality and inconsequence in relation to its seemingly welcomed obsolescence in the face of new aesthetic and cultural forms. And as critics can stubbornly and piously refuse to engage with art at all, a certain modality of contemporary criticism has, indeed, arrived at its terminus. [...]

It strikes one that in the wake of the long, episodic line of NEA fiascos – those enacted over Andres Serrano's 1989 *Piss Christ* (a Cibachrome print depicting a crucifix submerged in a ravishing pool of the artist's urine), Robert Mapplethorpe's questionably 'pornographic' photography, the work of the controversial performance artist Karen Finley, the Museum of Contemporary Art

in San Diego's 1993 distribution of ten-dollar bills to undocumented Mexican workers, or the Brooklyn Museum of Art's 1999 'Sensation' show easily come to mind – the status of the critic *should* be at its apogee. And yet, we are now witnessing the waning of a historical moment in which criticism might have had real social and political purchase. Instead of entering a public sphere of discourse, artistic production and institutionalization, most critics of late have chosen to retreat into academic solipsism and abstruse theoretical models, further marginalizing their attempts at appraisal in favour of jargon-laden rhetorical gymnastics, or, alternately, offering the market congratulatory and blithely affirmative pieces. Croce's text might have been hyperbolically inflammatory, although its wager must have been its implicit proposal for a mode of intervention. That such a move is required – on the right or the left – to provoke a critical outpouring sadly points to the real bankruptcy of criticism.[2] We might profitably ask what, at present, is recoupable for criticism and the advanced art it should, seemingly, be equipped to discuss.

One answer to this impasse seems to be that of the return of the aesthetic and its attendant mode of exegesis, belles-lettres. Certainly a form of compensation given the terrain that I have, thus far, summarily sketched out, a return to beauty and ideas of taste and morality reads symptomatically as a desire to move beyond the abject and the victimized, to repress the AIDS crisis and its representations, and to shore up culture in the face of identity-politic relativism. Beauty, that most conciliatory of philosophical rubrics and justifications, is back with a vengeance, while beautiful writing about beautiful objects and their beautiful makers additionally denotes the triumph of academic philosophy as well as the democratization of the no-longer autonomous and privileged realm of the aesthetic. […]

The rise of beauty, as I will suggest, has everything to do with the crisis of criticism of which the Croce run-in is but an emblematic and explicitly catalytic example. Beauty represents the other side of the coin, as it were, that which can fill the spaces left vacant in the evacuation of strident critical activity, and that which can operate in exactly those interstices otherwise deterritorialized and thus rendered mute. In short, beauty too often serves to placate an anxious public, operating in the service of the maintenance of the status quo. This is not to suggest that beauty cannot be invested with other purposes, or even that it is insufficient as a productive aesthetic term in its own right, but rather that its ubiquity at present can be explained, at least in part, by its unparalleled ability to mollify and appease, in short, to reconcile. […]

Even the 2002 Museum of Modern Art, New York, retrospective of Gerhard Richter unleashed a fury of praise couched in terms of beauty and aesthetic primacy. Robert Storr, the exhibition's chief curator and the author of two MoMA

Richter publications, appeared on the PBS programme *Charlie Rose* pronouncing and reiterating the beauty of Richter's paintings (candles and landscapes rated high in this context), while Peter Schjeldahl's review of the show for *The New Yorker* said that the 1988 'Vermeeresque' painting of Richter's daughter, *Betty*, 'seems to me the single sharpest blow struck in recent art-world debates about the value of aesthetic pleasure. It is a one-punch knockout for the revival of beauty'.[3] When read against Schjeldahl's assenting 1994 'Notes on Beauty' (first published in *Art issues*, and reprinted in the anthology *Uncontrollable Beauty*, New York, 1998), this comment is to be expected, even if he does note therein: 'I do not discuss beauty with curators. It would only discomfit them and embarrass me.' Moreover, he writes, 'Beauty ... is always mixed up with something else, some other quality or value – or story, even, in rudimentary forms of allegory, "moral" or "sentiment".' 'Beauty entails a sense of the sacred.' 'There is something crazy about a culture in which the value of beauty becomes controversial.'[4]

Of late, Hal Foster too has come down on the question of beauty in Richter, arguing against this kind of conciliatory position for beauty as represented by Schjeldahl as much as by Kant or Schiller or, above all, Stendhal. He writes:

> Such reconciliation is not possible for postwar artists like Richter, for whom art, beauty and semblance are all transformed not only by mass media but by the historical traumas of world war and the Holocaust. Richter does deliver beauty, to be sure, but when it is credible it is beauty with a traumatic core, a 'wounded' beauty that works over (but not through) its own loss – as beautiful painting, as great tradition, as resplendent semblance.[5]

Beauty here is operable only in so far as it entails a certain implacability, so that it holds tensions in play rather than wistfully papering them over or simply and improbably wishing them away. I think that this is a right assessment given the historical circumstances Foster invokes, as well as the previously suggested situation made legible by means of the AIDS crisis and the concomitant NEA debates. For artists such as Richter and Felix Gonzalez-Torres, beauty – as a deliberate, strategic mode of aesthetic presentation and performance – opens onto questions of the political and loss quite specifically. Beauty, then, in its most apposite contemporary manifestations has everything to do with Foster's notion of credibility, or to put the matter somewhat differently, its timeliness and its utter and unsettled self-consciousness.

Dave Hickey's seminal if highly fraught *The Invisible Dragon* has much to say in this regard. His book was the first to take up the condition of beauty in the present, and it is rife with anecdotes and even endorsements – we find none other than Schjeldahl on the back cover saying: 'Dave Hickey is my hero and the

best-kept secret in art criticism, a great mind driven not by necessity but by desire – erudite, generous, free. If this book of shocking intelligence and moral hope is read widely and above all well, word for word, it will help the world.' Circulating here is an appeal to the implicit connection between ethics and aesthetics to which Scarry similarly has recourse, as well as a suggestion that the real nature of Hickey's interest lies in his position as an unknown outsider 'driven not by necessity but by desire'. The latter claim is fictive to be sure – in fact, Hickey is positioned within the academy, teaching at the University of Nevada, Las Vegas, and he has additionally owned and directed an art gallery, curated SITE Santa Fe's Fourth Biennial (2001), and even won the prestigious MacArthur Fellowship (also in 2001) – although the point is that Hickey's reputation turns on precisely such rhetoric. When compounded with Hickey's consummate skill as a writer, his market-driven democratic aesthetic becomes invidious, as his prodigious claims are too often taken up by a suite of like-minded critics eager to appease the directives of their publication venues and, importantly, their audiences. However, I do not mean wholly to dismiss Hickey's work either; indeed, his argument is at times seductive, especially when he contextualizes the stakes of beauty in the late eighties.

Hickey is particularly good on the question of the role of the market and beauty's function within it. In this vein he writes, 'if you broached the issue of beauty in the American art world of 1988, you could not incite a conversation about rhetoric – or efficacy – or pleasure – or politics – or even Bellini. You ignited a conversation about the market.'[6] In short, beauty signified merely 'how something looks' as opposed to the more highly valued 'what something means', thus framing the debate in terms of the bifurcation of appearance and content as if the two terms were mutually exclusive.

Of course, much has changed in the past decade. Such a transformation of the status of beauty from an index of art's market conditions to the very stuff of which art gets made and through which it gets discussed has, I contend, everything to do with the culture wars and the place of the public for contemporary American art. Accordingly, Mapplethorpe figures prominently in Hickey's account (both in terms of his actual project and its public and critical reception), as he well should, given the enormous implications and consequence of his photography's presumed cultural defamation: a Mapplethorpe retrospective organized by the University of Pennsylvania's Institute of Contemporary Art in 1989 – ironically the twentieth anniversary of the Stonewall Rebellion – had received $30,000 in NEA funding. It was scheduled to open at the Corcoran Gallery of Art in Washington, D.C., when Dick Armey, a Republican congressman from Texas, mounted a campaign culminating in a letter signed by a hundred other members of Congress threatening to cut the

agency's budget in an attempt to end its sponsorship of 'morally reprehensible trash'.[7] This is precisely what happened, although it did not stop there: more conservative members were appointed to the NEA's governing body, grant decisions were overturned, and right-wing politicians called the populace to arms, a moral charge such politicians meant Americans to take seriously. [...]

At the centre of such debates – and here the Croce situation returns as both epigraph and coda – is an anxiety about the body and disease. More broadly, however, the debate is, as always, a matter of public culture and who constitutes the body politic. Moreover it is a matter of the place of art's activism or the conditions of possibility for praxis, whether in terms of the responsibility and interest of the artist or the critic. So, to return once more to the Mapplethorpe phenomenon, Hickey encapsulates his reading of the situation as follows:

> This uproar seemed to be one of those magic occasions when the private visual litigation that good art conducts might expand into the more efficacious litigation of public politics – and challenge some of the statutory restrictions on the conduct Robert's images celebrate. I was wrong. The American art community, at the apogee of its power and privilege, chose to play the ravaged virgin, to fling itself prostrate across the front pages of America and fairly dare the fascist heel to crush its outraged innocence.[8]

Hickey is rightly disappointed and openly aggrieved by the art world's placating brand of politics, although his claims are later interestingly and rather baldly grounded in the context of beauty. In short, the problem with Mapplethorpe's work was 'not that men were making it, then, but that Robert was "making it beautiful"'. Hickey continues in a citation worth repeating at length:

> It was, exactly, [Mapplethorpe's 'X' Portfolio's] beauty that had lit the charge – and, in this area, I think, you have to credit Senator Jesse Helms, who, in his antediluvian innocence, at least saw what was there, understood what Robert was proposing, and took it, correctly, as a direct challenge to everything he believed in. The senator may not know anything about art, but rhetoric is his business and he did not hesitate to respond to the challenge. As one would hope, he had a right to. Art is either a democratic political instrument, or it is not.[9]

This question of art as democratic or even populist is, in a word, what underlies Hickey's critical project. In this regard, the question of exhibition practice and the criticism it engenders acquires an important meaning as a means of social (again read democratic) participation and form of cultural and discursive legitimacy. And while I am sympathetic to Hickey's impassioned recognition of

an art public to be addressed at all, I think that it is precisely the failure of the democratic model that he invokes that ultimately franchises the return of beauty and conciliatory aesthetics yoked to consensual politics.

Indeed, Hickey's own curatorial work on the 2001 SITE Santa Fe Biennial 'Beau Monde: Toward a Redeemed Cosmopolitanism' attests to the ways in which popular gestures end up as mechanisms of cultural consolidation. Here, under the aegis of beauty and a contingent recourse to design, 'Beau Monde' offered regional identities and discrete projects as just so many pretty rooms. As stated in SITE Santa Fe's press release, Hickey conceived of this situation as 'a melting pot in which nothing melts'. This seems to be precisely what the organizers of the exhibition explicitly required, as Louis Grachos, the SITE Santa Fe director, commented that choosing Hickey was the unequivocal antidote to the overtly political biennial mounted by curator Rosa Martínez in 1999. Her show had provoked protests 'from residents who thought their town was being desecrated by radical artists'.[10] 'Hickey', as Grachos demurred, 'brings us back indoors'.[11]

Nevertheless, Hickey's earlier intuition vis-à-vis Mapplethorpe – that beauty is political when wielded in certain knowing ways,[12] and when it is applied to particular, contentious subjects – is useful in so far as it recuperates the aesthetic as a rhetorical strategy. So, by way of a rather protracted conclusion, I would like to propose a kind of counter-model to that of Mapplethorpe as understood by Hickey. At the time when Mapplethorpe was throwing beautiful scenes of homosexual *frisson* in the face of a maligned public and Congress, Felix Gonzalez-Torres was working with piles of candy, stacks of paper, jigsaw puzzles, billboards, mirrors and strings of light. It was not that his work was not political – his work is nothing if not political – or did not address sexual politics in the wake of AIDS, but rather that it did not unreservedly flaunt this fact. In his reworking of the tropes of Minimalism and conceptual art, installation and institutional critique, Gonzalez-Torres' project counters notions of absence, longing and loss with the kind of 'wounded' and self-critical beauty outlined above. His use of past artistic languages that contest normative aesthetics (and, importantly, are devoid of visual pleasure) works to undermine the autonomy of art, even as his contemporary use of such precedents registers their implicit, if paradoxical, status as political and aesthetic in equal measure.

Gonzalez-Torres' mode, then, is one of infiltration, one that he alternately, and significantly, likens to being in drag,[13] or to a virus.[14] Meaning or content is implicit in most pieces, remaining latent without becoming peripheral, while beauty is neither the means for redemption (be it aesthetic or personal), nor contestation per se. It is instead a *strategy* of aesthetic production capable of veiling and communicating claims for art and its function within a community.[15] [...]

Premised on ideal heights and weights and determined, in part, by the

particularities of each installation site, the stacks dwindle over the course of an exhibition, as viewers are encouraged to take sheets away. Further, the owner or the institution exhibiting the work is not obligated to maintain the ideal height – the stacks can either be constantly replenished or the floor space can be left empty after the last sheet has been taken, which allows the owner or curator a great deal of flexibility and interpretive freedom. The stacks mimic the solidity of sculpture from a distance, only to disintegrate one sheet at a time. The paper might be understood as an antidote to institutional possessiveness, becoming a kind of gift or souvenir for the viewer, all the while resisting a move into the strictly conceptual as analogue to a kind of dematerialized aesthetic withdrawal. And yet, the sheets also undermine the status of the autonomous art object, instancing, if dissolving, the boundaries between object and image or sculpture and photography, additionally staging a self-reflexive dispersal of sculpture beyond the walls of the institution. Likewise, the integrity of a stable and unitary work is thereby renounced, as the structure of the work quite literally (formally) enacts the absence upon which its wounded beauty is premised, encouraging the viewer to meditate on the participatory space the work engenders. […]

Take, for example, the memento mori of 1991, entitled *Untitled (Perfect Lovers)*. This piece is characteristic in that it is evocative, not illustrative; two synchronized clocks hung side by side mark off the passage of time. While the piece is clearly 'about' Gonzalez-Torres and his partner, it is also about any lovers, be they homosexual or heterosexual, and the reality of impermanence and the threat and fear of imminent loss.

When contrasted with Nayland Blake's *Every 12 Minutes* (also from 1991), the role of beauty becomes clear. Where Gonzalez-Torres' clocks have blank faces, Blake's comes replete with text ('One AIDS Death/STOP IT'), thereby exhibiting the artist's ideological underpinnings and political aspirations. The point of this comparison is not a matter of aesthetics, but rather the ways in which activism is, or refuses to be, pictured. As Simon Watney reminds us, that 'there can be no single approach or strategy for representing AIDS adequately or appropriately', these different modes are precisely just that.[16] And yet, I would argue that Gonzalez-Torres' piece is the more successful of the two, in that it circulates – read infiltrates – art and other spaces and discourses that Blake's, by virtue of its heavy-handedness and its blatant desire for propagandistic transgressiveness, never could.[17] As Gonzalez-Torres puts it:

Two clocks side by side are much more threatening to the powers that be than an image of two guys sucking each other's dicks, because they cannot use me as a rallying point in their battle to erase meaning. It is going to be very difficult for members of Congress to tell their constituents that money is being expended for

the promotion of homosexual art when all they have to show are two plugs side by side, or two mirrors side by side, or two lightbulbs side by side.[18]

A turn towards abstraction and poetics here provides a strategy with real political efficacy for an artist caught between the hostile government and the placating institution. Beauty is, in this way and context, a kind of Trojan horse, capable of smuggling disruptive ideas and concerns into otherwise disinterested institutional spaces. [...]

Gonzalez-Torres turned his experience as a supposedly marginalized gay, HIV-positive, Cuban-American man into a mode of artmaking that does not reconcile so much as play an elaborate and subtle game of infiltration and critique. Here beauty – at once motivated and self-differing – preserves its 'traumatic' and credible core, as it stands as counter-measure to the formulaic recourse to beauty we have witnessed in the last few years. Gonzalez-Torres repeatedly remarked in interviews that his work rehearsed his fears of having his lover disappear (Ross died of AIDS-related complications in 1991). Beauty then serves as a way to work over, if not through, loss and the mourning of a community, its inequities, and, even more generally, the power of art to redeem the experience of suffering or death. 'The meaning is really just there', Gonzalez-Torres explained, 'one only has to look'.[19] [...]

1 Arlene Croce, 'Discussing the Undiscussable', The New Yorker (26 December 1994 – 2 January 1995) 54–60.

2 [footnote 6 in source] I am here dealing with a particular kind of critic who, by means of public reputation or institutional affiliation, would actually be heard in the context of larger discussions of art and culture.

3 [7] Peter Schjeldahl, 'The Good German', The New Yorker (4 March 2002) 84–5.

4 [8] Peter Schjeldahl, 'Notes on Beauty', Uncontrollable Beauty: Toward a New Aesthetics, ed. Bill Beckley with David Shapiro (New York: Allworth Press, 1998) 53–9.

5 [9] Hal Foster, 'Semblance According to Gerhard Richter', Raritan, no. 3 (Winter 2003) 175.

6 [10] Dave Hickey, 'Enter the Dragon', The Invisible Dragon: Four Essays on Beauty (Los Angeles: Art Issues Press, 1993) 13.

7 [11] As quoted in Carol S. Vance, 'The War on Culture', Don't Leave Me This Way: Art in the Age of AIDS, ed. Ted Gott (Melbourne: Thames & Hudson, 1994) 94.

8 [14] Hickey, op. cit., 21.

9 [16] Michael Rush, 'In Santa Fe, Searching for the Meaning of Beauty', New York Times, section 2 (8 July 2001) 31.

10 [17] Ibid. [...]

11 [18] To be clear, I mean to suggest that beauty becomes political at the determinate moment when the credibility of 'beauty' as a value or quality is brought into question, forcing the critic

or viewer into a difficult confrontation with – and an altogether uncertain relation before – the contradictory work at issue.

12 [19] Tim Rollins, *Felix Gonzalez-Torres* (New York: A.R.T., 1993) 14.

13 [20] 'I want to be like a virus that belongs to the institution. All the ideological apparatuses are … replicating themselves, because that's the way culture works. So if I function as a virus, an impostor, an infiltrator, I will always replicate myself together with those institutions.' Gonzalez-Torres, in *Ad Reinhardt, Joseph Kosuth, Felix Gonzalez-Torres. Symptoms of Interference, Conditions of Possibility* (London: Camden Arts Centre, 1994) 76.

14 [21] Gonzalez-Torres' billboard projects – importantly sited outside the gallery or museum context – make especially clear the depth of his engagement with questions of the public *and* a public for his practice. […]

15 [24] Simon Watney, 'Art from the Pit: Some Reflections on Monuments, Memory and AIDS', *Don't Look Now*, op. cit., 61.

16 [25] As Hal Foster has suggested, as is the case with much late eighties art, such transgression often effectively served to strengthen the law rather than profitably to break it. See his *The Return of the Real* (Cambridge, Massachusetts: The MIT Press, 1996) 153–68.

17 [26] As cited in Nancy Spector, *Felix Gonzalez-Torres* (New York: Solomon R. Guggenheim Museum of Art, 1995) 73.

18 [27] Ibid.

19 [29] Ibid., 75.

Suzanne Perling Hudson, extracts from 'Beauty and the Status of Contemporary Criticism', *October*, no. 104 (Spring 2003) 115–30 [Some footnotes abbreviated].

Saul Ostrow
The Eternal Problem of Beauty's Return//2003

[...] Beauty, which had once been considered the supreme good, has come to be identified as a source of oppression and discrimination. Since the late 1800s, avant-garde intellectual and artistic circles had repeatedly disparaged beauty as an objective. By the early 1950s it seemed finally to have exited the scene. First, it had been traded in for the sublime, and then in the 1960s, as artists turned to aestheticizing industrial and abject materials, standardized forms, common objects and processes, the sublime was desublimated. The irony is that just at that moment the subject of beauty was being reinvented as a political and cultural issue. In the early 1960s Stokely Carmichael, chairman of the Student Non-Violent Coordinating Committee (SNCC), declared, 'Black is Beautiful'. This slogan of self-affirmation was meant to counter among peoples of colour the self-hatred that resulted from beauty's WASP ['White Anglo-Saxon Protestant'] norm. Likewise, the women's movement, by condemning the exploitation of both beauty and sex, sought to contest the influence of the media and the fashion industry on women's self-conceptions. Many feminists held that beauty was not only a source of envy and antagonism among women, but also reduced them to mere objects in the eyes of men. This account of denigration and control has haunted our conception of beauty ever since. [...]

It is in this context that beauty comes to be reconceived as a node in a complex network, connecting our concepts of aesthetic judgement to truth, purity, art, the political, etc., rather than as a thing in itself. Given the irreconcilable nature of the opposing visions of beauty, many writers and artists who now promote an anti-aesthetic vision of art and culture are equally as dangerous as those who claim art to represent a fixed truth, for both standardized models lead to the repression of all things unfixable. The proponents of the anti-aesthetic model fail to see how their position, rather than avoiding the problem of anaesthetizing politics, actually promotes it. [...]

Taking a positive rather than a reactive stance seems to me to be the only way that we might come to learn and take responsibility for how our reflections on beauty affect our own existence as well as that of the 'other'. Rather than argue that our concepts of beauty must be either jettisoned or defended, we need to generate positions that are self-consciously personal, perverse, positive, philosophical and practical. [...]

Saul Ostrow, from 'The Eternal Problem of Beauty's Return', *Art Journal*, 62: 3 (Fall 2003) 113; 115.

Arthur C. Danto
The Aesthetics of Brillo Boxes//2003

[...] **The Disappearance of Beauty**

It is a matter of some irony in my own case that while the aesthetics of Pop art opened art up for me to philosophical analysis, aesthetics itself has until now had little to contribute to my philosophy of art. That in part is because my interests have largely been in the philosophical definition of art. The issue of defining art became urgent in the twentieth century when art works began to appear which looked like ordinary objects, as in the notorious case of Marcel Duchamp's readymades. As with the Brillo boxes of Andy Warhol and James Harvey, aesthetics could not explain why one was a work of fine art and the other not, since for all practical purposes they were aesthetically indiscernible: if one was beautiful, the other one had to be beautiful, since they looked just alike. So aesthetics simply disappeared from what Continental philosophers call the 'problematic' of defining art. I must admit this may have been an artefact of the way I set about addressing the problem. Still, aesthetics had been too closely associated with art since it first became a topic for philosophy in ancient times to be entirely disregarded in a definition. And as my experience with the *Brillo Box* demonstrates, the aesthetics of artworks has a place in an account of why they please us, even if it is not much different from the way aesthetics functions in everyday choices – in selecting garments or choosing sexual partners or picking a dog out of a litter or an apple out of a display of apples. There is doubtless a psychology of everyday aesthetics to be worked out, and if there are what one might call laws of aesthetic preference, it would be greatly to our advantage to learn what they are. Intuitively, apple merchants polish pieces of fruit, and give prominence to especially well-formed items. And everyone knows the way cosmetics are employed to make ourselves look more desirable – to make the eyes look larger and the hair shinier and fuller and the lips redder and more moist. But is that the way it is with the aesthetics of works of art? To make them look more attractive to collectors? Or has it some deeper role to play in the meaning of art?

The philosophical conception of aesthetics was almost entirely dominated by the idea of beauty, and this was particularly the case in the eighteenth century – the great age of aesthetics – when apart from the sublime, the beautiful was the only aesthetic quality actively considered by artists and thinkers. And yet beauty had almost entirely disappeared from artistic reality in the twentieth century, as if attractiveness was somehow a stigma, with its crass commercial

implications. Aesthetics was the very substance of artistic experience in Abstract Expressionist culture. But what made paintings 'work' seemed poorly captured by the way beauty had been classically formulated, with reference to balance and proportion and order. 'Beautiful!' itself just became an expression of generalized approbation, with as little descriptive content as a whistle someone might emit in the presence of something that especially wowed them. So it was no great loss to the discourse of art when the early Logical Positivists came to think of beauty as bereft of cognitive meaning altogether. To speak of something as beautiful, in their view, is not to describe it, but to express one's overall admiration. And this could be done by just saying 'Wow' – or rolling one's eyes and pointing to it. Beyond what was dismissed as its 'emotive meaning', the idea of beauty appeared to be cognitively void – and that in part accounted for the vacuity of aesthetics as a discipline, which had banked so heavily on beauty as its central concept. In any case it seemed to have so little to do with what art had become in the latter part of the century that what philosophical interest art held could be addressed without needing to worry over much about it – or without needing to worry about it at all.

Another Look at Beauty

Things began to change somewhat in the 1990s. Beauty was provocatively declared to be the defining problem of the decade by the widely admired art-writer Dave Hickey, and this was hailed as an exciting thought. My sense is that it was exciting less because of beauty itself, than because beauty was proxy for something that had almost disappeared from most of one's encounters with art, namely enjoyment and pleasure. In 1993 when Hickey's essay was published, art had gone through a period of intense politicization, the high point of which was the 1993 Whitney Biennial, in which nearly every work was a shrill effort to change American society. Hickey's prediction did not precisely pan out. What happened was less the pursuit of beauty as such by artists than the pursuit of the idea of beauty, through exhibitions and conferences by critics and curators who, perhaps inspired by Hickey, thought it time to have another look at beauty.

A good example to consider is an exhibition that took place at the Hirschhorn Museum in Washington, in October 1999. In celebration of the museum's fiftieth anniversary, two curators – Neil Benezra and Olga Viso – organized an exhibition called 'Regarding Beauty: Perspectives on Art since 1950'. In 1996 the same two curators had mounted an apparently antithetical exhibition titled 'Distemper: Dissonant Themes in the Art of the 1990s'. Only three years separate the two shows, but the contrast is sharp enough to have raised a question of whether there had not been some artistic turning point in this narrow interval – a hairpin turn in the *Kunstwollen* – and even a reappraisal of the social function of art.

Dissonance had been the favoured ambition for art for most of the preceding century. The shift from dissonance to beauty could hardly appear more extreme.

Olga Viso told me that it was the fact that many who saw the first show remarked to her on how beautiful many of the 'dissonant' works struck them, that inspired her to put together a show just of art that was expressly made with beauty in mind. But if in fact the dissonance in contemporary art turned out to have been compatible with the works' being beautiful, dissonance could not have been quite so anti-aesthetic as the term and the spirit it expresses suggested. If, that is to say, the works from 'Distemper' were found beautiful, they were probably not that different from the works in 'Regarding Beauty' after all, and in fact that turned out to be the case. My own view [...] is that the beauty of the works in the earlier show would have been incidental rather than integral to their meaning, as was supposed to be the case in the second show. But still it would be there. By 'integral' I will mean that the beauty is internal to the meaning of the work.

Consider, for illustrative purposes, the notorious example of Marcel Duchamp's perhaps too obsessively discussed *Fountain*, which, as by now everybody knows, largely consisted of an ordinary industrially produced urinal. Duchamp's supporters insisted that the urinal he anonymously submitted to the Society of Independent Artists in 1917 was meant to reveal how *lovely* this form really was – that abstracting from its function, the urinal looked enough like the exemplarily beautiful sculpture of Brancusi to suggest that Duchamp might have been interested in underscoring the affinities. It was Duchamp's patron, Walter Arensberg, who thought – or pretended to think – that disclosing the beauty was the point of *Fountain* – and Arensberg was a main patron of Brancusi as well.

Now Duchamp's urinal may indeed have been beautiful in point of form and surface and whiteness. But in my view, the beauty, if indeed there, was incidental to the work, which had other intentions altogether. Duchamp, particularly in his readymades of 1915–17, intended to exemplify the most radical dissociation of aesthetics from art. 'A point which I very much want to establish is that the choice of these "readymades" was never dictated by aesthetic delectation', he declared retrospectively in 1961. 'The choice was based on a reaction of visual indifference with at the same time a total absence of good or bad taste ... in fact a complete anaesthesia.' Still, Duchamp's supporters were aesthetically sensitive persons, and though they may have gotten his intentions wrong, they were not really mistaken about the fact, incidental or not, that the urinal really could be seen as beautiful. And Duchamp himself had said that modern plumbing was America's great contribution to civilization.

Let's say the supporters believed the beauty internal to the work, while I and many others think it incidental. But there can be no question that the work was,

for many reasons, *dissonant*. So it could appear in an exhibition meant to thematize dissonance – or it could appear just as easily in a show called 'Regarding Beauty'. And this might be quite generally the case, so that we can imagine two distinct exhibitions but containing all and only the same works, the one show illustrating dissonance and the other illustrating beauty. The objects in both shows would in fact be beautiful, and in fact be dissonant. It might be unduly costly to put on two distinct shows, requiring two sets of largely indiscernible objects. One could instead simply have one show called 'Distemper', and then another called 'Regarding Beauty', and have them run one after the other by changing the banners outside the museum. Or we could have two entrances to the same show, those with a taste for dissonance entering through one and those with a thirst for beauty through the other. Mostly, I think, the two bodies of visitors would be satisfied with what they saw – though there would always be the danger of two people meeting inside, having split up since she has a taste for dissonance and he for beauty – and each then wondering if they had made a mistake, walking through the wrong entrance. All sorts of Shakespearean fun can be dreamed up. We could train the docents to say, to one set of visitors, that the beauty (or dissonance) was incidental in the one show and inherent in the other – but this is carrying things too far, since there are cases where beauty is internally related to the dissonance – where the work would not be dissonant if it were not beautiful. This would be the case with the two artists most closely associated with conservative attacks against the National Endowment of the Arts – Robert Mapplethorpe and Andres Serrano.

Readers will object that I am simply indulging my imagination and letting it run wild. We all know that there are plenty of dissonant works that are not even incidentally beautiful, and plenty of beautiful works without any dissonant aspect at all. Can we not just work with clear-cut cases? The answer perhaps is No, and explaining why will be one of the merits of this book [*The Abuse of Beauty*, 2003], if the explanation is sound. Meanwhile, it will be of some value to recognize that the connection between *Fountain* and the particular urinal that Duchamp appropriated is pretty close to that between Warhol's *Brillo Box* and the Brillo carton designed by James Harvey. It was the aesthetics of the latter that got me so interested in the former, which had no aesthetics to speak of, other than what it appropriated from Harvey's boxes. But then Harvey's boxes had none of the philosophical depth of Warhol's, for much the same reason that the urinal manufactured by Mott Iron Works had none of the philosophical – and artistic! – power of *Fountain*, which after all helped transform the history of art. But it would be questionable whether the aesthetic power of the urinals – which were designed to be attractive, the way the Brillo cartons were – belongs to *Fountain* as a work of art at all. For that matter, the dissonance of *Fountain* is not

a property of urinals as such, which are perfectly straightforward fittings for bathrooms. In any case, there is a metaphysical question in distinguishing between *Fountain* and the urinal it consisted of, not altogether different from distinguishing between a person and his or her body.

Born of the Spirit and Born Again

Since I am a philosopher with a known involvement with the art world, I found myself invited to several of the conferences convened to discuss beauty, and I wrote a number of essays as well. The first time I had to confront the question of 'Whatever Happened to Beauty?' – a conference sponsored by the Art History Department at the University of Texas in Austin in 1993 – I found myself looking into Hegel's great work on aesthetics. Ever since I had begun to write on the subject of the End of Art, I found myself consulting Hegel, who of course had written on that same subject in the 1820s. His book became a kind of treasury of philosophical wisdom for me, in fact, and whenever I embarked on a subject new to me, I found it valuable to see if Hegel might not have had something to say about it. There were two thoughts, on the very first page of his work, which became deeply stimulating to me when I began to ponder the philosophy of beauty. One was the rather radical distinction he drew between natural and artistic beauty, in the very first lines of his text. And the other was his gloss on why artistic beauty seemed 'superior' to natural beauty. It was because it was 'born of the Spirit and born again'. That was a grand ringing phrase: *Aus den Geistens geborene und wiedergeborene*. It meant, as I saw it, that artistic beauty was in some sense an intellectual rather than a natural product. That did not entail that the two kinds of beauty were, other than through their explanations, necessarily different. If someone painted a field of daffodils, to use a Romantic example, it might have been beautiful in just the same way a field of daffodils itself is beautiful. Still, the fact that the painting was 'born of the spirit' meant that for Hegel it would have an importance that the natural phenomenon would lack. As always, I found profoundly stimulating the idea that two things might look quite alike but have very different meanings and identities – like *Brillo Box* and the Brillo boxes.

It was with this in my mind that I found a way of drawing a distinction that began to seem quite fruitful. I began to think that the beauty of an artwork could be internal to it, in the sense that it was part of the artwork's meaning. This idea dawned on me in thinking about Robert Motherwell's *Elegies for the Spanish Republic* […]. Motherwell's paintings were, in some sense, political – after all they were occasioned by an event in the political history of Spain. Their patent beauty followed naturally from being elegies, since elegies are in their nature meant to be beautiful. Somehow the beauty of the elegy is intended to transform

pain into something endurable. So the beauty would be internal to the meaning of the works. By contrast, the beauty of the urinal, if indeed urinals are beautiful, seemed to me quite external to *Fountain*, just as the aesthetics of the Brillo boxes were external to Warhol's *Brillo Box*. They were not part of the meaning. In truth I do not know what the aesthetics of Warhol's *Brillo Box*, if indeed it has any aesthetics, are. It, like *Fountain*, is essentially a conceptual work. [...]

I thought that what was distinctive of a work of art, as against a natural phenomenon, was that it had some kind of meaning, which would go some distance towards rendering into somewhat contemporary terms Hegel's idea of something being born of the spirit and born again. The meaning of a work of art is an intellectual product, which is grasped through interpretation by someone other than the artist, and the beauty of the work, if indeed it is beautiful, is seen as entailed by that meaning. It was not difficult to find other examples. I thought, for example, of Maya Lin's *Vietnam Veterans' Memorial*, where the beauty is internally generated by the work's meaning. And many other examples were ready to hand. [...]

Initially, I felt somewhat sheepish about writing on beauty. This was a lingering consequence of the attitude towards aesthetics that prevailed in my early years in analytical philosophy – that the really serious work to be done by philosophy was in language and logic and the philosophy of science. [...] But what had happened in art in the 1960s and afterwards was a revolution, to the understanding of which my writings had somewhat contributed, and I felt that the passing from artistic consciousness of the idea of beauty was itself a crisis of sorts. But even if beauty proved far less central to the visual arts than had been taken for granted in the philosophical tradition, that did not entail that it was not central to human life. The spontaneous appearance of those moving improvised shrines everywhere in New York after the terrorist attack of 11 September 2001, was evidence for me that the need for beauty in the extreme moments of life is deeply ingrained in the human framework. In any case I came to the view that in writing about beauty as a philosopher, I was addressing the deepest kind of issue there is. Beauty is but one of an immense range of aesthetic qualities, and philosophical aesthetics has been paralysed by focusing as narrowly on beauty as it has. But beauty is the only one of the aesthetic qualities that is also a value, like truth and goodness. It is not simply among the values we live by, but one of the values that defines what a folly human life means.

Arthur C. Danto, extract from 'The Aesthetics of Brillo Boxes', *The Abuse of Beauty: Aesthetics and the Concept of Art* (Chicago: Open Court, 2003) 2–4; 6–15.

Alexander Alberro
Beauty Knows No Pain//2004

[…] It is important to note that recent pleas for a renewal of beauty locate the pursuit of fairness, truth and justice firmly within the realm of abstract ideals. For while contemporary theorists of the beautiful keenly emphasize the link between judgements of beauty and moral judgements, at the same time they posit an art of immanence and contingency that seeks to demystify the work of art as beauty's greatest enemy. In other words, in so far as the figures of disintegration and disillusion in art practices that pursue fairness, truth and justice through an interrogation of art's own internal contradictions are made to serve an end (even if that end is dialectically yet *another* form of transcendence), they are condemned as having a deleterious effect on beauty, which by definition is experienced in a wholly disinterested manner, without a purpose. Instead of recognizing the historical (and dialectical) interdependence of the aesthetic and the anti-aesthetic, today's proponents of beauty remove these positions from their historical dynamic only to hypostatize the beautiful as the sole, undisputed and universal bearer of a better society. Rather than rethink the category of the aesthetic from a historical position that could account for what produced its critique in the first place, and rather than examine whether under current conditions the anti-aesthetic itself might have been consumed or reconfigured by the historical process, these writers simply seek to suspend the messiness of history in the hope of returning us to an idyllic and abstract past that knew of no internal tensions, disputes and contradictions. As if wanting to invite the reader to acts of unadulterated time travel, current writing on beauty revisits eighteenth- and early nineteenth-century notions of the beautiful with a desire to bring them back to our present. Yet this writing is not concerned with refunctioning those concepts or recomposing them for our historical context, but solely with reinserting them *tout court*, as if particular social and historical circumstances were irrelevant for acts of symbolic and intellectual transfer.[1]

But I do not want to leave this discussion of the parallels discernible in the arguments put forward by the recent proponents of beauty without at least commenting on another reason advanced by these authors for the twentieth-century disavowal of beauty – namely, the fact that 'beautiful art *sells*.'[2] Repeatedly, our authors point to the very success of beauty on the market as one of the fundamental reasons for its critical disavowal during the twentieth century. Strangely enough, rather than being troubled by art's association with commercial interest and imperatives, rather than seeing the commercialization of beauty as

threatening their own desire for disinterested pleasure, advocates of the beautiful such as Hickey argue that beauty's impressive sales record over time testifies to the universal pleasure that it offers and vindicates its continued viability.[3]

To put it polemically, then, recent attempts to revalidate the experience of the beautiful are, first, driven by intensely nostalgic impulses; they promote ahistorical views of the past in the hope of returning us to a state unclouded by the insights and advances made in a wide range of theoretical and discursive practices, including critical theory, sociology, cultural studies and psychoanalysis. Second, though it might once again toy with Schillerian utopias of aesthetic education and political mediation, today's writing on beauty is deeply antipolitical. It is mostly unwilling to contemplate the legitimacy of artistic practices that take a stand and bring together the aesthetic, the cognitive and the critical, preferring instead to value artworks that operate independently of any practical interest.[4] And third, this new discourse on beauty is trenchantly antimodernist, seeing modernism and its dialectical relation to transcendence as antithetical to, as Steiner puts it, 'the perennial rewards of aesthetic experience, identified as pleasure, insight and empathy.'[5] Interestingly enough, in privileging the transcendent experience of beauty over the realities of the world's disenchantment, the position of many of today's champions of beauty comes to look remarkably like the one they censure, namely, that of the detached professional aesthete produced – as they argue – by the category of the modernist sublime.

Many of course would stop here and dismiss this inherently nostalgic call for a revalidation of the beautiful as hopelessly retrograde and unproductive. But I want to push the analysis of this phenomenon further, for I think that it is in several ways indicative of a larger cultural condition. Nostalgic turns such as the current one towards beauty are usually symptomatic of deeper structural problems; they help distract us from topical issues whose unabashed recognition would disturb one's self-assured path through present and future.[6] Thus, we need to try to locate the deeper socially symbolic meaning, the threats and anxieties, from which current revivals of beauty – whether it is thought of as inherently self-contained or, in Beckley and Shapiro's words, as 'uncontrollable' – divert us.[7]

At the most immediate level, the calls for a return to beauty's order and perfection are part and parcel of a rejection of the political dimension of the phenomenon that came to be referred to as postmodernism. Jean-François Lyotard famously defined postmodernism in terms of the sublime and posited it as presenting what is unpresentable, excessive, regardless of order and perfection. The role of the sublime was advanced to search 'for new presentations, not in order to enjoy them but in order to impart a stronger sense

of the unpresentable.'[8] From this perspective, the call for a return to beauty in art functions as an obvious attempt to restrain the politics of (post)modernism, which (for better or worse) enormously expanded the field of art in the past thirty years, not only in actual practitioners but also in the subjects, genres and media deemed appropriate for art in the first place.

These calls are also symptomatic of the perceived loss of the sensual and transcendent dimensions of the artwork in the wake of the critical art practices of the 1960s and 1970s that negated the myth of artistic autonomy and disabused the artwork more than ever before. Rather than locating the sites of meaning and value exclusively within the intrinsic properties of discrete objects, such connotative procedures were shown by a large number of artists and art tendencies that emerged in the context of the social and political protest movements of the era to belong to an intricate network of discursive and institutional practices. And this is where the other shoe drops for critics who today posit as ruthlessly materialist a visual art that expands the conventional parameters and yet refuses to be received solely through the senses.

Another level of the problematic comes into view when we consider that we have now reached an age in which it is possible synthetically to produce flawless harmony, perfection and wholeness. This ability has been (or is in the process of being) achieved in diverse fields: from digital sampling of images and sounds, to the recent boom in aesthetic or plastic surgery, to genetic engineering, cloning and virtual reality. While these technological developments have largely been greeted with enthusiasm, they also evoke deep-seated and at times profoundly unconscious anxieties. In the areas of artistic and cultural practice, they have produced a new epistemology of the image. Not only have the ways in which traditional art media are produced, exhibited and distributed been radically transformed, but the new technologies have also led to the invention of new art forms and media that eliminate from the production process the role that chance, error and the uncontrollable formerly played. Flawless images are now fairly easy to manufacture. But digital image production today also throws into question the formerly crucial distinction between copy and original in ways not even imagined by mid-twentieth-century theorists of reproducibility such as Walter Benjamin. Whereas this total collapse of the difference between copy and original requires an entirely new category of cognition and conceptualization, contemporary musing on the beautiful – though deeply troubled by how computer-based image manipulation might privilege becoming over being, physical flux over temporal stability – in the end finally wants us to return to *old* orders of experience and cognition, orders in which premodernist myths of reference and uniqueness alone can warrant the possibilities of truth, justice and social harmony. As such, the new context, this emergent cultural condition, is

not as much addressed as it is evaded or ignored. In so far as it *is* addressed, it is placed within and displaced by a framework of the familiar, thereby at once domesticating its unique features and denying its radical difference from what was previously known.

Just as there is no longer a clear distinction between the original and the copy, the difference between art and culture has also become highly nebulous. For increasingly today art is conflated with ideas and customs prevalent in everyday life. From this perspective, the return to a way of experiencing art in a bygone era when the spheres of art and culture were clearly distinct might very well be a symptom – conscious or unconscious – of the sense of malaise produced by the blurring of these boundaries, an effort to alleviate the anxiety produced by the indeterminate condition in which that blurring necessarily leaves the work of art itself.[9] Yet, at the same time, the mobilization of a well-established theory of the beautiful also functions as part of a concerted attempt to wrest the experience of the beautiful from the vernacular where the new technologies allow it to proliferate and to link it to objects that are unambiguously high art.

But the contemporary malaise to which I have pointed here also concerns the question of agency, or at least the relationship of the human subject to history at a moment when history seems to have run out of control, catastrophically blowing us backwards into the future. Indeed, in the face of the onslaught of catastrophes that have come to define our contemporary moment, it is not entirely surprising that writers who unequivocally reject the validity of critical artistic practices should call instead for a pathos-infused, humanist aesthetics. For in the eyes of many of those who have recently advocated a return to the beautiful in art, the experience of beauty helps coalesce the disparate itineraries of human subjects through unspoken feelings and intuitive responses to magnificent works of art. What is particularly – and literally – pathetic about this, since I have just referred to it as a pathos-infused, humanist aesthetics, is the fact that one no longer sees art's pursuit of transcendence in dialectical tension with the quest for knowledge, understanding and the improvement of our contemporary condition. Rather, it is now solely in the most personal, fleeting and insubstantial facets of experience – namely, in the aesthetic and only in the aesthetic – that humans are seen to be able to come together in keeping with one another.

1 [footnote 8 in source] To be accurate, it must be said that this is not true in Arthur Danto's case. *The Abuse of Beauty* revives aesthetic response via Hegel, not Kant, allowing Danto to claim that beauty can work in the service of politics, inducing an empathic awareness of social injustice: his model is not Kantian, disinterested, but empathic, as is Elaine Scarry's. Indeed, this is also a less-than-accurate description of Dave Hickey's notion of beauty as social transgression that,

rather than disinterested *à la* Kant, is better described as a diluted version of Georges Bataille's aesthetics.

2 [9] On this point see Hickey's essay 'Enter the Dragon: On the Vernacular of Beauty,' in *The Invisible Dragon*, 11–24.

3 [10] As Hickey puts it: The arguments mounted 'to the detraction of beauty come down to one simple gripe…. Beautiful art *sells*. If it sells itself, it is an idolatrous commodity; if it sells anything else, it is a seductive advertisement. Art is not idolatry, they [the academic radicals] say, nor is it advertising, and I would agree – with the caveat that idolatry and advertising are, indeed, art, and that the greatest works of art are always and inevitably a bit of both.' Ibid., 16–17.

4 [11] For Scarry, both the sublime and the political or 'real' have been the enemy of beauty. 'Permitted to inhabit neither the realm of the ideal nor the realm of the real, to be neither aspiration nor companion, beauty comes to us like a fugitive bird unable to fly, unable to land' (*On Beauty and Being Just*, 86). Danto is even more pronounced in his indictment of engaged art: 'That is always a danger in activist art, I'm afraid. I can understand how the activist should wish to avoid beauty, simply because beauty induces the wrong perspective on whatever it is the activist wants something to be done about' ('Beauty and Morality,' in *Uncontrollable Beauty*, 36).

5 [12] Wendy Steiner, *Venus in Exile: The Rejection of Beauty in Twentieth-Century Art* (Chicago: The University of Chicago Press, 2001) xv.

6 [13] The indulgence in nostalgia is explicitly noted by Steiner, who explains the decision behind the 1997 National Book Critics' Circle selection committee as 'redolent with nostalgia for a lost pleasure in art: a reluctant nostalgia' (Steiner, 193).

7 [14] See Beckley and Shapiro, *Uncontrollable Beauty*. Steiner indicates an awareness that the calls for a return to beauty are symptomatic of 'a cultural readiness to move on' from dominant aesthetic conventions (Steiner, xxv); 'a way of registering the end of modernism and the opening of a new period in culture' (xviii). Yet, she makes no attempt to understand this 'new period in culture' or to comprehend why invoking beauty should be the legitimate response. We need to try to discern what change is taking place on the horizon and what its arrival brings to an end. Coming to terms with these phenomena may help us understand why beauty reemerged as a critical category at the end of the twentieth century.

8 [15] Jean-François Lyotard, *The Postmodern Condition: A Report on Knowledge*, trans. Geoff Bennington and Brian Massumi (Minneapolis: University of Minnesota Press, 1984), 81.

9 [16] My discussion of the conflation of art and culture takes as its starting point Fredric Jameson's analysis of the postmodern implosion of the aesthetic and everyday life in *A Singular Modernity* (New York: Verso, 2002). For a provocative 'disagreement with Jameson's picture of modernism' to which my paper is also indebted, see T. J. Clark, 'Origins of the Present Crisis,' *New Left Review* 2 (March/April 2000): 85–96.

Alexander Alberro, extract from 'Beauty Knows No Pain', *Art Journal*, vol. 63, no. 2 (Summer 2004) 38–43.

Diurmuid Costello, Arthur C. Danto, Anna Dezeuze, Martin Donougho, Thierry de Duve, James Elkins, David Raskin, Dominic Willsdon, Richard Woodfield
The Art Seminar//2006

Dominic Willsdon There's a growing idea that once we take away the really big claims that were made about beauty, and begin to explore the many kinds of qualities that I was talking about yesterday (art that is 'sweet, candid, camp and knowing') and that Arthur [Danto] was mentioning, then people find the new aesthetic qualities in new areas.

Aesthetics-at-large is a heading under which we could talk about the affective traits of any number of images and objects, inside or outside art museums or art history. It would give us a licence to explore, for example, certain works by Felix Gonzalez-Torres (who is a wonderful artist) alongside the memorials to the victims of traffic accidents or fatal crimes that we see so often in the streets of big cities. Even if we were to judge a particular example of the latter to be somehow more valuable than a particular Gonzales-Torres, the Gonzales-Torres is acceptable to the curator, in his or her professional judgement, and the street memorial is not. We can distinguish between art happenings and raves, but not aesthetically. There's no difference between the kind of aesthetics assumed by curators and the aesthetics-at-large that includes street memorials and raves. [...]

Arthur Danto What really got me started in aesthetics at all – not as an academic discipline, but as a living thing – were the shrines that were set up all over New York City the day after 9/11. They were put together spontaneously out of balloons, cards and flowers. No one taught anyone how to do that, or gave anyone instructions for how to put them on the sidewalk, in foyers, in stairways. I wondered why people responded not with anger but with beauty. No artist could have done better. That phenomenon does raise the question of where beauty fits in the normal, or abnormal, course of human life.

Anna Dezeuze Artists have been exploring the relation between art and everyday life, and aesthetics has lagged far behind: not because of problems defining art, but because of problems defining the everyday. Art history can turn here to theories from sociology and psychoanalysis that have been crucial for cultural studies; but especially in the Anglo-American world aesthetics still seems to have a restricted idea of how art relates to the everyday.

David Raskin It might be interesting to distinguish between a strong and a weak sense of aesthetics, and between the *directions* in which aestheticians and art historians go after their initial encounter with a work. Most art historians, I find, are guided by a weak sense of aesthetics: we make our decisions based on what is worth our time, what seems most compelling. I might find a Donald Judd more compelling than a Robert Morris, and at that point I will take a strong sense in my engagement: I will ask what the work means and why. On the other hand, aestheticians might take a strong sense of aesthetics and a weak sense of art. From the initial decision to consider a work, they will go backwards, questioning the premises of their engagement, and asking where it comes from.

Nothing illustrates this better for me than the contrast between my concerns and Diarmuid Costello's: we begin with the same works, but we flip-flop the relationship between the art and the philosophy. [...]

Diarmuid Costello [...] When Arthur says Kant belongs in the library and beauty in the conversation, I think that's getting things back-to-front. To my mind beauty generally doesn't help in discussions about works of art, but Kant does, if only because Kant has massively overdetermined the way in which ideas such as beauty or *aesthetic* value more generally are discussed today, certainly in art theory, and possibly also in art history. [...]

Returning to Kant need not mean a simple regression or recapitulation, as Nicholas seemed to be suggesting, but an opportunity to diagnose certain problems in the reception of aesthetics, notably what we mean when we speak of something having 'aesthetic value', that have arisen as a result of the way in which the third *Critique* has overdetermined subsequent debates. [...]

One of the problems of the dominant formalist reception and interpretation of Kant, for example, is that it has led to the idea of beauty being taken as synonymous, for all the wrong reasons, with the notion of the aesthetic in general. [...] But when Arthur talks about how the 9/11 shrines led him to reconsider the role of beauty in everyday life, what that illustrates, to my mind, is the fact that the category of the aesthetic is far broader than the category of the artistic – a fact often glossed over in art-historical and theoretical debates. [...]

Danto As a critic, let's say – putting on another hat here – I don't think I would get very far if I were to say, 'See this exhibition because it's beautiful', or 'Modigliani is to be preferred to Picasso because he is prettier'. Those are not interesting critical judgements. What's interesting is the role beauty plays in their paintings, or for example the role played by melancholy. Modigliani probably read Kant somewhere along the line, but I don't think any of that enters into why he is popular, or why he painted as he did. In explaining Modigliani, a critic is

obliged to explain how the aesthetic qualities are transmitted into the work.

Thierry de Duve Arthur, you force me to drive a wedge into the space that separates us. You said that what really got you started in aesthetics were the shrines set up all over New York City the day after 9/11. That's interesting. Must we understand that until then, you were involved with art theory *as opposed to* aesthetics? It is my feeling indeed that you have always opposed art theory to aesthetics, whereas I let both fields overlap to the point of perfect congruence. We might frame our debate within David's 'strong' and 'weak' senses of aesthetics, or, as I would prefer, within the alternative set by Dominic when he spoke of aesthetics-at-large, as opposed to what I would call art-at-large. It could be argued that you use aesthetics in the broader sense, whereas I use it in the narrow sense. I confine aesthetics to the domain of art, whereas you take aesthetic qualities, predicates, tributes and feelings out of art and into the domain of everyday life. Coming from someone who has made the question of indiscernibles the cornerstone of his theory of art, it makes me wonder where you draw the line. It struck me how, all of a sudden, by a strategic move in this conversation, you widened the field of aesthetics in everyday life to include the 9/11 shrines – hardly just a day like any other. And now it strikes me how you make aesthetic judgements about art look ridiculous by saying that 'Modigliani is to be preferred to Picasso because he is prettier'. Is this your way of preventing that the 9/11 shrines could be seen as art? You allow yourself, as a human being, to be moved by the shrines, whereas Warhol's *Brillo Boxes* merely titillate the theorist in you and Modigliani prompts you to make fun of aesthetics when applied to art. I wish someone, some day, will present a 9/11 shrine in an art gallery. Then you will be faced with the question of indiscernibles in such a way that it will force you to let your own emotional responses intervene in your notion of art – or else, surrender to the institutional theory of art, which many people ascribe to you and which you have refuted so far. Now I am going to argue that you are in fact narrowing aesthetics, while I am broadening it, because the field of art includes anything and everything today. Once a urinal or a Brillo box can be art, anything can be art. At stake in your Hegelian, 'post-historical' approach to art, on the one hand, and in your rehabilitation of aesthetics provided it is kept separate from art, on the other hand, is the question of how we should conceive the autonomy of art. In evoking the 9/11 shrines, you reminded me of the oddity of modernity. It could be said that art, as an aesthetic practice, has been embedded in religion for thousands and thousands of years, back to the point where we can locate the origins of both art and religion in funeral rituals. The so-called autonomy of art is autonomy *from religion*, and it is at the most two hundred years old; it is congruent with modernity. Are you in

a way saying, 'Close the parenthesis of modernism, terminate the autonomy of art from religion'? I'm pretty sure you're not saying that, because you don't see the shrines as art. But consider the indiscernibles. The minute such a shrine will be seen in an art gallery, your brand of rehabilitation of aesthetic qualities and feelings will be tantamount to allowing the confusion of art with religion to take over. I think this is very dangerous. There are signs everywhere that postmodernism might very well be the closing of the parenthesis of art's autonomy. And everywhere, religiosity is around the corner. My political philosophy is to keep the realms of the artistic and the religious separate. It is the achievement of the Enlightenment to keep *thinking* – cultural thinking, artistic thinking – from the domination of religious thinking. This is why Kant is the most enlightening philosopher in the Enlightenment, and why he is so useful and timely now, politically as well as intellectually.

One last thing, please, to make the opposition between us clear. The issue is not, why is Paul McCarthy disgusting?, or, what kind of point does McCarthy's *Bossy Burger* make that parallels Grünewald's Isenheim Altarpiece?, but rather, is Paul McCarthy on the level of Grünewald? I agree with you that this is where aesthetics and art history can come together. Assuming that McCarthy's work is disgusting (to me it's not: it's much too funny for that; it stages disgust at a remove, so to speak), the issue, however, does not revolve around our analysis of the words disgusting or *repulsive* as aesthetic terms. It revolves around whether you are ready to admit disgust among the feelings that make *you* say that something is art. That's the aesthetic issue. And it revolves around what makes McCarthy comparable to Grünewald. That's the art-historical issue. I happen to like the work of Paul McCarthy enormously; I think he's a major artist. I also think his link to the past goes via Bruce Nauman – that's the genealogy I would construct for Paul McCarthy. Once you get to Nauman, you can go back to Dada, and then further back to Courbet, when it was first an issue whether disgust –unredeemed by religion – could be a legitimate quality of art. And from there, the tradition goes back to Grünewald, easily. So for me, aesthetic issues and issues of art history are not separated. [...]

Dezeuze Another way to problematize the question we are asking, concerning whether aesthetics can be useful to art history, is this: Why is Kant more useful for understanding Paul McCarthy than, say, psychoanalysis?

de Duve Kant is not at all useful, neither in understanding nor in appreciating Paul McCarthy. Of course not. [...] Say you throw yourself out of the window, and you land on the sidewalk. Is Newton useful to you? You have just obeyed the law of universal gravity, that's all.

James Elkins [...] It is interesting to me that we have hardly mentioned the anti-aesthetic – meaning not the shift in art beginning in the 1960s, but the academic moment crystallized by the book *The Anti-Aesthetic* [ed. Hal Foster, 1983]. I imagine that for some readers it may seem surprising that we did not begin with the anti-aesthetic, or at least with its continuation and dispersal in subsequent art practices. It may seem we have refused to acknowledge that our discussion could only begin from the anti-aesthetic or its construction of modernism. [...]

A rediscovery of aesthetics by art historians would be a nostalgic attempt to return to elements of a modernist or even premodernist aesthetic. A certain support for this reading could be found in the recent spate of work on beauty by Dave Hickey, Elaine Scarry, Wendy Steiner and Alexander Nehamas.

Costello Well, it can be but it need not be. I think the problem is that the 'return' to aesthetics, signalled by slogans such as 'a return to beauty', often boils down to a retrieval of what postmodern anti-aestheticism rejected. To the degree that postmodernism cashes out as a negation of the privileged terms of modernism, this would simply be a negation of postmodernism that returns us to the previous moment. But taking issue with the characteristic expressions of postmodern anti-aestheticism need not issue in a nostalgic return to a modernist aesthetic, unless it is driven by an implicit or unwitting assumption that modernism got the aesthetic dimension of art more or less right. That, for example, the privileging of form over content, of feeling over cognition, the strict separation of the media, or of the high art from popular culture, and so on, are intrinsic to the idea of an aesthetic response to art. But even when such specific modernist assumptions are not at work, what is too often meant by 'a return to beauty' is, implicitly, returning to a broadly *formalist* conception of the aesthetic: one that focuses, crudely speaking, on how things look, and the feelings this induces, *at the expense* of the kind of cognitive engagement works elicit in their viewers. This opposition is itself questionable.

Elkins Certainly it could be argued that the anti-aesthetic is already almost a quarter of a century old, and the space 'beyond' its dichotomy of modernism and postmodernism is no longer an unoccupied space. But the strength of that assertion depends on what we take to be in that space. [...]

Diarmuid Costello, Arthur C. Danto, Anna Dezeuze, Martin Donougho, Thierry de Duve, James Elkins, David Raskin, Dominic Willsdon, Richard Woodfield, extracts from 'The Art Seminar', in *Art History versus Aesthetics*, ed. James Elkins (London and New York: Routledge, 2006) 70–3; 76–80; 81–5 [footnotes not included].

WE MIGHT COME TO
DESCRIBE ABSTRACT
EXPRESSIONIST
PAINTINGS BETTER
IF WE TOOK THEM,
ABOVE ALL, TO BE

VUL GAR

T.J. Clark, 'Vulgarity', 1999

CONCEPTS AND CONTEXTS

Theodor Adorno
On the Concept of the Beautiful//1970

If there is any causal connection at all between the beautiful and the ugly, it is from the ugly as cause to the beautiful as effect, and not the other way around. To put a complete ban on the concept of beauty would be as damaging for aesthetics as would the removal of the concept of psyche from psychology or that of society from sociology. The definition of aesthetics as being the theory of the beautiful, however, is sterile because the formal character of the concept of beauty tends to miss the bountiful content of the aesthetical. If aesthetics were nothing but an exhaustive and systematic list of all that can be called beautiful, we would gain no understanding of the dynamic life inherent in the concept of beauty. Actually, this concept is only a moment in the totality of aesthetic reflection. It points to something essential without being able to articulate that essence directly. To be sure, if people did not make statements about this or that artefact being beautiful in some manner or other, then all the interest in such an artefact would be unintelligible and nobody, artists and spectators alike, would have any reason to participate in that exodus from the realm of practical ends – in essence, self-preservation and the pleasure principle – an exodus that art by its very nature dictates.

Even Hegel arrests the dialectic of aesthetic thought by giving a static definition of beauty as 'pure appearance of the Idea to sense'. Beauty cannot be defined, but neither can the concept of beauty be dispensed with altogether. This is an antinomy in the strict sense of the term. Without conceptualization aesthetics would be mushy. It would merely be able to describe in historical and relativistic fashion what passed for beauty in different societies or different styles. While it is possible to distil certain common characteristics from these empirical data, the resultant abstract definition is necessarily a parody that fails to have any explanatory power when confronted with any specific art object picked at random. The ominous generality in the concept of the beautiful is however not accidental. The passage to the primacy of form, perpetuated by the category of the beautiful, already contains the germ of formalism – the coincidence of the aesthetic object with the most general subjective characteristics – which came to cause all the difficulties for the concept of beauty.

It would be a mistake to dump the formally beautiful in order to put beauty as a material essence in its place. Rather, the principle of formalism must be viewed as a historical product whose dynamic, and hence content, needs to be grasped. The image of the beautiful as being a unique entity emerges

simultaneously with the process of man's emancipation from his fear of the omnipotent oneness and homogeneity of nature. Because it is able to insulate itself against immediate existence and to carve out an inviolable domain, the beautiful appropriates and preserves that fear. Art is beautiful by virtue of its opposition to mere being. The shaping spirit of art allows only those elements to pass into the art work which it grasps or which it can hope to assimilate. This process is characterized by formalization. Therefore, when viewed in the context of its developmental tendencies, art is indeed something formal. The attempted reduction that beauty brings about in the dreaded mythical powers, by rising above them and by keeping them out of art as though art were some kind of temple – this attempt at reduction is rather weak, for the mythical threat digs in like the enemy outside the walls of a city, starving out its inhabitants. Beauty has to counteract this siege, in opposition to its own developmental tendencies, or else it will miss its *telos*.

As Nietzsche realized, the history of the Hellenic spirit was of vital importance because it was the foil for the interaction of myth and genius. Neither the archaic giants lounging in one of the temples of Agrigento nor the daemons of Athenian comedy are expendable remnants of myth. They are a necessary counterpart of form. The more form tries to keep them out, the more will it succumb to them. In all subsequent art of any note the mythical moment is sustained in ever-changing ways. This can be noted already in the Euripidian drama where the dread of mythical powers is refocused on the purified Olympian deities who, though on the side of beauty, are now accused of being daemons themselves. Afterwards Epicurean philosophy wanted to free the consciousness of the Greeks precisely from this form of dread. Since, however, the images of a dread-inspiring nature were from the very outset meant to appease nature through mimesis, it can be argued that even the painted faces, the monsters and the minotaurs of the archaic period were beginning to resemble man. Those mixed creatures already reflect the ordering principle of reason; and after some time natural history swept them away as fictions. In their time, they were dreadful because they reminded man of the fragility of his identity. But they were not chaotic. In fact, threat and order are intertwined in them. To mention another example, if only in passing, primitive music is characterized by repetitive rhythm, which too has a menacing and an ordering quality.

Archaic art carries its antithesis in itself. The qualitative leap of art is a minute transition. It is because of this dialectic that the image of beauty keeps changing with the overall movement of enlightenment. The law of formalization represented a momentary equilibrium in this process, an equilibrium that kept being upset by the relationship of beauty to non-beauty which beauty tries in vain to keep at bay. The dreadful powers understood as the compulsion that

emanates from form are lodged in the midst of beauty itself. The concept of the blinding glare (*das Blendende*) articulates this experience. The irresistibility of the beautiful, originating in the sphere of sexuality and passing into art through sublimation, rests on the purity of beauty, its distance from materiality and effect. This irresistible compulsion becomes sedimented in content. Initially hostile to expression, the formal nature of beauty half triumphantly transforms itself into a kind of expression wherein the menace of domination of nature is wedded to a sense of yearning for the defeated victims of that domination. Thus this expression is one of grief about subjugation and its vanishing point, i.e., death.

The affinity of all art with death is most noticeable in the idea of pure form imposed by art on the living manifold, which is thus snuffed out. In untarnished beauty the recalcitrant opposite of beauty would be completely pacified; this kind of aesthetic reconciliation proves fatal for the extra-aesthetic other. The grief that art expresses results from the fact that it realizes unreal reconciliation at the expense of real reconciliation. Art's ultimate function, then, is to grieve for the sacrifice it makes, which is the self-sacrifice of art in a state of helplessness. The beautiful not only speaks like a messenger of death, as Walküre does in Wagner's opera; it also assimilates itself to death conceived as a process. The road to the integration and autonomy of the artwork leads to the death of its moments in the totality. As works of art transcend their own particularity, they flirt with death, the epitome of which is the totality of the work. While the idea of works of art is modelled on immortality and eternal life, the road to that destination is strewn with the annihilated life of particulars. This too informs artistic expression. Just as expression is the death of totality, so totality marks the eclipse of expression. The urge of the artistic particular to be submerged in the whole reflects the disintegrative death wish of nature. The more integrated works of art are, the more disintegrated are their constituent elements taken separately. To that extent the success of artworks is synonymous with decomposition. This accounts for their deep ambiguity. At the same time, decomposition sets free the centrifugal counterforce that is inherent in art.

Less and less does the beautiful actualize itself in a particular purified shape; more and more does it manifest itself in the dynamic totality of the work of art. In so doing it both continues the trend towards formalization by emancipating itself from particularity, and assimilates itself to particularity by giving diffuseness its due. Potentially, this complex reciprocal relationship enables art to break out of the cyclical pattern of guilt and punishment in which it is implicated, thus opening a view upon a condition beyond myth. Art transposes that cycle on to the level of imagery, thereby reflecting and transcending it.

Loyalty to the image of the beautiful provokes an aversion to beauty, which implies the demand for tension and an opposition to the release of tension. The

strongest critical objection one can level against certain examples of modern art is precisely that they move towards a loss of tension, or in other words indifference towards the relation between parts and whole. On the other hand, to set up tension as an abstract postulate is equally wrong because it leads to meagre arts-and-craftsy results. The authentic concept of tension emerges from that which is in a state of tension, namely form and its other, which is represented in the work by particularities. Once the beautiful as the homeostasis of tensions has been transferred to the totality, however, it is sucked into an eddy. Totality, the convergence of parts in a unity, presupposes that the parts have a moment of substantiality. This requirement is more important for modern art than for traditional art, in which tension had a greater degree of latency, hidden as it was beneath accepted idioms. Since totality in the end swallows up tension and resigns itself to being ideological, the notion of homeostasis itself becomes untenable. This is the crisis of beauty and art brought on by the radical trends of the last two decades. The idea of the beautiful is victorious even in defeat, for it is a mechanism for discharging all that is heterogeneous or tainted by reification or posited by convention. For the sake of the beautiful, there cannot be a beautiful any more: because it has stopped being beautiful.

What can appear only negatively defies dissolution; it cannot be exposed as false. Beauty's aversion to anything that is overly smooth or looks like a univocal solution to an arithmetical problem, that aversion passes over into the resultant, which is as indispensable for art as are the tensions. It is possible at present to anticipate the prospect of a complete turning away from art for the sake of art. This is foreshadowed in modern works that show a tendency to fall silent or vanish. Even politically, they reflect true consciousness; no art at all is better than socialist realism.

Theodor Adorno, extract from *Ästhetische Theorie* (1970) (Frankfurt am Main: Suhrkamp, 1973); trans. C. Lenhardt, *Aesthetic Theory* (London: Routledge and Kegan Paul, 1984) 75–9 [footnotes not included].

Jacques Derrida
The *Sans* of the Pure Cut[1]//1978

[...] You recall: 'But a flower, for example a tulip, is held to be beautiful because, in perceiving it, one encounters a finality which, judged as we judge it, does not relate to any end.'

In [Kant's] *Analytic of the Beautiful*, the note is appended to the definition of the beautiful concluded from the third moment: the judgement of taste examined as to the relation of finality. According to the framework of categories imported from the *Critique of Pure Reason*, the *Analytic* was constructed and bordered by the four categories: quality and quantity (mathematical categories), relation and modality (dynamic categories). The problem of the *parergon*, the general and abyssal question of the frame, had arisen in the course of the exposition of the category of relation (to finality). The example of the tulip is placed right at the very end of this exposition: the last word of the last footnote, itself appended to the last word of the main text. At the end of each exposition, Kant proposes a definition of the beautiful for the four categories: according to *quality* (the object of a disinterested *Wohlgefallen*), according to *quantity* (that which pleases universally without concept), according to *relation* (the form of finality perceived *without* the representation of an end). Just when he has extracted this third definition of the beautiful ('Beauty is the form of the finality – *Form der Zweckmässigkeit* – of an object in as much as it is perceived in that object without the representation of an end – *ohne Vorstellung eines Zwecks –*'), Kant adds a note to answer an objection.

Once again, for obvious reasons, I am going backwards, by a reflective route, from the example (if possible) toward the concept. So it's to do with a flower. Not just any flower: not the rose, not the sunflower, nor the broomflower [*genêt*] – the tulip. But there is every reason for presuming that it does not come from nature. From another text, rather. The example seems arbitrary until we notice that a certain Saussure is often cited by Kant in the third *Critique*. Now this Monsieur de Saussure, 'a man as witty as he is profound', says Kant in the great 'General Remark concerning the Exposition of Reflexive Aesthetic Judgements', was the author of a *Journey in the Alps.* There we read something that Kant did not quote: 'I found, in the woods above the hermitage, the wild tulip, which I had never seen before' (i: 431).

Though it is taken from a book or an anthology, it is extremely important that Kant's tulip should nevertheless be natural, absolutely wild. A paradigmatics of the flower orients the third *Critique*. Kant always seeks in it the index of a

natural beauty, utterly wild, in which the *without-end* or the *without-concept* of finality is revealed. At the moment when, much further on (§ 42, on 'The Intellectual Interest of the Beautiful'), he wants to argue that the immediate interest taken in the beauties of nature, prior to any judgement of taste, is the index of a good soul, he has recourse to the example of 'the beautiful form of a wildflower'. This interest must of course be directed to the beauty of the forms and not to the attractions which would use these forms for purposes of empirical seduction. Someone who admires a beautiful wildflower, to the point of regretting its potential absence from nature, is 'immediately and intellectually interested in the beauty of nature', without the intervention of any sensual seduction. And it is quite 'remarkable' that if one substitutes an artificial (*künstliche*) flower (and, adds Kant, it is possible to make them entirely similar to natural ones), and if the trick is discovered, the interest disappears at once. Even if it is replaced by a perverse interest: using this artifical beauty, for example, to decorate one's apartment.

The example of finality without end must thus be wild. *Zweckmässigkeit ohne Zweck* – the phrase is just as faded as 'disinterested pleasure', but remains none the less enigmatic for that. It seems to mean this: everything about the tulip, about its form, seems to be organized with a view to an end. Everything about it seems finalized, as if to correspond to a design (according to the analogical mode of the *as if* which governs this whole discourse on nature and on art), and yet there is something missing from this aiming at a goal [*but*] – the end [*bout*]. The experience of this absolute lack of end comes, according to Kant, to provoke the feeling of the beautiful, its 'disinterested pleasure'. I leave aside deliberately all the problems of etymology – of derivation or affinity – which can be raised by this resemblance of *but* and *bout*. Let us merely note that they have in common the sense of the end [*fin*]; the term-with-a-view-to-which; the extremity of a | line or an oriented movement, end of direction and sense of the end [*fin du sens et sens de la fin*]. The feelings of beauty, attraction without anything attracting, fascination without desire, have to do with this 'experience': of an oriented, finalized movement, harmoniously organized *in view* of an end which is never *in view*, seen, an end which is missing, or a *but en blanc*. I divert this expression from the code of artillery: firing a *but en blanc* is to fire at a target [*blanc*] placed at such a distance that the bullet (or the shell) drops to intersect the prolongation of the line of sight. *But* refers here to the origin from which one fires *de but en blanc*: the gun barrel as origin of the drive. There must be finality, oriented movement, without which there would be no beauty, but the orient (the end which originates) must be lacking. Without finality, no beauty. But no more is there beauty if an end were to determine it.

'The wild tulip is, then, seen as exemplary of this finality without end, of this

useless organization, without goal, gratuitous, out of use. But we must insist on this: the being cut-off from the goal only becomes beautiful if everything in it is straining toward the end [*bout*]. Only this absolute interruption, this cut which is pure because made with a single stroke, with a single *bout* [blow – from *buter*, to bang or bump into something] produces the feeling of beauty. If this cut were not pure, if it could (at least virtually) be prolonged, completed, supplemented, there would be no beauty.

What justifies us perhaps in playing from *but* to *blanc*, in passing from *end* to *end* [*de bout en bout*] and from *but* to *bout*, is an association that appears strange at first approach. In Kant's footnote, the tulip appears to be placed, deposited on a tomb. In reply, then, to an objection.

The objection: there are final forms without end which are nevertheless not beautiful; so not every finality without end produces the feeling of beauty. Kant ascribes a curious example to the anonymous objector: in the course of excavating ancient tombs, there are often finds of stone utensils with a hole, an opening, a cavity [*Loche*], 'as if for a handle [*Hefte*]'. Does not their form clearly indicate a finality, and a finality whose end remains undetermined? The objection continues: this finality without end does not provoke any feeling of beauty. No one says that they are beautiful, these tools equipped with a hole without a handle, these tools [*outils*], these utensils, these finalized useful objects that have no visible goal or end, no end that is determinable in a concept.

To be sure, replies Kant, but it is enough to consider them as artefacts [*Kunstwerke*] in order to relate them to a determinable goal. So when we intuit them, we have no immediate *Wohlgefallen*. This reply is somewhat obscure. On the one hand, it opposes the *immediate* experience of finality in the tulip to the experience of the utensil, which is an experience mediated by a judgement. In both cases there is, supposedly, experience of beauty because the finality is without end both in art and in nature. On the other hand, if *Kunstwerk* designates a work of artifice in general and not the object of the fine arts, the experience of beauty would be absent from it to the extent that the supposed intention [*Absicht*] implies a determinable end and use: there would be not merely finality but end, because the pure cut could be bandaged [*La coupure pure y serait pansable*]. The finalized gadget is not absolutely cut off from its end, one can mediately prolong it toward a goal, virtually supply it, replace the handle in its hole, rehandle the thing, give the finality its end back. If the gadget is not beautiful in this case, it is for want of being sufficiently cut off from its goal [*but*]. It still adheres to it. There is an adherence – to be continued –between the detached end and the finalized organization of the organ, between the end and the form of finality. As long as there remains an adherence, even virtually or symbolically, as long as there is not a pure cut, there is no beauty. No pure beauty, at least.

As soon as he has closed the tomb again and covered over the place of the dig, Kant puts forward the example of the tulip: 'But a flower, for example a tulip, is held to be beautiful because in perceiving it, one encounters a finality which, judged as we judge it, does not relate to any end.'

The tulip is beautiful only on the edge of this cut without adherence. But in order for the cut to appear – and it can still do so only by its edging – the interrupted finality must show itself, both as finality and as interrupture – as edging. Finality alone is not beautiful, nor is the absence *of goal*, which we will here distinguish from the absence *of the goal*. It is finality-without-end which is *said to be* beautiful [*said to be* being here, as we have seen, the essential thing). So it is the *without* that counts for beauty; neither the finality nor the end, neither the lacking goal nor the lack of a goal but the edging in *sans* of the pure cut [*la bordure en 'sans' de la coupure pure*], the *sans* of the finality-*sans*-end.

The tulip is exemplary of the *sans* of the pure cut ⌐

L on this
 ⌐

sans which is not a lack, science has nothing to say

L the *sans*

of the pure cut emerged in the disused utensil, defunct [*defunctum*], deprived of its functioning, in the hole without a handle of the gadget. Interrupting a finalized functioning but leaving a trace of it, death always has an essential relation to this cut, the hiatus of this abyss where beauty takes us by surprise. It announces it, but is not beautiful in itself. It gives rise to the beautiful only in the interrupture where it lets the *sans* appear. The example of the unearthed axe was thus at once necessary, nonfortuitous and inadequate. A suture holds back the *sans* precisely in as much as the determinant discourse of science forms its object in it: I begin by inference to make judgements about what completes the tool, about the intention of its author, about its use, about the purpose and the end [*du but et du bout*] of the gadget, I construct a technology, a sociology, a history, a psychology, a political economy, etc.

Whereas science has nothing to say about the *without* of the pure cut. It remains open-mouthed. 'There is no science of the beautiful, only a critique of the beautiful' (§ 44, 'On the Fine Arts'). Not that one must be ignorant to have a relation with beauty. But in the predication of beauty, a non-knowledge intervenes in a decisive, concise, incisive way, in a determinate place and at a determinate moment, precisely at the end, more precisely with regard to the

end. For the non-knowledge with regard to the end does not intervene at the end, precisely, but somewhere in the middle, dividing the field whose finality lends itself to knowledge but whose end is hidden from it. This point of view of non-knowledge organizes the field of beauty. Of so-called natural beauty let us not forget it. This point of view puts us in view of the fact that an end is in view, that there is the form of finality, but we do not see with a view to what the whole, the organized totality is in view. We do not see its end. Such a point of view, suddenly [*de but en blanc*], bends the totality to be lacking to itself. But this lack does not deprive it of a part of itself. This lack does not deprive it of anything. It is not a lack. The beautiful object, the tulip, is a whole, and it is the feeling of its harmonious completeness which delivers up its beauty to us. The *without* of the pure cut is without lack, without lack of anything. And yet in my experience of the accomplished tulip, of the plenitude of its system, my knowledge is lacking in something and this is necessary for me to find this totality beautiful. This something is not some thing, it is not a thing, still less part of the thing, a fragment of the tulip, a bit [*bout*] of the system. And yet it is the end of the system. The system is entire and yet it is visibly lacking its end [*bout*], a bit [*bout*] which is not a piece like any other, a bit which cannot be totalized along with the others, which does not escape from the system any more than it adds itself on to it, and which alone can in any case, by its mere absence or rather by the trace of its absence (the trace – itself outside the thing and absent – of the absence of nothing), give me what one should hesitate to go on calling the *experience* of the beautiful. The mere absence of the goal would not give it to me, nor would its presence. But the trace of its absence (of nothing), in as much as it forms its *trait* in the totality in the guise of the *sans,* of the without-end, the trace of the *sans* which does not give itself to any perception and yet whose invisibility marks a full totality to which it does not belong and which has nothing to do with it as totality, the trace of the *sans* is the origin of beauty. It alone can be said to be beautiful on the basis of this trait. From this point of view beauty is never seen, neither in the totality nor outside it: the *sans* is not visible, sensible, perceptible, it does not exist. And yet *there is some of it* and it is beautiful. It *gives* [*ça donne*] the beautiful.

[...] Beauty does not function without this *sans*, it *functions* only with *this* particular *sans*, it gives nothing to be seen, especially not itself, except with that *sans* and no other. And moreover it does not give (itself) to be seen with this *sans*, since it has nothing to do [*rien à voir*] with sight, as we have just said, or at least, in all rigour, with the visible. We have just written, a few lines up: 'Beauty is never seen ... the *sans* is not visible. ...'

Of this trace of *sans* in the tulip, knowledge has nothing to say.

It does not have to know about it. Not that it breaks down in front of the tulip. One can know everything about the tulip, exhaustively, except for what it is beautiful. That for which it is beautiful is not something that might one day be known, such that progress in knowledge might later permit us to find it beautiful and to know why. Non-knowledge is the point of view whose irreducibility gives rise to the beautiful, to what is called the beautiful.

The beautiful of beauty pure and as such. It was necessary to insist on the *purity* in the trace of the *sans* of the pure cut [*Il fallait insister sur le 'pur' dans la trace du 'sans' de la coupure pure*]. I now return to it so as not to leave the wildflower.

Why does science have nothing to say about the tulip in as much as it is beautiful?

If we go back from the appearance of the tulip (at the end of § 17, 'Of the Ideal of Beauty', of which the tulip is thus the final example) to the preceding paragraph ('A judgement of taste by which an object is described as beautiful under the condition of a definite concept is not pure'), we already encounter the flower – first example – and the ruling out of account of the botanist as regards what the flower is beautiful for. '*Blumen sind freie Naturschönheiten*': flowers are free beauties of nature, beauties of nature that are free. Why free?

Two kinds of beauty: free beauty *(freie Schönheit)* and merely adherent beauty [*bloss anhängende Schönheit*], literally, 'merely suspended beauty, hung-on-to, de-pendent on.' Only free (independent) beauty gives rise to a pure aesthetic judgement, to a predication of pure beauty. That is the case with wildflowers. Kant gives the Latin equivalents of the expressions *free beauty* and *adherent beauty.* Free beauty, that of the tulip, is *pulchritudo vaga*, the other is *pulchritudo adhaerens.* Why these Latin words in brackets? Why this recourse to an erudite and dead language? It is a question that we must pose if we are to follow the labour of mourning in the discourse on beauty. In the first footnote to the following chapter, Kant analyses the models of taste (paradigm, paragon, pattern. *Muster des Geschmacks*). He prescribes that, in the 'speaking arts' at least, the models should be written 'in a dead and scholarly language'. For two reasons, one lexical and the other grammatical. So that these models should be spared the transformations suffered by living languages and which have to do first with the vocabulary: vulgarization of noble terms, obsolescence of much-used terms, precariousness of new terms; then with the grammar: the language which fixes the model of taste must have a *Grammatik* which would not be subject to 'the capricious changes of fashion' and which would be held in 'unalterable rules'.

Whether or not the third *Critique* proposes models of taste for the speaking arts, each time Kant has recourse to a scholarly and dead language, it is in order

to maintain the norms in the state of utmost rigidity, to shelter them, in a hermetic vault, from yielding or breaking up. When, digging in Kant's text, one comes across these Latin words whose necessity one does not immediately (and sometimes not ever) understand, one has something of the impression of those defunct utensils, endowed with a hole but deprived of a handle, with the question remaining of whether they are beautiful or not, with free beauty or adherent beauty. Kant's answer is that their beauty in any case could not be vague or free from the moment it was possible to complete it with a knowledge, supplement it with a thesis or a hypothesis.

What does this opposition signify? Why the equivalence of *free* and *vaga*? Free means free of all adherent attachment, of all determination. Free means *detached*. It had been announced that this discourse dealt with detachment in all senses, the sense [*sens*] and the *sans* of detachment. *Free* means detached from all determination: not suspended from a concept determining the goal of the object. *Pulchritudo vaga* or free beauty does not presuppose any concept (*setzt keinen Begriff*, and for us the learned and dead language is German, which we wear out, which we make use of with all the plays on words and modes, with the grammatical caprices that grow most quickly wrinkled) of what the object must be [*von dem voraus, was der Gegenstand sein soll*]. Thus *free* means, in the concept which relates it to beauty, detached, free of all adherence to the concept determining the end of the object. We understand better the equivalence of *free* and *vague*. *Vaga* is the *indefinite* thing, without determination and without destination [*Bestimmung*], without end [*fin*], without *bout*, without limit. A piece of waste land [*terrain vague*] has no fixed limit. Without edge, without any border marking property, without any non-decomposable frame that would not bear partition. *Vague* [i.e., 'wanders, roams' – Trans.] is a movement without its goal, not a movement without goal but without *its* goal. Vague beauty, the only kind that gives rise to an attribution of pure beauty, is an indefinite errance, without limit, stretching toward its orient but cutting itself off from it rather than depriving itself of it absolutely. It does not arrive itself at its destination. [...]

1 Literally 'The without of the pure cut', but the homophony with *sang* [blood] is important, as is the affinity with *sens* [sense(s), direction)s)]. [Trans.]
 [On the notion of 'the cut' in Clement Greenberg's aesthetics of painting, see the essay by Mark Hutchinson in this volume, page 152.]

Jacques Derrida, extract from 'The *Sans* of the Pure Cut', *La Verité en peinture* (Paris: Flammarion, 1978); trans. Geoff Bennington and Ian McLeod, *The Truth in Painting* (Chicago: The University of Chicago Press, 1987) 84–93 [footnotes not included].

Griselda Pollock
Woman as Sign: Psychoanalytic Readings//1988

I

[...] 'Woman' was central to mid-nineteenth-century visual representation in a puzzling and new formation. So powerful has this regime been in its various manifestations (latterly in photographic and cinematic forms) that we no longer recognize it as representation at all. The ideological construction of an absolute category *woman* has been effaced and this regime of representation has naturalized woman as image, beautiful to look at, defined by her 'looks'. This is best exemplified in those twentieth-century photographic images manufactured to sell the commodities, cosmetics, by which the supposed nature of our sex can be attained by donning the 'mask of beauty'.

This latter phrase derives from the title of an essay by Una Stannard published in 1972 which starts:

> Women are the beautiful sex. Who doubts it?... just as all men
> are created equal, all women are created beautiful.[1]

This bit of irony is put into historical context. Not only have the ideals of beauty varied historically, but much, often painful, artifice has been employed to ensure bodily or facial conformity with the ideal. Moreover for many centuries beauty was as avidly pursued by men. Stannard argues that the exclusive identification of women with physical beauty only emerged when men were no longer defined as sex objects. She dates the shift to around 1830.[2] Her point may be arguable but this nexus of changed relationships between the category woman and beauty introduces a significant historical transformation.

In 1979 some students at Leeds University staged a performance dealing with this complex of issues and they used my office as an environment. The walls were papered floor to ceiling with cosmetic advertisements which remained as a ghastly wallpaper for several months. It was only after a long and intimate acquaintance with the serried ranks of female faces that I saw through the powerful illusions the photographic representation sustained. Gradually I perceived the systematic disproportions of the faces, the absence of volume and of the remotest suggestion of three-dimensional bone structure — everything that would be stressed in teaching drawing of faces to art students. Often there was only a blank, airbrushed expanse of colour in which eyes freely floated above undulations of shocking and moistly shiny red lips. These were not faces, not

portraits but fantasy. I recognized a striking parallel with nineteenth-century drawings of female faces by Dante Gabriel Rossetti which were also *not* portraits.

The portrait documents an individual's presence and, only in recent times, appearance, inscribing by the same token social status and place. The drawings by Rossetti [*Elizabeth Siddall* (1854; 1855; 1860), *Emma Brown* (1856; 1860), *Fanny Cornforth* (1862), *Jane Morris* (1857; 1860)], offer no location except the blank page. These faces are transplanted to a realm apart, a world of decorative hatching, incised lines, smudged contours or empty expanses of pristine paper. On show is very little of the model, but a great deal of drawing. The myth of woman is that she is simply revealed by the genius of the artist; the heavily laboured surfaces belie that myth with evidence of the work required to manufacture it. The pleasure these images offer, their beauty, is manufactured by the rhetorics and codes of drawing, of painting or photography, yet the drawing, painting or photograph seems merely the medium through which the viewer enjoys specular contemplative access to the natural beauty which is woman. When we look at these images we conflate the beauty of the drawing or photograph with woman as beautiful, and fail to question what motivates this fantasy of visual perfection; why and for whom was it necessary?

The issue of sexual difference is operative in most societies but its forms vary historically and culturally. Putting it at its baldest, one of the key features in mid-nineteenth-century discourses on masculinity and femininity is the absoluteness of gender difference (the two terms gender and sexual difference are not synonymous: sexual difference refers to the socio-psychic construction of sexualities with its attendant positionalities; gender difference as used here refers to the public discourse about what men and women are/ought to be). Take for instance this verse from Tennyson:

> Man for the Field and Woman for the Hearth:
> Man for the Sword and for the Needle She:
> Man with the Head and Woman with the Heart:
> Men to command and Woman to obey;
> All else confusion.
> (*The Princess*, 1847)

An unarguable otherness is declaimed in these cryptic, noun-laden verses where man and woman are produced as absolute opposites. Difference is made obvious and self-evident while the anxiety which underpins these 'facts of nature' is hardly kept at bay by the aggressive brevity of the statements. The linguistic form is eloquent testimony to the contrivance of the poem's claims. In the visual sign, woman, manufactured in a variety of guises in mid-nineteenth-century

British culture, this absolute difference is secured by the erasure of indices of real time and actual space, by an abstracted (some would call it idealized) representation of faces as dissociated uninhabited spaces which function as a screen across which masculine fantasies of knowledge, power and possession can be enjoyed in a ceaseless play on the visible obviousness of woman and the puzzling enigmas reassuringly disguised behind that mask of beauty. At the same time, the face and sometimes part of a body are severed from the whole. Fetish-like they signify an underlying degree of anxiety generated by looking at this sign of difference, woman.

In the production of a signified woman as beautiful face, a newly defined order of sexual difference was being inscribed. Neither the masculine positionality of the producer/viewer nor the feminine positionality of the produced/viewed pre-existed the manufacture of the representations as if completely formed elsewhere, merely reflected in art. The specificity of visual performance and address has, moreover, a privileged relation to the issues of sexuality.[3] On the other hand this is not merely a phenomenon of visual representation. The renegotiation of sexual difference within the urban bourgeoisies of the nineteenth century was a complex process operating unevenly and contradictorily across multiple points of discourse and social practice. But nowhere was this *inscription* so compelling as in those sites where it could be consumed as mere *description*.

> The dominant form of signification in bourgeois society is the *realist* mode, which is fixed and curtailed, which is complicit with the dominant sociolects and repeated across the dominant ideological forms. Realism offers a fixity in which the signifier is treated as if it were identical with a pre-existent signified and in which the reader's role is purely that of consumer. … In realism, the process of production of a signifier through the action of a signifying chain is not seen. It is the product that is stressed, and production that is repressed.
> (John Tagg, 'Power and Photography', 1980)[4]

It may seem odd to introduce realism in this context. In art historical terms Rossetti is privileged over other Victorian artists precisely because he transcended contemporary realism, typified by the works of Holman Hunt, early Millais and so forth, by his interest in colourism, allegory and poetic symbolism.[5] John Tagg's Barthesian notion of realism does not have a great deal to do with definitions of realist art as a matter of socially inflected contemporary subject matter, a preoccupation with the material qualities of painting, or precise naturalistic schemes of representation — truth to nature. Realism as *a mode of signification* (not a matter of style or manner) became increasingly dominant in

bourgeois culture – in literature as well, and more so with the establishment of photographic practices. Photographs offer particular pleasures and sustain specific illusions. A sense of actuality – someone like this was here, once – combines with and plays against the freedom of fantasy, for the only actual presence, now, is the viewer's. Fantasy can be satisfied by realist means which secure the credibility of the imaginary scene, with details of costume, setting, accessories. The realist mode of signification disguises the fact of production beneath its veneer of appearance. It can work therefore just as powerfully in the satisfaction of fantasy by means of its management of specifically visual pleasures for a viewer who is protectively placed as privileged voyeur.

Works collectively classified by the author name 'Rossetti' have been selected for this study for several reasons. These paintings provide a symptomatic site for the study of a new regime of representation of woman on the axis of bourgeois realism and erotic fantasy. In no sense do I wish to privilege Rossetti as representative artist, nor do I intend to interrogate his personal or even social life to explain the paintings.[6] I am concerned here to provide a textual analysis of a series of paintings which are related by the fact of a common producer. But they are in themselves inconsistent in the manner of their handling of an obsessive subject whose insistence is socially determined rather than privately motivated, namely, the negotiation of masculinity as a sexual position.

II

After 1858 Rossetti began to produce a series of oil paintings, few of which were ever exhibited for they were mostly made to commission or offered to a limited circle of regular buyers, many of whom were industrialists and businessmen. 'Female heads with floral attributes' was William Michael Rossetti's term for this repetitious cycle of half-length paintings of female figures in varying settings [such as *Monna Vanna*, 1866]. Despite their opacity there has been no lack of enterprise in their interpretation. Writing in 1897, F.W.H. Myers offered an extremely pertinent assessment of these paintings. Although he identified them as sacred pictures in a new religion, he also specified precisely the 'oddities' which should detain us:

> The pictures that perplex us with their obvious incompleteness, their new and daunting beauty, are not the mere caprices of a highly dowered but wandering spirit. Rather they may be called … the sacred pictures of a new religion: forms and faces which bear the same relation to that mystical worship of beauty on which we have dwelt so long. It is chiefly in a series of women's faces that these ideas seek expression. All these have something in common, some union of strangeness and puissant physical loveliness with depth and remoteness of gaze.[7]

Myers' comments are spot on. This text identifies the salient features of these works. Even if the idea of a new religion of beauty no longer compels, it invokes the cult, or iconic quality, of many of these images, which resides in that particular combination of physical *loveliness* and a remote *look*. [...]

VI

Lacanian theories of desire and the imaginary introduce a function for the image as a means to regain visual access to the lost object. This is in seeming contrast with the earlier use of psychoanalytic theories of fetishism in images which indicated a need to disavow and keep a distance from a potentially threatening sight and the knowledge of difference that sight precipitates. This conflict is not the only one and some recapitulation may be of use. I began by matching novel pictorial schemes for representation of female heads and mid-Victorian ideological polarization of man and woman as absolute and self-evident opposites. The Rossetti drawings signify woman as visibly different, and the sign woman is equated with a beautiful object to-be-looked-at. At the next level of analysis this phenomenon was examined under the rubric of woman as sign of difference. Beautification functioned as the means to manage the threat and loss upon which sexual difference is constructed. In addition, at this structural, psychic level, the troubled relationship between masculine *sexuality* and sight was proposed. Sexuality, in this theoretical account, is a product of the establishment of sexual difference, not an innate capacity or precondition. Sexuality is produced with desire, both predicated upon the patriarchal price of acquiring gender and language — the repression of the mother and the dyadic unity of mother and child. The play of desire within and generated by looking at images is fundamentally contradictory; a) fearful of the knowledge of difference (woman as threat) and b) fantasizing its object (the image of woman as a fantasy of male desire, its sign). The use of psychoanalytic theory not only provides some interpretative tools for understanding the obsessive preoccupation with images of woman and their inconsistent characters, but shifts attention away from iconographic readings to the study of the process of the image, what is being done with it and what it is doing for its users.

In her now rightly famous article ['Visual Pleasure and the Narrative Cinema', 1975], Laura Mulvey demonstrated both uses of psychoanalysis. She posed the cinema as an apparatus which managed pleasure for its viewers in accordance with the psychic formations of masculine sexuality within bourgeois patriarchal societies. She argued firstly that the image of woman (note it is a question of an image) 'stands in patriarchal culture as the signifier of the male other, bound by the symbolic in which man can live out his fantasies and obsession through linguistic command by imposing them on the silent image of woman still tied to

her place as bearer and not maker of meanings'.[8] But Mulvey also identified the paradoxes of phallocentricism in whose representational systems the pleasures generated by the visual domination and voyeuristic consumption of images of a female form evoke the anxiety that female form is made to signify within a patriarchal culture. The resulting regime of representation is fetishistic. Fetishism as an avenue of escape and a defence mechanism is imposed upon an earlier pre-Oedipal organization of the drives, the component instincts of sexuality, the prime one of which is scopophilia, love of looking. This love of looking derives, according to Freud, from the pleasure taken by the incompetent and immobile infant in imagining control over another by subjecting them to a controlling gaze. The combination of scopophilia and fetishism, fetishistic scopophilia 'builds up the beauty of the object transforming it into something satisfying in itself'.[9] Mulvey also points out how this process takes place outside of the linear time, suspending the narrative of a film, feasting the eye with a forty-foot close-up of Dietrich's or Garbo's face.[10] Is there not some echo here of Holman Hunt's regret [in a letter of 12 February 1860 to the collector Thomas Combe, cited in part III of this essay] at Rossetti's lack of narrative and his anxieties about gratification of the eye?

The paintings which mark the turning-point from 1858 onwards were increasingly devoid of narrative, relying instead on linguistic messages in the form of titles and poetry inscribed often on the canvas or frame. These word-signs serve as relays not to complete narratives elsewhere but to sonnets, a form which establishes particular positions from which the object in the poem or painting is obliquely viewed, like Medusa's head in a mirror. ... A position of vision is quite explicit in phrases such as 'lo! there she sits' or 'I saw Beauty enthroned', etc. The positionalities of viewer and viewed enact a specific order of sexual difference and determine whose ordeal is being negotiated. It is not a natural order that men should like to look at lovely women, however much that order has been naturalized. The relations of pleasure in this activity have to be constructed and managed to deal with the attendant dangers when that look is focused on that which signifying differentiation also implicates loss and death.

The peculiarities of anatomical structure only matter within a cultural order which makes variety signify difference, 'a' and 'not a'.[11] The term man is secured as meaningful only in negative relation to another. This occurs in human societies in which the primary bond is between a female caretaker/mother and children of all sexes. Differentiation is dependent upon the introduction into this dyad mother and child of a third term, an Other, a 'father' figure, an authority who can intervene and delimit the mother-child relation. The imaginary phase refers to that moment when the child is forced to intimate its own separateness on two registers — of its mother's body from itself and of itself as a discrete

entity perceived firstly as an image in another place, a mirror. The discovery is compensated for by identifying with the mother, imagining oneself to be like her. It is the confrontation with what the culture defines as two different terms, mother and father, which precipitates the crisis Freud called Oedipal. Once difference is introduced to shatter the imaginary unity of mother and child, the child is forced to adopt a position relative to these terms of difference, i.e., to take up a position as masculine or feminine subject, and give up the mother for a substitute object. Within a patriarchal system difference is ordered in the name of the father. The attributes of the father function as props for the signifier of difference, the phallus which as a result signifies both power/presence *and* loss/absence. It is also the signifier of desire, which is produced at this moment of loss of unity with the mother. Sex is therefore acquired at the price of the repression of the mother and submission to the law of the father. Masculinity is shaped by the ordeal and femininity is produced as its sign. This schematic scenario is highly abstract. Indeed as in the case studies undertaken by Freud the hypotheses are construed from life stories which demonstrate the variability of each trajectory through this formation and its instability. Organized negotiation of the pressures and limits of psycho-sexual formation are the substance of the pleasures and purposes of a vast amount of cultural production.

Earlier in this essay I stressed the methodological issue of replacing interpretation of meanings in paintings by examination of the work being done through their production and consumption. It might seem that I have reneged on that commitment by using psychoanalysis to explain the typologies and even the stylistic and material properties of the works in question. Psychoanalysis has not been used here as a key, but rather as a means to identify the process of psychic formation under a specific social and ideological order. The practices of representation are both shaped within such processes and contribute to their ceaseless reproduction. But if they are sites for the production of meanings and their attendant positionalities they can also be sites for their negotiation. Thus when I asked why the bourgeois male buyers of these paintings liked to look at them, I had in mind the possibility that the paintings would both function within prevailing ideological fields (intimated for instance by the Ruskin and Hunt texts quoted [in parts III and IV]) and also permit some journey across their symbolic boundaries. The Lacanian account of the potential slippage between the two orders of meaning constitutive of our making as subjects enabled me to articulate that process.

VII

To make this point plainer I want to turn to one final painting, *Astarte Syriaca* (1877), painted from yet another facial type, that associated with Jane Burden

Morris, which is characterized by a wealth of dark, crinkly black hair, large eyes under heavy and continuous brows and a hugely exaggerated red mouth. The *Astarte Syriaca* is the image of the Syrian goddess of love which breaks the mould of the Rossetti work in both the '[Fanny] Cornforth' and '[Alexa] Wilding' typologies. The figure is upright, seen almost full length, as if striding towards the viewer out from her pictorial space.

The 'Morris' face dominates production by Rossetti in the 1870s. Its features were subjected to extreme schematization and symmetry. This is vividly shown in a preparatory pastel drawing dated 1875 of the head of the Astarte which was made by Rossetti into an independent work [*Study for the head of Astarte Syriaca* (1875)]. It epitomizes the development of the face-object adumbrated in the drawings of the 1850s discussed at the beginning of the chapter. Here a head floats on a field of blank paper, severed from its body, a flat, perfect object of a face. But the difference between this format and the effect of the face reunited with its mobile body in the final painting is striking and revealing. The face of the Astarte figure is more charged with expression. It appears as if Astarte looks down upon a spectator/subject/worshipper who is positioned in subordination to this towering and monumental figure. Here the question of scale is vital, for it dramatically removes the viewer from a voyeur's intimacy with the private space characteristic of *Bocca bacciata* (1859) for instance. The relations of looking are reversed in a manner reminiscent of medieval cult images where the image as icon was endowed with the power to look upon the viewer. Some art historians have found *Astarte Syriaca* a cruel and frightening image of love,[12] obviously reading it as a kind of *femme fatale*. I would like to propose an entirely opposite reading, seeing in its scale, active posture and empowered glance an image which transcends the stalemated, fetishistic quality of so many of the images previously discussed.

In an essay on 'Woman and the literary text' John Goode examined the ways in which literary analysis could be useful to feminist studies. Working against any tendency to reduce a literary text to something outside itself – be it history or intellectual trends (or artistic personalities), he stressed the necessity of analysing the articulation of the text – or the manner in which as text it transforms the materials which are its subjects. He furthermore distinguishes between two kinds of coherence which we can perceive in texts – an ideological coherence, where the material/representation remains untransformed, unexposed, familiarized; and a fictional coherence where we become 'conscious of the sense of ideology itself, shaping, motivating the representation'.[13] At that point, as I shall argue in the case of *Astarte Syriaca*, the dominant ideological structures within which the fetishistic regime of representation is founded are exposed and the viewer is positioned against the patriarchy.[14]

In one section of the essay Goode deals with images of dangerous women, discussing George Macdonald's novel *Lilith* (1895) and also H. Rider Haggard's *She* (1887). Goode reads *She* as a novel about the ordeal of masculine sexuality of which Ayesha, She, is the primary cause and also its liberation. The tale is about a desiccated and misogynist academic, Holly, and his young companion Leo Vincey, who set out to avenge the murder of Vincey's forebear Kallicrates by Ayesha.

The narrative soon gives way to metaphors of sexual struggle which make plain the nature of their project as a 'crusade against female power over man'. 'She' rules a matrilinear society where women choose their sexual partners non-monogamously. Like Lilith, working-class prostitutes and 'primitive' peoples, they embody a female sexuality antipathetic to the bourgeois regulations institutionalized as femininity. When Ayesha appears she does not, however, symbolize the anticipated and primordial evil. 'She' embodies an alternative principle of knowledge based on love, through which she aims to revolutionize the world. 'She' dies, however, in the flame through which she hoped to gain eternal life (compare Lilith's dangerous eternity). The ideological necessities of the order within which the novel is produced demand that this transgression of eternal law be punished by death: 'She' cannot be allowed to succeed. But Goode argues that what makes *She* a fine novel is that the fictional characters Holly and Vincey and thus the readers are estranged by the novel from that ideological law:

> The journey outward becomes not release from the past (the revenge intention) but a journey back to that past to reveal the puniness of male fear and its comfortable accommodation within eternal law, so that there can be no return journey … *She* is a fine novel because it brings us (the readers) to ask the repressed question of its project: what does the destructive woman destroy, ourselves, or ourselves' subjugation?[15]

The fictional trope of a return journey serves the fantasy of regression to a moment prior to the fixing of the patriarchal law which demands subjugation to an order that denies the primary object of love on pain of loss of self/death and initiates unfulfillable desire. *She* reveals the price exacted by the patriarchal ordering of sexuality, the incompatibility of love and desire.

I want to suggest that, momentarily, *Astarte Syriaca* also appeals to that realm of fantasy and achieves a similar order of fictional coherence. It raises to a visible level the pressures that motivated and shaped the project of 'Rossetti' – the negotiation of masculine sexuality in an order in which woman is the sign, not of woman, but of that Other in whose mirror masculinity must define itself. That other is not, however, simple, constant or fixed. It oscillates between signification of love/loss, and desire/death. The terrors can be negotiated by the

cult of beauty imposed upon the sign of woman and the cult of art as a compensatory, self-sufficient, formalized realm of aesthetic beauty in which the beauty of the woman-object and the beauty of the painting-object become conflated, fetishized. But on occasions some works transcend that repetitious obsessive fetishization and image a figure before which the masculine viewer can comfortably stand subjected. The Syrian Venus, in scale, activity and gaze constructs a fantasy image of the imaginary maternal plenitude and phallic mother. But the majority of female figures in the oeuvre of Rossetti do not function this way. Like the goddesses of the Hollywood screen they take on an iconic fascination of being seen, while *unseeing*. Rossetti's paintings trace a journey where Woman is obsessively pursued but where woman as woman rarely appears. Woman as sign is a function of a struggle to accommodate to the order of sexuality in the process of being established, but an order which is constantly threatened by the return of the repressed, by the regression to the imaginary, a regression characterized by the hankering after the super-real permanent object – a desire that was to be better fulfilled in the frozen, unchanging 'here' and 'thenness' of the still photograph, or the cinematic close-up, both of which rapidly superseded the function of the painting in dealing with these areas of representation and sexuality.

The dominant tendency to become obsessed with the fetishized image, the petrified 'face-object', functioned on the axis of social and sexual regulation of the emergent bourgeois order in mid-nineteenth-century Britain. Rossetti and the circle of intellectuals and artists with whom he mixed negotiated on behalf of that order the accommodation of masculine sexuality, effecting an ideological form of representation on behalf of the class they served.[16] The texts they produced inscribe the struggle to adjust to a social order instated at the level of the psychic formation of sexuality — and usually addressed by the management of the gaze and viewing positions. This is therefore a question of sexuality and the mode of representation. Rossetti's works predate Freud and the Hollywood cinema. But out of the same formations and its ordeals came both the analytic theories of Freud and the representational project of classic Hollywood cinema.

1 [footnote 4 in source] Una Stannard, 'The Mask of Beauty', in Vivian Gornick and Barbara K. Moran, eds, *Woman in a Sexist Society* (New York: Mentor Books, 1972) 187.

2 [5] Ibid., 191.

3 [6] For example Jacqueline Rose in 'Sexuality in the Field of Vision', in *Difference: On Representation and Sexuality*, ed. Kate Linker (New York: New Museum of Contemporary Art, 1985) 33; reprinted in Jacqueline Rose, *Sexuality in the Field of Vision* (London and New York: Verso, 1986).

4 [7] John Tagg, 'Power and Photography', *Screen Education*, no. 36 (1980) 53.

5 [8] T.J. Clark, 'Preliminaries to a possible treatment of *Olympia* in 1865', *Screen*, vol. 21, no. 1 (1980) 38–41.

6 [9] See *Aesthetics and Politics: Debates between Ernst Bloch, Georg Lukacs, Bertolt Brecht, Walter Benjamin, Theodor Adorno*, translation editor Ronald Taylor (London: New Left Books, 1977).

7 [10] Peter Wollen, 'Manet: Modernism and Avant-Garde', *Screen*, vol. 21, no. 2 (1980) 25.

8 [51] Laura Mulvey, 'Visual Pleasure and the Narrative Cinema', *Screen*, vol. 16, no. 3 (1975) 7.

9 [52] Ibid., 14.

10 [53] I have found Barthes' essay 'The face of Garbo' extremely suggestive in attempting to analyse the development of the face-image; see *Mythologies* (1957), trans. Annette Lavers (London: Paladin, 1973). Laura Mulvey's analysis of the iconic function of the image of woman is specifically based on the cinematic machine. She locates fetishistic scopophilia precisely, however, in those moments when the narrative drive and flow of cinematic imagery is suspended by iconic insertions of gigantic close-ups of disembodied faces, unnaturally illuminated and floating freely, abstractly, on the vast surface of the screen. There is a connection from the cinema conditions of viewing such images to other sites of consumption, through the circulation of these close-ups and other fashioned similarly as publicity stills for fans. I am suggesting a structural link between the emergence in the mid-nineteenth century of a pictorial convention of representation producing woman as icon in a 'freeze frame' and the insertion into narrative cinema of the atemporal icons which makes Mulvey's analysis particularly pertinent. Fetishism refers, however, not only to the remaking of the imaged figure, but to a structure of viewing which depends upon a relation between separation (of the viewer) – (from) representation – (in a position of) speculation (i.e., a mirror). Although the cinematic machine organizes spectatorship precisely in this fetishizing manner, in the dark, cut off from consciousness of one's own body and place by prolonged immobility and exclusively visual excitation, the viewing of still photographs or framed paintings can achieve a similar structure. In the still image which the cinematic close-up replicates, separation is assured by the absence of what is represented at the time of viewing and by the mirror-like effects of the framed image. The spectatorship of paintings is rhetorically as well as socially cued and these images were produced for relatively private contemplation within the study or home. This fetishistic character of imagery and image consumption as defined by Mulvey is identified precisely with the atemporal close-up of a body part. Voyeurism, on the other hand, concerns narratives of investigation and punishment.

11 [54] Jacqueline Rose, 'Introduction II', in J. Mitchell and J. Rose, eds, *Feminine Sexuality, Jacques Lacan and the École Freudienne* (London: Macmillan, 1982) 42: 'Sexual difference is then assigned according to whether individual subjects do or do not possess the phallus, which means not that anatomical difference is sexual difference (the one strictly reducible from the other), but that anatomical difference comes to figure sexual difference, that is, becomes the sole representative of what that difference is allowed to be.'

12 [55] Julian Treuherz, *Pre-Raphaelite Paintings from the Manchester City Art Gallery*

(Manchester, 1980) 108. [...]

13 [56] John Goode, 'Woman and the literary text', in Juliet Mitchell and Ann Oakley, eds, *The Rights and Wrongs of Women* (Harmondsworth: Penguin Books, 1976) 218.

14 [57] The theoretical resources used by Goode are clearly the writings of Pierre Macherey, *A Theory of Literary Production*, which also inform T.J. Clark's formulation in his essay 'On the social history of art', in *Image of the People* (London, Thames & Hudson, 1973), from which I am adopting this argument about the way in which texts rework the ideological materials which structure their production.

15 [58] Goode, op. cit., 237.

16 [59] See Raymond Williams, 'The Bloomsbury Fraction' in *Problems in Materialism and Culture* (London: Verso Editions, 1980) 158–9. 'But in their effective moment, for all their difficulties, they were not only a break from their class ... but a means towards the necessary next stage of development of that class itself.' [...]

Griselda Pollock, extracts from 'Woman as Sign: Psychoanalytic Readings', *Vision and Difference* (London and New York: Routledge, 1988) 167–74; 201–11.

Jay Bernstein
Beauty and the Labour of Mourning//1992

[…] How indeterminate is reflective judging? The force of this question becomes apparent when we apply the standard objection to the judgement of taste directly to Kant's epistemology. Remember, the standard objection stated that if just the necessary subjective conditions for objective judgement were sufficient for a judgement of taste, then Kant would have to declare all sense-perceptible objects beautiful. What this presupposes, and what now appears to be presupposed by Kant's general theory of knowledge, is that there are invariant features of perceptual manifolds which are regarded as invariant in virtue of their conformity to the invariant features of the understanding. What goes wrong with this account, and what is pointed to if not stated by the standard objection, is that there is a slippage between invariance and recognition, and between recognition and synthesis. The complex doubling of invariance (ascribable to features both of manifolds and of the understanding), we might say, tends to licence a more causal conception of what occurs than is readily compatible with an acceptance of the account offered of the kind of mental activity requisite to register invariance. The gap opened up and insisted upon by the standard objection, while appearing to ask for something more than invariance as a condition of beauty, which it of course does do, does so through an invocation of a discerning, discriminatory activity which simultaneously undermines the putative causal role of invariant features of manifolds in the epistemological story. But this is just to say that applicability of the categories to experience must be regarded as a non-trivial achievement; and only by conceding this point can any sense of the role of reflective judgement be maintained.

Again, what makes this argument plausible is the role of reflective judgement in determinate judgement. What seems to be implied by this role is that the determination of which appraised features of an object conform to the invariant features of the understanding presupposes a non-nomological common sense, in virtue of which variant and invariant features are sorted. […]

Now let us attempt to conceive of a state of affairs in which categorial invariance is not yet secure; what, then, would have had to be the case in order for it to be secured? Two conditions would need to have been fulfilled, some evidence for which will be given below. First, there must have existed a common sense, a shared appraising discourse; and second, an interest in producing what we (now) regard as objective judgement, that is, an interest in regarding objects in terms of those properties that permit determinate identitary judgements. […]

Both conditions are of consequence. To claim that, in the first instance at least, we cannot conceive of the application of objective categories in the absence of a common sense, is to claim that nothing ensures or guarantees the existence of an intersubjective world a priori; unless we already shared a way of viewing the world, shared concepts and capacities for appraising and discriminating, then the distinction between variant and invariant could not find purchase. That it does find purchase, equally assumes that we have an 'interest' in producing judgements that are disconnected from what anyone desires, or thinks beautiful or holy or good. Even this is too weak; for if we are to imagine an instance in which the satisfaction of this interest is to be a source of pleasure, then we must equally be imagining a situation in which this interest, in producing objectively valid judgements in accordance with the categories of the understanding, has become an identifiable interest apart from other forms of interest.

Is this the time of which Kant was speaking when he claimed that, once upon a time, pleasure appeared from the application of categories and the sorting of individuals into genera and species? It is certainly difficult to imagine a set of conditions other than what has been proposed that would satisfy this claim. In conceiving of such a time we are initially conceiving a world in which the judgements of common sense predominate; in which, that is, reflective judgements as such had a certain sort of dominance over determinate judgements. Such a dominance would obtain if the core judgements concerning objects were made on the basis of indeterminate rules incapable of determinate evidential confirmation. But to conceive of a situation like this is just, I want to suggest, to conceive of one in which objectivity and 'truth' are not distinguished from the beautiful or the good or, say, the holy; where, perhaps, to be true is to be good, or where nothing is beautiful that is not also holy or good or true. [...]

A world premised upon common sense and not objective rules is one in which there would be a lawfulness without law; and this approximates what Hegel will term *Sittlichkeit*, customary practices in which form as condition is not separated from what it informs. Such an idea models, we might say, such a world. The modelling is not ideal, however, since the objects of such a world are not conceived of as without end or purpose external to themselves; on the contrary, they are deeply enmeshed in an endless series of teleological references (this approximates to what Heidegger will designate as a 'world'). What differentiates objects so judged from the objects of the understanding, however, is that the judgement placing them within the teleological whole is reflective rather than determinate: their ultimate determination is not made on the basis of their sense-perceptible features. Judging them would have been more like an indeterminate diagnosis than an assertive judgement of fact. Conversely, *Kantian invariance is reductively bound to the sense-perceptible*

features of objects, or rather, Kant's idea of the sense-perceptible features of things, which provides for the invariance his theory requires, must be construed as reductive if reflective judgement is perceptual. [...]

To now conceive of a world in which determinate, subsumptive judgement predominates over common sense is to conceive of a world in which the interest in knowledge has come to mean an interest in what things are apart from any other interests; and where, therefore, what provides the commonness of the world, its shareability, are the sense-perceptible properties of ordinary objects in their (reductively) determinate relations to one another. Since the claim has been that the interest subtending this state of affairs is 'subjective', then the recovery of the history producing it will amount to a genealogy of reason. [...]

From the perspective of reflective judgement the attainment of such a world looks like a loss; a loss of commonness and solidarity. Or better, it images a common world without solidarity. Things and persons are meaningless, without value, in terms or what can be said about them 'objectively', perceptually, through the deliverances of the senses.

In such a world, our world, judgements of beauty are memorial: in making aesthetic judgements we judge things 'as if' from the perspective of our lost common sense, a common sense that may never have existed (evidence for it deriving strictly from the torsions of the analytic articulation of aesthetic experience). This 'remembered' common sense is, as Kant has it throughout the third *Critique*, both presupposed in the judgement of taste and yet to be obtained. It is present by virtue of its absence. As remembered/presupposed, common sense is constitutive of the judgement of taste; as not existent, it is regulative. Hence the answer to Kant's remarkable and curious question (*Critique of Judgement*, § 22, 239–40): is common sense, the necessary condition for the possibility of judgements of taste, constitutive or regulative?; the answer is both. Of course, if a common sense did exist, then Kant's moral theory would become redundant; alternatively, if Kant took common sense as regulative, then the disinterestedness of aesthetic judgement would have been infringed upon. In accordance with the letter of the critical system, then, common sense can neither be presupposed nor demanded and judgements of taste are not possible. Only by conceiving of the judgement of taste as memorial can we comprehend how and why Kant vascillated over what is a lynchpin of his argument.

Common sense can provide the ground for a judgement of taste only to the degree to which it exists, since by definition it lacks the sort of a priori form which can be imposed on an independent content. As its placement in the imagination indicates, and as Kant's wide definition of imagination in the third *Critique* as sensibility plus imagination emphasizes, common sense is the becoming-form-of-content *and* the becoming-content-of-form. The freedom of the imagination in

reflective judgements of taste marks its freedom from the constraint of a priori legislation as such. Kant contrasts the understanding's determinate judgement with aesthetic reflective judgement on precisely this basis:

> The aptitude of men for communicating their thoughts requires, also, a relation between the imagination and the understanding, in order to connect intuitions with concepts, and concepts, in turn, with intuitions, which both unite in cognition. But there the agreement of both mental powers is *according to law*, and under the constraint of definite concepts. Only when the imagination in its freedom stirs the understanding, and the understanding apart from concepts puts the imagination into regular play, does the representation communicate itself not as thought, but as an internal feeling of a final state of mind. (*Critique of Judgement*, § 40, 295–6)

Although there is an activity of the understanding in aesthetic reflective judgements, it is not the understanding of the first *Critique*; here it is 'stirred' into activity by the materials offered to it, and although it interacts with the imagination, it does not subsume or legislate.

Kant, then, was quite right in § 41 not to let the presupposed communicability of aesthetic judgement become a demand; to demand common sense, to morally require it, is to destroy it. Common sense is not form, but the non-formal condition of form, as lawfulness without law is law without legislation, and therefore without constraint. Common sense is the communicability of feeling, and not the demand for such. But such a common sense does not now exist, or exists only as a memory; but in so far as 'we' remember it (in virtue of serious participation in aesthetic discourse and practice), judge through it, it does exist. In its existing it binds us, not as a constraint or external law binds us but as ties of affection (and disaffection) do. *From the perspective of common sense, legislative morality is a remedial virtue.*

Because common sense is only activated through participation in aesthetic discourse, and because, as Kant concedes, that participation is exhausted by the kind of communicability tokening common sense, then it is unsurprising that Kant should regard the 'universal communicability of the mental state' in judgement as the ground of our 'pleasure in the object' (*Critique of Judgement*, § 9, 217). Only when we judge in accordance with our lost common sense is there an *aesthetic* feeling of pleasure in the object. Kant's making the feeling of pleasure in the object consequent on its universal communicability, a presumption that appears backwards from a naturalistic perspective, however hesitantly, acknowledges the primacy of common sense over categorical understanding and moral reason.

By conceiving of the judgement of taste as memorial we can now provide at

least the rudiments of a solution to the problem of the standard objection, that is, the problem of what sorts of non-trivial, if indeterminate, conditions are met by objects judged beautiful that distinguish them from other sense-perceptible objects. Roughly, a judgement of taste is appropriate to the degree to which we are able, in considering the object, to abstract from the determinate concepts that constitute that object as belonging to an objective realm. The thought lying behind this requirement is that the less an object 'must' be conceived of in terms of determinate judgement, the less it is caught in the 'web' of subsumptive thought, the more suitable it is for the work of remembrance constitutive of aesthetic reflective judgement.

At first glance, this requirement appears to get caught in a difficulty directly analogous to the difficulty which so troubles Kant's discussion of free and dependent beauties. There Kant appeared to suppose that for some objects, like churches and horses, we are unable to abstract from the determinate ends they serve; and with art works, we are unable to abstract from the causal, intentional history through which they are produced. Against Kant, on the question of works of art, it has been argued that he 'failed to notice that a power of abstraction broad enough for his general theory of aesthetic response would also be broad enough to allow free judgements on the beauty of objects which are, as a matter of fact, works of art and even representational art'. And that generally, 'it is not clear whether the mere *presence* of any concepts – the mere knowledge of their applicability to a given manifold, even the mere fact of such applicability – is sufficient to constrain the imagination, or whether the imagination can always abstract from concepts known to apply to objects.'

Now in contending that we are not always free to abstract from the net of determinate concepts and ends which 'saturate' different objects to various degrees, and further, that whether we are or are not so free is essential to what makes an object suitable for aesthetic appraisal, Kant was, I am claiming, on to something important. It seems evident that such constraints do operate. Kant ran into difficulty on two counts: first because he wanted to draw the line between where we could and could not abstract on a priori grounds; and secondly because he could not explicate why pure judgements of taste should be so central to constituting the domain of taste, given that its value (import and significance) seemed to reside in dependent beauties. And, again, the latter difficulty is operative because Kant could not conceive of value (import and worth) apart from the space opened up by the categorical imperative, while the disinterestedness of taste and the presupposition of common sense clearly opens up an alternative conception of value. (Indeed, from this perspective the claim that beauty is a symbol of the morally good appears the wrong way round: is not the morally good a symbol for the indeterminate beauty of common sense?)

Nonetheless, Kant rightly recognizes that there is a question here, and that there is a contestation between constraint and freedom; what he cannot do is successfully locate the ground of the contestation. We now have the thesis that the ground of that contestation is precisely the degree of saturation of an object, or set of objects, by determinate thought and practical ends, a point Kant obliquely registers in his disqualification of craft works as suitable objects of aesthetic regard on the basis of their entrapment within commodity production (*Critique of Judgement*, § 43, 304; § 51, 321) with the further proviso that the indeterminate judgement of saturation is itself historically and culturally variable. If this is correct, then we would expect there to be a history of taste wherein different objects (arts and styles of art) became paradigmatic on the basis of their suitability for aesthetic reflection; where such suitability was judged on the basis of those objects' distance from or ability to resist the claims of determinate judgement and the social practices which forward those claims. Perhaps the movement from representational painting to 'free' nature, to romantic poetry, to the realist novel, to modernist art and literature inscribes just such a history. What that history would record is the collective labour of mourning through which the claims of common sense have been kept alive. A version of just such a history forms the core of Adorno's aesthetic theory. […]

Jay M. Bernstein, extract from *The Fate of Art: Aesthetic Alienation from Kant to Derrida and Adorno* (Pennsylvania: Penn State Press/Cambridge: Polity Press, 1992) 188–224 [footnotes not included].

Fredric Jameson
Transformations of the Image in Postmodernity//1995

[...] In a period in which the 'Decadence' is itself undergoing some very interesting revaluations, it only seems appropriate in the present context to recall beauty's subversive role in a society marred by nascent commodification. The *fin de siècle*, from William Morris to Oscar Wilde, deployed beauty as a political weapon against a complacent materialist Victorian bourgeois society and dramatized its negative power as what rebukes commerce and money, and what generates a longing for personal and social transformation in the heart of an ugly industrial society. Why then can we not allow for similar genuinely proto-political functions today, and at least leave the door open for an equally subversive deployment of beauty and art-religions? It is a question that allows us to measure the immense distance between the situation of modernism and that of the postmoderns (or ourselves), and between tendential and incomplete commodification and that on a global scale, in which the last remaining enclaves – the Unconscious and Nature, or cultural and aesthetic production and agriculture – have now been assimilated into commodity production. In a previous era, art was a realm beyond commodification, in which a certain freedom was still available; in late modernism, in Adorno and Horkheimer's *Culture Industry* essay, there were still zones of art exempt from the commodifications of commercial culture (for them, essentially Hollywood). Surely what characterizes postmodernity in the cultural area is the supersession of everything outside of commercial culture, its absorption of all forms of art high and low, along with image production itself. The image is the commodity today, and that is why it is vain to expect a negation of the logic of commodity production from it; that is why, finally, all beauty today is meretricious and the appeal to it by contemporary pseudo-aestheticism is an ideological manoeuvre and not a creative resource. [...]

Fredric Jameson, extract from 'Transformations of the Image in Postmodernity' (1995); first published in English in Fredric Jameson, *The Cultural Turn: Selected Writings on the Postmodern 1983–1998* (London and New York: Verso, 1998) 134–5.

Thierry de Duve
Kant after Duchamp//1996

Critique of the Modern Aesthetic Judgement

In its eighteenth-century version, the antinomy of taste is at the core of the *Dialectic of Aesthetic Judgement*, itself the centrepiece of Kant's *Critique of Aesthetic Judgement*, which is the first part of the *Critique of Judgement*. Here is how Kant stated it:

> Thesis. The judgement of taste is not based upon concepts; for, if it were, it would be open to dispute (decision by means of proofs). Antithesis. The judgement of taste is based upon concepts; for otherwise, despite diversity of judgement, there could be no room even for contention in the matter (a claim to the necessary agreement of others with this judgement).[1]

Kant's definition of taste is that it is 'the faculty of judging of the beautiful', and his main concern is with beauty in nature. (Although he has interesting things to say about art, they will not come under review here.) A judgement of taste is essentially sentimental, not cognitive:

> In order to distinguish whether anything is beautiful or not, we refer the representation, not … to the object for cognition, but … to the subject and its feeling of pleasure or pain. The judgement of taste is therefore not a judgement of cognition, and is consequently not logical but aesthetical, by which we understand that whose determining ground can be *no other than subjective.*[2]

Such a judgement naturally expresses itself (if it expresses itself out loud, which is of course not necessary) through a sentence such as 'this is beautiful'. Let's call it the classical aesthetic judgement. Other formulas, even the most contemporary and colloquial ones, such as 'this is super', as well as the ones that are usual in regard to works of art, such as 'this (painting) is good', may replace it without its ceasing to be a classical aesthetic judgement. With the readymade, however, the shift from the classical to the modern aesthetic judgement is brought into the open, as the substitution of the sentence 'this is art' for the sentence 'this is beautiful'. To say of a snow shovel that it is beautiful (or ugly) doesn't turn it into art. That judgement remains a classical judgement of taste pertaining to the design of the snow shovel. The paradigmatic formula for the modern aesthetic judgement is the sentence by way of which the snow shovel

has been baptized as a work of art.[3] Whether or not 'this is art' still *means* 'this is beautiful' or something similar is irrelevant. As I have tried to show in the previous chapters [of *Kant after Duchamp*], a lot depends on whether one situates one's judgement within the accepted conventions of art, or whether those conventions are themselves at issue. The history of modernism and of avant-garde art tilts the balance toward the latter but settles the question of meaning only in those extreme but highly significant cases where disgust has prompted first the rejection then the acceptance of the work. Indeed, every masterpiece of modern art – from Courbet's *Stonebreakers*, Flaubert's *Madame Bovary* and Baudelaire's *Fleurs du mal* to Manet's *Olympia*, Picasso's *Demoiselles d'Avignon*, Stravinsky's *Rite of Spring*, Joyce's *Ulysses* and Duchamp's readymades – was first met with an outcry of indignation: 'this is not art!' In all these cases, 'this is not art' expresses a refusal to judge aesthetically; it means, 'this doesn't even deserve a judgement of taste'. Reasons invoked boil down to either disgust or ridicule, the two feelings that Kant deemed incompatible with the judgements regarding, respectively, the beautiful and the sublime. In the third *Critique*, Kant wrote: 'One kind of ugliness alone is incapable of being represented conformably to nature without destroying all aesthetic delight, and consequently artistic beauty, namely, that which excites disgust.[4] And in the *Observations*, he had already noted: 'Nothing is so much set against the beautiful as disgust, just as nothing sinks deeper beneath the sublime than the ridiculous.'[5] Yet all the works just listed – and there are many more – have subsequently been judged as masterpieces of avant-garde art, and of art *tout court*, and it is safe to assume that, even for us now, they retain some of their ability to arouse an uncanny feeling of disgust or of ridicule that disturbs the enjoyment of beauty or of sublimity. In the face of the historical record concerning these crucial cases, we must part with Kant, and this is important in helping us to understand why the historical record strongly supports (though does not prove) the thesis that 'this is art', as applied to a readymade (or to a Courbet, a Matisse, or anything for that matter) is an aesthetic judgement, while not necessarily one of taste. Although Kant wanted taste to rest on the feeling of pleasure or displeasure, he never excluded other feelings, except these two: in case a work arouses disgust or ridicule, 'this is art' cannot *mean* 'this is beautiful'. In all other cases it may retain that meaning, but the important thing is that here too, 'art', whatever it means, *substitutes* for 'beauty'.

The re-reading of Kant, which will now be attempted, rests on only one hypothesis: that the sentence 'this is art', though not necessarily any longer a judgement of taste, remains an aesthetic judgement, even though no particular meaning is attached to the word 'aesthetic' until the re-reading is completed. The logical thing is to replace the word 'beautiful' by the word 'art' wherever it

occurs in the third *Critique*, starting with the antinomy itself, which then becomes:

Thesis. The sentence 'this is art' is not based upon concepts.
Antithesis. The sentence 'this is art' is based upon concepts.

Or, in a more condensed and more general phrasing:

Thesis. Art is not a concept.
Antithesis. Art is a concept.[6]

The mutual excommunication of Greenberg's formalism and Kosuth's conceptualism exemplifies the antinomy clearly when couched in such terms. Although, as hopefully I have established, this antinomy summarizes the whole *ACT* versus *ART* dilemma that overdetermines the sixties, it is easier to unfold it in their respective texts. It is clear that formalism upholds the thesis while conceptualism upholds the antithesis. As Greenberg said in one of the Seminars in which he struggled with the 'theoretical service' rendered by Duchamp and his conceptualist epigones:

I don't think it is appreciated enough that aesthetic judgements, verdicts of taste, can't be proven in the way it can be that two plus two equals four, that water is composed of what is called oxygen and what is called hydrogen, that the earth is round, that a person named George Washington was our first president, and so on. In other words, that aesthetic judgements fall outside the scope of what is ordinarily considered to be objective evidence. Kant was the first one I know of to state (in his *Critique of Aesthetic Judgement*) that judgements of aesthetic value are not susceptible of proof or demonstration, and no one has been able to refute this, either in practice or in argument.[7]

For Kosuth, on the other hand, 'One begins to realize that art's "art condition" is a conceptual state'.[8] Now, both formalists and conceptualists must have felt that upholding only one side of the antinomy is not enough. Greenberg was, of course, aware that judgements of taste claim a universality of agreement that makes quality in art a seemingly objective fact. He was also aware that taste has a history intimately intertwined with that of the medium and its conventions. In a puzzling article contemporary with the Seminars, 'Can Taste Be Objective?', he suddenly broke with his hitherto often-asserted Kantianism and upheld a historical version of the antithesis:

The objectivity of taste is probatively demonstrated in and through the presence of a consensus over time. ... And there's no explaining this durability – the durability which creates a consensus – except by the fact that taste is ultimately objective. The best taste, that is; that taste which makes itself known by the durability of its verdicts; and in this durability lies the proof of its objectivity. (My reasoning here is no more circular than experience itself.)[9]

I have discussed this passage and its implications elsewhere.[10] Suffice it to say that there is some truth in Greenberg's claim that his argument is 'no more circular than experience itself', and this is due to the fact that consensus over time can only be 'verified' by the aesthetic judgement that approves of it, making this 'verification' reflexive rather than circular, but also, suppressing its actual objectivity and leaving only the *claim to* objective consensus valid.[11] This would be the Kantian approach to the antinomy, but Greenberg does not work it out. On the contrary, he boldly states: 'I realize that I take my life in my hands when I dare to say that I've seen something better than Kant did.'[12] Alas, he hasn't, and in the end, his argument is circular: 'It's the record, the history of taste that confirms its objectivity and it's this objectivity that in turn explains its history.' [13] Whereas circularity is a problem for Greenberg's formalism, it is the solution for Kosuth's conceptualism:

A work of art is a tautology in that it is a presentation of the artist's intention, that is, he is saying that that particular work of art is art, which means, is a definition of art. Thus, that it is art is true a priori.[14]

To repeat, what art has in common with logic and mathematics is that it is a tautology; i.e., the 'art idea' (or 'work') and art are the same and can be appreciated as art without going outside the context of art for verification.[15]

It is of course easy to dismiss a theory that stakes a claim to a tautological definition, since it is no theory at all but rather a *petitio principii.* Philosophically speaking, 'Art after Philosophy' is in any case full of loopholes: neither its inverted Hegelianism nor its borrowed Wittgensteinianism resist close examination.[16] Suffice it to say that Kosuth's most blatant confusion is between the logical genre of discourse, which does not need a referent to assign truth value to a proposition, and the cognitive genre, which requires the designation of a referent for its verification. In short, conceptualism simply ignores the thesis in the modern version of the Kantian antinomy, by making the sentence 'this is art' run in circles. Both formalism and conceptualism remain unsatisfactory.

How does Kant solve the antinomy of taste?

In the thesis we mean that the judgement of taste is not based upon *determinate* concepts, and in the antithesis that the judgement of taste is based upon a concept, but an *indeterminate* one (viz. of the supersensible substrate of phenomena). Between these two there is no contradiction.[17] [...]

The solution to the antinomy lies in the indeterminate concept of the *supersensible*, referred to [...] as 'the supersensible substrate of phenomena' on the side of the judged objects, and as 'the supersensible substrate of humanity' on the side of the judging subjects. It is well known to readers of the first and the second *Critiques* that the supersensible is not a concept of understanding but an Idea of reason. It is beyond the sensible, because nothing can be shown or otherwise presented and communicated through sensible, empirical experience that could be subsumed under its idea. And it is not provable or demonstrable as are mathematical equations, which are also beyond intuitive perception, but which rely on the categories and the schematism of pure understanding. The supersensible is a realm, or rather a field, 'an unbounded but also inaccessible field' beyond the sensible, whose reality cannot be asserted and should certainly not be believed in, but whose necessity ought to be postulated and which 'we must indeed occupy with ideas'.[18] It is therefore a transcendental Idea, which means that it is known and recognized to be merely an idea, but a necessary one.[19] It is a requirement of reason, without which it is impossible to think that nature is intelligible (first *Critique*), or that ethical freedom exists (second *Critique*), or that the judgement of taste is entitled to claim universal validity, although it is the outcome of a merely subjective, personal feeling. What the supersensible thus postulates, from the vantage point of the third *Critique*, is a subjective principle which, although subjective, is not merely personal but shared by all human beings. This 'subjective principle, which determines what pleases or displeases only by feeling and not by concepts, but yet with universal validity'[20] is what Kant called *sensus communis*. This common sense, or better, common sentiment, is not a certainty but ought to be presupposed, that is, posited *as if* we were certain that it is a common substrate of humanity. Whether it is constitutive or simply regulative cannot be determined, *so that* the claim to universal aesthetic judgements merely testifies to the necessary presupposition of a *sensus communis*. [...]

It is thus for Kant one and the same thing to call these subjective conditions the supersensible substrate of humanity, a *sensus communis*, or more simply the faculty of taste (which shows that even if we were not going to replace 'taste' by 'art', taste in the Kantian sense is of a much broader scope than mere preferences and cultural habits). Taste, not this or that taste, but the faculty of taste, which ought to be supposed or postulated as the endowment of every human being, is

what justifies not the universality itself (my taste being no more universal than yours), but the claim to universality of every singular aesthetic judgement. [...]

The faculty of taste is the faculty of judging the beautiful, whether in nature or in art. This faculty is a *sensus communis*, that is, a feeling necessarily assumed to be common to all men and women. Now, what if, as suggested, we read 'art' wherever Kant wrote 'the beautiful', and simply draw the consequences of this substitution, refraining from all interpretation? The presumed *sensus communis* then becomes a *faculty of judging art by dint of feeling* common to all men and women. The readymade, which has led to this reading, also erases every difference between making art and judging it, so that we must suppose that, by the same token, this faculty also becomes a *faculty of making art by dint of feeling*. The artist chooses an object and calls it art, or, what amounts to the same, places it in such a context that the object itself demands to be called art (which means that, if only privately and solipsistically, the artist has already called it art). The spectator simply repeats the artist's judgement. Anyone can do it; the required skill, the know-how, is nil; it is accessible to the layman. Kant, of course, could not foresee such a perfect coincidence of art with the aesthetic. In his time, art-making evidently involved the apprenticeship and mastery of a skill and had to obey all sorts of rules and conventions, within which room was left for judgements about beauty. But Kant was also aware that if the artist's talent merely consisted in mastering skill and applying rules, the judgement of beauty (his or hers as well as the spectator's) would not be free (*pulchritudo vaga*) but dependent (*pulchritudo adhaerens*) on those very rules and conventions, that is, on a concept determining what an artwork should be. In order to allow for the free judgement of taste in the making of art, talent had to involve something else, something unconscious even in the artist, a gift of nature rather than an acquisition of culture, through which the artist could transcend or bypass the rules and conventions of his or her trade. This 'innate mental disposition (*ingenium*) through which nature gives the rule to art' was *genius*.[21]

> For estimating beautiful objects, as such, what is required is *taste*; but for fine art, i.e., the production of such objects, one needs *genius*.[22]

Since, with the readymade, estimating and producing art are condensed into one and the same act, we are led to suppose that 'taste' and 'genius' also merge into one and the same faculty. (These words are in quotation marks so as to insist that we are dealing with the formal consequences of a substitution of words, not with their content.) And since Kant defines genius as 'the faculty of *aesthetic Ideas*',[23] we are led to project this definition onto that of taste, that is, the faculty of 'merely reflective aesthetic judgements'. But what is an 'aesthetic Idea'?

Ideas, in the most comprehensive sense of the word, are representations referred to an object according to a certain principle (subjective or objective), in so far as they can still never become a cognition of it. They are either referred to an intuition, in accordance with a merely subjective principle of the harmony of the cognitive faculties (imagination and understanding), and are then called *aesthetic*; or else they are referred to a concept according to an objective principle and yet are incapable of ever furnishing a cognition of the object, and are called *rational Ideas*. … An *aesthetic Idea* cannot become a cognition, because it is an intuition (of the imagination) for which an adequate concept can never be found. A *rational Idea* can never become a cognition, because it involves a concept (of the supersensible), for which a commensurate intuition can never be given. Now the aesthetic Idea might, I think, be called an *inexponible* representation of the imagination, the rational Idea, on the other hand, an *indemonstrable* concept of reason.[24]

Thus, to re-read Kant after Duchamp, replacing the judgement 'this is beautiful' by the judgement 'this is art', is to consider that the word 'art' conflates genius and taste and refers both to an 'inexponible' aesthetic Idea and to an 'indemonstrable' rational Idea. (In the Kantian vocabulary, *exponible* means 'what can be established theoretically'; *demonstrable* means – in this context – 'what can be shown to the senses'.[25] And 'intuition' means perception, a presentation precisely offered to the senses in the perceptual world.) This re-reading, by the way, sheds light on the aporias of formalism and conceptualism. When Greenberg acknowledges the coincidence of the aesthetic with the artistic experience as 'the great theoretical service of the kind of recent art that strives to be advanced', he believes the aesthetic Idea whose name is art to be 'exponible', if only as a *conceptual* uncertainty in distinguishing art from non-art. And when Kosuth identifies the work of art with its 'art idea' and this, in turn, with art in general, he believes the rational Idea whose name is art to be 'demonstrable', if only as an impossibility of escaping the *formal* presentation of the work. Both succumb to the same transcendental illusion, which is to believe, as Kant would say, in the possibility of *intellectual intuition*. […]

Kant's supersensible, of course, never assumes a plastic form. As a postulate of pure understanding, it is beyond the sensible and stays there. As a postulate of pure practical reason, it requires freedom transcendentally, but it does not ground ethics, let alone the world, in the free self-conscious subject, as it did for the author of the *Oldest Systematic Programme*. Which is why, as we shall see, a 'Kantian-after-Duchamp' reading of Beuys' notion of creativity inevitably betrays Beuys. Yet it offers another, radically non-utopian interpretation, of his 'Everyone an artist'. Concretely, Kant's *sensus communis* may be restated after Duchamp as follows: every woman, every man, cultivated or not, whatever her

or his culture, language, race, social class, has aesthetic Ideas which are or can be, by the same token, artistic Ideas. This cannot be proven but has to be supposed. Neither the 'good taste' of the ruling class nor the 'bad taste' of the oppressed classes nor, for that matter, the numerous insurrections aimed at overthrowing this hierarchy, prove that there exists a faculty of aesthetic/artistic Ideas shared by humankind as a whole. Neither do they prove the opposite. That all women and men have 'taste' and even 'genius' is merely a requirement of reason. It can be empirically denied on elitist or on populist grounds, denounced or deconstructed as an ideology reflecting particular class interests, or idealized and fostered as a goal to be attained in a future liberated or emancipated state of humankind. But there is no empirical, sociological or historical settling of the question of whether there exists such a thing as a universal faculty of judging/making art by dint of feeling and not of concepts.

There is, however, a historical correlate to the mere thought of such a thing, as it was prompted by the re-reading of Kant after Duchamp: this woman and this man, who ought to be granted the faculty of aesthetic/artistic Ideas, are the modern woman and the modern man. They belong to the historical era that starts with the Enlightenment (or shortly before) and that ends (but is it ended?) with the readymade or shortly after, with its repeated reception by the postwar neo-avant-gardes. The ground for Kant's third *Critique* had been prepared by the writings of Roger de Piles and the Abbé Dubos, who had claimed for the mere amateur the right and the ability to judge art aesthetically, that is, by dint of feeling. This right had been implemented, in France at least, from the end of the seventeenth century, by the Salons where, though juried as art, the practice of living painters and sculptors was annually opened to public appraisal and subjected to the layman's judgement of taste. Toward the middle of the nineteenth century, with the quarrel of Courbet's Realism and then with the *Salon des Refusés*, the jury's refusal to judge aesthetically, and thus to call art, what it found disgusting or ridiculous, was countered by the institutional decision to appeal to the layman's verdict. There had been sharp controversy among the jury members as to the fate of the nine paintings Courbet had sent in for the 1851 Salon. All but one, the *Burial at Ornans*, were taken upstairs and refused in the *Salon Carré*. As to the *Salon des Refusés* (1863), despite its anti-institutional character, it was placed under the auspices of *Sa Majesté L'Empereur.* There is no doubt that demagogy, not cultural egalitarianism and not aesthetic insight, is what motivated Napoleon III. But the result is the same: the padlock of the jury was broken, and for the first time in history, the crowd was invited to decide not merely whether the refused paintings were beautiful, but whether they were art. From this moment on, it was art that was at stake rather than beauty within art. The last link in that chain, which in the previous chapter I

called the history of institutionalized aesthetic judgement, was Duchamp's 'Richard Mutt Case': it symbolically granted the layman the right to produce art aesthetically, that is, by dint of a feeling whose source – to be taken with a grain of salt, for sure – was not merely 'taste' but also 'genius', in the provocative guise of a disgustingly plebeian taste and a ridiculously sick genius. [...]

As the century went on and the various artistic/political utopias already implied, for example, in Schiller's *Letters on the Aesthetic Education of Man* merged with the climate of bohemianism of later romanticism, both madness and genius began to be conceived as forms of alienation that could be brandished as signs of the artist's exclusion from bourgeois society. Herein lies one of the romantic roots of anti-art: this alienation stood and accounted for a paradoxical *sensus communis*, which ran against the bourgeois common sense and was rather a taste for the marginal, the bohemian, the *Lumpen,* the socially deviant. Combined with this taste, the irrational power of the unconscious was to be the liberating potential of everyone except the 'bourgeois', whose revenge, not surprisingly, came in the form of criminology. It is unfair to Freud to lump him together with [the criminologist] Lombroso, but the fact remains that most heuristic ideas of psychoanalysis stem from a *zeitgeist* conviction that the secret of the most exceptional creative talent had to be sought in neurosis, the most common fate of common man. And the fact that, for Freud, talent and neurosis alike betray themselves in slips of the tongue, puns and spoonerisms – in other words, in *Witze* – is also an indirect heritage of romanticism, more precisely, of the most philosophical branch of early romanticism, that of Iena and the *Athenaeum*.[26] It took a century or so for the *Witz*, defined by Friedrich Schlegel as 'fragmentary geniality', to become a matter of common sense (or nonsense) pried open by the *Psychopathology of Everyday Life.* But then the times were ripe for a Duchamp; the times were ripe for the layman's wit to be called art, and the times were ripe for Duchamp's Freudian (even Lacanian) witty and ironic redefinition of the romantic self: 'The personal "art coefficient" is like an arithmetical relation between the unexpressed but intended and the unintentionally expressed'.[27] [...]

The 'personal art coefficient' measures the individual creative act, but *creativity* is the universal faculty of making art that is thereby presupposed. Now, creativity is precisely the name, the modern name, that has been given to the conflation of taste and genius and their various 'arithmetical' relations. That it is quantifiable and that it can thus be increased through cultural progress is the fundamental belief of every modernist and avant-garde utopia. But for Duchamp it was only an analogy, an 'as if-belief': 'the personal art coefficient is *like*. ...' However, this analogy is a necessary one, not because it is a fact that all men and women on earth have taste and genius, if only that little, and not

because it is the noble purpose of culture to allow anyone, if only potentially, to become an artist; rather, the analogy is necessary because everyone is assumed to be an artist already. This assumption is, after all, nothing but a requirement of the sentence with which the readymades have been called art. Unless the antinomy between formalism and conceptualism, between *ACT* and *ART*, between modernism and avant-gardism, between the mainstream and the 'tradition of the new', or between the Picasso- and the Dada-lineage in modern art, is to remain forever unsolved and the ensuing historical double bind never allowed to loosen its grip on today's art world, the sentence 'this is art', by which a readymade is both produced as a work of art and judged to be one, ought to be read as an aesthetic reflexive judgement with a claim to universality in the strictest Kantian sense. [...]

1 [footnote 29 in source] Immanuel Kant, *Critique of Judgement* (1790), trans. C. Meredith (Oxford: Clarendon Press, 1952) 206.

2 [30] Immanuel Kant, *Critique of Judgement*, trans. J.H. Bernard (New York: Hafner, 1951) 37. I have sometimes used the Bernard and sometimes the Meredith translation. References will hereafter be indicated by the translator's name.

3 [31] [discussed in chapter 1 of *Kant after Duchamp*].

4 [32] Meredith, 173–4.

5 [33] Immanuel Kant, *Observations on the Feeling of the Beautiful and Sublime*, trans. J.T. Goldthwait (Berkeley: University of California Press, 1965) 83.

6 [34] This second phrasing derives directly or indirectly from the first one: directly when the concept upon which the sentence 'this is art' is based (or not based) is the concept of art itself, and indirectly when it is some other concept. In the latter case, art is instrumental with regard to its grounding concept and must therefore be a concept too.

7 [35] Clement Greenberg, 'Seminar II' (1971), 72 [reprinted in Greenberg, *Homemade Aesthetics: Observations on Art and Taste*, ed. Charles Harrison (Oxford: Oxford University Press, 2000)].

8 [36] Joseph Kosuth, 'Art after Philosophy I and II', *Art After Philosophy and After: Collected Writings, 1966-1990* (Cambridge, Massachusetts: the MIT Press, 1991) 83.

9 [37] Clement Greenberg, 'Can Taste be Objective?', *ARTnews* (February 1973) 23.

10 [38] See my 'Les tremblés de la réflexion'.

11 [39] The concept of jurisprudence, with which I defined the 'consensus over time' [in chapter 1 of *Kant after Duchamp*], accounts for this.

12 [40] Greenberg, 'Can Taste be Objective?', op. cit., 92.

13 [41] Ibid., 23.

14 [42] Kosuth, 'Art after Philosophy I and II', op. cit., 83.

15 [43] Ibid., 85.

16 [44] See Richard Sclafani, 'What Kind of Nonsense is This?', *Journal of Aesthetics and Art Criticism*, no. 33 (1975) 455–8.

17 [45] Bernard, 186.

18 [49] Ibid., 11.

19 [50] I shall from now on capitalize the word 'Idea' (including in the quotations from Kant) each time I mean it as a transcendental Idea in the sense just defined.

20 [51] Bernard, 75.

21 [55] Ibid., 150.

22 [56] Meredith, 172.

23 [57] Ibid., 212.

24 [58] Ibid., 209–10.

25 [59] 'To reduce a representation to concepts is the same thing as to *expound* it [*exponieren*]' (Bernard, 189). '*To demonstrate* [*demonstrieren*, as opposed to *beweisen*] (*ostendere, exhibere*), is equivalent to presenting a concept in intuition. ... If the intuition ... is empirical, then the object is displayed by means of which objective reality is assured to the concept' (Bernard, 188).

26 [63] See Lacoue-Labarthe and Nancy, *L'absolu littéraire*.

27 [64] Marcel Duchamp, 'The Creative Act' (1957), in *Salt Seller: The Writings of Marcel Duchamp*, ed. Michel Sanouillet (New York: Oxford University Press, 1973) 139.

Thierry de Duve, extract from *Kant after Duchamp* (Cambridge, Massachusetts: The MIT Press, 1996) 301–20.

Jason Gaiger
Incidental and Integral Beauty: Duchamp, Danto and the Intractable Avant-Garde//2008

The Intractable Avant-Garde

In his most recent book, *The Abuse of Beauty*, the philosopher Arthur Danto has presented a characteristically lively and thought-provoking analysis of the historical and philosophical significance of the work of Marcel Duchamp. In this essay, I want to challenge his conclusions and to argue for an alternative way of understanding the readymades.[1] Danto identifies Duchamp as a leading member of the 'intractable avant-garde' and claims that he was at the forefront of the Dadaist revolt against beauty, a revulsion at the sham of Western culture that issued in the horrors of the First World War. Dada artists not only refused to make beautiful objects for the gratification of those who had brought about this catastrophe, they also sought to dismantle the long-held assumption that there is an intrinsic connection between beauty and morality.[2]

Danto contends that the great philosophical significance of the intractable avant-garde lies in its demonstration that 'beauty was no part of the concept of art'. Indeed, the products of the avant-garde are 'misperceived if perceived as beautiful' for this is not their point or ambition.[3] According to Danto, 'It was Duchamp above all others whose work was intended to exemplify the most radical dissociation of aesthetics from art, particularly in his readymades of 1915–17.'[4] Not only has Duchamp 'single-handedly demonstrated that it is entirely possible for something to be art without having anything to do with taste at all, good or bad', he is 'the artist who above all has sought to produce an art without aesthetics, and to replace the sensual with the intellectual'.[5]

Testadura

From this perspective, to argue for the beauty of the readymades or to claim that their aesthetic properties play an indispensable role in determining their meaning is to make a gross error of judgement, equivalent to relapsing into the traditional conception of taste that Duchamp had sought to render redundant. We can imagine someone, let us call him *Testadura* or hard-head, after a figure in another of Danto's essays, who is ravished by the smooth contours, gleaming white surface and elegant curves of *Fountain* (1917).[6] It is not hard to see that such a person has made a fundamental category mistake and he has failed to recognize the radical intentions behind the work.

According to Danto, this mistake was made by Duchamp's patron Walter Arensberg, who claimed that Duchamp's intention in submitting a urinal for

display at the Independent Artists' Exhibition in 1917 was to draw attention to 'a lovely form, freed from its functional purpose'.[7] My own view is that Arensberg was not as naïve as Danto suggests and that he knew exactly what he was doing in making these remarks – he was, so to speak, in on the joke. However, there are plenty of others who have defended the view that the readymades are beautiful works of art, though here, too, it is hard to gauge the sincerity or irony of their remarks. Robert Motherwell, for example, in his anthology of *Dada Painters and Poets* of 1951, claimed that 'it is evident, 35 years later, that the bottle rack ... has a more beautiful form than almost anything else made, in 1914, as sculpture'.[8]

Man Ray's 1936 photograph of *Bottle Rack*, which Duchamp used for his *Box in a Valise* of 1941, also comes perilously close to aestheticizing the readymades. By making miniature copies and placing them alongside reproductions of his other works, Duchamp retrospectively established an underlying unity of purpose and appearance. Nonetheless, in the final decade of his life, when he was being rediscovered by a new generation of artists, he consistently opposed the 'aesthetic' reading of his work. In an interview given in 1961, he insisted that his choice of objects was not in any way determined by aesthetic factors: 'The great problem was the selection of the readymade. I needed to choose an object without it impressing me, that is to say, without it providing any sort of aesthetic delectation.'[9] And in a panel discussion held at MoMA in 1964, he responded to Alfred Barr's question, 'Why do [the readymades] all look so beautiful today?', with the disarming reply: 'Nobody is perfect'.[10]

The Aesthetic Interpretation

The most committed exponent of the aesthetic interpretation is William Camfield. Contrary to Duchamp's protestations in the texts and interviews from the 1960s, Camfield claims that when we turn to the readymades themselves 'we find not aesthetic indifference but an *oeuvre* of extraordinary visual and intellectual rigour'. Duchamp possessed 'a keen eye and mind' that enabled him to 'perceive visual properties of very diverse sorts', properties that could satisfy both an aesthetic and an intellectual interest.[11]

Let us consider two examples, both of which relate to *Fountain*. Camfield argues that Duchamp saw in this piece of industrial plumbing remarkable formal similarities to the sculpture of Constantin Brancusi, especially *Princess X* (1916). Both objects – the manufactured and the hand crafted – 'are characterized by sleek, simple shapes that suggest anthropomorphic forms with sexual connotations'.[12] Similar concerns also animate Picabia's mechanomorphic images, such as *Girl born without a mother* (1916–17). Camfield's second example derives from a remark that Duchamp is supposed to have made when

visiting an aeroplane exhibition in Paris in 1912 with Léger and Brancusi. Léger recalled that Duchamp 'walked among the motors, the propellers, without saying a word. Then he suddenly spoke to Brancusi: "Painting is finished. Who can do better than that propeller? Tell me can you do that?".'[13] On Camfield's interpretation, the choice of the early readymades, such as *Bicycle Wheel* (1913), *Bottle Rack* (1914) and *Fountain* was governed not by aesthetic indifference but by the new machine aesthetic: Duchamp, like many others at the time, was sensitive to the beauty of industrially manufactured objects and to the way in which form was made to follow function.

Incidental and Integral Beauty

Danto's means of addressing the problems that such arguments present to his theory is to introduce a distinction between two different types of beauty. This is the distinction between 'incidental' and 'integral' beauty, which I have taken as the title for this essay. Whereas the beauty of an ancient Greek sculpture, such as the *Antinous* in the Belvedere, is 'integral' to its meaning, Danto claims that whatever beauty might be possessed by *Fountain* is merely 'incidental'. Even if *Fountain* is 'beautiful in point of form and surface and whiteness', this is irrelevant, because the meaning of the work is entirely 'conceptual'.[14]

Danto concedes that there are works of twentieth-century art that possess integral beauty – he gives as an example Motherwell's series *of Spanish Elegies* – but he insists that after Duchamp beauty is optional rather than essential for art. The 'era of taste' has been succeeded by the 'era of meaning': the question is no longer, is something in good or bad taste? but, what does it mean? Through the readymades Duchamp succeeded in 'overcoming taste', thereby dissociating art from aesthetics.[15]

The identification of Duchamp as an agent of revolutionary change who brought about a radical and irreversible transformation in the practice of art rests on an overly simplified opposition between two different eras of art. Neither side of the distinction is stable. On the one hand, the period that Danto terms the 'era of taste' was undoubtedly more sophisticated and intellectually rich than his argument admits – no one would want to claim that artists such as Poussin or Rubens were only interested in 'retinal pleasure' and that theirs was not also an art of ideas. On the other hand, it seems misguided to suggest that so-called conceptual or post-conceptual art takes off into a purely cognitive realm in which – with some rare exceptions – it no longer matters what the artwork looks like.

Duchamp's readymades provide an important test case for this issue, not only because of the pivotal role that has been accorded to them by Danto and others in the history of modern, or rather, postmodern art. But also because it

seems fundamentally misguided to talk about the aesthetic properties of a found or chosen object.

Supervenience and Aesthetic Concepts

How, then, are we to proceed? In order to find a way out of this impasse, I want to draw on an argument put forward by the English philosopher Frank Sibley in a paper entitled 'Aesthetic Concepts', which was first published in 1959.[16] While Sibley was exclusively concerned with what me might term 'traditional' works of art, I want to show that his ideas can also be used to cast an interesting light on the readymades.

Sibley starts out by drawing a distinction between aesthetic and non-aesthetic predicates. This is less complex than it sounds. Examples of non-aesthetic predicates include: 'red, square, curved, smooth, pale, 1.95 metres tall, made of marble', and so forth. Examples of aesthetic predicates include: 'unified, balanced, powerful, delicate, moving, elegant, garish'. When looking at a work of art we can generally agree that a line is curved rather than straight; that the sky is depicted as blue rather than red; that there are six figures not five; and that the tonal range is bright rather than sombre. Non-aesthetic predicates such as these describe observable, physical properties of the artwork. By contrast, the application of aesthetic predicates requires the deployment of a special sensitivity or perceptiveness; they indicate features that we must first come to see and whose presence or absence can be a matter of meaningful dispute.

Sibley's core argument – at least for our purposes here – is that the two sets of predicates stand in a relation of *dependence:* aesthetic terms always ultimately apply because of, and aesthetic qualities always ultimately depend upon, the presence of features which, like curving or angular lines, colour contrasts, the placing of masses, or speed of movement, are visible, audible or otherwise discernible without any exercise of taste or sensibility.[17]

Sibley notes that when we apply aesthetic predicates we often explain why by referring to an artwork's non-aesthetic predicates: we say that a gouache is 'delicate because of its pastel shades and curving lines' or that a painting 'lacks balance because one group of figures is so far off to the left and is so brightly illuminated'.[18]

We cannot, of course, infer from the fact that a painting has pale colours that it will be delicate: we do not arrive at aesthetic judgements through a process of inductive reasoning. Nonetheless, in order to support the application of aesthetic terms we frequently refer to non-aesthetic features. Sibley's argument is that aesthetic properties are grounded in non-aesthetic properties. In the language of contemporary analytic philosophy, we can say that aesthetic properties are *supervenient* on non-aesthetic properties: the two sets of

properties are so related that there cannot be a change in the first set without there being a change in the second. Since a work of art owes its aesthetic character to its non-aesthetic properties, aesthetic justification makes legitimate appeal to observable features of the object of appreciation.

Revisited

If we keep this argument in mind, and consider once again Duchamp's *Fountain*, we can see that the relation of dependency that Sibley describes is broken. The appropriate aesthetic predicates for *Fountain* are terms such as 'witty, daring, provocative, subversive, funny, intelligent', and so forth. But the application of these predicates does not depend on *Fountain* being white, curved, smooth, rounded, biomorphic, etc. On the contrary, these are properties that we normally associate with the judgement that something is elegant, stylish, graceful, etc., which *Fountain* clearly is not.

It seems, then, that Danto is right to claim Duchamp has succeeded in producing a work of art without aesthetics and that the 'standards of taste' that had remained operative for hundreds of years no longer apply to the readymades.

But Sibley's distinction between aesthetic and non-aesthetic predicates can also help us to cast doubt on this conclusion. For in order to recognize the wit and provocation of *Fountain* one has to see that it *is* troublingly similar in its physical appearance to the most advanced modernist sculpture such as Brancusi's *Princess X*. Duchamp has chosen an object that should cause problems not only for the most conservative members of the selection jury, but also for the most avant-garde. For if one can appreciate an abstract object such as *Princess X* for its smooth surface, rounded shape and biomorphic form, why should one not also appreciate *Fountain* in the same way?

Similarly, it is only if we recognize *Fountain's* proximity to the prevailing machine aesthetic, with its doctrine of form following function, that we can register the absurdity of presenting a piece of plumbing on a plinth. Even the exaggeratedly handwritten signature – with its mockery of the finished 'work' – and the economical gesture of turning the urinal upside down, contribute to its meaning. In the case of *Bottle Rack* there is a troubling proximity to post-Cubist 'constructed' sculpture, such as Picasso's *Guitar* (1912) and Tatlin's *Corner Relief* (1914). Duchamp plays with, and thereby disrupts, not only conventional ideas about art but also the most advanced views of his time. A randomly chosen object would not have the same 'resonances' or result in the same complication of aesthetic judgement.

It is therefore wrong to claim that the readymades are beautiful in the traditional sense of the term, as Camfield and Motherwell propose. Duchamp does not simply present us with a found object that can be appreciated as if it

were a work of modernist sculpture or design. Instead, he does everything he can to disrupt the expectations that the viewer brings to the work of art, including the expectations of the avant-garde.

Nonetheless, it is also wrong to claim that the beauty of the readymades is merely 'incidental' and that Duchamp has succeed in producing art without aesthetics, replacing the sensual with the conceptual, as Danto argues. For unless we are alert to the 'beauty' of these objects, we will miss their proximity to the icons of the avant-garde. To register the full aesthetic and cognitive *dissonance* of the readymades is thus to be sensitive to their observable, physical properties as well as to the 'idea' behind them.

If we treat the readymades merely as the embodiment of an idea or concept, their interest is quickly exhausted. To apply the appropriate aesthetic predicates – witty, daring, provocative, subversive – we also need to be sensitive to their non-aesthetic properties, for it is by exacerbating the conjunction between the two that Duchamp complicates and confounds the expectations that both conservatives and radicals alike bring to the encounter with art.

1 This essay is an edited version of a talk given at the conference 'Against the Avant-Garde?: Duchamp, Man Ray, Picabia' held at Tate Modern, London, in 2008. I would like to thank Dave Beech for suggesting that I include the paper in this collection and for his helping to edit the text for publication.

2 See Arthur C. Danto, *The Abuse of Beauty: Aesthetics and the Concept of Art* (Chicago and La Salle, Illinois: Open Court, 2003). Some of the arguments in this book were originally presented in Danto, 'Marcel Duchamp and the End of Taste: A Defence of Contemporary Art', published in the online journal *tout-fait*, vol. 1, no. 3, 2000 (www. toutfait.com).

3 Danto, *The Abuse of Beauty*, xv; 49.

4 Danto, *The Abuse of Beauty*, 94.

5 Danto, 'Marcel Duchamp and the End of Taste', 6; and *The Abuse of Beauty*, 96.

6 See Danto, 'The Artworld', *The Journal of Philosophy*, vol. 61 (1964) 571–84.

7 Danto, 'Marcel Duchamp and the End of Taste', 7. Arensberg's remarks were recorded by Beatrice Wood; they are cited in Jason Gaiger, 'Interpreting the Readymade: Marcel Duchamp's *Bottlerack*', in *Frameworks for Modern* Art, ed. Jason Gaiger (New Haven and London: Yale University Press, 2003) 86.

8 Robert Motherwell, ed., *The Dada Painters and Poets. An Anthology* (1951) (Cambridge, Massachusetts: The Bellknap Press of Harvard University Press, 1989) xxiii.

9 Alain Jouffroy, 'Conversations avec Marcel Duchamp', in *Une révolution du régard* (Paris: Gallimard, 1964) 118–19; my translation, in Gaiger, 'Interpreting the Readymade', 89.

10 Cited in Calvin Tomkins, *Duchamp: A Biography* (London: Random House, 1997) 427. It is worth noting that the majority of these interviews were given several decades after the first readymades; there is thus scope for a certain scepticism about Duchamp's remarks, or, at the

least, for critical reflection on the specific context in which they were made. Nonetheless, Duchamp's comments provide the basis for what is now the standard interpretation of his work.

11 William A. Camfield, 'Marcel Duchamp's *Fountain:* Its History and Aesthetics in the Context of 1917', in Rudolf Kuenzli and Francis M. Naumann, eds, *Marcel Duchamp: Artist of the Century* (Cambridge, Massachusetts: The MIT Press, 1989) 81–3.

12 Camfield, 'Marcel Duchamp's *Fountain*', 85.

13 Cited in Camfield, op. cit., 81.

14 Danto, *The Abuse of Beauty*, 9.

15 Danto, 'Marcel Duchamp and the End of Taste', 6-7.

16 Frank Sibley, 'Aesthetic Concepts', *The Philosophical Review*, vol. 68 (1959) 421–50; reprinted in a slightly revised version in Frank Sibley, *Approach to Aesthetics: Collected Papers on Philosophical Aesthetics*, ed. John Benson, Betty Redfern and Jeremy Roxbee Cox (Oxford: Oxford University Press, 2001) 1–23. My references are to this edition.

17 Sibley, 'Aesthetic Concepts', 3.

18 Ibid.

Jason Gaiger, lecture given at the Open University Study Day, *Against the Avant-Garde? Duchamp, Man Ray, Picabia* (London: Tate Modern, Saturday 8 March 2008); revised for this volume, 2008.

T.J. Clark
Vulgarity//1999

[...] We might come to describe Abstract Expressionist paintings better if we took them, above all, to be *vulgar*. The word for us is pejorative, and to be understood as such in the arguments that follow. But this should not present an insuperable problem, especially for anyone used to thinking about modernism in general. After all, modernism has very often been understood as deriving its power from a range of characteristics that had previously come under the worst kind of pejorative descriptions: from ugliness, for example, or from the fragmentary and accidental; from the material as opposed to the Ideal; from the plain and limiting fact of flatness, from superficiality, from the low and the formless.

Nonetheless there still may be a slight *frisson* to the idea that the form of Abstract Expressionism's lowness is vulgarity. [...] To call an artwork vulgar is obviously (at least for now) to do something a bit more transgressive than to call it low or *informe*. To have made it vulgar in the first place – to have had vulgarity be the quality in it (maybe the only quality) that raised the work from inertness and had it speak a world – this surely must have felt weird to those doing the job, and for much of the time was barely recognized or tolerated by them, at least when it came to finding words for what they were up to. Pollock's drip paintings, for instance, seem to me to have been begun at the end of 1947 in a mood of triumphant access to the gaudy and overwrought. *Vortex* is typical; and yet the title Pollock settled for, beautiful as it is, somewhat naturalizes the painting's mad centrifugal force. The same is true, ultimately, of most of the titles he and his friends dreamed up at this moment – of *Phosphorescence* and *Reflection of the Big Dipper*, or *Galaxy* and *Watery Paths*, or even *Sea Change* and *Full Fathom Five*. They all try to conjure back depth and tactility (I mean natural tactility, the look and feel of the elements) into paintings that hinge, in my view, on not having much of either. They offer the sea and stars, not an indoor (*Unfounded*) fireworks display.

It is an advantage to the term 'vulgar', as far as I am concerned, that discursively it points two ways: to the object itself, to some abjectness or absurdity in its very make-up (some tell-tale blemish, some atrociously visual quality which the object will never stop betraying however hard it tries); and to the object's existence in a particular social world, for a set of tastes and styles of individuality which have still to be defined, but are somehow there, in the word even before it is deployed. Herein, I hope, lies the possibility of class ascription in the case of paintings like *The Oracle* and *Woman* – the possibility of seeing at

last, and even being able to describe, the ways they take part in a particular triumph and disaster of the petty bourgeoisie. But I am coming to that.

In Abstract Expressionism – and here is the painting's continuing (maybe intensifying) difficulty for us – a certain construction of the world we call 'individuality' is revealed in its true, that is to say, contingent, vulgarity. And so is painting; or rather, so are paintings like Hofmann's *The Garden* (1956) and Adolph Gottlieb's *Black, Blue, Red* (1956) – done as they were under the sign of such a construction. […]

What is special about Abstract Expressionism – what marks it off from all other modernisms – is that the engagement is with the vulgar as opposed to the 'popular' or 'low'. I think we should understand the 'popular' in nineteenth- and twentieth-century art as a series of figures of avoidance of the vulgar: that is, figures of avoidance of art's actual belonging to the pathos of bourgeois taste: a perpetual shifting and conjuring of kinds of simplicity, directness, naïvety, sentiment and sentimentality, emotion and material force, in spite of everything about art's actual place and function that put such qualities beyond its grasp. Abstract Expressionism does little or no such conjuring. That is what makes it hard to bear. We are used to an art that always sets off again in search of the true underlying the tawdry, and where the tawdry may divulge the true (to the artist) just because the tawdriness is someone else's, out there in the mass or the margin. But Abstract Expressionism does not go elsewhere for its language, and at its best (its most appalling) it seems in search of the false underlying the vehement; where the point is that cheap vehemence, or easy delectation, are what painting now is – the only values, the only forms of individuality, that it can stage without faking. Only those Abstract Expressionist canvases will do that are truly consumed with their own empty intensity, with painting as posturing, with a ludicrous bigness and lushness and generality. […]

I realize that it is still not clear what I mean by the word 'vulgarity' as applied to paintings. And I do not think it ever will be. The word is opaque: it points, as Ruskin knew, to a deep dilemma of bourgeois culture: it is as close to an ultimate term of ethics or metaphysics as that culture maybe will ever throw up. 'Two years ago,' ends Ruskin's chapter 'On Vulgarity' in *Modern Painters*,

> when I was first beginning to work out the subject, and chatting with one of my keenest-minded friends [Mr Brett, the painter of the Val d'Aosta in the Exhibition of 1859], I casually asked him, 'What is vulgarity?' merely to see what he would say, not supposing it possible to get a sudden answer. He thought for about a minute, then answered quietly, 'It is merely one of the forms of Death.' I did not see the meaning of the reply at the time; but on testing it, found that it met every phase of the difficulties connected with the enquiry, and summed the true

conclusion. Yet, in order to be complete, it ought to be made a distinctive as well as conclusive definition; showing *what* form of death vulgarity is; for death itself is not vulgar, but only death mingled with life. I cannot, however, construct a short-worded definition which will include all the minor conditions of bodily degeneracy; but the term 'deathful selfishness' will embrace all the most fatal and essential forms of mental vulgarity.

I do not bring on this passage of Ruskin in hopes of solving our problem of definition, but more because it shows (more clearly than anyone nowadays would dare to) what the problem is – what terrible cocktail of class ascriptions and bodily disgust the word 'vulgar' is an empty container for, and how fatal and essential is the sliding within it between a handy form of class racism and a general sense of class doom. Vulgarity is foulness and degeneracy, it is a 'dullness of bodily sense', 'all which comes of insensibility'. 'The black battle-stain on a soldier's face is not vulgar, but the dirty face of a housemaid is.' But Brett's dictum is ultimately impatient of such distinctions. We are all housemaids now. [...]

The trouble with Barnett Newman is that he was never vulgar enough, or vulgar only on paper. 'The First Man was an Artist', 'The Sublime is Now', 'The True Revolution is Anarchist!' etc.

The great Rothkos are those everybody likes, from the early 1950s mainly: the ones that revel in the new formula's cheap effects, the ones where a hectoring absolute of self-presence is maintained in face of the void; with vulgarity – a vulgar fulsomeness of reds, pinks, purples, oranges, lemons, lime greens, powder-puff whites – acting as transform between the two possibilities of reading. *The Birth of Tragedy* redone by Renoir. [...]

What remains to be thought about Abstract Expressionism (though the thought haunts everything written on the subject, especially those texts most anxious to repress it) is the painting's place in a determinate class formation; one which, though long prepared, took on the specific trappings of cultural power in the years after 1945. I said 'its place in a determinate class formation', not in a state apparatus, or a newly improvised system of avant-garde patronage, or a museum/art-world superstructure. Not that the latter are irrelevant. But they cannot be what we mean, fundamentally, when we talk about a certain representational practice inhering in the culture of a class. We mean that the practice somehow participates in that class's whole construction of a 'world'. We are talking of overlap and mutual feeding at the level of representational practice – at the level of symbolic production (ideology). When we say that the novel is bourgeois, the key facts in the case are not eighteenth-century subscription lists, or even the uses early readers made of *The Sufferings of Young Werther*.

Clement Greenberg begins a review of an exhibition of Courbet at

Wildenstein's in January 1949 by saying that 'Bosch, Brueghel and Courbet are unique in that they are great artists who express what may be called a petty bourgeois attitude.' Like Barr, he seems to me to be averting his eyes from Pollock and Clyfford Still. What is new in their case, of course, is that now a particular (hybrid) form of petty-bourgeois culture [...] has become the form, the only viable medium, of bourgeois class power.

Abstract Expressionism, I want to say, is the style of a certain petty bourgeoisie's aspiration to aristocracy, to a totalizing cultural power. It is the art of that moment when the petty bourgeoisie thinks it can speak (and its masters allow it to speak) the aristocrat's claim to individuality. Vulgarity is the form of that aspiration.

Or could we say: Abstract Expressionism is the form of the petty bourgeoisie's aspiration to aristocracy, at that fateful moment when the bourgeoisie itself no longer so aspires; when the petty bourgeois has to stand in for a hidden – nay, vanished – bourgeois elite. [...]

Vulgarity, then, is the necessary form of that individuality allowed the petty bourgeoisie. Only that painting will engage and sustain our attention which can be seen to recognize, and in some sense to articulate, that limit condition of its own rhetoric. Maybe it will always be a painting that struggles to valorize that condition even as it lays bare its deficiencies – for here we touch, as Adorno never tired of telling us, on some constitutive (maybe regrettable) link between art and an ethics of reconciliation or transcendence – but what we shall value most in the painting is the ruthlessness of (self-) exposure, the courting of bathos, the unapologetic banality. The victory, if there is one, must always also be pyrrhic.

You see now why the concept 'vulgarity' has more and more the notion of betrayal written into it as the nineteenth century goes on. For the bourgeoisie's great tragedy is that it can only retain power by allowing its inferiors to speak for it: giving them the leftovers of the cry for totality, and steeling itself to hear the ludicrous mishmash they make of it – to hear and pretend to approve, and maybe, in the end, to approve without pretending. [...]

Certain moments and sequences of work in Abstract Expressionism that everyone, then and since, agrees to have been a turning point for the new painting begin [in the light of interpreting painters such as Gottlieb as vulgar] to take on a different valency. For example, De Kooning's *Woman* series, and the vehemence of Clement Greenberg's reaction to it. (Actually, the 'vehemence' is mainly a matter of Greenberg's conversation as recalled by witnesses. He said little in print about the *Women*. But that, of course – coming from the person chosen to write the catalogue essay for de Kooning's 1953 retrospective – was felt to be the point. Greenberg's silence, or his occasional offhandedness, was telling above all by contrast with the general run of journalism at the time,

which took it for granted that, love them or hate them, the *Women* were Abstract Expressionism's truth.) What Greenberg was recoiling from, I think, is the way in which choosing *Woman* as his subject allowed de Kooning to extrude a quality of perception and handling that stood at the very heart of his aesthetic, and fix it onto an Other, a scapegoat. 'The black battle-stain on a soldier's face is not vulgar, but the dirty face of a housemaid is.' For 'dirty face of a housemaid' read 'perfect smile of the model in a *Camels* cigarette ad'. Greenberg drew back from this not, need I say it, out of concern over de Kooning's misogyny, but from an intuition that such splitting and projection would make it impossible for de Kooning's painting to go on sustaining the right pitch of tawdriness, idiot facility, overweening self-regard. I think he was right. Only when de Kooning found a way to have the vulgarity be his own again – or rather, to half-project it onto cliché landscape or townscape formats, which were transparently mere props – did he regain the measure of meretriciousness his art needed. The male braggadocio, that is to say, had to be unfocused if he was to paint up a storm. It had to be a manner in search of an object, and somehow aggrieved at not finding one. What was wanted was generalized paranoia, not particular war of the sexes.

Vulgarity is gendered, of course. At the moment we are looking at, the attribute belonged (as a disposable property) mainly to men, or, more precisely, to heterosexual men. Not that this meant the art done under vulgarity's auspices was closed to reading from other points of view. What Beaton and Alfonso Ossorio and Parker Tyler and Frank O'Hara did to Pollock, with or without Pollock's permission, is clearly part – sometimes, as I have said, a central part – of any defensible history of the New York School. It seems important that, apart from Greenberg, the strongest early readings of Pollock's work (the strongest, not necessarily the best) all came from gay men. Namuth's films and photographs partake of the same homosocial atmosphere. Perhaps the deep reason why Greenberg was never able to realize his cherished project of a book on Pollock was that he found no way to contain, or put to use, the erotic hero-worship that sings in the prose of his shorter pieces about his friend. [...]

T.J. Clark, extract from *Farewell to an Idea: Episodes from a History of Modernism* (New Haven: Yale University Press, 1999) 375–97 [footnotes not included].

Caroline A. Jones
The Discourse of the Studio Meets
the Technological Sublime//1996

As one approaches the 1960s in the discourse of the studio, there is a certain acceleration, a sense of contested terms and heightened stakes. Abstract Expressionist rhetoric had already encouraged an obsession with process and the place it occurred, reflected in the early 1950s by Harold Rosenberg's metonymic construction of the canvas as an arena (standing both for the studio and the artist-creator at its centre. During the same period *ARTnews* (the influential art magazine then dominated by articles about the New York School) inaugurated a popular series of studio-action pieces titled '[X] Paints a Picture', featuring photographs by Hans Namuth, Rudy Burckhardt and others, depicting the solitary artist at work. [...]

Hans Namuth, Alexander Liberman and others had brought the probing eye of the camera into the studio in the 1950s, reinforcing tropes of isolated genius even as they disrupted that isolation, intervened in the process of creation, and embedded their images in a nostalgia that signalled its imminent demise. Books such as Liberman's 1960 *The Artist in His Studio* had tried to pin it all down, locating the artist in an eternal isolated studio – cordoned off from women, untouched by others, set off from the world. But those photographs documented a lost world. Taken in the late 1940s and 1950s, they were steeped in death and nostalgia. [...] By the time Liberman's images were published, photojournalist Fred McDarrah was ready to present *The Artist's World in Pictures* (printed in 1961), showing an ebullient crowd of New York painters playing baseball, eating Chinese food, and revelling at packed gallery openings. If Liberman was nostalgic, McDarrah was exultant. His photographs, published initially in the *Village Voice*, celebrated the new social nature of the American artist, the end of isolation, and the beginning of what Allan Kaprow would call 'the artist as man of the world'. The isolated studio, along with the solitary artist, was an endangered species; the location for the production of the sublime was becoming an increasingly noisy place. At the moment of the early 1960s, it was clear that the studio was contested territory.

The *nature* of the sublime was also an issue of some debate in the early 1960s, indicating that the romantic theme still held a powerful, if vexed, significance. Writers of the time addressed whether nature or psyche constituted its subject, and asked how America functioned as its generative source. Following Barnett Newman's positioning of the sublime as central to the American-ness of the new art, two writers emerged in the early 1960s to stake

their claims on sublimity's terrain. Robert Rosenblum was first (of the post-Newman crowd), writing in 1961 of the 'abstract sublime' and promising to explain 'how some of the most heretical concepts of modern American abstract painting relate to the visionary nature-painting of a century ago'. [...]

The British critic Lawrence Alloway specifically contested Rosenblum in his own 1963 essay 'The American Sublime', accusing the American writer of adopting the topographical fallacy and making national what is only accidental. For Alloway, the sublime is located entirely within the artist (it is not an external subject of his art, or object of his contemplation). It is sublime only because of the stylistic attributes that happen to be found in American postwar art (the big picture which dominates the spectator, the Burkean 'fuscous' colours), and, to a lesser extent, because of the 'cultural reflexes' which associate the sublime with 'the big country' to which the paintings of Still, Rothko and Newman are continually being compared. [...]

Alongside all of these early 1960s essays on American sublimity in art discourse, Leo Marx was developing his thesis on the contradictions embedded in the American sublime as reflected in American literature, symbolized for Marx by the trope of *The Machine in the Garden*, his book of 1964. The publication of this work, long in the making, itself points to the renewed fascination that eighteenth- and nineteenth-century concepts of sublimity and Romanticism held for mid-twentieth-century Americans; more important for my argument, in his book Marx articulates the fissures that were then beginning to appear in the nostalgic façade of 'the natural paradise'. Marx's project was to clarify the conflicts 'always already' present in the articulation of a virginal American landscape, and to demonstrate their uselessness in present-day culture. Briefly reviewing the rural, agrarian, pastoral myths used to sell everything from cigarettes to political programmes, Marx argued: '[In] public discourse, at least, this ideal [of the pastoral idyll] has appeared with increasing frequency in the service of a reactionary or false ideology, thereby helping to mask the real problems of an industrial civilization.' In Marx's redemptive conclusion, we must accept the fate we have created, own the technologies that we have built, confront our dreams as the fantasies that they are and seek resolution to our problems in society – through engagement, not in some mythical escape. Reflecting the optimism of early 1960s liberalism, combined with a sobering sense of the challenges to be faced, Marx wrote: 'To change the situation we require new symbols of possibility, and although the creation of those symbols is in some measure the responsibility of artists, it is in greater measure the responsibility of society. The machine's sudden entrance into the garden presents a problem that ultimately belongs not to art but to politics.'

Marx's text is a document of its time, but [in the present context] it is also a

model for my enquiry into the change in studio practices and artist roles in the period from 1945 to 1970. Like Marx, I want to emphasize the ubiquity and constancy of the conflicts embedded in the American dream: conflicts between technology and pastoralism, Warhol's 'city and country', society and the individual, the primitive and the cultured, the 'unspoiled' and the 'improved', and – although Marx does not deal with this level of meaning, it is everywhere implicit – conflicts between 'masculinist' and 'feminist' discourses on nature and civilization. The convulsions in American society that seemed to be on the brink of erupting in 1964 had erupted as well a century before, and were implicit in the founding documents of a hundred years earlier. [...]

The story I want to tell in this book [*Machine in the Studio*, 1996] is played out less within specific discrete texts or art objects than in competing aesthetic and cultural systems, but Marx's taxonomy serves me well. As he demonstrates, in contrast to the 'pure' pastoralism imposed by early European observers on the 'primitive' American soil, and against the dire warnings of European philosophers such as Schiller and Carlyle regarding the emerging industrial society, there developed in America a complex hybrid of technological progressivism and the pastoral ideal. Marx terms this 'the rhetoric of the technological sublime' and positions it in a mid-nineteenth-century America bursting with steam boats and knit together by churning locomotives. I want to suggest that this rhetoric of the technological sublime also characterized much of the 1960s, in which a growing ecology movement paradoxically coexisted with a sometimes utopian, sometimes cynical belief in technology as a pragmatic or aesthetic solution to the problems of the day. The 1960s appearance of the technological sublime was necessarily specific to its time – moon shots, superhighways, and the penetration of the technological into human nature, all changed the impact of this discourse dramatically. [...]

In the shift from a sublime centred on the individual male observer in his relation to nature (the outer nature of topography, in Marx's case, or the inner nature of the individual psyche, in our example of the New York School), to a rhetoric celebrating technology's sublime power over that very nature, are mirrored outlines of the shift from the isolate studio (with its hushed privacy and creator genius) to the expanded workshop (with its busy machinery and executive boss). In the exultations of one 1844 writer, who championed steam engines for 'annihilating space', we hear a curious forecast of the 1960s artists' aesthetics of flatness that would replace the radiant and absorptive voids of the abstract sublime. Against Walt Whitman's lyrical body electric, his 'singing the strong light works of engineers', we place Warhol's laconic aspiration to 'be a machine'.

At the moment of the 1960s when Warhol's social machinery and Stella's flattened canvases appeared, the continuing discourse of the studio and the

sublime took on a heightened urgency. The writings of Marx, Rosenblum and Alloway all reflected the need to look, and look again, into the aesthetics of sublimity, at a time when contemporary artists were aligning their art with models of postwar industrial management and a developing technological order. [...] [In] Warhol's world an artist could desire, and functionally succeed in his goal, to 'be a machine'. Henry Adams could aspire at the turn of the century to worship the Dynamo rather than the Virgin, but in Stella's career an artist could conceive of incorporating the Dynamo into his own practice, becoming the executive artist at the heart of the surging industrial workshop. By the end of the decade, such ambitions appeared exhausted in the entropic, desublimating practice of Robert Smithson, who ironized the position of artist and viewer, making the transcendence of sublimation an inaccessible and undesirable goal. The machine in the studio was new in 1960, but it was a configuration dependent on the strength of a booming centralized economy; in Smithson's 'post-studio' practice at the end of the decade, production disperses to the peripheries of a post-industrial landscape in the throes of economic decline.

The dominant art and artists of the sixties were viewed as explosively departing from the work and careers of the preceding generation of Abstract Expressionists. The production of younger artists such as Stella (and his associates Judd, Flavin, Andre), Warhol (and his colleagues Lichtenstein, Oldenburg, Rosenquist), and Smithson (linked with other Earthworks artists Heizer, Morris, Holt, De Maria) was seen as radically incommensurate with what had gone before (in the best avant-garde tradition) – so much so that New York School artists left prestigious galleries rather than coexist with what they saw as the cynical accommodations of the Pop artists (as happened with Sidney Janis's 1962 exhibition 'The New Realists'). The Abstract Expressionists' defenders muttered epithets of 'juvenile delinquent!' when they heard the businesslike rhetoric of the early Minimalist painters (such as Stella's praise for executive artists). But by the time Robert Smithson's writings were collected in 1979, the reign of the New York School was viewed as definitively over, with Smithson positioned as the logical (if quirkily anti-heroic) heir to the 'Triumph of American Painting'. [...]

These differences transcended conventional stylistic oscillations; indeed, the styles of these younger artists were themselves seen as conflicting, oppositional and utterly diverse. In charting this history, we must move beyond style as a determining factor in periodization – if style is taken merely as a manifestation of formal commitments. We must instead attempt to locate change in a deeper order of beliefs and actions that styles serve simply (and variously) to express. Certainly style and subject matter changed a great deal from the New York School painters to the Pop, Minimalist, Earthwork and other artists of the 1960s

– but can it be argued that style and subject constituted the central difference between the two generations? Was Warhol's portrayal of Marilyn Monroe so alien to Willem de Kooning, who had earlier painted her as one of his *Women*? Was Stella's admiration for the works of the Abstract Expressionists completely incredible to them, and completely invisible in his early paintings? I suggest that the basis for the perceived gulf between the painters who came to maturity in the 1940s and the artists who achieved their fame in the 1960s lies in deep methodological and epistemological differences rather than artistic styles (although I want to maintain that those styles encoded such differences) or subjects (although subjects, too, have significance for epistemological shifts). I want to argue that the art's mode of production, and the artists' way of knowing the world, were what had changed. Nothing less was at stake than how to make art; nothing more than how to be an artist in mid-century America. How the work looked would follow from those choices. [...]

From the Abstract Expressionist's flowing heroism, which summoned resources from beyond exhaustion to create works of unparalleled genius, the focus shifted in the 1960s to the hardened nugget of Stella's semi-alienated labour, which he later articulated: 'I just wanted to do it [make a painting] and get it over with so I could go home and watch TV.' The performative met the iconic: Stella's silvery objects, shaped like machined and die-cut forms, matched his workmanlike approach to painting; Warhol's series of silkscreened celebrity 'logos' suited his Factory production; Smithson's scattered sites and collaborative endeavours resonated with his discourse of post-industrial entropy and 'post-studio' art.

To say that Stella, Warhol and Smithson invoked the industrial is not to say that these artists worked literally to make machines, or sought employment in actual factories (although Richard Serra drew famously from his work in steel mills to make his sculptures of stacked steel). What Stella, Warhol, Smithson and other purveyors of the 1960s technological sublime intuitively understood was the need to play the codes: that is, to tolerate the seemingly necessary and always enforced 'uniqueness' of the art object and establish their own author-functions within art discourse (through statements, interviews, exhibitions), while simultaneously asserting and performing assembly-line production techniques, 'executive artist' efficiency, or geological agency that resonated with other cultural systems. Unlike numerous earlier artists of the technological sublime, the artists of the 1960s unified the iconic and the performative in the place of the studio (or, in Smithson's case, in place of the studio), effecting this change across 'styles' and 'isms' as different as Minimalism, Pop and Earthworks and expressing it in the useless objects of Art. That they sought (and achieved) a kind of sublimity (in technological form) is a measure of their ambition – to reach

for that overwhelming response that had always been held out as the highest goal for American art. [...] Stella's praise of 'executive artists' and use of assistants in producing his brand was one unifying move; another was Warhol's conversion of studio into Factory, use of assembly-line silkscreen techniques on serial objects, and claims to delegate art production to 'Brigid' and 'Gerard'. A seemingly final, 'post-studio' stage was initiated by Smithson, who moved art production to the industrially mediated peripheries of abandoned quarries and mining sites, and located its meaning in discourse rather than in the object above all else. This was not some 'Triumph over American Painting' (to twist the standard paean against itself). It was an inversion and critique, an 'anti-romantic anti-studio' dependent for its luminous salience on the Romantic constructs of an earlier age.

Discourses of the 1940s and 1950s constructed art's meaning as well, but did so through the construction of the artist as private creator of an art the meaning of which was, in part, its failure to signify in a public sphere. The time-worn attributes of sublimity – obscurity, largeness and terror – are matched by a defeating relation to signification. Verbal and visual representations must recreate (not represent) the experience of sublimity in the individual reader/viewer, for by its very nature sublimity cannot be described. The private drama of the Abstract Expressionist canvas was held to be its public meaning – a meaning generated by an individual for an individual, the epitome of democratic freedom symbolized by the inaccessibility of private life and private meaning. The studio stood crucially intact, in this discourse, as the guarantor and origin of that individual freedom. Both the painter and his viewer were encouraged to 'spit down' on demagoguery and turn inward, to the interior worlds of dreams and mirrors. [...]

Caroline A. Jones, extract from 'The Discourse of the Studio Meets the Technological Sublime', *Machine in the Studio* (Chicago: University of Chicago Press, 1996) 51–8 [footnotes not included].

John Roberts
Replicants and Cartesians//2007

In the 1980s the debate on simulacra, copying, surrogacy and authenticity dominated Anglo-American art discourse. There was a widespread assumption that claims to subjective expression and aesthetic originality on the part of the artist were a myth, a delusional handover from the Cartesian fantasy of the 'inner self' as an authentic expressive self. Since the 1920s and the social claims of the early avant-garde the continual expansion of technology into art's relations of production made it increasingly difficult to equate normative value in art with such claims. Touch and manual dexterity had lost their place as markers of artistic taste and authority. As such, the artist was no longer seen as a self-confirming 'creator', but as a synthesizer and manipulator of extant signs and objects. What largely united these earlier anti-Cartesian moves was a theory of montage as social praxis. Sergei Eisenstein, Dziga Vertov, Alexander Rodchenko, El Lissitzky, John Heartfield, Hannah Höch, Raoul Hausmann, all saw themselves, essentially, as artistic *constructors* and *fabricators*. As Hausmann declared: 'We call this process photomontage because it embodied our refusal to play the role of artist. We regarded ourselves as engineers, and our work as construction: we *assembled* [in French: *monteur*] our work, like a fitter.'[1] In the 1960s and 1970s, this, in turn, was taken to be part of a deeper historical shift in the subjectivity of the artist: the dissolution of the creative *singularity* of the (male) artist. The post-gendered *monteur* was now merely an ensemble of techniques, functions and competences. In the 1980s much critical art and much art theory under the banners of postmodernism and poststructuralism was produced within this framework. Today this sense of a 'paradigm shift' is the commonplace stuff of postmodern history and theories of the 'end of modernism', taught in art schools and art history and cultural studies departments in Europe and North America. Where once the expressive skills of the (male) artist were existentially inflated, now they are deconstructively deflated. Indeed, the critique of authorship is now the template of contemporary neo-Conceptual art and post-object aesthetics from Glasgow to Manila. Yet, despite this would-be theoretical displacement of the artist from the privileged scene of his or her production, the issues of simulacra, copying, surrogacy, virtuality and the readymade remain largely one-dimensional in art theory and contemporary cultural theory. This is because the theoretical moment of the debate on authorship in the 1980s has come down to us through a discourse of apocalyptic anti-humanism, unnuanced anti-aestheticism and undialectical

social categories. The effect is to reduce the critique of authorship either to the 'end-game' reproduction of pre-existing artistic moments or styles, or to an eclecticized intertextuality. As a consequence the critical agency of the artist's labour has become diminished or flattened out, as if the critique of authorship was equivalent to the *end* of representation, the *end* of art, the *end* of meaning, and the *end* of subjectivity. But, unfortunately, this simplistic historical elision is what has usually stood for thinking in art schools and cultural studies departments in the 1980s and 1990s, dominated as they were by versions of poststructuralist simulation theory and deconstructionism. [...]

Questions of appropriation, copying, replication, simulation, and so on, have become the necessary terrain on which art after Conceptual art continues to pursue its sceptical skills. There is no value (or critique of value) in art without these forms of scrutiny. Indeed, since the high point of 'appropriationist art' in the early 1980s, a generation of artists have taken this as a 'given' and have largely internalized some notion of the artist as technician, *monteur*, ideas-manager, constructor, etc. This is why, despite the recurrence of various defences of 'aesthetics', the humanist exaltation of 'self-expression' continues to be theoretically marginalized – at least in the leading academic and cultural institutions, to the rancour of cultural conservatives and leftist philosophers of aesthetics alike. Furthermore, the notion of the artist as a *monteur* in the broad sense is now one of the key moves identifiable with the dissolution of the boundaries between fashion, style and art in our consumerist-led culture. Many younger artists see their identity as linked to the execution of tasks across formal, cultural and spatial boundaries. Commitment to one method of production or form of distribution, one set of cognitive materials, one outlook, is decried. One of the consequences of this is the emergence of a historically novel tension between a received (and depoliticized) older notion of the avant-garde critique of authorship, and the reinvention of the artist as creative entrepreneur (under the increased glare of celebrity culture).[2] This produces an intense conflict of ideologies: the artist's identity may be deconstructed under the impact of the social relations of advanced art, but it is simultaneously *reconstructed* as an enchanted image under the reified forms of the mass media. The idea of the artist as an ensemble of functions, becomes a set of multi-tasking *career opportunities.*[3]

But of, course, at the level of political economy, this novel situation for the artist is not so novel as to be historically anomalous. Rather, it is further evidence of how the laws of exchange operate on art in the epoch of its technological expansion and diversification. The acceptance of some aspects of the critique of authorship in early avant-garde art and Conceptual art in current art has become the means whereby the new administration of art has *reinvented* itself in order to secure its access to the new, entrepeneurial, technologically driven culture

and to new areas of cultural capital. In the absence of the pressures of the traditional artistic and cultural hierarchies, artists are freed up – indeed encouraged – to become curators and critics, and curators are freed up to be artists and critics, in ways that benefit the multiple commercial ventures of the mass distribution of art. Just as workers involved in immaterial labour are encouraged – or forced – to be multi-tasking, modern artists are encouraged to think of themselves as active as artists beyond the 'limited' point of production, because, it is claimed, artists need to think of themselves as directly engaged in the mediation of the meanings of their work.

But if this multi-tasking defines the shift of the social identity of the artist from someone who 'externalizes' his or her self from a position of repressed marginalization, to someone who works openly within a complex division of labour (in the way a designer might for example), it is not the darker side of the critique of authorship, or an understanding of the place of artistic labour within the social totality, that is emphasized. As a model of the artist-as-entrepreneur the notion of the artist as an ensemble of functions turns largely on the pursuit of market opportunities. The militant, destabilizing, uncomfortable aspects of the critique of authorship have been written out of the reckoning, or treated in a cursory and peripheral fashion. This is because, by identifying 'appropriation' and artistic 'hybridity' with the end of the avant-garde, and by linking multi-tasking with a benign pluralism of forms, the effects of cultural and social division that precede and shape the labour of signification – the materiality of signification – are comfortably disavowed. The allegorical complexities of the intentions and competences that underwrite the critique of authorship – in fact sustain its logic of negation – have been dissolved into a cultural studies model of semiotic consanguinity. Hence we have a situation in which the informal aspects of Conceptual art are now being replicated as a neo-avant-garde, but with little sense of the troubling negation of the social world that shaped the early avant-garde's and early Conceptual art's critique of the category of art. This has led, overwhelmingly, to a critique of authorship without the discomforts of ideology critique and the critique of the capitalist value-form, as if attacking the myth of self-expression was in and of itself a critical strategy. Indeed, the deconstructionist attack on authorship as an intertextual version of *bricolage*, is perfectly compatible with the most conservative views on what artists should now do to define themselves as modern.

Nevertheless, the critique of this benign pluralism is not an argument for the revocation of the original avant-garde or the recovery of a 'lost' Conceptual art. To critique contemporary neo-avant-gardism is not to think of the 'neo' as an inevitable falling away of art from the achievements and commitments of the past. On the contrary, the 'neo' is the necessary space in which the afterlives of

art and theory continue to be *reinscribed* with new and living content. As such we need to examine just what the 'neo' of contemporary neo-avant-garde actually comprises, before we can make a judgement about its criticality.

What I am proposing [...] is a model of the 'post-expressivist' artist which actually takes on the challenges of expression and representation that now confront the artist of the new millennium. This means re-theorizing what we mean by the artist as critic and re-presenter in a world of proliferating doubles, proxies, simulations, etc. For what is increasingly clear (beyond the recent moments of the radical negation of authorship in Conceptual art and critical postmodernism) is the need for a model of the artist which is *unambiguously* post-Cartesian, that is, a model of artistic subjectivity which refuses the bipolar model of interiority and exteriority on which modernist and anti-modernist models of the artist are usually based.

In the 1960s the opposition between interiority and exteriority in art took the form of the familiar conflict between modernism (as an expanded sense of art's expressiveness and affectivity) and social realism (as an expanded sense of art's claims on ethical witness and social truth). In the 1980s, this re-emerged in the form of a conflict between neo-expressionism and a photographically expanded neo-Conceptual art practice. Today, however, the taking up of a position on either side of the 'interiority' or 'exteriority' debate is inert, if not dead; there is no 'expressiveness' to be won through painting-*as*-painting, just as there is no social truth to be secured through photography (or even photography and text) *as* photography. This is why the weak pluralist intertextuality of contemporary neo-Conceptual art and theory has become so hegemonic: it takes the very real crisis of the exterior/interior dualism as a point of exit from 'interiority' and 'exteriority' altogether and not as the point through which their boundaries might be reformulated. In dissolving the reified identities of 'inside' and 'outside' pluralist intertextuality comes to dissolve 'expression' and the 'self and the 'real' *tout court.* The crucial question, then, is how the self-evident collapse of older models of expression and critique in art might allow us to continue to discuss questions of criticality, expression and representation in the twenty-first century. How is it possible to think critique and critical difference in an extended world of neo-artefactuality and neo-visualization? [...]

Essentially, since the 1960s the self-identity of the artist has become detached from the traditional hierarchies of artistic media. Artists may continue to work as painters, photographers and sculptors, but painting, photography and sculpture are not in themselves privileged sites of expression and meaning for the artist. Rather, specific media are staging areas for the warping and weaving of the process of semiosis across forms, genres and non-artistic disciplines. In this way the artist's skills as a maker of self-conscious artistic signs is

indistinguishable from the artist's competence as a theoretical manipulator of 'stand-ins', performative strategies and prosthetic devices. Yet, in most accounts of the critique of authorship, from the readymade to digital technology, there is an unreconstructed tendency to adopt the Cartesian model of the artist as the self-bound manipulator *of* such devices, props and strategies. The artist's creativity is never implicated *in* these processes; that is, strategies of repetition, re-presentation, reinscription and replication are rarely seen as extending the identity and competences of the artist. Technique, technology and artistic subjectivity – art and social *technik* – are separated. This is because simulacra, copying, surrogacy and replication are not seen as the superstructural conditions of art under advanced capitalism, but as simply modes or devices of artistic audaciousness. In other words, if art is always and already embedded in the technological relations of its time, then the technologies of copying, simulacra and surrogacy are the material basis of art's modern semiosis and not mere stylistic options. Second-order is first-order. Consequently, the early and late twentieth-century critique of authorship is the site where the dissolved category of art and the reconstituted content of artistic technique meet, the gateway through which new artistic identities and relations might be formed and the critique of ideology and the value-form sustained. It is not where the identity of the artist is lost or to be mourned.

From this perspective artistic subjectivity *is* the use and manipulation of 'stand-ins'. There is no point, no place, where the artistic self is free of the constraints of prosthetic devices (be it paintbrush or digital camera), the demands of copying (identification and reclamation), and as such the performative voice or persona (recognition of the split between work and authentic self). In this sense we need to distinguish a fundamental set of conditions for art in the twenty-first century.

Under the capitalist value-form social reproduction – the unceasing production and reproduction of the commodity – and technical reproducibility (general social technique) are conjoined, one driving the other. That is, just as general social technique is subject to the law of value, the law of value is subject to the technical transformations of general social technique. Hence in a system where the continuity of production is based on technological forms of replication and duplication, the technical conditions of social and cultural life will necessarily be based on forms of iteration (the neo-effect). Social reproduction and technical reproducibility become indivisible. The result is that the production of art is no less subordinate to the fundamental logic-of-repetition of commodity-production than other non-cultural commodities. In order for art to secure its 'newness' it must, like other commodities, reiterate itself, otherwise it becomes the thing it once was, abandoning itself to the past

and the same. But, if the artwork is subject to the drive-to-repetition of the commodity, the artwork's escape from its own heteronomous conditions of production is not like other commodities. Because artworks are invariably distinct singularities, rather than repeated prototypes, their emergence from heteronomy and their inauguration of the 'new' represents a qualitative break in the *subsumptive* repetition of the commodity form. That is, although artworks seek to reiterate themselves, as all commodities must, this reiteration is determined by the autonomy of artistic subjectivity (as opposed to the heteronomy of productive labour). In other words, in contrast to productive labour's repetition of the 'new' as the 'same', the 'new' is transformed into the 'new' as different, as other to its immediate conditions of production. This event of 'newness', as such, is precisely non-heteronomous, and therefore opposed to the very logic of subsumptive repetition that brings it into being. The important point here is that as a system of commodity production art is both formed by, and is in resistance to, the iterative logic of commodity form; or, rather, the resistance to iteration and the production of iteration are the same thing. The conditions of autonomy and heteronomy are interwoven. [...]

In this regard many theorists since the 1960s have argued that there has been a qualitative technical transformation in how images are produced in art and in mass culture in the late capitalist world. With the expansion of the commodity form, a corresponding expansion of the conditions of reproducibility has occurred, bringing with it an unprecedented freedom from the myths of authenticity and originality. Some of this writing embraces this condition[4] and some of it decries its would-be detrimental social and cultural consequences: the loss of a sense of 'tradition', 'artistic skills', and 'stable social identities'.[5] Less prevalent is thinking of the copy from *inside* the conditions of social reproduction and technical reproducibility. By either celebrating or denigrating replication and copying, the *nachfolgen* [following after] function of the copy is divorced from its constitutive place within the commodity's dialectic of autonomy and heteronomy. One of the results of this is that artistic technique and the various technical conditions of social reproducibility across scientific and technological domains are divorced. If this means thinking of the copy in cultural production from inside general social technique, it also means thinking of general social technique, more broadly, in relation to the sciences of replication; for example, genetic engineering, the new cosmology, theories of Artificial Intelligence and so on. [...] The upshot being that the copy is not that which fails the status of novelty, or that which lacks authenticity, but the thing *out of which* claims for novelty – what drifts or mutates the identity of the antecedent – is produced.[6]

Since the 1930s when Walter Benjamin was the first to theorize the

conditions of technological reproduction in its modern cultural forms, the supersession of the artisanal in modern life defined the expectations for new forms of art and marked out the new forms of experience emergent from this art. If Benjamin was highly optimistic about these forms and experiences, we at least understand from his work an important historical truth: *art and general social technique does not stand still.* Indeed, Benjamin's writing presaged a vast transformation in the content of artistic and social *technik* in the second half of the twentieth century. Since the 1930s the realities of image reproduction and artistic surrogacy or authorship-at-distance have represented the high ground upon which debates on value in art have been fought out. In fact seventy years on we can now see that the debates on the readymade, on photography, on post-object aesthetics have been the phenomenal forms of a much deeper and more profound response to art's place in the social division of labour. Not only does capitalism strip the artisan of his or her means of production and status, it also strips the artist of his or her traditional 'all round' skills. Under advanced capitalism, therefore, debates on modernism, the avant-garde and postmodernism have been principally about rethinking and reinscribing the skills of the artist into these transformed conditions. The contemporary critique of authorship is no more nor less the theoretical expression of these long-term changes. But today the remnants of any nostalgia for the artisanal which once hung over the early twentieth-century debate have long vanished, as consciousness of the copy in our daily technological practices has dismantled notions of expressive and formal uniqueness. The implications for art from this are indisputable. Art is not just a series of unique inheritable objects produced by diligent individualized handcraft, but also the outcome of a set of shared iterative skills, temporal forms and collective relations. In this its forms are dispersible, expandable and endlessly reproducible. Yet discussions of skill, deskilling and reskilling in art are barely broached in contemporary art theory.' Too much theory and history, in fact, filters its sense of art's futurity from a narcissistic mourning of art's would-be lost affective qualities and possibilities. As a result the interpretative disciplines can hardly keep up with the social, cognitive and cultural forces that are now bearing down on the category of art. But, if mourning for the the lost object has become a substitute for its dialectical appropriation, this does not mean that dialectics itself should lose sight of what is empty, repressive or diminished in the iterative culture of our time. To reposition artistic technique in relation to replicant thinking and general social technique is not an attempt to provide art with a set of functional use-values borrowed unmediated from science, as if the solution to the alienated social form of art was art's greater openness to scientific method and technology per se. [...] Rather, the fundamental issue remains: how might the autonomy of artistic technique be a condition *of*

general social technique, and of use-values external to the realm of art? [...]

The production of value in modern art is inconceivable without the idea of the critique and the reworking of notions of skill and technical competence. The very interrelationship between artistic technique and general social technique is predicated upon this. Indeed, it is on the basis of this relationship that the complex labours of art – its 'intangibilities of form' – have been constituted and reconstituted during the twentieth century.

It is the readymade, above all else, that is key to understanding the development of the modern conditions of reproducibility in art and art's relationship to general social technique. With the readymade we are, at once, in the realm of artistic labour and productive labour, art's autonomy and post-autonomy, novelty and the copy.

1 Raoul Hausmann, quoted in Hans Richter, *Dada: Art and Anti-Art* (London: Thames and Hudson, 1965) 118.

2 [footnote 3 in source] This also works in the opposite direction. The dispersal of 'artistic technique' across disciplinary boundaries has clearly been appropriated as a model of 'good practice' and 'open' management in some of the creative and new services industries. [...]

3 [4] Tracey Emin's career is a perfect example of this: from neo-Conceptual marginalia to designer of smart bags for the luxury luggage maker Longchamp.

4 [8] See Jean Baudrillard, *In the Shadow of the Silent Majorities* ... or *The End of the Social* (1982), trans. Paul Foss, Paul Patton and John Johnston (New York: Semiotext(e), 1985).

5 [9] See Paul Virilio, *The Aesthetics of Disappearance* (1980), trans. Philip Beitchman (New York: Semiotext(e), 1991).

6 [10] Genetic engineering instates this process clearly. Cloning – Cell Nuclear Replacement – is the infinite reproduction of the same as the 'new'. That is, cloning is not the *exact* reproduction of the prototype in physiology or consciousness (just as twins born within seconds of each other are not exactly identical). The genome may be reproducible but the behaviour and individual characteristics of human beings are not. [...]

7 [11] Where it has, it has borrowed its models from the biological, neurological and other physical sciences. One such model is the neurocomputational account of consciousness in the new neurobiology. [...]

John Roberts, extracts from 'Replicants and Cartesians', *The Intangibilities of Form: Skill and Deskilling in Art After the Readymade* (London and New York: Verso, 2007) 8–20 [footnotes abbreviated].

Mark Cousins
The Ugly//1994

[...] Since antiquity, beauty has been regarded as possessing a privileged relation to truth. From this it follows that an ugly representation, or an ugly object, is a negation not just of beauty, but of truth. The category of beauty plays an epistemological role; it presents the truth of an object. Ugliness belongs to whatever negates that truth. It belongs to a series of categories which similarly distort the truth of objects. It belongs to what is contingent, for contingency cannot admit of the truth of objects. It belongs to what is individual, for individuality does not express the truth of objects. It belongs to the hell of error; it can never accede to the haven of what is ideal and what is necessary. This philosophical drama, in which the forces of truth and of error wage war over the territory of art, determines the character of ugliness. Ugliness is condemned to the role of the mistake, to the role of the object that has gone wrong. [...]

Ugliness, contingency, individuality are all terms which belong to the pole of negation. As a consequence, it follows that ugliness will be thought of from the point of view of beauty. At a logical level, ugliness is the negation of beauty; at the level of perception, ugliness is the opposite of beauty. All speculation about ugliness travels through the idea of what it is not. This is indeed characteristic of philosophy's attempt to postpone or prevent any encounter with ugliness as such. Ugliness is always shadowed by the beautiful. The argument that will be presented here is part of an attempt to suggest that ugliness has little to do with beauty and that, in fact, beauty and ugliness belong to quite different registers.

What we might call the philosophical account of ugliness was already laid down in antiquity. For Aristotle, the beautiful object is one which has the ideal structure of an object; it has the form of a totality. [...] Internally it exhibits coherence; externally it establishes a sharp boundary between itself and the world. This establishes a relation between perfection and the idea of the beautiful object. In this case, perfection does not mean, as it does to us, the zenith of beauty. The perfect object is, rather, one which is finished, completed. Any addition or subtraction from the object would ruin its form. [...]

This stress upon the object's being perfect and therefore finished already suggests a philosophical criterion as to what will function as ugly. It is that which prevents a work's completion, or deforms a totality – whatever resists the whole. An ugly attribute of a work is one that is excessively individual. It is not just that monsters and characters from low life belong to a class of objects which are deemed ugly; it is that they are too strongly individual, are too much

themselves. As such, they resist the subordination of the elements of the object to the ideal configuration of a totality. The ugly object belongs to a world of ineluctable individuality, contingency and resistance to the ideal. [...]

Ugliness can deform a work, but it can also strengthen it. For the stronger the totality of a work of art, the more it has had to overcome those elements within itself that oppose its unification. Indeed, if this is true, a new doubt about a certain type of beauty arises. If the structure of a beautiful object has been too little tested by whatever opposes that structure, then it is facile, 'merely' beautiful.

Ugliness, by complicating beauty, achieves an ambiguous status – utterly excluded from beauty, and at the same time a 'moment' in the unfolding of a beauty whose form as a totality is all the more triumphant for having overcome the resistance to itself in its 'moments' of ugliness.

The discourse of aesthetics, especially in Kant's third *Critique*, fundamentally complicates and radically skews this relation, but does not reverse it. Commentators have frequently identified the category of the sublime as one which overthrows the limits of the classical conception of beauty. [...]

The sublime is neither an image nor an object of a particular type, but the enactment of a scene in which the subject and object have a dynamic relation to each other within a specific setting. The awfulness of the object does not immediately threaten the subject, but rather – given the subject's safety-in-danger – it awakens in the subject an apprehension that his potential scope, even his scale, is greater than the vast and fearful object. [...] Indeed, there seems to be something almost inescapably cinematic about Kant's description of the site of the sublime. I sit (safely) confronting such arresting, awful, fearful representations.[1] As long as the gap between the subject and the object constitutes a margin of safety, as long as the subject does not cross that fateful boundary between the fearful and fear, the relation of the sublime can be maintained. If it is crossed, if the subject goes too far or the object comes too close, the sublime will collapse. The paradox of the sublime – or rather its inherent ratio – is that the closer I am to the boundary, the more intense is my experience of the sublime. The moment of its zenith is also the moment of its collapse.

But the vastness of the object, its indistinctness, its lack of proportion or symmetry, does not necessarily signal a revolution in the relation between beauty and ugliness has occurred. For, if the totality of the object seems to be absent in all these sublime representations of the world with its unfinished and unlimited character, this does not mean that the sublime abandons the category of the totality. Here, totality is an attribute, not of the object but of the subject, and of the subject's relation to the object. The attributes of symmetry and proportion, which now may seem to be lacking in the object, none the less reappear as a symmetry and proportionality *between* the subject and the object. [...]

We can now move to a hypothesis concerning ugliness: *Aesthetics cannot deal with ugliness, save as a negation and as a moment of beauty*. Aesthetics is the theoretical knowledge of beauty and the subject's relation to beauty, and it therefore follows that there cannot be an aesthetics of ugliness. It also follows that the experience of ugliness is not an aesthetic experience as such. Kant's notion of aesthetic experience and of judgement cannot admit propositions such as 'This is ugly'. The judgement 'This is beautiful' does not have an opposite. The failure to form a judgement of beauty is just that; it is not an assertion of ugliness. If ugliness is to become an object of inquiry, this inquiry will have to be conducted outside the scope of aesthetics. But like aesthetics it cannot afford to collapse into the relativism of taste. For, if the investigation of the ugly is reduced to the question of what is held, here and now, or there and then, to be ugly, there is nothing to say, beyond the fact that some people say one thing, some another. The sociological and historical investigation of personal preferences, or the cultural machinery of taste, can never accede to the problem of beauty and ugliness. For that problem is not about the variability of taste, but about a certain modality of subjectivity in relation to the object.[2]

We have argued that beauty and ugliness operate in different registers, but this much they do have in common: they cannot be accounted for in terms of the way in which a culture imposes a scale and a hierarchy of preferences. The problems of beauty and of ugliness both exceed, though differently, the way in which cultures use the terms. Like beauty, ugliness entails a certain relation of a subject to an object; nor can ugliness be reduced to a set of attributes which are assigned to it. It exists, decisively and fundamentally, within the relation. But what is this relation?

The next hypothesis is as follows: *The ugly object is an object which is experienced both as being there and as something that should not be there*. That is, *the ugly object is an object which is in the wrong place*. It is important to detach this definition of ugliness as far as possible from aesthetics, for it is not at all a question that an object, having been judged to be ugly, is experienced as something which should not be there. This is not a theory of propriety. It is, rather, that the experience of the object as something which should not be there is primary and constitutive of the experience of ugliness. At this level such an experience is identical to the idea of its being in the wrong place. This does not mean that there is a right place for the ugly object; there is no such place. For this is not a relation of incongruity or impropriety; the 'wrong place' is an absolute. But in what respect is the ugly object an object which is in the wrong place? Briefly, from the position of the subject to whom the object discloses itself as ugly.

But where may we look for help in thinking out the issue of something which is out of place? Undoubtedly the strongest thoughts about what is 'out of place'

come from religious taboos and from the clinical analysis of obsessional neurosis. Both sources (if indeed they are not the same source) betray an underlying concern with things being in their place, and the opposite of this, which is *dirt*. Mary Douglas has famously remarked that dirt is matter out of place. What makes dirt dirty is not its substantial form, however much we commonly believe this to be the case, but the fact that it is in the wrong place. In Judaism the earliest ideas concerning sin were expressed, not as abstract issues of ethics, but as the material problem of the *stain*. And it is the stain which leads that early notion of sin to imagine its expiation in terms of purification rather than restitution. A stain must be cleansed.[3] Is this because the stain is ugly? The stain is not an aesthetic issue as such. It is a question of something that should not be there and so must be removed. The constitutive experience is therefore of an object which should not be there; in this way it is a question of ugliness. This connection between a thing being in the wrong place, sin and ugliness still obtains where the prohibitions within a culture take the form, not of elaborate reasoning, but of swift revulsion from the 'ugliness' of an act. An economy of dirt is therefore one way of opening up the question of ugliness.

This economy can also be translated into spatial terms. In so far as dirt is matter out of place it must have passed a boundary, limit or threshold into a space where it should not be. The dirt is an ugly deduction from 'good' space, not simply by virtue of occupying the space, but by threatening to contaminate all the good space around it. In this light, 'dirt', the ugly object, has a spatial power quite lacking in the beautiful object. One way of clarifying the difference between the registers of beauty and ugliness is to translate them into topological entities. Broadly speaking, the beautiful object remains the same size as itself, while the ugly object becomes much larger than it is. There is an important reason for this. All objects exist twice, both as themselves and as representations of themselves. But I have a vested interest in pretending to myself that this is not so, for if I were forced to recognize this I would have to conclude that my own existence – as myself and as my representation of myself – are different, and in certain conditions might even come apart. It is not just an idealization of the human body which is implied in the Vitruvian scheme of proportion; it is a manic insistence that an even more fundamental proportion in man is guaranteed: that he takes up only as much space as his form displaces. This phantasy depends upon a conviction about isomorphism, about the relation between objects and space. Firstly, that there will be an isomorphic relation between an object and the space it occupies. Secondly, that there will be an isomorphic relation between the outside of an object (representation) and its inside (existence). Thirdly, that this is most true when the object is a human being. For the thought of an inside being larger than its outside is one which repels human beings.

But how different is the space of the ugly object, and how little Archimedes understood of it. Contamination, at a logical level, is the process whereby the inside of an object demonstrates that it is larger than its outside or representation. This is one reason why it is important for architecture to be able to think the ugly object. It is also the topographical reason why the ugly object as dirt is not merely a question of 'where the object shouldn't be'. It is not just that the ugly object has trespassed into a zone of purity, for the ugly object is voracious and, through contamination, will consume the entire zone. This demonstrates that an important aspect of the ugly object is its relation to space – including, as we shall see, the space of the subject.

No one knows this better than the obsessional neurotic. Leaving aside the question of cleansing as a form of assuaging guilt, it is clear that for the obsessional the answer to the question 'Where should the object *not* be?' is 'Close to me'. It is not just that the obsessional wants to keep ugly objects as far away as possible; it is, rather, that they become ugly by getting closer. Underlying this is the conviction that what is at a distance is under control, and what is closer is out of control. The obsessional thinks in terms of the formula that ugliness is a function of proximity, but also thinks that the way to stop an object getting closer, to bring it under control, is to clean it. This involves a phantasy about gleaming surfaces; whatever gleams is sufficiently distant from myself. What I polish recedes; what is dirty approaches. But the hopelessness of the task of cleaning is all too apparent. The more you clean something, the dirtier it gets. As the surface is cleaned it reveals those fewer but more stubborn stains which demonstrate even more starkly how the remaining stains consume the surrounding space. The case of the obsessional shows that the ugly object, in its relation to the subject, is not static but is always eating up the space between it and the subject.

But what is this subject? Why is it confronted by something which is in the wrong place? In order to answer this it is necessary to remember that the 'subject' referred to here is not the 'subject' that Kant has in mind, nor the subject of philosophical discourse in general. Still less is it the 'subject' that serves as the bearer of cultural codes in the human sciences. It is, rather, the subject that responds to objects as a determinate psychical apparatus, that is, as a radical division between unconscious and conscious life – a being which is the locus of desire as well as the locus of institutions of defence against those desires.

This has immediate consequences for a psychoanalytic account of the difference between our responses to beauty and to ugliness. In so far as beauty may be taken as an object of desire, the subject is governed by the pleasure principle. But it is the nature of desire to work in respect of representations. 'Representation' here does not refer to the nature of an object, whether it be a

painting or a person: it refers, rather, to the fact that the economy of desire is intrinsically about representation. All objects of desire are representations, since they are substitutions for something that is experienced as having been lost. This economy of desire can be illustrated by reference to the infant. The infant does not experience desire as long as he is satisfied. The first gap in existence occurs with a lack of satisfaction. The infant does not exactly 'experience' this lack. Rather, experience is born of it. The infant deals with the lack of satisfaction by hallucinating what he imagines is the object that would restore satisfaction. But hallucination involves a relation to a representation; it does not produce satisfaction. The representation, in this sense, is a substitute for something which is now lost, and which constitutes the subject as a complex of lacks. The infant assumes subjectivity as the catastrophic precipitation into a world of desire (lack) and substitutions for a lost object. However much the subject strives to fulfil his desires, the economy of lack can never be satisfied. The lost object can never be found because it is no longer an object; it is the condition of desire. Caught between what is experienced as lost and the illusions of desire, the subject follows the plot of his own fiction.[4]

This economy governs both the life of phantasy and life in the world. But the world includes obstacles to desire; indeed the world itself may be thought of as an obstacle to desire. It is this which leads Freud to define 'reality' in a special sense, one which is quite alien to definitions offered by philosophers or by the human sciences. If the philosopher defines reality or existence as the sum of what there is, and if the anthropologist defines it as the sum of what there is from the standpoint of a culture, those definitions are no part of Freud's reasoning. For him reality is anything that functions as an obstacle to desire. The idea of 'reality testing' is not the cognitive adventure that psychologists imagine, but the painful blow, or wound, that is delivered to our narcissism. Reality is that which, being an obstacle, both arrests and denies us our pleasure. It is in this sense that we can consider a thesis which might otherwise seem petulant and melodramatic: *The ugly object is existence itself*, in so far as existence is the obstacle which stands in the way of desire. And so it is, from the point of view of desire, that the ugly object should not be there. Its character as an obstacle is what makes it ugly. [...]

1 In a section which follows the quotation above, Kant gives an unusual definition of the brave
 soldier: 'one whose sense of safety lasts longer than others'.
2 Since the late eighteenth century an argument has existed that assertions that something is
 beautiful or ugly are nothing more than a linguistic assertion that the subject 'likes' or 'dislikes'
 something. As such, aesthetics is ruled out of court, in favour of the analysis of preferences or
 taste. Contemporary sociology attempts to show how the mechanisms of taste serve the

interests of certain social classes and relations of cultural prestige. But these forms of argument, however appealing, fall short of Kant's problem.

3 There is a necessary ambivalence about the stain itself which must be cleansed, or the place of the stain. The space as a whole has been violated. Contamination is a process which by definition *spreads*. This is why both religious taboos and the obsessional are concerned with minutiae. For even the tiniest violation of a boundary always has large consequences.

4 This is an absurdly contracted statement of a psychoanalytic view of the birth of the subject, which is so different from the birth of the infant. It is concerned to signal that from the point of view of desire all objects are also representations. Such a condition reaches a point of intensity in the wish to see. For what is it that we wish to see, beyond what we see?

Mark Cousins, extract from 'The Ugly' (Part I), *AA Files*, no. 28 (London: Architectural Association, 1994) 61–4.

Mark Hutchinson
Nausea: Encounters with Ugliness//2002

The failure of surface is ugliness. Ugliness has become interesting in recent art, I think, because it breaches a discourse of surfaces. It offers a model for the relationship between artwork and spectator of immediacy, urgency and proximity. This cuts through a still dominant economy in art of detachment and exclusion. Ugliness is close, threatening and exciting. Both obscene and fascinating, the ugly is a trope of contradiction and excess: it is too much. Ugliness stalks the subject: it doesn't go away when you shut your eyes because it is always out to get you. In the failure of surface is the threat and the promise to end everything, permanently.

Surface was a modernist obsession. Various formalisms made a living emphasizing, negating, displacing (and so on) surfaces and the optical picture plane. The centrality of questions of surface was an article of faith in the modernist orthodoxy. Surface was something of a fetish, a token of art's autonomy. In fact, it seemed one of the few things you had left, once the necessity of representation had, apparently, been removed. It was the carnal knowledge of modernism coming to self-consciousness: no more innocent picture making without the knowledge of what you were doing with surfaces. When it is taken for granted that art is a practice of making objects, then surface is the hidden truth behind representation: what one always already sees is a surface.

Clement Greenberg highlighted this loss of innocence when he talked about 'the cut': the first mark a painter makes on a surface. What is 'cut' is the optical surface of the picture plane. The relationship between mark and surface is conceived in terms of a relationship between figure and ground. This rests on the ideology of the inescapable fact of pictorial space and therefore art's confinement to the visual. For Greenberg, 'the cut' is the truth in painting. It is not only what painting is about, it is what painting should self-consciously be about: 'the cut' is what painting does. To disavow this truth, to hide the surface (by painting pictures which are *of* something, for example), is an act of betrayal, falsity, corruption, delusion and foolishness.

This all sounds impossibly quaint. Surfaces, it now seems, like all signs, are what you make of them: detached from a fixed and stable reality. There is no way of deciding the primacy of the literal surface over the pictorial or metaphorical surface: no figure which is not also a ground. Indeed 'the cut' of the modernist surface gave way to the 'cut and paste' of the fragmented postmodernist surface. All kinds of accumulation and appropriation of

conflicting styles and iconography were the order of the day as the idea of an overdetermined, multiple and contradictory surface made itself apparent. Artists embraced this willing failure of the unified, optical surface as a liberation from the tyranny of bureaucracy, management and control.

A surface of fragments and optical contradictions is still a surface, although one articulating the idea of the arbitrary and conventional rather than the idea that it is the bearer of some kind of truth. But the failure to have a consistent and unified surface is not the same as the failure to have a surface per se. A truly ugly face is not one lacking the requisite proportions for beauty but one lacking a properly containing surface: not one with a bad surface but one which is missing some surface. A face with disproportionate features, for example, may not be considered beautiful but is not ugly: a face lacking in features (one lacking eyes, or a nose, or lips, etc.) is what is ugly. It threatens to stop being a face at all.

The ugly is a catastrophe for surface. It cuts through the surface. It is a breach in the continuum of surfaces. Beyond the surface is raw matter, is stuff. The failure of surface is the failure of the illusion of the containing wall of stuff: the failure of an object to remain a discrete object. The failed surface lets formless stuff out into the world: a kind of ontological meltdown.

Ooze and slime and drool epitomize ugliness because they are escaped stuff, uncontained by surface. A viscous, sticky liquid is not quite a proper liquid, more like an unreliable solid, the surface of which is constantly changing as it spreads. It spreads because it does not have enough surface and it has too much stuff. As the ooze spreads, it does not flow over things, as a liquid would, but rather leaves a trace: a sticky contamination of the surfaces it has passed over. Its sticky coating impugns those surfaces too. The unreliability of its surface is demonstrated in its stickiness: the surface comes off on your hand. Its edge is indistinguishable from the rest of it: it is relentless goo, the same all the way through. The surface is indistinguishable from what it should contain. In this sense, in fact, it is without a surface at all. [...]

When an object ceases to hold its symbolic integrity, it is as if the inside has become bigger than the outside, breaking down the spatial logic of the relationship between the self and the world. It is as if the inside has started to grow. In coming through the surface, the ugly stuff is getting closer. Traditionally, in horror films, the 'undead' have bad skin. It breaks and falls off. Rancid blood and putrefying flesh ooze out through their inadequate surface, through their broken, incomplete skin. This ugly stuff is always too close to us and we have to run away. The 'undead' pursue us because the ugly is always breaking down the spatial isolation of the subject. On a more prosaic level, spots, snot, dribbling saliva, piss (the physical eruptions of other bodies) are always closer to you, psychologically, than the rest of the person. [...]

The ugly always looms large. It is the focus of attention of the ego because it is what escapes its hallucinatory architecture: its ability to negotiate the world through symbols. The ugly is horrifying yet compulsive. It gets closer in the same way that if someone tells you not to think of something horrible, you can think of nothing else. The more you try to forget, not to think about it, the more it fills your thoughts. Ugliness is relentless. It threatens to dissolve distance. It is apocalyptic. In ugliness the subject sees the end of distinctions; the end of difference; the end of space; the end of time; the end of everything. As such, the ugly both threatens death and promises to fulfil utopian longing.

Leakiness is contagion. Not only does the ugly object threaten to explode the symbolic order – to eat away the distance that keeps the world at bay – it also threatens to make the subject ugly too: to turn you back into your component parts. The breakdown of other things into matter is an unwelcome reminder that you, too, are just a heap of nasty stuff barely contained by a fragile and fallible surface. When the 'undead' monster drips onto you, the uncontained bodily ooze is a picture on the skin of what is under the surface; it is tangible evidence of how similar the ugly object is to the living subject. They don't need to catch you for you will become one of them: your own ugliness is only ever kept at bay. [...]

This is a truth that the anorexic knows. When he or she refuses to feed more stuff into the treacherous vessel of the body, it is an attempt to do away with the threat of the ugly altogether by doing away with the body. The anorexic is always too fat because he or she does not see the surface of the body but the ugly stuff therein. The anorexic sees fat not in terms of the surface of the body, not in terms of what it does to skin, but rather sees fat as just stuff. Here, fat is not relative but an absolute: 'too fat' does not make sense because any fat at all, any stuff of the body, is always already too much. Anorexia is the doomed attempt to reduce the subject to symbolic purity: to have an outside with no treacherous inside at all. The anorexic puts all of his or her investment in the maintenance of image, at any cost. What the anorexic cannot contemplate and cannot bear, is the contingency of the real, with all the pleasure and pain that that promises.

Cutting through the symbolic with another level of base reality, ugliness is a figure which makes everything exist in the same way; a figure which obliterates distinctions; a figure which murders the ground. The ugly is the breaking down of the distinctions which keep the excluded away. The ugly is the unrepresentable; it is unaccountable and unimaginable. What the cultural anorexic cannot contemplate and cannot bear is the contingency of the real: the knowledge that there is something through the surface, which cannot be contained.

The reaction of the subject to ugliness is contradictory and bodily. When ugliness hits you. it is overwhelming in its immediacy and excess. It is not as if you have a choice. A typical reaction to ugliness might be to turn away and then

look back over your shoulder; or to cover your eyes and then peep through your fingers. The ugly provokes an immediate reaction, which is one of both irresistible fascination and horrified repulsion. As such it offers a model of looking which is complex, open and not specialized.

At the beginning of the last century, Walter Benjamin considered whether democratic technology in the form of mechanical reproduction might transform the aura of artworks and, indeed, transform what art might be. A change in the way that art was produced might bring art in closer proximity to the world and everything else. This collapse of distance would press art against unthinkable responses and illicit experiences. Art might cease to exist as a result. It could not survive unmolested. The ugly is a trope that threatens to dissolve symbolic distinctions. It, too, contains the threat to destroy art altogether, in the name of that which does not have a proper place.

Mark Hutchinson, extract from catalogue essay, *Nausea: Encounters with Ugliness*, ed. Hutchinson and Nicola Cotton (Nottingham, England: Djanogly Gallery, March 2002) n.p.

Simon O'Sullivan
Art and the Political: Minor Literature, War Machines and the Production of Subjectivity//2005

[...] In [*Kafka: Towards a Minor Literature* (1975)] Deleuze and Guattari give three determining characteristics of a minor literature, or, which is to say the same thing, of the conditions in which a literature becomes revolutionary:

1. *That a minor literature should deterritorialize the major language* (*Kafka*, 16). Such a deterritorialization involves the neutralization of sense, or the signifying aspects of language, and a foregrounding of the latter's asignifying, intensive aspects. This involves a kind of stammering and stuttering – or 'becoming a stranger' – in one's own tongue. Deleuze and Guattari give the example of Black Americans 'use' of English (as well, of course, as Kafka's own 'use' of German). We might think of the ongoing creolization of the English language in general. A side effect of this is that a minor literature operates to counteract the transmission of 'order words', and the exercise of power this entails ('To hate all languages of masters' as Deleuze and Guattari remark [*Kafka*, 26]).

2. *That in a minor literature everything is political* (*Kafka*, 17).
Political here means that the lives and individual concerns of the characters in a minor literature are always linked to the larger social, and indeed asocial, milieu (and not, for example, fixated on the familial, domestic unit). It is in this sense that a becoming animal is always political, a line of escape (for Kafka's Gregor, for example) from conjugality and the nuclear family. This links up with point 1: the animal cry – as sound, as deterritorialized noise – operates to neutralize sense, we might say to neutralize the habits of representation, of 'being human'. Asignification here takes on an explicitly political function; it disrupts dominant systems of signification and representation. In fact, the relationship between asignification and signification, and between literary-linguistic systems in general is itself a 'political situation', expressing as it does relations of power (relations of domination and resistance).

Deleuze and Guattari, following Henri Gobard, provide a tentative matrix for these relations, in fact a four-way model: vernacular language (local and territorial), vehicular language (international, a deterritorialization of the former), referential (the language of sense and culture, a cultural reterritorialization) and mythic. This last is positioned 'on the horizons of cultures, caught up in a spiritual or religious reterritorialization' (*Kafka*, 23). This schema can only be provisional. The relationships between, and functions of, different languages will always vary

depending on the specifics of space and time, which is to say a definition of the minor will depend on a definition of the major.

3. *That a minor literature is always collective* (*Kafka*, 17).
Collective in the sense that a minor literature works as a collective enunciation. There is less emphasis on individual authors and talents, which are at any rate scarce within a minor literature, and more on the collective production of work (its always already collaborative status). It is in this sense that we can see the artistic production of statements as a kind of precursor of a community (and often a nation) still in formation. This is the utopian function, specifically *immanent*, of a minor literature. A minor literary machine then prepares the way, in fact in many senses calls into being, the revolutionary machine yet-to-come ('We might as well say that minor no longer designates specific literatures but the revolutionary auditions for every literature' [*Kafka*, 18]).

It is this last point especially, it seems to me, that gives us a framework for thinking many recent contemporary art practices which might be seen to be involved with precisely this utopian pursuit: the collectivization of subjectivity and the calling forth of new kinds of community that this implies. Before I go on to consider this I want briefly to think through points 1 and 2 also in relation to contemporary practice.

First point 1, the deterritorialization of a major language. Deleuze and Guattari point out that a minor literature does not occur 'elsewhere' or 'apart from' a major literature (this is not a dialectic) but on the contrary operates from within, using the same elements as it were but in a different manner. In fact, it is not so much a question of the minor or of the major but of a *becoming* minor in the sense of producing movement from 'within' the major (if the minor names this movement – these 'crystals of becoming' – then the major is the name for their immobilization). What then might we understand as the major, and thus the minor, language(s) of contemporary art practice? Here are five suggestions.

First, we might think of the major and relatively recent tradition of Western art, that is to say modernism, and thus identify practices that are specifically minor to this. Both feminist and postcolonial art practices and art histories might be seen as minor in this sense, involving as they do a kind of deterritorialization, or stammering, in the 'international language' of modernism. We might take this further and identify practices of art and indeed art history that deterritorialize legitimate critiques of modernism, and indeed other 'legitimate' postmodern practices (and this might well involve a return to previously evacuated terrain). Indeed, minor practices will emerge wherever and whenever a priest and a party line emerge and order words are given.

Second, we might also think of those marginal and dissonant practices that were themselves part of modernity but which also in some senses turned against it; modernity's 'other voice' as it were. Dada, for example, which was nothing if not the making stammer, the stuttering, of language and art. We might note here the Dada manifestos, and indeed the other dissident manifestos of modernity (from Futurism to the Situationists) all of which would precisely fit our above three criteria of a minor literature. Here the question of how, when and why a minor literature – or any minor practice in general – becomes major (the apparatus of capture) will be particularly pertinent. In fact, artistic strategy might well involve a 'return' to some of these practices that have retained a deterritorializing function, for it might be the case that a minor practice does not necessarily become major but is simply passed over by the major.

Third, leading on from the above, we might alter our focus slightly and think about the major media of art, specifically painting, and thus characterize those practices as minor which abandoned the canvas (happenings, performance, and so on) or otherwise deterritorialize the figure. We might begin to identify a general 'becoming minor' in art here. Art begins with a deterritorialization of forms that have become fixed. The expanded practices of today would be but the latest moment in this genealogy of a minor art positioned explicitly outside the gallery and indeed 'outside' typical and traditional definitions of art.

Fourth, it is also important to recognize that contemporary art increasingly has itself a form derived from the international art market (and in particular the increasing presence of international biennales) – a kind of vehicular-referential 'global' language. A minor practice might then involve itself in 'stammering' the global language of contemporary art production, for example, in a focus on the local (a turn to the vernacular) or in the use of specifically non-artistic materials. Thomas Hirschhorn's 'monuments' to various philosophers would be a case in point, although we might want to ask whether a practice commissioned by Documenta can ever really be positioned as minor in this sense. A better example might be 'outsider art', although this category would itself need to be broken down and specific practices looked at on their own terms, and an account would have to be given of the increasing commodification of many examples. A key question here is the relationship of the minor to capitalism. On the one hand we might identify the minor as operating at the sharp end of capital's expansion; the minor involving the production of new forms. On the other hand, a minor practice will precisely stammer and stutter the commodity form, disassembling those already existing forms of capital and indeed moving beyond the latter's very logic.

Fifth, in each case this deterritorialization of the major will to some extent involve the neutralization of sense and the foregrounding of art's intensive,

affective quality. Here art 'stops being representative in order now to move towards its extremities or its limits' (*Kafka*, 23). A minor art pushes up against the edges of representation; it bends it, forces it to the limits and often to a certain absurdity. This is not to say that a minor art cannot itself work through representation (or at least through fragments of representation). Indeed, affective ruptures – which themselves utilize existing materials – are the fertile ground for new forms of representation, new signifying regimes. Deterritorialization is always accompanied by reterritorialization in this sense. A minor practice must then be understood as always in process, as always becoming – as generating new forms through a break with, but also a utilization of, the old. It is also in this sense that the argument might be made that a practice can still be 'activated', or become minor, even if it is located 'within' a major institution, or has otherwise 'become major'. Here the question of the spectator's investment in, and participation with, a particular practice becomes crucial, which is to say, his or her specific production of subjectivity and propensity for deterritorialization.

As a brief aside we might point to the use of humour in such a deterritorialization of language. Humour can operate as a strategy of dissent but also of affirmation. In fact, we might see humour as a form of affirmative violence; a violence against typical signifying formations. Humour here is not the irony of postmodern practice, but something affirmative, celebratory even, and something that works on an intensive rather than a signifying register.

Point 2, the political. A minor art will connect different regimes together, and in particular will connect art to the wider social milieu. This is to restate the importance of rhizomatics, or simply a general principle of connectivity. Again, we might think here of the artistic avant-garde groupings of modernity and beyond, those that seek to 'bring art back down' to life (which we might rephrase here as a desire to connect art to life). Even more pertinent are those recent collectives and groups that interact, and indeed position themselves as part of, the wider social and economic fabric. The socially engaged projects of groups such as Superflex or n55 would be a case in point (although this does not necessarily mean such practices will fit our other criteria of a minor practice). This turn away from a certain kind of autonomy (from art about art, or art about the art world) also involves a turn away from typical forms of political and social engagement. A minor art practice is not political in the usual sense. It does not involve itself necessarily with political – or what we might call molar – organizations, rather it works to connect up the different aspects of life, be they individual or social (or indeed non-human) so as to produce new lines of causality and new pathways of experimentation, precisely the production of what Guattari once called 'molecular revolutions'. If a minor practice is always

political then it is because it is always opening itself up to an outside in this sense. It is in this sense also that the minor produces a different kind of relative autonomy, for example, an association of individuals who have 'being against' the major in common. We might add here that a minor practice will also often look to 'popular', or what we might call immanent cultures (those that are self-organizing as it were). Graffiti for example would be a paradigmatic example of a minor literature, as would so called underground forms of music, such as punk, and more recently dance. Again, attention would need to be given to the specific apparatus of capture of these minor forms.

Finally point 3, the collective character of minor literature and its 'futurity', or what we might call its prophetic function. A minor art will involve a collective enunciation, the production of collaborations and indeed the calling forth of new kinds of collectivities. Here a minor practice joins forces with what Deleuze and Guattari call philosophy, that practice which in itself calls forth 'a new earth, a new people' (*What is Philosophy*, 99). Philosophy, for Deleuze and Guattari, involves a resistance to the present in its specifically future orientation (it creates concepts *for* a new earth and a new people). We might say that a minor art practice parallels philosophy's more abstract (and absolute) deterritorializations in offering a resistance to the present in the form of its imagined communities and prototype subjectivities. Indeed, we might say that minor practices, like philosophy, involve a 'diagramming of becoming', the invention of new modes of existence. A minor art in this sense summons its audience into being. [...]

We might say then that the Third-World filmmaker often lacks an audience, and as such must call his or her audience into being *through* his or her films. Importantly, this minor practice is produced through a manipulation of the elements of the major. [...] we might say that this is the use of cliché in order to disrupt cliché. We might add that this minor cinema is of course not just apparent in what Deleuze terms the 'Third World', but in any and all practices that somehow deterritorialize – stutter and stammer – the major language of film, or indeed any major representational tropes (we might think of the films made by Godard, as well as those more recent ones made under the Dogma rubric). In fact, we might recognize such minor practices as being very much part of the expanded field of contemporary art as it exists today: the so-called documentary turn in art practice (the increasing presence of video art). The development of hand-held camcorders, as well as the ongoing development of digital technology in general, although it can operate in the service of the major, allows the production of different forms of 'minor cinema' in this sense.

In this respect, we need also note, as Deleuze reminds us, that: 'the difference between minorities and majorities isn't their size. A minority may be bigger than

a majority. What defines majority is a model you have to conform to. ... A minority, on the other hand, has no model, it's a becoming, a process' (*Nomadology*, 173). Furthermore, this missing people is not necessarily someone else (or not just someone else) but ourselves too, 'for, if the people are missing, if they are breaking up into minorities, it is I who am first of all a people, the people of my atoms' (*Cinema 2*, 220). It is then not a question of waiting for the missing people (there is no hanging around in messianic time), for these people are in a sense already here, albeit masked, obscured by habitual modes of representation and commodified productions of subjectivity, precisely, the major.

All of this gives the minor an affirmative function. To refuse, or somehow negate, the existing language (and thus the existing major forms) is important, but a minor art must do more than this. It must also involve creation. It is also this that gives the stuttering and stammering of a minor practice such an inspirational, we might even say hopeful, tenor. A minor art is involved in the invention and imagining of new subjectivities as well as turning away from those already in place. A minor art then does not just orientate itself against, or position itself in, an 'outside'. Rather it operates at a more oblique angle (it looks for other entry points). It is at once inside and outside the major, *in* the 'world' but not quite *of* it. [...]

Simon O'Sullivan, extracts from 'Art and the Political: Minor Literature, War Machines and the Production of Subjectivity', in *Art Encounters. Deleuze and Guattari: Thought Beyond Representation* (London: Palgrave, 2005) 70–5; 75–6 [footnotes not included].

Beauty in danger becomes more beautiful but beauty in dirt becomes ugly

Andy Warhol, *The Philosophy of Andy Warhol: From A to B and Back Again*, 1975

POSITIONS

Rosalind Krauss
The Photographic Conditions of Surrealism//1981

[...] Surrealist photography exploits the special connection to reality with which all photography is endowed. For photography is an imprint or transfer off the real; it is a photochemically processed trace causally connected to that thing in the world to which it refers in a manner parallel to that of fingerprints or footprints or the rings of water that cold glasses leave on tables. The photograph is thus generically distinct from painting or sculpture or drawing. On the family tree of images it is closer to palm prints, death masks, the Shroud of Turin, or the tracks of gulls on beaches. For technically and semiologically speaking, drawings and paintings are icons, while photographs are indexes.

Given this special status with regard to the real, being, that is, a kind of deposit of the real itself, the manipulations wrought by the surrealist photographers – the spacings and doublings – are intended to register the spacings and doublings of that very reality of which *this* photograph is merely the faithful trace. In this way the photographic medium is exploited to produce a paradox: the paradox of reality constituted as sign – or presence transformed into absence, into representation, into spacing, into writing.

Now this is the move that lies at the very heart of surrealist thinking, for it is precisely this experience of *reality as representation* that constitutes the notion of the Marvellous or of Convulsive Beauty – the key concepts of surrealism.[1] Towards the beginning of *L'Amour fou* there is a section that Breton had published on its own under the title 'Beauty Will Be Convulsive ...' In this manifesto Breton characterizes Convulsive Beauty in terms of three basic types of example. The first falls under the general case of mimicry – or those instances in nature when one thing imitates another – the most familiar, perhaps, being those markings on the wings of moths that imitate eyes. Breton is enormously attracted to mimicry, as were all the surrealists, *Documents* having, for example, published Blossfeldt's photographs of plant life imitating the volutes and flutings of classical architecture. In 'Beauty Will Be Convulsive' the instances of mimicry Breton uses are the coral imitations of plants on the Great Barrier Reef and 'The Imperial Mantle,' from a grotto near Montpellier, where a wall of quartz offers the spectacle of natural carving, producing the image of drapery 'which forever defies that of statuary'. Mimicry is thus an instance of the natural production of signs, of one thing in nature contorting itself into a representation of another.

Breton's second example is 'the expiration of movement' – the experience of something that should be in motion but has been stopped, derailed, or, as

Duchamp would have said, 'delayed'. In this regard Breton writes, 'I am sorry not to be able to reproduce, among the illustrations to this text, a photograph of a very handsome locomotive after it had been abandoned for many years to the delirium of a virgin forest.'[2] That Breton should have wanted to show a photograph of this object is compelling because the very idea of stop-motion is intrinsically photographic. The convulsiveness, then, the arousal in front of the object, is to a perception of it detached from the continuum of its natural existence, a detachment which deprives the locomotive of some part of its physical self and turns it into a sign of the reality it no longer possesses. The still photograph of this stilled train would thus be a representation of an object already constituted as a representation.

Breton's third example consists of the found-object or found verbal fragment – both instances of objective chance – where an emissary from the external world carries a message informing the recipient of his own desire. The found-object is a *sign* of that desire. The particular object Breton uses at the opening of *L'Amour fou* is a perfect demonstration of Convulsive Beauty's condition as sign. The object is a slipper-spoon that Breton found in a flea market, and which he recognized as a fulfilment of the wish spoken by the automatic phrase that had begun running through his mind some months before – the phrase *cendrier Cendrillon*, or Cinderella ashtray. The flea-market object became something that signified for him as he began to see it as an extraordinary *mise-en-abyme:* a chain of reduplications to infinity in which the spoon and handle of the object was seen as the front and last of a shoe of which the little carved slipper was the heel. Then *that* slipper was imagined as having for its heel another slipper, and so on to infinity. Breton read the natural writing of this chain of reduplicated slippers as signifying his own desire for love and thus as the sign that begins the quest of *L'Amour fou.*[3]

If we are to generalize the aesthetic of surrealism, the concept of Convulsive Beauty is at the core of that aesthetic: reducing to an experience of reality transformed into representation. Surreality *is*, we could say, nature convulsed into a kind of writing. The special access that photography has to this experience is its privileged connection to the real. The manipulations then available to photography – what we have been calling doubling and spacing – appear to document these convulsions. The photographs are not *interpretations* of reality, decoding it, as in Heartfield's photomontages. They are presentations of that very reality as configured, or coded, or written. The experience of nature as sign, or nature as representation, comes 'naturally' then to photography. It extends, as well, to that domain most inherently photographic, which is that of the framing edge of the image experienced as cut or cropped. But I would add, though there is no space here to expand on it, that what unites *all* surrealist production is

precisely this experience of nature as representation, physical matter as writing. This is of course not a morphological coherence, but a semiological one.

No account of surrealist photography would be complete if it could not incorporate the unmanipulated images that figure in the movement's publications – works like the Boiffard big toes, or the 'Involuntary Sculptures' photographed by Brassaï for Salvador Dalí, or the straight image of a hatted figure by Man Ray made for *Minotaure*. Because it is *this* type that is closest to the movement's heart. But the theoretical apparatus by which to assimilate this genre of photograph has already been developed. And that is the concept of spacing.

Inside the image, spacing can be generated by the cloisonné of solarization or the use of found frames to interrupt or displace segments of reality. But at the very boundary of the image the camera frame which crops or cuts the represented element out of reality-at-large can be seen as another example of spacing. Spacing is the indication of a break in the simultaneous experience of the real, a rupture that issues into sequence. Photographic cropping is *always* experienced as a rupture in the continuous fabric of reality. But surrealist photography puts enormous pressure on that frame to make it itself read as a sign – an empty sign it is true, but an integer in the calculus of meaning: a signifier of signification.

The frame announces that between the part of reality that was cut away and this part there is a difference; and that this segment which the frame frames is an example of nature-as-representation, nature-as-sign. As it signals that experience of reality the camera frame also controls it, configures it. This it does by point-of-view, as in the Man Ray example, or by focal length, as in the extreme close-ups of the Dalí. And in both these instances what the camera frames and thereby makes visible is the automatic writing of the world: the constant, uninterrupted production of signs. Dalí's images are of those nasty pieces of paper like bus tickets and theatre stubs that we roll into little columns in our pockets, or those pieces of eraser that we unconsciously knead – these are what his camera produces through the enlargements that he publishes as involuntary sculpture. Man Ray's photograph is one of several to accompany an essay by Tristan Tzara about the unconscious production of sexual imagery throughout all aspects of culture – this particular one being the design of hats.

The frame announces the camera's ability to find and isolate what we could call the world's constant writing of erotic symbols, its ceaseless automatism. In this capacity the frame can itself be glorified, represented, as in the photograph by Man Ray that I introduced at the outset. Or it can simply be there, silently operating as spacing, as in Brassai's seizure of automatic production in his series on graffiti.

And now, with this experience of the frame, we arrive at the supplement.

Throughout Europe in the twenties and thirties, camera-seeing was exalted as a special form of vision: the New Vision, Moholy-Nagy called it. From the Inkhuk to the Bauhaus to the ateliers of Montparnasse, the New Vision was understood in the same way. As Moholy explained it, human eyesight was, simply, defective, weak, impotent. 'Helmholtz,' Moholy explained, 'used to tell his pupils that if an optician were to succeed in making a human eye and brought it to him for his approval, he would be bound to say: "This is a clumsy piece of work".' But the invention of the camera has made up for this deficiency so that now 'we may say that we see the world with different eyes'.[4]

These, of course, are camera-eyes. They see faster, sharper, at stranger angles, closer-to, microscopically, with a transposition of tonalities, with the penetration of X ray, and with access to the multiplication of images that makes possible the writing of association and memory. Camera-seeing is thus an extraordinary extension of normal vision, one that supplements the deficiencies of the naked eye. The camera covers and arms this nakedness, it acts as a kind of prosthesis, enlarging the capacity of the human body. [...]

1 [footnote 31 in source] Louis Aragon's 1925 definition of the Marvellous reads, 'Le merveilleux, c'est la contradiction qui apparaît dans le réel' ('Idées', *La Révolution surréaliste*, vol. 1 [April 1925] 30).

2 [32] André Breton, *L'Amour fou* (Paris: Gallimard, 1937) 13.

3 [33] Ibid., 35–41.

4 [34] László Moholy-Nagy, *Vision in Motion* (Chicago, 1947) 206.

Rosalind Krauss, extract from 'The Photographic Conditions of Surrealism' (first published in *October*, Winter 1981), in *The Originality of the Avant-Garde and Other Modernist Myths* (Cambridge, Massachusetts: The MIT Press, 1986) 110–16.

Benjamin H.D. Buchloh
Robert Morris's Paradoxes//1990

The problem has been for some time one of ideas – those most admired are the ones with the biggest, most incisive ideas (e.g., Cage & Duchamp) ... I think that today art is a form of art history.
– Robert Morris, letter to Henry Flynt, 13 August 1962

Quite evidently, Morris's approach to Duchamp, in the early 1960s, had already been based on reading the readymade in analogy with a Saussurean model of language: a model where meaning is generated by structural relationships. As Morris recalls, his own 'fascination with and respect for Duchamp was related to his linguistic fixation, to the idea that all of his operations were ultimately built on a sophisticated understanding of language itself'.[1] Accordingly, Morris's early work (from 1961 to 1963) already pointed towards an understanding of Duchamp that transcended the limited definition of the readymade as the mere displacement of traditional modes of artistic production by a new aesthetic of the speech act ('this is a work of art if I say so'). And in marked distinction from the Conceptualists' subsequent exclusive focus on the unassisted readymades, Morris had, from the late 1950s when he discovered Duchamp, been particularly engaged with work such as *Three Standard Stoppages* and the *Notes for the Large Glass (The Green Box)*.

Morris's production from the early 1960s, in particular works like *Card File* (1962), *Metered Bulb* (1963), *I-Box* (1963), *Litanies* and the *Statement of Aesthetic Withdrawal*, also entitled *Document* (1963), indicated a reading of Duchamp that clearly went beyond that of Johns, leading towards a structural and semiotic definition of the functions of the readymade. As Morris described it retrospectively in his 1970 essay 'Some Notes on the Phenomenology of Making':

There is a binary swing between the arbitrary and the non-arbitrary or 'motivated' which is ... an historical, evolutionary or diachronic feature of language's development and change. Language is not plastic art but both are forms of human behaviour and the structures of one can be compared to the structures of the other.[2]

While it is worth noticing that by 1970 Morris already reaffirmed apodictically the ontological character of the category 'plastic' art versus that of 'language', it was in the early 1960s that his assaults on the traditional concepts of visuality

and plasticity had already begun to lay some of the crucial foundations for the development of an art practice emphasizing its parallels, if not identity, with the systems of linguistic signs, i.e., Conceptual art.

Most importantly, as early as 1961 in his *Box with the Sound of Its Own Making,* Morris had ruptured both. On the one hand, it dispenses with the modernist quest for medium-specific purity as much as with its sequel in the positivist conviction of a purely perceptual experience operating in Stella's visual tautologies and the early phases of Minimalism. And on the other, by counteracting the supremacy of the visual with that of an auditory experience of equal if not higher importance, he renewed the Duchampian quest for a non-retinal art. In *Box with the Sound of Its Own Making,* as much as in the subsequent works, the critique of the hegemony of traditional categories of the visual is enacted not only in the (acoustic or tactile) disturbance of the purity of perceptual experience, but it is performed as well through a literalist act of denying the viewer practically all (at least traditionally defined) visual information.

This strategy of a 'perceptual withdrawal' leads in each of the works from the early 1960s to a different analysis of the constituent features of the structured object and the modes of reading it generates. In *I-Box,* for example, the viewer is confronted with a semiotic pun (on the words *I* and *eye*) just as much as with a structural sleight of hand from the tactile (the viewer has to manipulate the box physically to *see* the *I* of the artist) through the linguistic sign (the letter *I* defines the shape of the framing/display device: the 'door' of the box) to the visual representation (the nude photographic portrait of the artist) and back. It is of course this very tripartite division of the aesthetic signifier – its separation into object, linguistic sign and photographic reproduction – that we will encounter in infinite variations, didactically simplified (to operate as stunning tautologies) and stylistically designed (to take the place of paintings) in Kosuth's *Proto-Investigations* after 1966.

In *Document (Statement of Aesthetic Withdrawal),* Morris takes the literal negation of the visual even further, in clarifying that after Duchamp the readymade is not just a neutral analytic proposition (in the manner of an underlying statement such as 'this is a work of art'). Beginning with the readymade, the work of art had become the ultimate subject of a legal definition and the result of institutional validation. In the absence of any specifically visual qualities and due to the manifest lack of any (artistic) manual competence as a criterion of distinction, all the traditional criteria of aesthetic judgement – of taste and of connoisseurship – have been programmatically voided. The result of this is that the definition of the aesthetic becomes on the one hand a matter of linguistic convention and on the other the function of both a legal contract and an institutional discourse (a discourse of power rather than taste).

This erosion works, then, not just against the hegemony of the visual, but against the possibility of any other aspect of the aesthetic experience as being autonomous and self-sufficient. That the introduction of legalistic language and an administrative style of the material presentation of the artistic object could effect such an erosion had of course been prefigured in Duchamp's practice as well. In 1944 he had hired a notary to inscribe a statement of authenticity on his 1919 *L.H.O.O.Q.*, affirming that '… this is to certify that this is the original "ready-made" *L.H.O.O.Q*; Paris 1919'. What was possibly still a pragmatic manoeuvre with Duchamp (although certainly one in line with the pleasure he took in contemplating the vanishing basis for the legitimate definition of the work of art in visual competence and manual skill alone) would soon become one of the constituent features of subsequent developments in Conceptual art. Most obviously operating in the certificates issued by Piero Manzoni defining persons or partial persons as temporary or lifetime works of art (1960–61), this is to be found at the same time in Yves Klein's certificates assigning zones of immaterial pictorial sensibility to the various collectors who acquired them.

But this aesthetic of linguistic conventions and legalistic arrangements not only denies the validity of the traditional studio aesthetic, it also cancels the aesthetic of production and consumption which had still governed Pop art and Minimalism. Just as the modernist critique (and ultimate prohibition) of figurative representation had become the increasingly dogmatic law for pictorial production in the first decade of the twentieth century, so Conceptual art now instated the prohibition of any and all visuality as the inescapable aesthetic rule for the end of the twentieth century. Just as the readymade had negated not only figurative representation, authenticity and authorship while introducing repetition and the series (i.e., the law of industrial production) to replace the studio aesthetic of the handcrafted original, Conceptual art came to displace even that image of the mass-produced object and its aestheticized forms in Pop art, replacing an aesthetic of industrial production and consumption with an aesthetic of administrative and legal organization and institutional validation.

1 [footnote 14 in source] Robert Morris as quoted in Maurice Berger, *Labyrinths: Robert Morris, Minimalism and the 1960s* (New York: Harper & Row, 1989) 22.

2 [15] Robert Morris, 'Some Notes on the Phenomenology of Making: The Search for the Motivated', *Artforum*, 9 (April 1970) 63.

Benjamin H.D. Buchloh, 'Robert Morris's Paradoxes', section of the essay 'Conceptual Art 1962–1969: From the Aesthetic of Administration to the Critique of Institutions', *October* (Winter 1990) 115–19.

Robert Smithson
An Aesthetics of Disappointment//1966

Many are disappointed at the nullity of art. Many try to pump life or space into the confusion that surrounds art. An incurable optimism like a mad dog rushes into the vacuum that the art suggests. A dread of voids and blanks brings on a horrible anticipation. Everybody wonders what art is, because there never seems to be any around. Many feel coldly repulsed by concrete unrealities, and demand some kind of proof or at least a few facts. Facts seem to ease the disappointment. But quickly those facts are exhausted and fall to the bottom of the mind. This mental relapse is incessant and tends to make our aesthetic view stale. Nothing is more faded than aesthetics. As a result, painting, sculpture and architecture are finished, but the art habit continues. The more transparent and vain the aesthetic, the less chance there is for reverting back to purity. Purity is a desperate nostalgia that exfoliates like a hideous need. Purity also suggests a need for the absolute with all its perpetual traps. Yet we are overburdened with countless absolutes and driven to inefficient habits. These futile and stupefying habits are thought to have meaning. Futility, one of the more durable things of this world, is nearer to the artistic experience than excitement. Yet the life-forcer is always around trying to incite a fake madness. The mind is important, but only when it is empty. The greater the emptiness the grander the art.

Aesthetics have devolved into rare types of stupidity. Each kind of stupidity may be broken down into categories such as: bovine formalism, tired painting, eccentric concentrics or numb structures. All these categories and many others all petrify into a vast banality called the art world which is no world. A nice negativism seems to be spawning. A sweet nihilism is everywhere. Immobility and inertia are what many of the most gifted artists prefer. Vacant at the centre, dull at the edge, a few artists are on the true path of stultification. [...]

[Written in response to '9 Evenings: Theater & Engineering' – a series of theatre, dance, music and performances at the New York 69th Regiment Armory in 1966 by 10 New York artists, organized by E.A.T. (Experiments in Art and Technology)]

Robert Smithson, extract from 'An Aesthetics of Disappointment: On the Occasion of the Art and Technology Show at the Armory' (1966); reprinted in Robert Smithson, *The Collected Writings*, ed. Jack Flam (Berkeley and Los Angeles: University of California Press, 1996) 334–5.

Andy Warhol
On Beauty//1975

I've never met a person I couldn't call a beauty.

Every person has beauty at some point in their lifetime. Usually in different degrees. Sometimes they have the looks when they're a baby and they don't have it when they're grown up, but then they could get it back again when they're older. Or they might be fat but have a beautiful face. Or have bow-legs but a beautiful body. Or be the number one female beauty and have no tits. Or be the number one male beauty and have a small you-know-what.

Some people think it's easier for beauties, but actually it can work out a lot of different ways. If you're beautiful you might have a pea-brain. If you're not beautiful you might not have a pea-brain, so it depends on the pea-brain and the beauty. The size of the beauty. And the pea-brain.

I always hear myself saying, 'She's a beauty!' or 'He's a beauty!' or 'What a beauty!' but I never know what I'm talking about. I honestly don't know what beauty is, not to speak of what 'a' beauty is. So that leaves me in a strange position, because I'm noted for how much I talk about 'this one's a beauty' and 'that one's a beauty'. For a year once it was in all the magazines that my next movie was going to be *The Beauties*. The publicity for it was great, but then I could never decide who should be in it. If everybody's not a beauty, then nobody is, so I didn't want to imply that the kids in *The Beauties* were beauties but the kids in my other movies weren't so I had to back out on the basis of the title. It was all wrong.

I really don't care that much about 'Beauties'. What I really like are Talkers. To me, good talkers are beautiful because good talk is what I love. The word itself shows why I like Talkers better than Beauties, why I tape more than I film. It's not 'talkies'. Talkers are *doing* something. Beauties are *being* something. Which isn't necessarily bad, it's just that I don't know what it is they're being. It's more fun to be with people who are doing things.

When I did my self-portrait, I left all the pimples out because you always should. Pimples are a temporary condition and they don't have anything to do with what you really look like. Always omit the blemishes – they're not part of the good picture you want.

When a person is the beauty of their day, and their looks are really in style, and then the times change and tastes change, and ten years go by, if they keep exactly their same look and don't change anything and if they take care of themselves, they'll still be a beauty.

Schrafft's restaurants were the beauties of their day, and then they tried to

keep up with the times and they modified and modified until they lost all their charm and were bought by a big company. But if they could just have kept their same look and style, and held on through the lean years when they weren't in style, today they'd be the best thing around. You have to hang on in periods when your style isn't popular, because if it's good it'll come back, and you'll be a recognized beauty once again.

Some kind of beauty dwarfs you and makes you feel like an ant next to it. I was once in Mussolini Stadium with all the statues and they were so much bigger than life and I felt just like an ant. I was painting a beauty this afternoon and my paint caught a little bug. I tried to get the paint off the bug and I kept trying until I killed the bug on the beauty's lip. So there was this bug, that could have been a beauty, left on somebody's lip. That's the way I felt in Mussolini Stadium. Like a bug.

Beauties in photographs are different from beauties in person; it must be hard to be a model, because you'd want to be like the photograph of you, and you can't ever look that way. And so you start to copy the photograph. Photographs usually bring in another half-dimension. (Movies bring in another whole dimension. That screen magnetism is something secret – if you could only figure out what it is and how to make it, you'd have a really good product to sell. But you can't even tell if someone has it until you actually see them up there on the screen. You have to give screen tests to find out.) […]

Beauty really has to do with the way a person carries it off. When you see 'beauty', it has to do with the place, with what they're wearing, what they're standing next to, what closet they're coming down the stairs from.

Jewelry doesn't make a person more beautiful, but it makes a person *feel* more beautiful. If you draped a beautiful person in jewels and beautiful clothes and put them in a beautiful house with beautiful furniture and beautiful paintings, they wouldn't be more beautiful, they'd be the same, but they would think they were more beautiful. However, if you took a beautiful person and put them in rags, they'd be ugly. You can always make a person less beautiful.

Beauty in danger becomes more beautiful, but beauty in dirt becomes ugly. […]

Some people, even intelligent people, say that violence can be beautiful. I can't understand that, because beautiful is some moments, and for me those moments are never violent.

A new idea.

A new look.

A new sex.

A new pair of underwear.

There should be a lot of new girls in town, and there always are.

The red lobster's beauty only comes out when it's dropped into the boiling water ... and nature changes things and carbon is turned into diamonds and dirt is gold ... and wearing a ring in your nose is gorgeous.

I can never get over when you're on the beach how beautiful the sand looks and the water washes it away and straightens it up and the trees and the grass all look great. I think having land and not ruining it is the most beautiful art that anybody could ever want to own.

The most beautiful thing in Tokyo is McDonald's.

The most beautiful thing in Stockholm is McDonald's.

The most beautiful thing in Florence is McDonald's.

Peking and Moscow don't have anything beautiful yet.

America is really The Beautiful. But it would be more beautiful if everybody had enough money to live.

Beautiful jails for Beautiful People.

Everybody's sense of beauty is different from everybody else's. When I see people dressed in hideous clothes that look all wrong on them, I try to imagine the moment when they were buying them and thought, 'This is great. I like it. I'll take it.' You can't imagine what went off in their heads to make them buy those maroon polyester waffle-iron pants or that acrylic halter top that has 'Miami' written in glitter. You wonder what they rejected as not beautiful – an acrylic halter top that had 'Chicago'? [...]

When you're in Sweden and you see beautiful person after beautiful person after beautiful person and you finally don't even turn around to look because you know the next person you see will be just as beautiful as the one you didn't bother to turn around to look at – in a place like that you can get so bored that when you see a person who's not beautiful, they look very beautiful to you because they break the beautiful monotony. [...]

Andy Warhol, extract from *The Philosophy of Andy Warhol: From A to B and Back Again* (New York: Harcourt, Inc., 1975) 61–71.

Rasheed Araeen
Cultural Imperialism: Observations on Cultural Situation in the Third World//1976

If art is the expression of beauty [...] then the meaning of this Beauty must be sought not in the old classics, not in foreign cultures, nor in metaphysics, but in the material reality of our existence as a people and our own cultural life today.

What is art? If we are genuinely interested in this question and wish to disentangle all its complexities, we must approach it and look for its answer beyond the futile academic exercises and meaningless phrasemongering of the so-called critics [whose failure] to produce any meaningful analysis in this respect is the consequence of their inability or incompetence to deal with the problems of our contemporary socio-cultural situation in the context of foreign domination.

It is also a reflection of the lethargic condition of our 'intellectuals', created by this domination, who thus cannot react critically to a situation that demands imitation of foreign values as the basic criterion of a 'better' and 'progressive' life. [...] Art cannot be created, nor developed, by a set of values or rules imposed from abroad. [...] Art can only be created by and through an evolving process as part of a socio-cultural evolution generating its own new ideas and concepts at every stage of its development and thus maintaining its continuous transformation.

Dogmas as well as imposed values, particularly of foreign origin, become obstacles in this process, stifling the imagination and thus destroying the creative and productive capacity of its participants. The imposition of foreign values on to the people (and the acceptance of these values by them) who are under direct or indirect foreign domination, negates their historical process, resulting in the stagnation and, in the event of no resistance to this domination, destruction of this process. It is in fact the purpose of foreign domination to destroy the indigenous values of the people and replace these values with the values which are not the product of their own development.

Why do we, then, always look for the criterion of Art or our own art and culture in the past or in Western culture whose dynamics of development were and are very different from ours? This question cannot be answered with any justification without looking into our own past history or the period when our country, like other Third World countries, was under Western colonial rule; because without the understanding of this past we cannot deal with the concrete problems arising from our present socio-cultural predicament and from which our present concept of Art or Beauty cannot be separated.

Colonialism destroys – and has destroyed – the development of the productive forces of the colonized people by the negation of their historical

process or processes and then imposing upon them a process or an economic system which mainly serves the interests of the colonialists. This is and has been carried forward into the neo-colonialist situation that exists today, known as 'underdevelopment'.

Cultural propaganda is one of the main tools used in the perpetuation of neo-colonialism. The predominance of Western cultural values in most Third World countries today only reflects the fact that these countries have not yet actually LIBERATED themselves from Western domination and exploitation.

Before we proceed further to examine and analyse our new relationship with the West in the so-called post-independence period and how this relationship affects and has affected our contemporary art and culture and our concept of Beauty, we must look into the working of the Western economic system and its inherent characteristics. The Western economic system that concerns us here is not only an international economic system but it is also hierarchical, the functioning of which depends not only on the coordination of its different parts working at different levels internationally along its vertical ladder but more essentially on the capacity of the system to control its own functioning through its ideology generated at the top. This causes and has caused the accumulation of wealth – generated within this system – at the top (Western Europe, North America, and now Japan as well), creating an international socio-economic, political and ideological dominance that reduces the rest of the world wherever this system operates to a mere subsistence level.

Therefore, any native ruling class of any Third World country which chooses and has, after the so-called independence from colonialism, chosen this system for its socio-economic development becomes and has become, knowingly or unknowingly, part of the exploitative mechanism of this system. This class, therefore, cannot function within this system any other way but accept, willingly or unwillingly, its total domination, the result of which is neo-colonialism that demands exploitation and oppression of the people caught in this situation.

In other words, the native bourgeois class, owing to its specific function in neo-colonialism as go-between and the socio-economic benefits it receives from it, cannot but accept Western culture as the basis for its new existence as a ruling class. It must become an instrument of the propagation of Western values. By identifying with Western culture, by becoming a model of Western life, it projects itself as an example of a 'higher' form of human achievement and a symbol of 'progress'. And since this projection is deliberately set against the indigenous culture, the native bourgeoisie by this subjects its own people to an inferior status and thus to their socio-economic backwardness by utilizing all the resources only for the maintenance of the Westernized life of a small local elite.

Consequently, the basis of socio-cultural relations of the people themselves

is eventually shifted from their native soil to the West, along with the transfer of their material wealth from their exploited country to the metropolises of the Western world where this wealth is utilized in further development of modern technology, production of consumer goods, and, of course, Western cultural forms. The consumer goods thus produced in the West, or in the industrialized capitals of the Third World, are then wrapped in Western cultural forms (publicity material) before their eventual release for consumption by the people – the very same people who in the first place have been robbed of their material resources and their ability to transform their resources into something that will fulfil their own genuine needs.

The attempt of Western imperialist domination is to destroy the indigenous development of the people in the Third World and in doing so deprive them of their inner or socio-historical motives that are necessary in the development of their full creative or productive potential. This is now achieved not by conquering a country or countries, although military interventions are not ruled out (as in Vietnam) when it is necessary to maintain the economic and political domination, but more importantly through the insidious and complex cultural penetrations that upset or destroy the very fabric of indigenous social life, art and culture. The result is not only psychological trauma among many but also mental enslavement that makes people accept easily whatever is offered, whatever they get hold of in their struggle for survival. This, in effect, creates mechanistic consumption of foreign produced goods, submission to foreign values, imitation or imitators of foreign cultural forms, whose eventual function becomes the entertainment of the native ruling class which besides representing foreign interests also thus prevents the people from liberating themselves from such a disgraceful subjugation.

In this neo-colonial situation, the acceptance of Western concepts of Beauty or Art by the Third World intellectual creates a milieu in which the intellectual exists virtually trapped and alienated from the masses. He looks down upon people, in repudiation of his own and their indigenous values, accepting self-emasculation which then prevents him from any meaningful social intervention. The masses are, at the same time, subjected to the daily vulgarities of the commercial mass media. The images which are constantly projected to the public by the TV, films, newspapers, magazines, and particularly by commercial ads, produce contents that act as a kind of 'catharsis' in order to give them some comfort in their psycho-sexual predicament created by the deprivation of their basic physical and menial needs. The vicious circle continues while the addicted public is provided regularly with its daily ration of cultural 'drug' and huge profits for the 'respectable' pedlars.

Moreover, these images constitute forms and relationships that necessarily

produce propaganda for Western culture. A man dressed in Western style is always projected in a context or relationship that reflects his higher socio-economic status, his achievement in the modern world. And thus Western dress (Western culture) becomes a symbol of modern 'progress': more 'beautiful', more 'desirable', and in effect, more 'real'. This not only creates a cultural identity crisis among the urban classes, it clearly relegates the culture of the masses to a status of backwardness.

What is more worrying and sad is its disturbing effects on our so-called intellectuals – artists, poets, writers, critics, etc., from whom one would expect some kind of original thinking, from whom one would (and should) expect an awareness of our present socio-cultural predicament and its critical reflection in their work. Instead most have become not only victims but also instruments of Western cultural propaganda projected daily on our national TV network.

You only have to cast a cursory glance at the way most of these 'intellectuals' appear in public. Their manners alone betray their enslavement to the vulgarities of Western culture, let alone the context of their activity. Even many of our poets, for example, who write in our own languages and who talk about our old values, appear on TV dressed in the latest Western style. To some extent this criticism may look trivial, but the fact of the matter is that their appearance becomes part of the culture or cultural propaganda that degrades the actual way of life of the majority of people. They become a reinforcement of the visual symbols used in commercial ads to lure people into the acceptance of Western life as a solution of their socio-economic problems.

Against this background of Western cultural dominance, we must, therefore, look for a concept of Beauty or its expression that reflects our own present life. We must seek for a beauty which is an evolving entity or concept, and the dynamic of which must lie in the productive forces of our people brought about by their own conscious efforts and their awareness of the process of change.

Any concept of Beauty which is imposed on our people from outside, is the negation of their own productive and creative capacity; it is the negation of their ability to participate in a historical process of their change (to quote Paulo Friere) 'WITH AN INCREASING CRITICAL AWARENESS OF THEIR ROLE AS SUBJECTS OF THEIR TRANSFORMATION'. It is a denial of the dialectical process through which alone our people could and should develop their critical awareness and thus act to move forward in history.

If we do not find today a concept of Beauty that affirms our own existence as a free people, as part of the present technological age with our own contribution to and reflection on its development, then there must be something fundamentally wrong with our present society. The illusion of progress created by the consumption of Western goods and cultural values cannot be anything

but an ugliness: the ugliness that we notice today in every walk of our life and which we have mistakenly taken as Beauty and are embracing, perhaps unknowingly, for our own destruction. Therefore, it is our duty to oppose this ugliness in order to destroy it before it destroys us. This demands an action along its critical reflection instead of hollow slogans like 'all that is beautiful shall abide' of our emasculated intellectuals.

Rasheed Araeen, 'Cultural Imperialism: Observations on Cultural Situation in the Third World', first published as a newspaper article in Karachi in 1976 under the title 'The Terror of Cultural Invasions', in response to a text which had appeared in that paper; reprinted in Rasheed Araeen, *Making Myself Visible* (London: Kala Press, 1984) 69–72.

Gerhard Richter
Notes//1985

20 February 1985. Of course I constantly despair at my own incapacity, at the impossibility of ever accomplishing anything, of painting a valid, true picture or even of knowing what such a thing ought to look like. But then I always have the hope that, if I persevere, it might one day happen. And this hope is nurtured every time something appears, a scattered, partial, initial hint of something which reminds me of what I long for, or which conveys a hint of it – although often enough I have been fooled by a momentary glimpse that then vanishes, leaving behind only the usual thing.

I have no motif, only motivation. I believe that motivation is the real thing, the natural thing, and that the motif is old-fashioned, even reactionary (as stupid as the question about the Meaning of Life).

22 February 1985. 'Formal conception', 'composition', 'line', 'distribution of light and shade', 'balance or disparity of colour' – such concepts are meant to explain that what counts in a work of art is not its content, the representation of an object: the thing represented is there only to serve the realization of those formal concerns, which are the truly important thing, the real point of the painting. Someone wrote about Hausmann's *Nude, Back View* that the real statement of the work was the 'design', the 'swelling and contracting of the lines, the juxtaposition of masses and planes, the contrast between shaded and fully lit passages' – and described the nude itself, its erotic and existential message, as the banal and earthly aspect, which is spiritualized and transcended through art. Happily, the exact opposite is the case: the line and all the formal elements are as boring as only line can be, and the only interesting thing is the naked woman, her partly familiar and partly alienated physical presence, which fascinates by virtue of its subtle multiplicity of meanings.

(Comparable nonsense is written about Baselitz: by being turned through 180 degrees, his figures are said to lose their objective nature and become 'pure painting'. The opposite is true: there is an added stress on the objectivity, which takes on a new substance.) Anyway, pure painting is inanity, and a line is interesting only if it arouses interesting associations.

28 February 1985. Letting a thing come, rather than creating it – no assertions, constructions, formulations, inventions, ideologies – in order to gain access to all that is genuine, richer, more alive: to what is beyond my understanding.

At twenty: Tolstoy's *War and Peace*. It doesn't matter how rightly I remember, the only thing that stayed with me, that struck me at the time, was Kutuzov's way of not intervening, of planning nothing, but watching to see how things worked out, choosing the right moment to put his weight behind a development that was beginning of its own accord. Passivity was that general's genius. (The Photo Pictures: taking what is there, because one's own experiences only make things worse. The Colour Charts: the hope that this way a painting will emerge that is more than I could ever invent. At the same time, no truck with chance painting, painting blind, drug painting.) The Abstract Pictures: more and more clearly, a method of not having and planning the 'motif' but evolving it, letting it come. (About six years ago, that endless series of lacquer studies, all of which I destroyed: letting the lacquers merge, observing the countless rich pictures that emerged – and disappointment at a kind of naturalism that was completely unusable, arty-crafty, kitschy.) Now the constant involvement of chance (but still never automatism), which destroys my constructions and inventions and creates new situations (As ever, Polke, I am glad to say, is doing something comparable.)

Using chance is like painting Nature – but which chance event, out of all the countless possibilities?

25 March 1985. The Kiefer exhibition.[1] These so-called paintings. Of course this is not painting at all; and, since they lack this essential quality, they may well have the initial, shocking fascination of the macabre. But when that wears off, if not before, these 'paintings' convey just what they do possess: formless, amorphous dirt as a frozen, mushy crust, nauseating filth, illusionistically creating a naturalism which – while graphically effective – has, at best, the quality of a striking stage set. The whole thing is delivered with panache and undoubted self-assurance – as well it may be, because its motivation is literary: it's all in the content. Every lump of filth stands for one scrap or another, snatched from the bran chest of history – make the most of the fact that, so long as you avoid a definition, anything at all will serve to prompt an association. The one thing that frightens me is that I might paint just as badly.

18 May 1985. The way I paint, one can't really paint, because the basic prerequisite is lacking: the certainty of what is to be painted, i.e., the Theme. Whether I mention the name of Raphael or of Newman, or lesser lights such as Rothko or Lichtenstein, or anyone else, down to the ultimate provincial artist – all of them have a theme that they pursue, a 'picture' that they are always striving to attain.

When I paint an Abstract Picture (the problem is very much the same in

other cases), I neither know in advance what it is meant to look like nor, during the painting process, what I am aiming at and what to do about getting there. Painting is consequently an almost blind, desperate effort, like that of a person abandoned, helpless, in totally incomprehensible surroundings – like that of a person who possesses a given set of tools, materials and abilities and has the urgent desire to build something useful which is not allowed to be a house or a chair or anything else that has a name; who therefore hacks away in the vague hope that by working in a proper, professional way he will ultimately turn out something proper and meaningful.

So I am as blind as Nature, who acts as she can, in accordance with the conditions that hinder or help her. Viewed in this light, anything is possible in my pictures; any form, added at will, changes the picture but does not make it wrong. Anything goes; so why do I often spend weeks over adding one thing? What am I making that I want? What picture of what?

30 May 1985. No ideology. No religion, no belief, no meaning, no imagination, no invention, no creativity, no hope – but painting like Nature, painting as change, becoming, emerging, being-there, thusness; without an aim, and just as right, logical, perfect and incomprehensible (as Mozart, Schoenberg, Velazquez, Bach, Raphael, etc.) We can identify the causes of a natural formation, up to a point; the same causes have led to me and, in due course, to my paintings, whose immediate cause is my inner state, my happiness, my pain, in all possible forms and intensities, until that cause no longer exists.

1 Städtische Kunsthalle Düsseldorf (24 March – 5 May 1984).

Gerhard Richter, Notes (1985), *The Daily Practice of Painting: Writings 1962–1993*, ed. Hans-Ulrich Obrist (London: Thames & Hudson in association with Anthony d'Offay Gallery/Cambridge, Massachusetts: The MIT Press, 1995) 118–21.

Paul Wood
Truth and Beauty: The Ruined Abstraction
of Gerhard Richter//1994

Recovery of a Critical Aesthetic

The quintessential experience of late modernity in the West is one of rampant technological development in a murderous embrace with social stagnation: half of our sensation is of being whirled down the rapids, half of being stuck in the mudflats. It is less a sense of particular crisis which seems to matter, in this or that area of social practice, than of the twentieth century's vision of the future being systematically voided. The question of imagination therefore becomes paramount. According to the not unfamiliar avant-garde logic of dialectical inversion, wherein the forcing of a strategy to its limits gives rise to work on a different and apparently opposed order of problem, Gerhard Richter (and perhaps a handful of other artists) passed through the looking-glass of critical practice and found himself in a world the aesthetic had never abandoned. The point, difficult though it is to establish, is that the repressed aesthetic dimension includes or incorporates that challenge to 'expressive' aesthetics effected by the critical practices of Conceptualism and its cognates. This is a historical logic, inseparable from wider social, political and economic developments since the sixties. The aspiration to cultural fusion, to the sublation of art into life, is one thing in circumstances where social transformation is or appears to be a realistic possibility. It is quite another in circumstances of deep fissure and uncertainty in the transformational project. Whereas for Alice passage through the glass gave on to a world of fantasy, here it was the fantasy of cultural radicalism which was left behind for the reality of practice in a darkening circumstance.

The relations between an exercise of critical imagination and tactical intervention, between idealism as wishful thinking and utopian modelling, make for a shifting landscape. In this world of mists – our present life perhaps – one thing only is, paradoxically, certain: that the claim to certainty rings hollow. It is precisely the clash of moral rectitudes, their cognitive undecidability inseparable from their experiential poverty, that reinstates engagement with the aesthetic as a critical necessity.

It is entirely apposite for Benjamin Buchloh to point to the lack of realism which characterizes attempts to reinvest traditional naturalizations of the relation of pictorial signs and emotional referents. The legitimate target of this criticism is, however, not signs per se, but signs taken for wonders. The resumption of authenticity is bathos. But this does not mean that pictorial signification is nullified in perpetuity; nor that the forms of such signification

must forever lack aesthetic effect. Richter's late abstraction reconstitutes aesthetic totality *from* the ruin of modernism. It compels conviction because, rather than pretend that the ruination never happened, it is made *of* that debris, that negation. In this circumstance, the charge of a decline into 'affirmation' in the Marcusian sense appears misplaced. For an aesthetic built upon the critique of authenticity, what is affirmed is less the culture of expressive authenticity itself than the requirement of criticism. But equally – and this is where the challenge occurs – what is also affirmed is the insufficiency of mere criticism, of mere cultural intervention. Cutting against the grain of sociologism, Richter indicates the 'mereness' of contingent history. Much is therefore at stake, in so far as the historically contingent is in one sense all we have. 'The world is all that is the case': that is to say, not heaven and earth, but earth alone. Historical materialism, the pre-eminent theory of the earth alone, has repeatedly been enlisted in its vulgar forms to underwrite scepticism of the ineffable. Fear of the aesthetic, however, is ultimately nothing more than a tacit admission of fear of the tests of one's own experience: preference is no respecter of propriety. Evaluation is both a kind of psychological constant, in its continual occurrence, and a rogue element in its unpredictability. Historical materialism thus requires an aesthetic dimension in so far as the latter is integral to the sense of what it is to be an embodied being; and embodied consciousness cannot adequately be represented while shorn of its evaluative aspect. [...]

In his earlier abstract paintings of the mid-seventies, perhaps continuing into the eighties, it seems plausible that Richter was carrying forward the basic strategy of his previous work. Many of these paintings looked as though they might have been assembled from a 'catalogue' of abstract devices: of figure/ground relationships, of lines and planes, of expressive gesture and mechanical reproduction, of thickness and thinness of paint, of flatness and roundness. To this extent, then, there are grounds for Buchloh's claims that Richter is deconstructing the rhetoric of painting without engaging in it.[1] In effect, this is a claim that it was historically not possible for Richter abstractly to express mood or content, and mean it. At most what could be 'meant' was the absence of the possibility of such meaning. But as the project developed, the paintings quite palpably began to lose any sense of being demonstrations and to be able to sustain readings as totalities in their own right. This type of reading was invited not least by the fact that during the eighties the constituting pictorial elements came to be increasingly subsumed by an all-over surface. If the problematic which informs these works is indeed one of drawing the laminations of meaning into a work such that the painting containing those meanings comes to constitute a unity itself capable of generating meaning anew, then such work amounts not to a negative revelation of the impossibility of

painting meaningfully, but rather to a representation of the constraints upon contemporary meaning: for example, that it cannot settle, that it is not susceptible to a unified ordering. Such a rigorous pluralism is, however, distinct from liberalism as commonly understood, and lived, in contemporary Western societies. What is arguably in play in Richter's late abstraction is a refusal both of the way things are and of extant remedies.

One of the features which distinguishes this work from modernist abstraction, however, is its continued co-existence with a form of figurative painting. In the gravitational field of canonical modernism, such a conjunction would have been unthinkable: abstraction unequivocally marked the supersession of figuration. Only extraordinary historical circumstances, such as the cultural counter-revolution of the early thirties in the Stalinized Soviet Union, could mitigate the force of that opposition: and the work to which it gave rise – Malevich's so-called 'post-Suprematism' – was highly unstable. For Richter, the situation is very different. Doubly distinct from modernism, both in respect of his early enculturation into Socialist Realism and its filtering of German tradition, and in respect of his appearance in the West at the moment the modernist paradigm began to break down, the painterly forms of abstraction took on the character not of, so to speak, irrevocable epistemological breakthrough, but of a potentially available, relatively complete, representational resource, along and on a par with others: such as photography; such as mass-media technology; such as traditional figurative painting. What was in one sense a levelling was also, quite clearly, a liberation.

Richter has said of his figurative work in this period, when it mainly comprised landscapes, with a smaller number of still lifes and portraits, that it had something of the status of a wish, an idealization; whereas the abstract works represented the hard realities of their time. This seems to allude to both the inaccessibility and the ever-presentness of the classical genres to us. We can never inhabit the world which produced the convincing *memento mori*, the *vanitas*. But the works themselves, both in themselves and in reproduction, do live on into our world, almost as reminders of what it is that we have lost. Their particular sense of the combination of the material and the spiritual must forever remain outside of us, but *that* such a sense existed can be ours. When he paints a candle or a skull, Richter neither offers a convincing representation of the fear of death nor simply abrogates modernism's evacuation of the genres. By a process resembling subtraction, he represents our culture's silence, its lack of resources for certain types of representation. It is the present that is being painted, but it is a historic present, shadowed by a past it cannot feel, but which yet remains the only measure of our own limitations.

One conjunction of figuration and abstraction seems both particularly close

and particularly challenging. In 1987 Richter produced the suite of fifteen paintings titled *18. Oktober 1977* (Richter numbers 667–1 to 674–2) the date of the deaths in prison, either by murder or by suicide, of members of the Red Army Faction, known also as the Baader–Meinhof group. At this time, or shortly after, he was also engaged in the production of abstract paintings, some of which seem, experientially at least, to emanate from the same matrix of feeling. Much has been written of the Baader–Meinhof paintings, and Richter was subject to censure from both the right and the left. For the former, by failing overtly to condemn the group, he condoned terrorism. For the latter, by failing to condemn the state, he condoned the status quo, and was, moreover, guilty of a voyeuristic use of the tragedy of others to dignify the caution and safety of his own practice. More positively, Benjamin Buchloh has interpreted them as a breaking of the silence which the largely oppressive culture of the Federal Republic draped over the moment of its profoundest crisis.[2] [...] One canot help feeling, however, that such an account misses a certain quality in the works which is less congenial to a forcefully expressed materialism. When seen, as they are intended to be, ensemble, the Baader–Meinhof paintings performed the puzzling feat of making an obviously deeply-felt address to the tragic 'light', yet without in the least 'making light' of tragedy. In many cases one would approach art which set out to address such a subject in expectation of the full force of semi-officially felt profundity, as every single stop on what Adorno called the Wurlitzer organ of the spirit built in a tragic crescendo. Richter's paintings had none of this, and were the more genuinely felt for it. They maintained a kind of *thinness* which instantly disabled the proclivity to mourn; in effect which prohibited the sentimentalization of both the individual deaths and the death of a certain distorted utopianism. Quite unlike the *memento mori* of the skulls and candles, contemporary death was somehow awarded its due. For a death without adjectives, the fifteen blurred light grey paintings played not a funeral march, but a single repeated note on the edge of silence.

Perhaps, however, the matter does not end there. For this mood appears to carry over into some contemporary abstractions, notably the four *Uran* works (Richter numbers 688, 1–4), and the large *Abstract Painting* (number 695). However conscious one may be of the facticity of pictorial meaning (and surely the enforcement of such awareness has been a feature of the best modern art since at least Cézanne, and arguably of the best art per se), and however constantly one may be reminded of the quasi-mechanical process whereby the signifying surface of these works is produced, a sense of their grandeur and austerity cannot be dislodged. [...] The paintings *have* this character, however much their means may be the common property of art history, however much their contexts of display are a function of capitalist property relations. [...]

In a situation in which religion is unavailable and ideology a recipe for war, Richter places the entire weight of redemption on art. It is against this background that we must understand Richter's conception of painting as a moral act. Both modernist aesthetics, at least in its etiolated and stereotypical form of being prised loose from material concern, and a postmodernist refusal of the aesthetic in the name of a pragmatic eclecticism, are inadequate. For Richter, there is still a truth to be told. It is the business of art to tell this truth, and the means of its doing so is the reconstitution of beauty: as he puts it, a 'downgraded' word that none the less offers the only antidote to 'war, crime and sickness'.[3]

This is far from the conventional terrain of contemporary theory, its preoccupation with difference, its subsumption of art into the factions of contemporary cultural struggle. Richter's work, which on some readings can be made to exemplify the deconstructive force of modern theory, its abandonment of what it holds to be the metaphysical myths of the past Western tradition, would seem to be made out of an aspiration which is in large part concerned to re-animate that tradition: to render it somehow available to use, now, as a resource for contemporary practice. There are two sides to this implication. Either that an emphasis on the gulf between experience and representation of the need both to construct meaning and simultaneously to subvert it is not new but an integral part of the history of a critical approach to modern painting. Or that the aspiration to open a contemporary art onto the art of the past under a rubric of comparable ethical effectivity is not necessarily a conservative desire.

This is not the terrain of deconstruction. Or, rather, in the determining conditions given to Richter's oeuvre, given to us, it is *and* it isn't. This is a terrain of difference *and* it is a terrain of continuity. For some time, relativism has tended to eclipse any sense of epistemological constraint. The play of interpretation has supervened over truth in the domain of radical culture. But this in turn has been subjected to the arguments of a reinvigorated philosophical realism. One example of this is the demonstration by Norman Geras that historical materialism does not require of us that we abandon a concept of human nature: the paradigm, one could say, of continuity. The claim, rather, is that historical materialism, both as explanation and as norm, *requires* a concept of human nature; 'it is fundamental to historical materialism in the exact sense of being part of its theoretical foundation'. He goes on:

> if diversity in the character of human beings is in large measure set down by Marx to historical variation in their social relations of production, the very fact that they entertain this sort of relations, the fact that they produce and they have a history, he explains in turn by some of their general and constant, intrinsic, constitutional characteristics: in short by their human nature.[4]

Richter's painting undoubtedly deconstructs certainties and inherited conventions – ideological, political, religious, moral and aesthetic. In order to do so, however, it relies upon a concept of shared human experience, of continuity in history, and commonly held powers of imagination. Imaginative reflection upon the paintings operates under a dual aspect: the paintings as paintings, *and* the paintings as models; the latter being secured solely on the basis of the successful achievement of the former. Success is an open question. Its achievement is to be found in the process of looking at what is shown; though such looking is always embodied, and always discursive. This is not, however, to say that conditions of absorption, contemplation and solitude are not prerequisities of an engagement with art.

After fascism, during and after communism, Richter's work is acutely positioned as both of and about the world that is left. What confers its unique place in that world is that it has never conceded the world as one in which art has no place. To paint thus, in the world of corporations, is both to accept with realism that such a world exists and one is of it, and with equal realism to exemplify at the level of the imagination that it may be otherwise. The possibility of imagining such difference, and of having grounds rather than mere desires for doing so, is a precondition of its realization. It is this which separates art, conceived as a moral act, from ideology. It demands an extension of one's experience. Our capacity imaginatively to face the consequences of experience is the measure of our being in the world.

1 [footnote 12 in source] Gerhard Richter, interview with Benjamin H.D. Buchloh, in Roald Nasgaard, *Gerhard Richter: Paintings*, (London: Thames & Hudson, 1988).

2 [13] Benjamin H.D. Buchloh, 'A Note on Gerhard Richter's *18. Oktober 1977*, October, 48 (Spring 1989).

3 [15] Gerhard Richter, quoted in Coosje van Bruggen, 'Gerhard Richtcr: Painting as a Moral Act', *Artforum* (May l985) 82–91.

4 [16] Norman Geras, *Marx and Human Nature: Refutation of a Legend* (London and New York: Verso, 1983) 66–7.

Paul Wood, extracts from 'Truth and Beauty: The Ruined Abstraction of Gerhard Richter', *Art Has No History! The Making and Unmaking of Modern Art* (London and New York: Verso, 1994) 192–3; 193–6; 196–7; 197–9.

Leon Golub and Nancy Spero
Interview with Adrian Searle//1990

Adrian Searle Both of you have incorporated in much of your work images of great violence, of horror and terror, images positive and negative which co-exist in the same place. It also seems to me that the revulsion and horror are a charade. In a piece of Nancy's I was looking at today, there was a woman being hanged, and another woman dancing on the top of a gibbet. In some of Leon's work there are interrogations, there are women being tortured, there are leering interrogators staring out at the viewer, yet we are compelled to look, and this seems to be terrifying. In both cases one is simultaneously fascinated and revolted by the imagery. I wonder, when you are making these images, whether you have to have a certain indifference to the protagonist, a sense that you are their masters?

Nancy Spero Not really, although it might look that way. There is a certain risk, in that there is a distancing. I have to remove myself, but then I get into the process of art itself. It's a funny way of being passionately engaged and disengaged simultaneously. The images repeat themselves and they appear in different pieces. I am dispassionately looking at the roles they may take and the possibilities which any given character can be and can embrace. I do feel passionate against certain acts of atrocity and so I show it in context and, in the contrast, a range of possibilities.

Searle The positive possibilities, the goddesses and athletes, are entirely oblivious of the fate of some of the other figures, even in the same scroll work.

Spero The goddess symbols are now so important because we are given multiple ideals or functions in particular cultures. They are multiple personalities, which is an extension of what we all are. This is the sense of a utopia which, in a naïve sense, may prove a bulwark.

Leon Golub Nancy has a greater range than I do, because she deals with violence and the sadistic, but also with Apollonian and exuberant points of view.

Spero May I just say something? We share a studio. Leon is on one side and I am on the other. On his side he is painting monsters, mostly male, so I felt there had to be a little beauty on the other side.

Golub If I paint a torture scene, for example, to what extent am I implicated? I am responsible for it, I have planned it out. I have been crudely indifferent on one level, as I go about the technical process. But in the end, I know what I am about: I am capable of recognizing in myself sadistic and masochistic attitudes, and I am capable of recognizing them outside of myself. [...] The art world is such a precious, protected enclave, whose purpose has been to suture us in the most delicate and subtle ways, and give us back an image which is felt flattering to such a degree. Or, if what is grotesque or horrific is permitted, it is with a look of disgust that says: well, we just have to tolerate this imagery, although that is not what we participate in as artists or as citizens, that is not what art is about. I would also say that if someone in England joined the police force, the odds are that this person would not ordinarily be engaged in interrogations, 'interrogation' in this context really meaning torture. Let's say you join a police force in El Salvador. The odds are that you will participate whether you intended to or not. If you are called upon to join others in a certain act, if you hold back, they become suspicious of you. Eventually all these people join in, and some of the participants find that they begin to like it and they go after it with avid interest. This thing is pervasive. It's not that you are naturally directed that way, but economic and social factors can force you into situations where you become part of public policy in such a way that you totally adapt to the situation. Now, I'm interested in exploring this through such a clumsy medium as paint. [...]

Searle To make your work tenable there has to be a notion of redemption – otherwise paintings of interrogations as backdrops to parties are against nature.

Golub There is no redemption. I think they are fatalistic, and I think that I have a fatalistic view of life and existence. I think one has to fight to remove what one construes as evil, one has to fight for social justice. To be strong enough, to make this possible, one has to be unremitting, but as far as redemption comes in, I don't think there is such a thing.

Spero I think that if there is any redemption in our work it is first of all in the act of painting, and that the act of redemption comes in recognizing what is on these canvases: that they are beautiful, that the ugly can be beautiful and transcendent. I am speaking about the subject of women in control of their own bodies. What I am really talking about is more utopian than ever these days, particularly in the United States with all the repressive measures being passed. This is not an old issue and yet I have these figures dancing, cavorting. How is it to be understood that I am talking about power, self-power, not as it is invested in those men who claim to control destinies in such a very powerful way?

Searle The chimera of censorship is raised again. Does that have something to do, in Leon's work, with the return of the Sphinx?

Golub The Sphinx represents at one level a kind of bio-engineering possibility, it's a mixture of human and animal. It interests me and I went back to it because I was trying to show a kind of fatality. We are trapped in our bodies and we build up huge symbolic systems to reassure ourselves in terms of mortality. The Sphinx plays a part in this. I was trying to show something that is fatalistic, and trapped, in terms of our time. I picked up a photograph of a little figure, a sculpture, that they date 52,000 years ago, which is as far back as you can probably find representations. There were two parts to this figure: one is the head of an animal, and the other is the body of a human. So at the very beginning of representation, at the beginning of any kind of technology for making artefacts, there were individuals trying to understand that kind of relationship, which was another way of coming to understand who we are.

Audience question Is there a subject that cannot be represented in art, given that you are working in realms of the horrific, in terms of what human beings can do to each other?

Golub There are no subjects that cannot be represented in art by someone, but there are certain subjects that I would not represent. There are certain sexual themes, political themes, that I would not wish to represent. I reserve the right to choose and decline.

We are trying to intersect the real, whatever the real is. Whatever it is that is occurring, we are trying to get in the way, we are trying to trip it up to more or less obnoxiously get in the way. If I were to do a painting of this group sitting here, the idea would bore me. This is a passive situation here. I personally think that you have to go to extremes, to the edges and peripheries, and you have to intersect them *in extremis.* You may fail in this, you may stereotype, you may be corny, but you have either to fall into it or do something so that you are part of whatever it is that is going on in your time.

Audience question In relation to the recent wave of clampdowns on the National Endowment for the Arts in the United States and the whole question of obscenity and pornography in terms of what can be publicly shown, what are your views on the situation?

Spero It is pretty bad, and overt, in the sacrosanct field of museums and modern art, into which I don't think legislators ever dared enter before. Jesse Helms did

all he could to create a ruckus and in that way ensure re-election by trying to quiz all his fellow senators whether they thought a certain art is pornographic. In that way they are put on the spot with the constituencies. Doing this creates a pull towards self-censorship. It is a very dangerous thing. It is a kind of inquisition and it has caught on; the country is moving to the far right and I personally feel threatened.

Golub I think that it is a fight over the whole modern world in a really fundamental way, a struggle over modernism in the widest sense of the word: the modernization of the modern world. People who are critical of modernism are willing to accept technology, but they don't want to accept many of the social attitudes and issues that relate to this, and they are fearful. There are probably more fundamentalists in the United States than there would be in Great Britain, and what they are really afraid of is their way of life.

One can understand their fears. Modern art and modernism have suddenly come to the attention of some of these people. They hadn't paid attention to it before. You accuse someone of obscenity, anti-Americanism, blasphemy etc. There's going to be a big struggle in the States for a long time over these issues.

Spero On the other hand in the States there are a lot of pro-abortion advocates, yet somehow our legislature has become more conservative and increasingly repressive. It was a group of feminists who threatened a nationwide boycott of potatoes if the anti-abortion bill was passed in Idaho.

Audience question The two categories of art and obscenity seem quite elastic in a way. We often talk about being incorporated into the category of art, and yet objects that we might feel secure about describing as art can be defined as obscenity. How would you define the differences between art and obscenity?

Spero I have tried to use obscenity, or open up ideas, particularly in the war series, in addressing the ideas of war. During the Vietnam war I wanted to bring together the imagery of sex and power and war, or open up ideas, art or sexual connections, and use images because the image of woman has been abused over the years. I do as I please. Any limitations anger me because all this censorship is enough – limitations on sexual imagery, or limitations by theorists who state what is viable in conceptual or feminist practice. [...]

Leon Golub and Nancy Spero, extracts from interview with Adrian Searle, Institute of Contemporary Arts, London, 1990, in Adrian Searle, ed., *Talking Art* (London: Institute of Contemporary Arts, 1993) 44–52.

Agnes Martin
Interview with Irving Sandler//1993

Irving Sandler What would you like your pictures to convey?

Agnes Martin I would like them to represent beauty, innocence and happiness; I would like them all to represent that. Exaltation.

Sandler You also think of your art as classical, because it is detached from the world, cool and untroubled, and strives for perfection and freedom from whatever drags people down. Do you think of your painting as continuing a classical tradition in the history of art?

Martin No, I just hope I have the classical attitude.

Sandler At the same time that you value a detached and cool art, you require that your art express feeling. It is commonly thought that detachment and feeling are antithetical, yet you would like to bring them together.

Martin I think that personal feelings, sentimentality and those sorts of emotions, are not art but that universal emotions like happiness are art. I am particularly interested in the abstract emotions that we feel when we listen to music. All music is absolutely abstract, except for one piece, 'The Flight of the Bumble Bee', which is not abstract! People are not aware of their abstract emotions, which are a big part of their lives, except when they listen to music or look at art. These are the emotions that align with art.

Sandler Today, there are many artists who view modern life as a series of disasters – two world wars, the holocaust, rabid nationalism, ecological devastation – and who believe that the future will be no better. These artists attempt to embody this negative outlook in their art. Has this kind of expression a place in art in your view?

Martin I don't respect their negative art, I think it's illustration. I consider exaltation to be the theme of art and life.

Sandler Your art is non-objective which, as you have written, is of extreme importance to you.

Martin I think that the abstract emotions of which we are not conscious are tremendously important, especially since they are all positive. I mean they are happy emotions that we only feel when we get away from daily care and turn away from this common life. I don't think human welfare and comfort are the artist's responsibility. I mean every other activity, every other kind of work contributes to human welfare and comfort. But art has no time for that materialistic area. The reason I think that music is the highest form of art is because it manages to represent all our abstract emotions. I don't think that artists should be involved in political life because it's so distracting.

Sandler Your ideas seem to owe much to the Bible, Taoism and Zen Buddhism. Would you comment more specifically on the influence these sources had on you?

Martin What I'm most interested in are the ancient Chinese like Lao Tse and I quote from the Bible because it's so poetic, though I'm not a Christian.

Sandler John Cage was a follower of Zen Buddhism; were you friendly with him?

Martin Well, just to speak to. But I don't agree with him.

Sandler Why not?

Martin Well for one thing, he wrote a book called *Silence* and in the very first line he said 'there is no such thing as silence'. But I think there is. When you walk into a forest there are all kinds of sounds but you feel as though you have stepped into silence. I believe that is silence. John Cage believed in chance, and I very strongly disagree. Every note Beethoven composed was invested with his whole mind and being. I think that composition depends on accepting what you put down. Our mind asks, 'is this right?' and it answers, 'yes' or 'no'. [...]

Sandler Despite all the turmoil in our world today, over the decades you have held on to a belief in transcendental experience and exaltation.

Martin I think that happiness, innocence and beauty are the first concern of everybody. You see, don't think it is just me. I think that everybody is concerned and that, if they don't have any experience of these positive emotions, they really crack up. That's how important I think they are. You see, we are educated in the intellectual and ego side of things – that's the orientation of our culture – and so the other, happiness, innocence and beauty, has to be stressed. I'll tell you the difference between the intellectual response and the artist's response: the

intellectual response is about facts and reaching decisions – reduction, classification, logic – everything we've been educated in. That's the intellectual response. And then there's the intuitive response. That's what art is about.

Sandler One last question: is there anything you would like to add?

Martin I would like to say that artists should depend on inspiration. Everybody protests that artists are irresponsible, but artists are not concerned with the material world. I would advise them to turn away from this world and go on a picnic or something. Go into the forest and feel the difference. If you are on the beach and you are looking at the shining waters and the flight of birds, and you are tranquilized by it, and somebody comes down to the beach with a transistor radio and turns it on, you are irritated. That's the difference. The artistic attitude is the one on the beach before the world interferes. Artists are intuitive. They wait for inspiration. That's what art is about, the intuitive, not the intellectual. Art about ideas stimulates ideas, but art that comes from inspiration stimulates feelings of happiness, innocence and beauty.

Agnes Martin and Irving Sandler, extract from interview for *Art Monthly*, no. 169 (September 1993), reprinted in *Talking Art: Interviews with Artists since 1976* (London: Art Monthly and Ridinghouse Editions, 2007) 422–3; 429. Agnes Martin text © 2008 The Estate of Agnes Martin/ARS, New York.

Alex Katz
Interview with David Sylvester//1997

David Sylvester [...] I see in your work a search for clarity of gesture and also for something found in Piero and David among others: ideal facial beauty. While your images of faces are very specific – conveying a feeling that they aren't invented but belong to particular people – they also seem intended to create a canon of ideal beauty, as Piero's do. I sense that very strongly in paintings such as *The Red Band* (1975) and the *Face of the Poet* series (1978)

Alex Katz I don't know about the word ideal but it involves a search for beauty; the paintings are involved with that. [...] Living in the city, where their value is placed on elegance and beauty, that's one of the things I'm involved with. I think some people find it hard to accept that as being art – elegance and beauty. They want to see social messages, suffering, inner expression, all the things I'm not interested in.

Sylvester So if I see in your work a desire to create paragons of beauty, I'm not seeing something that is unconscious?

Katz Well, no, it's conscious. The [format of] *Face of the Poet* is also like a big movie screen, it's like a glamorous Hollywood star. It's a complicated symbol, it has multiple readings. Well, of course, it's that person who is beautiful. Anne Waldman is a poet, she is beautiful. She's also high-style bohemian and you see that too.

Sylvester By the way, I do mean beauty, and also glamour, but I don't mean sexiness.

Katz It can be sensuous but not sexy. Once you have sexy you have problems with beauty and you have problems with glamour.

Sylvester And maybe it was the greatness of the Hollywood still photographers of the 1930s that they didn't go for sexiness?

Katz No. It was more for glamour and beauty.

Sylvester Why is it that you've done so little with the nude?

Katz Well, I have done nudes; I haven't shown many of them. I haven't done a lot, though, and one of the reasons is, I think, that you don't deal with them in a civilized form, clothed; you deal with them in a less styled form. The other thing is that I always wanted to do nudes in a non-traditional way; I've done a couple but they haven't been seen. But mostly it's due to the more generalized time-frame. I want to get out there in the exact minute I live in. [...]

Sylvester It's true that on the beach a girl in a bikini is much more of her time than a topless girl.

Katz A topless girl could be of any time.

Sylvester Being as steeped in European art as you are, you've never actually felt tempted to work in Europe, have you?

Katz No, I haven't. As they say about New York, it's a great place to visit but I wouldn't want to live there. No, I never wanted to work outside New York. I like working in New York. I could conceive of painting in Los Angeles. I was in Paris, I guess, for three weeks. That's a long period for me and I didn't feel like doing any artwork and I didn't miss it. It just didn't seem interesting to me. If I was forced to live there I guess I could do it, but it isn't a place I would want to go to paint.

Sylvester Is this because of the spiritual and social climate of New York being very sympathetic or is it also very much, or even more, that incredible light of New York which seems to be related to the kind of light in your paintings?

Katz I don't know whether it's the light. I think it's the subject matter that turns me on. The people in New York turn me on, the way they wear clothes, etc., their gestures and their clothes, it's specific and I like that. And I like working in Maine because the light is so beautiful, it's completely different to European light. And you have a kind of social freedom in Maine that I wouldn't have in Europe. Maine is sort of really live and let live. It's very uncivilized, it's beer cans all over the place, people do whatever they want to do. [...]

Alex Katz and David Sylvester, extract from interview in *Alex Katz: Twenty-Five Years of Painting*, ed. David Sylvester (London: Saatchi Gallery, 1997); reprinted in David Sylvester, *Interviews with American Artists* (New Haven: Yale University Press, 2001) 248–50.

John Currin
Interview with Robert Rosenblum//2000

Robert Rosenblum [...] What's eerie, especially in your paintings that look like Pleasantville, is that the happy people come out so grotesque; the anatomy, the emotions, get warped. How do you approach the paintings?

John Currin It's not intentional. I find things get weirder and more cartoony the more normal I try to make them look. It boils down to figuration as a kind of unnatural thing, against the grain of contemporary art. You already feel like you're doing something silly, and maybe that puts you in a silly frame of mind. The worst thing, in my mind, anyway, is serious figuration. When I was in grad school that was always the domain of the married grad students or Christians who would be painting Hopperesque psychological tableaux that always looked awful to me. At that time I was trying to be an abstract painter. As I later came to figuration, it was the whole enterprise of being nerdy and out of it that attracted me. Ten years ago, what would be taken seriously and considered smart, contemporary New York art, was not figurative work. So I was already in a state of mind where nothing mattered; no one was going to take it seriously.

Rosenblum It's funny, because when I hear what you say I think about certain parallels with Lichtenstein's early works. One of the shocks of his early cartoon blow-ups was that the people in them – which you normally passed over because they were part of everyday life – were totally bizarre when looked at blown up and up close in his paintings. The anatomies were weird; the expressions were synthetic.

Currin Lichtenstein always maintained a very clever irony. People in his paintings are acting out a modernist situation. You know, 'I can see the room and there is no one in it', its bubble caption commenting about it not being a proper, modernist painting. He saw that making figurative painting was basically a damned state, or an ironic state, banished from modernity. He was pretty dead on: the future of American figuration is this kind of damned state.

Rosenblum I'm glad you say that, because obviously your work looks totally different on the surface. His is built of flat colour and ben day dots, and yours uses more traditional modelling, but the feel of it – of looking at 'Americana' fresh, and in quotation marks, really scrutinizing how creepy the emotions, the

anatomies and the narratives are – this is something that you seem to be updating some thirty years later.

Currin Americans back in the 1940s and 1950s were looking at the Italian Renaissance: that was the way you were taught to draw. I think that Lichtenstein saw that comics had that kind of Florentine perfection. The drawing was everything. Think about his black-and-white curtain paintings, or the ones of flowers – they are perfect and they are irreducible. I wasn't drawn to that type of hard perfection. I am sort of now, but when I was trying to change myself into a figurative painter, I was more drawn to the rococo and the other damned souls of art history.

Rosenblum Getting back to American fantasies, I'm curious – were you ever involved with looking at the traditional pin-up girls of the 1940s – like Petty girls or Vargas girls?

Currin I never liked those much.

Rosenblum If you look at them afresh today, they have the same kind of strangeness as your figures do in terms of synthetic anatomy.

Currin I never liked the way they were done. As a kid I had Frank Frazetta's book. I did like that a great deal. I don't know if you know him, but he did Conan the Barbarian – comic based, muscular women with really big breasts. They are painted in this French manner. The Vargas stuff I just never liked. I never liked the way they looked, I never liked the technique. I'm much more into the girly photographs from the 1960s magazines – the best one was *Modern Man* – just before *Playboy* wiped out that entire group. They're not hardcore magazines. They had immensely beautiful photographs. The women were not as pretty as in *Playboy* but the photographs were absolutely gorgeous, old-fashioned looking colour photographs. And they were beautifully done, the skin tones. I have a whole bunch of those and I look at them a lot. I don't know whether I look at them because I like looking at naked ladies or because I want to get colour ideas, or both. [...]

Rosenblum I love hearing that you are a fan of Boucher and Fragonard, because twenty years ago they were very low in the pecking order of which artists of the past were venerated.

Currin Well, that was for political reasons, too. A lot of Marxists had influential

positions in art history departments and they don't like luxury; it seems immoral to them.

Rosenblum Looked at today, from the angle of vision you offer in your re-creations of women, nude or clothed, Boucher is someone new. What becomes so fascinating about him are these weirdly erotic bodies, with their tiny heads and long legs – previews of Barbie dolls.

Currin And everything being habitual. That's the part that I can't imitate, the utterly habitual positioning of the third finger, that kind of stuff. There are so many different systems that work in tandem automatically on the canvas. That's why Lichtenstein was attracted to comics, that's the only contemporary place you find that type of complicated machinery moving forward in unison in a picture. For some reason, I've never liked comics that much; they don't entertain me. I think of drawing as an isolated, anxiety-ridden thing rather than the professional, sporting attitude of comic book drawing.

Rosenblum You seem to have a much wider range of anatomical possibility in the way you stretch and contract your figures compared with comics or even Boucher.

Currin I used to really like Boucher and the rococo, but lately I've been thinking more about Northern art, and also Italian Mannerism.

Rosenblum That brings up a question close to everybody's heart today, especially mine, which is your relationship to old art history. People have noticed again and again, quite rightly, that many of your latest pictures look as though they are retakes on sixteenth-century painting, especially German painting, Cranach and the Mannerists in particular. When did you come to that? If I'm not mistaken, originally these references were not there, they crept in.

Currin Normally, I would have been reluctant to paint something so close to an old artist because people can easily compare what I do with them. Obviously my stuff isn't going to be as good as Cranach's, or rather, it wouldn't be able to compete on his terms. And perhaps I hope that Cranach's can't compete on my terms. But in terms of sheer loveliness and beauty – I got married. It's a lame excuse, but I got married and ever since I met my wife I've fallen off balance. Before I met my wife, I thought of myself as an expressionist artist who worked on negative expressionist impulses – anger, depression, and misery. Which is why I've always thought people were wrong to think that I was an ironic artist;

repressed anger is different from irony. After I met my wife I no longer had the raw material of an expressionist artist. I just didn't know how to paint for a while, and then once we got married, a kind of neutrality descended on me. I really just wanted to make things beautiful. I had no interest in constructing a painting out of its references or its ideas or out of its grudges. Grudge is a good word because I used to total up my grudges and think of pictorial allegories for them. That kind of resentment in my painting used to come of pictorial allegories for them. That kind of resentment in my painting used to come naturally, and it doesn't any more. I went to Florence and Venice on my honeymoon, and when I came back I was so empty and so happy. I thought, okay, I'll paint a nude woman. I'll make her body the way I want it and give it a black background. I don't care if it's old fashioned. So I did that for about two years and hardly ever got tired of it.

Rosenblum I hate to sound like a shrink but it sounds like the logical and happy progression from being a teenager to a grown-up.

Currin Maybe. In a way it has this feeling – which is why I'm a little leery of it – of a rock-and-roll person who gets interested in orchestral arrangements. And that sucks. They decide to get grand and it turns horrible, like jazz fusion. On the other hand, you get better at painting as you do it. You can't preserve the violence and freshness of your ignorance. I couldn't do those middle-aged women now. They have a kind of concentrated energy that I can't duplicate because I know how to paint so much better.

Rosenblum It's true that they look as though they're about to explode, even though every single thing is so tightly corseted.

Currin I like those a lot, but I can't do them over again because now I would be so distracted by other concerns that I am able to address. I hate to think that I can't take a look at my older work. So in other words, I've realized my own fear and I have turned into a reprehensible jazz fusion Don Henley guy, but you can't help that. There's no way to get around it. In fact, it's the most fascinating artistic problem – how real emotions survive in spite of, and because of, all the fakery. […]

John Currin and Robert Rosenblum, extracts from interview, *Bomb* magazine, issue 71 (Spring 2000).

Wendy Steiner
On Marlene Dumas//2001

[...] Perhaps no artist has more effectively used a model-centred art to cut through the monstrous legacy of modernism than the painter Marlene Dumas. Born white in South Africa, she was well placed to observe the ideological force of female beauty, though she has lived in Amsterdam since her student days. In South Africa, it was illegal to display images of nude whites, but 'black women could be depicted with bare breasts on postcards, thus underlining the difference between them and whites (nature versus culture).' Dumas's culture could not conceive an innocent representation of a woman. Though abstraction would seem a safe alternative, she rejected it. 'I cannot feel any respect', she stated, 'for the many painters who still regard the problem of an exciting-painting-without-an-exciting-subject as the sole task of painting.' Her work as a result is full of images of women, and interestingly for an artist in revolt against formalism, it uses paint and colour with an extraordinary lushness, exuberance and self-consciousness.

Dumas's work is a thoroughgoing exploration of the model's role in art. What Dürer's *Instruction in Proportion* did to define this matter for the Renaissance or Picasso's *Suite Vollard* for modernism, Dumas's oeuvre will do for the period of art opening before us, a period in which beauty will not be such an automatic point of resistance. But unlike Picasso or Dürer, Dumas takes the model's viewpoint, placing her consciousness at the centre of art. As the model is treated, so art is treated. Modernist men – artist, audience – may have suffered with 'the image as burden' [the title of one of Dumas's works], but that was because for them the beautiful woman was a *dead* weight. From the model's point of view, she is engaged in self-presentation, and hence she is vivid, alive. She carries herself with aplomb and is no one's burden.

As we might expect, Dumas's model is a tricky character. She may be Naomi Campbell today, a real model; tomorrow she may be Bathsheba or Snow White, storied objects of the male gaze. She is all too aware of the roles prescribed for her. In *The Model Imitates the Dead* she takes a pose identical to that of the naked corpse above her – horizontal, exposed, passive. After all, this passivity is what people expect of her. But by deliberately taking the pose, she undermines its passivity, and Dumas includes her point of view by inserting her words in the picture: 'The model disapproves. The model won't obey the rules. [...]

Dumas makes art under the shadow of Edgar Allan Poe's dictum, which she paraphrases, outraged: 'The death of a beautiful woman is unquestionably the

most poetic topic in the world.' If Poe wants dead beautiful women, Dumas supplies them with a vengeance, with the model for these corpses angry, arch, subversive. Dumas thinks it is time to hear from the model, from women in general. 'I did not paint Freud', she asserts; 'instead I painted his wife'. Dumas also has a bone to pick with Manet. Though the *Olympia* overtly presents its female subject as the prostitute that other artists were secretly depicting, that honesty does not do much for the model. 'If we return to the female nude and notions of ideal beauty, we come to Manet who broke the rules with his "Olympia", but then we see idealism replaced by the "realism" of the prostitute', says Dumas. A model with the spirit to look back at her beholders should not automatically be taken as a whore. Indeed, there is no need to construe Olympia this way.

Dumas questions how real realism is, and decides that it is based on arbitrary conventions. She once painted a male nude in a horizontal pose and was astonished to be criticized for producing male pornography. In realism, horizontal means passive; passive means objectified; objectification is pornographic: *voila!* A horizontal nude is perceived as passive regardless of sex, associated automatically with transgression and prostitution. This is the way blacks are pictured in racist cultures, too, Dumas understood. The reality of the model's identity and the intentions of the painter are irrelevant in this rush to the stereotype. […]

If we specify the meaning of the artwork as prostitute, pornographic, black, gay, we have no further interpretive responsibility to it. Imaginatively, we have reduced it to a corpse. This is why Dumas's female subjects are models as such. They refuse to lie back and accept their role as anything other than a pose *imposed* from the outside. They take off their clothes, but they are never laid bare in the process. As Dumas writes: 'My best works are erotic displays of mental confusions (with intrusions of irrelevant information).'

The artwork must be saved from a simplistically pornographic reading in which everything is known and therefore dead. Models must be saved from such a stereotyped treatment as well. The series 'Models' makes a glancing allusion to Andy Warhol's *Marilyns* or *Jackies:* rows and rows of female heads. But Dumas's models are not multiples; each head is that of a different woman, and celebrities are mixed in with 'ordinary' women. Though Dumas depicts Mary Magdalene and Snow White and fashion models and Lolita, 'Models' also includes scores of faces of unknown women, some old, unattractive, possibly insane – outsiders in terms of prevailing norms of attractiveness.

It's not the fallen woman
nor the temptress I'm after.
It's not the babydolls I want

nor the Amazons. It's everything
mixed together to form
a true bastard race.
(Marlene Dumas, from *Miss Interpreted*, 1997)

This bastard race is woman, who has no essence, no singular meaning, however much male modernists have wished to impose one on her.

Dumas puns on this situation in her exhibition and book title, *Miss Interpreted*, suggesting that to be female is to present an interpretive enigma that often leads to errors. Her 'intrusions of irrelevant information' contribute to the difficulty, and so do the feminine stereotypes from fairy tales and the history of art that her models so often inhabit. They do so ironically and rebelliously, but clichés are easier to take at face value than to read through. This is too bad for women, and equally so for art. In Dumas's work, the model's plight is identical to that of art. To misinterpret one is to misinterpret them both.

Moreover, this interpretation is not trivial. Dumas's epigraph for *Miss Interpreted* is a 1963 statement by Bertrand Russell concerning nuclear war. Russell warned that 'what is most likely in Berlin or elsewhere is simply *war by misinterpretation*. You may get a meteor or something like that showing up on a radar screen, and someone will press the button.' Just as the author Don DeLillo traces the wasteland to the Cold War, Dumas sees the elimination of woman from art as proceeding from a simplistic Cold War mindset. True, nuclear war may not result from treating art as a meaning to expose or the female subject as a prostitute, babydoll or Amazon, but the devastation of the Culture Wars and the gender wars has been all too real. No one did press the nuclear button, but a thousand deathly buttons have reduced beauty, art and the model to corpses mourned by generations of bereft but relieved oversimplifiers.

In the 1988 drawing series. *Defining in the Negative*, Dumas shows what happens to the female image and hence to art at the hands of male artists. She calls Balthus's treatment of the nude 'sperm on a silk handkerchief' – an elegant record of the painter's virility. In David Salle, Dumas sees the nude emptied of meaning, abstract; Baselitz turns his nude upside down so that he can concentrate on pure painting. The other artists in the series – Eric Fischl, Allen Jones and David Hamilton – exemplify the desire to detach art from woman and beauty from femininity, but even more, to deny the model her agency. For Dumas, these connections cannot be broken. Male artists may do so out of a desire for domination, for determinacy of meaning, but the result is pornography rather than erotics and a distortion of the very nature of art.

Dumas derides this attempt with her sarcastic works. *Waiting (for meaning)* and *Losing (her meaning)*, both from 1988. In *Waiting*, a black nude lies prone

on a draped table, her legs limply dangling open at one end, her arm arched under her head in a classic pose of sleep or abandon. She is like a sacrificial victim waiting to be penetrated or a corpse defenceless against entry – the entry of meaning as sex, rape, the impregnation of the passive non-meaning, woman. In *Losing (her meaning)*, a nude leans over in a pool or lake, her face and the front of her body immersed in water. She appears to be merging with the water, perhaps a suicide. From the modernist viewpoint Dumas mocks, to lose determinate meaning is to cease to be, but the model knows better.

So does Dumas. She does not treat her subjects or her art as passive containers of meaning. Instead, the relation between the painter and her models is like that of a girl and her doll:

THE PAINTER AND HER MODELS –
or GIRL WITH A DOLL

Painting is my oldest subject
Fashion is my newest
and Beauty is my youngest.
(from *Miss Interpreted*)

In this enigmatic poem, Dumas's subjects are art, fashion and beauty. Just as a girl plays with her doll to act out motherhood, so a female painter uses her models to enact creativity. She loves her models, just as the girl loves the doll or the mother loves the child, for the model and the doll and the child are all versions of the artist herself. There is no alienation and refusal to nurture in this scenario, and because Dumas believes that 'One cannot paint a picture of / or make an image of a woman / and not deal with the concept of beauty', this art about models is inevitably a meditation on beauty. An art that tries to separate beauty from the feminine in order to be 'pure' is not impossible, but only sterile, misogynistic, self-hating or boring. It misinterprets woman, and makes beauty inseparable from death.

Dumas's response to this misinterpretation is like that of Angela Carter and many other female artists, and specifically *not* like that of Mary Wollstonecraft. We recall that Mary Shelley's mother agreed with the standard misogynist claims of her day – that women were ignorant, self-centred, frivolous and purely physical, using their beauty to gain power over men, showing no ability to create or appreciate art. Blaming these faults on the inferior education women received, she argued for educational reform so that women could become more like men.

In contrast, Dumas accepts the most traditional idea of woman's interests, her work running over the same ground as women's magazines: art, fashion,

beauty. But there has never been a woman's magazine like this. Suddenly, to be a woman is to be an artist, to explore beauty, and in the process to encounter an irresolvable paradox and a total denial of one's value. The only sensible response for a woman is to turn this situation back onto the men who create it. Snow White is a past mistress of this strategem, exposing herself to the dwarfish gaze of her seven critics – little voyeuristic boys who stare at the sleeping nude – but at the same time showing them up. In *Snowwhite and the Broken Arm*, she is deprived of this revenge. With her arm broken, she can no longer take polaroids. *Dumas's* arm is just fine, however, and the 'shots' keep coming. She also takes other people's photographs and liberates the models in them. 'My people were all shot by a camera, framed, before I painted them', she claims, and indeed, she very frequently paints not from female models in the flesh but from female models as they appear in photographs. In this way, she recovers models from their reductive images. [...]

In the 1960s, Susan Sontag, tired of interpretation and eager to celebrate formal beauty, urged 'in place of a hermeneutics ... an erotics of art' ['Against Interpretation', 1964]. But erotics *is* a hermeneutics of art; indeed, it is *the* hermeneutics. Marlene Dumas situates her work 'between the pornographic tendency to reveal everything and the erotic tendency to keep what it's all about secret'. The erotics of art is a hermeneutic hook, the showing/hiding that lures all readers and viewers of either sex into fictive worlds. When Dumas describes her best works as 'erotic displays of mental confusions (with intrusions of irrelevant information)', she is providing a definition of art for our day. [...] Confusions displayed are the very hiding and revealing essential to art, and the female subject is the perennial evocation of this complication. The evocation of beauty in art is thus not nostalgic pabulum or overblown pornography or disguised traditionalism, but an image of the very engine of art: the invitation, the enigma, and the virtuality that are its pleasures. Dumas takes us far on the road to finding woman beautiful, finding art beautiful, and accepting woman as a conscious model rather than a passive symbol of the beauty of art. [...]

Wendy Steiner, extract on Marlene Dumas, *Venus in Exile: The Rejection of Beauty in Twentieth-Century Art* (Chicago: The University of Chicago Press, 2001) 222–30 [footnotes not included].

Art & Language
On Painting//2003

Michael Baldwin We propose to talk about the possibility of painting with a certain background in view. We should make clear from the outset that by painting we do not just mean handmade pictures. What we do and can mean may become clearer as we proceed. The background we have in mind is both theoretical and practical. The theoretical background takes the form of the so-called Institutional Theory, which has been virtually hegemonic within the art world for some forty years, and determining upon people who in the majority have probably never heard of it.

Charles Harrison An informal version of the Institutional Theory was in circulation among certain artists, dealers and curators in the late 1950s, but it was given its first persuasive articulation by the philosopher Arthur Danto in 1964. Danto wrote of the end of art, meaning the end of an art governed by specific criteria and by specific notions of historical progress. It is now conventional wisdom that painting reached a terminus of sorts with the blank canvas. Danto and others following him marked the end of the developmental narrative of modernism with the problem of indiscernibles: objects, one of which is art and the other of which is not, and which cannot therefore be told apart except by reference to the different parts they play in the discourse of an art world. Danto mistakenly based his original argument on Warhol's all-too distinguishable *Brillo Boxes*. It fits Duchamp's snow shovel [*In Advance of the Broken Arm*, 1915] rather better. In fact we might say that at first sight the Institutional Theory is practically required by Duchamp's first unassisted readymade.

Mel Ramsden The practical part of our background consists in real institutions, their concrete acts and occasions – this occasion among them. In talking of this as background, we do not wish to conflate the Institutional Theory with the practical art world and its institutions. However, there *is* a connection in so far as the theory has been useful – indeed necessary in excess of its actual explanatory power – in supplying the institutions in question with their practical self-description. They need it to account to themselves for the power that they have come to wield over the status of objects as art. [...]

But painting tends to be problematic for the Institutional theory. This is not because the art world doesn't or can't ratify them. But one of the capacities paintings seem to possess is to generate anomalies with respect to an exemplary

case that the theory addresses; namely the problem of indiscernibility. There are in fact very few practical cases in which indiscernibility is a problem – and Danto notwithstanding, Warhol's *Brillo Boxes* was not among them. We might conceive of blank paintings as things that need to have art status conferred upon them by the art world. But which blank paintings would we have in mind? Rauschenberg's? Klein's? Ryman's? Richter's? Do we actually have any difficulty in telling these apart from each other or from other things that are not paintings? It turns out that paintings have the cheek to look a bit like art whether the art world thinks they do or not.

Charles Harrison If this or some refined form thereof is not accepted we are left with an entirely uniform field of artworks – one in which there can be nothing *intrinsic* about x to tell us why we are paying attention to it. But the field of artworks, as we know, is not yet uniform; the cases we confront are not all neat philosophers' examples, and we don't go about asking the same question of everything. We would even go so far as to say that the art world itself is not completely uniform. Not yet.

Ramsden The more uniform the art world gets, the more terrifying it is. We might say that it's trying these days to *become* more uniform – to establish curatorial power plus. If every other thing Tate Modern shows is stretching the boundaries of art, what's the nature of the boundary that's being stretched, and what properties are ascribed to the things doing the stretching? The point is that if there were really infinite numbers of items waiting at the disputed edge of art for the art world to confer status on them, few or none of them could be paintings.

Baldwin Painting seems to be of interest because it may act as an irritant to a central doctrine of institutional theory. The Institutional Theory is, we argue, founded on a *Gedankenexperiment* [thought experiment] that bases itself on the example of Duchamp's snow shovel, while painting conceived in a certain way refuses to be exemplified by the artefact of which that is a type. This example is supposed to cover all art. If it did, the idea of a generic art would indeed follow naturally. In Joseph Kosuth's formulation, generic art develops through critical operations on the concept of art; you cannot if you are making painting or sculpture be questioning the concept of art since they are merely fixed kinds of art, i.e., mere subsets of the generic class. In this world, painting is either an authenticist anachronism or it is one postmodern option among many. [...]

Ramsden You can do anything: take a photograph, stick some stuff in a box, do a painting, anything, because everything is art in the same way. This is seen as

anti-elitist and the democratization of art. What it effectively does, however, is to empower the institution to make the selections that get to count while it masks its own non-cognitive operations with circularity. We will come to this in more detail later. It seems to us an odd democratization that as more and more is distributed across the net of art and doesn't have to answer for itself, the success or failure of work gets harder directly to determine. The development of criteria in this connection becomes very uncertain, and falls easily into the hands of the manager and the therapist. [...]

Harrison What's confusing is that submission to that power can seem commensurate with liberation from posh talk about inherent quality, and from the idea that art status is decided by empirically verifiable visual properties. In the late 1960s this sense of liberation released a certain appropriative gesture into the world. But this appropriative gesture faced the critique that it was still Cartesian in its artwork ontology. If perception and description were often the same thing as the later Wittgenstein suggested, then a conversation had to take over. Conversation tends to generate projects for itself. It imagines its 'objects' as always problematic, (always) deflated and deflating. (This is perhaps the beginning of a sense of resistance also to another programme that we have described as bureaucratic, managerial and spectacular.)

Baldwin In the form of the doctrine of indiscernibles, the Institutional Theory argues that the status of art is conferred upon objects by the art world. There are thus still objects that somehow lie 'behind' the artwork, however installed, evasive and dematerialized they may be. Here is an instance of Cartesian theatre, the machine behind the artwork's ghost. Perception and description are pulled apart. In the case of the snow shovel we are supposed to perceive a snow shovel and describe it as a work of art. But in the case of a painting of even minimal internal complexity, our address to it will tend to obliterate a Cartesian object in the background, even if we allow the implicit ontology to linger. If an object is an artwork under description as such, then certain worrying if consequences easily follow. It is as if David Beckham's free-kick against Greece [for England in a World Cup qualification match] had to be thought of as a perceived bodily movement, a knee jerk, that has been placed under the description of the scoring of a goal. Our argument is, of course, that the scoring of the goal and David Beckham's action are not intelligibly separated. We would say that even painting of a traditional authenticist type has the power to point to the Cartesian pitfalls of the Institutional Theory of art objects. [...]

Ramsden Painting is not only a problem for Institutional Theory; it holds within

it a possible critique of those real institutions that use the theory and that constitute the world into which paintings are uttered. There is a non-professional tradition both in the production and the consumption and display of paintings. We may well dismiss (some) of these objects as bibelots, but there is little doubt that the non-professional tradition exists and that we might as well call its constituents 'art', just in case. Yet one of the more telling things about painting, with regard to the matter of conferred status as art, is that we are often either quite unconscious or unselfconscious as to its status as art at all. We might say that we go straight to the painting in a cognitive style that is more or less unable in its language game to think of the object behind it. We are freed from reflections upon the art world and its conferring power by the very boundedness of many paintings – by our tendency to assign them an autonomy that is the analogue of moral personality.

Harrison Imagine showing somebody a painting by Jackson Pollock. You would be acting unintelligibly if you tried to get them to perceive the object that the Pollock is and then to think of its unexhibited character as a work of art. You would also be acting oddly if you tried to explain that it was a work of art because the art world deemed it so. You would be more likely to say that it was a painting and that it possessed certain properties and that these had some connection with criteria for calling it a work of art – this because a certain agreement existed in the matter. This would then, in the end, involve an 'institutional' pragmatics. Works of art can only *be* works of art as perceived and described things whose classification is somehow 'agreed'.

Baldwin What we are saying, perhaps, is that the pragmatic route that invokes agreement as to the art status of most paintings is such that the status is in fact invoked in the perception-description inter alia and not as a description sundered from the description of the object. Of course we don't say that all (or any) painting is entirely immune to contextualization. This can and indeed does confer status, but the status conferred is not necessarily art status – not at least in any way in which we can seriously imagine conferral.

Ramsden It is hard, for instance, to imagine someone nowadays asserting to any serious purpose that Velasquez's *Las Meninas* is a work of art. We might say that from its lofty vantage point *Las Meninas* is sceptical about the power of an institution to confer status on it as art. It outranks the institution, as it were – and we don't just mean the Prado or its other contents. By analogy, we might argue that there are things or activities, sceptical and existing at a different 'social altitude', that can never be explicitly ratified, but which might be of

interest in ways that are at least analogous to the ways that *Las Meninas* is. The institution may merely 'outrank' them. They operate on the institution in ways that it can't account for –ways that it can't assimilate.

Harrison *Las Meninas* refuses to be institutionally *aufgehebt* [upraised]. From its lofty position, it is subversive of the institution's conferring power. There is a sense, however, in which it is not mere loftiness that makes it do the subverting work. So far as the institution is concerned, it is perhaps at too vulgarly aesthetic a level to be of critical interest. But this very vulgarity may be productive of some scepticism vis-à-vis the prospect of institutional assimilation. If we try to think of things that evince an analogously subversive or sceptical property but from a position that does not outrank the institution but is outranked by it, then we may run into trouble. The history of the avant-garde is stuffed with assimilated provocations. Indeed, it is a mere commonplace to say that it would be hard to find an act or item dirty enough or low enough as to be finally inadmissible to the institutional picturesque and thence to be an object of conferred status. *Low* is not exactly where we should look for scepticism.

Baldwin One possible place to look might be into a world with an unassailable, and from the institutional perspective, banal aesthetic. Take engineering artefacts. Let's say that the old six-cylinder-in-line BMW engine is a rather satisfying thing to look at; even beautiful. It was very durable and looks it, and so on. Here is a sort of 'aesthetic' that connected to purpose – is unKantian in its origins, but in its nerdy way nevertheless aesthetic. We might say that this nerdy aesthetic protects the object from a certain institutional ratification. There is, certainly, no way that it can be assimilated in accordance with institutional theory as mad-artist's-cum-self-publicist's-cum-avant-gardist's charter. The aesthetic operation in relation to the car engine stays just below the condition – or is it very slightly above it? It can't be rescued by the institution in ways that would allow its aesthetic to be mapped onto that of the institution. And this has something to do with the car engine's internal complexity. Its informal aesthetic has, as it were, a life of its own that makes it resistant to and sceptical of assimilation. It is possible, perhaps, to think of certain painting as rooted in its domestic occasions and as similarly resistant.

Harrison Another engineering example comes to mind concerning Anish Kapoor's sculpture *Marsyas* [installed in Tate Modern turbine hall, 2002]. We might say of this enterprise that the work of the engineers and riggers is admirable, and might mean this in a sense that could be understood as aesthetic. This would be to configure the work in an implicitly sceptical description. The

institution presumably had something more in mind. That something more provides conditions of assimilation as the vulgar something less does not.

Ramsden [...] If we are to imagine painting subversive of institutional power, then it will have to take examples like that into its self-description – into its aboutness. They will have to be paintings that know about the infra-institutional or extra-institutional life of the paintings in the example but are unable directly to claim such status. This may mean, for example, that they hide their infra-institutional autonomy and internality in apparent forms – installations – that are client to institutional power. Another way to hide is as text – but text configured so that it is recovered as *pictorial* detail as much as read, paintings that malinger, hide their faces and lose their looks, and know that they are at best the asymptotes of a scandalous circle. [...]

Baldwin [...] We suggest that it is its possible resistance to the genericist's reduction that makes painting worth bothering with. We do not take this apparent resistance for granted, though. It is rather that there is a constructive pleasure in painting conceived as the anomaly that besets institutional theory. Of course painting is also itself beset – or *aufgehebt* – by Institutional theory. Painting must always live with the possibility of reduction to the status of ordinary object among others. Our point is rather that one possible mode for trying to think about painting lies in such apparently broken-down – even philistine – statements as, 'Well, you can tell a painting is art by looking at it.' This goes even for most *real* blank canvases. That's because of something that's internal to them, and that is not reducible to their relations to a given context.

Harrison We might even say that Danto himself is not entirely dazzled by the transfiguration of the ordinary, nor wholly immune to the recalcitrance of painting. He may admire the snow shovel and the misperceived *Brillo Boxes* but in life as opposed to theory he'd take a Chardin or a Morandi if he were given the choice. Isn't that because of their internal complexity – because, rather than raising questions of status conferral that are marooned in Cartesian theatre, they remind us of the advantages of keeping perception and description together?

Ramsden Perhaps it is easier to do this with regard to those things we might conceive of living with, rather than those we can only visit in museums. We don't say that painting belongs only in the first category and generic art only in the second, but we do say that the antagonisms between them are disturbingly shadowed by considerations such as these. On the question of the relations between painting and generic art, there is no last word. The force of the question

in any event varies according to cultural, curatorial and economic circumstances.

Baldwin While painting may put up a sceptical and vulgar fight against reduction to the generic condition, it may not follow that a form or forms of painting that labour in the shadow of Conceptual art are capable of such untidy behaviour. It might be argued that in so far as Conceptual art does indeed finally implement the Duchampian generic condition, then anything that plays in its shadow – or more dubiously in its light – must be ipso facto generic. […]

Harrison Conceptual art insinuates text. Not necessarily as painting, but so as to make painting and text fight it out for the status of 'origin'. In saying this we do not intend to suggest that the text and the picture by which it is *mediated* are in anything like the relation between a description and the instantiation that satisfies it. If we describe a possible painting and somebody then makes a painting treating the text as its 'specification', the result will not be the exhaustive satisfaction of the text by the painting or the exhaustion of the painting by the text. […]

Ramsden Suppose we look back to painting's moment of high insecurity in the mid-1960s. Minimal art actually took its cues from painting, but it established a kind of literalism in defiance of what Donald Judd derogated as 'European relational painting'. To do this it had to be installed in institutions that protected its place with a kind of social decorum. If it was in an art gallery it was art and if it wasn't other ways of drawing attention to it had to be devised – magazines, publicity and texts. Arthur Danto was not alone in operating an institutional theory. He was simply its more persuasive and elegant exponent. Don Judd, for example, gave it an individualistic, almost solipsistic cast in the form of the dictum: 'If someone says it's art it's art'.

Baldwin This was liberation of a sort for all of us. Quickly, however, it appeared as an empty yet simultaneously imperialistic assertion of the new professionalism of the artist. Next to the objects of minimalism, the minimalist paintings of Jo Baer, David Novros and others now forgotten just looked displaced and sad. For a while the blank canvas seemed like a goer. Everyone tried their hand at it, including us, though its admittedly marginal internality seemed to turn its back on the possibilities that minimal sculpture appeared to disclose. In the ensuing theatre, the conditions for an avant-garde arms race were created. The advent of Conceptual art had the effect of stifling it, however. It took a few years for this professionalized psychosis to re-emerge, pumped-up by money and management. […]

Harrison [...] We are trying to say that while Conceptual art may serve to deprive painting of its authenticity, it does not reduce such self-contextualizing power as painting may retain without it. The puzzle is how that power might now actually be exercised – and exercised in a world where such powers are suspect if they are admitted at all. The answer seems to be that in so far as its self-contextualizing power *has* been retained, painting survives through a kind of malingering. If the ordinary object is upraised, installed in the museum and transfigured by the art-world's attention, then painting, already crippled by a mediating agency, but still bravely and quietly possessed of its memories and virtues, refuses the upraising effect or renders it in large measure otiose.

Baldwin In the end the Duchampian moment may just mean that some internalist objects are a bit beleaguered. Perhaps it is through its very beleaguered state that the internalist object can defeat or undermine the power of the institution. Perhaps it is through its internal complexity that it can both reveal and resist the arbitrariness and ultimately the vacuity and coercive power of the institutional reality. Artworks are recursively self-describing and, in so far as they are interpreted, can mean almost anything that Humpty Dumpty wants. We have to work critically – that is to say transformatively – at the conditions in which that is so. What can art do to resist? Tighten the criteria; go 'inward' and make it hard for the Institutional theory to invoke Duchamp's putative legacy without embarrassment. More to the point, make it hard for the reality that that theory contingently represents to set the conversational agenda. Make work that can fight for its moral and political rights. That means that art not only has internality, it means that it *does* have a reflexive description, a sense of its own project. This will be a question of what the work does and what the artist does.

Harrison We are desperately in need of a degree of vulgarization. We need either to expand ad infinitum our sense of the institution and the ways objects are manipulated in or as or by it – a solution that puts the power into the hands of an already discredited management – or we need to recognize that if there is a crisis it is a crisis of real institutions. The samizdat is often – but, of course, not always – in a frame. What we mean by this is that it is possible that under conditions of mediation and restraint, painting in some form may well be a medium of resistance. The basis of this resistance lies not only in the fact that painting supplies anomaly in respect of many attempts at an Institutional theory, but also in the fact that painting itself is capable of resisting the power of the institution. Its possible internality in every sense is the key to that.

Ramsden If there is a crisis in the arts, it is a crisis produced by the institutional

ordering and management of art. For this reason, painting is surely worth a try. Concentrate, throw away the commuter's pass and go somewhere. On our analysis, painting perhaps stands in relation to the rest of art as singing a song stands to the rest of music.

Harrison In the words of Samuel Beckett: '*Quand on est dans la merde jusqu'au cou, il ne reste plus qu'à chanter*'.

Ramsden 'If you're in the shit up to your neck, the only thing you can do is sing.'

Baldwin There's certainly good reason not to dance. [...]

Art & Language, extracts from 'On Painting', online edited transcript from lecture for 'Painting Present' series, Tate Britain, London, 18 March 2003, in collaboration with Central Saint Martins College of Art and Design. The full text of this paper was composed collaboratively by the three authors; the speaking parts were then divided up and were allocated on a more-or-less random basis; *Tate Papers* (London: Tate, 2004).

Rudolf Sagmeister
Endangered Beauty: On Gary Hume//2004

[...] The ambivalence of shapes that often can be interpreted in more than one way, the iridescence and disintegration of background and foreground, of shape and ground, of positive and negative, and the resulting irritation of, or rather, challenge for the viewer, runs through Gary Hume's entire work.

In his work he explores and develops these same motifs and models. In his paintings *Love Love's Unlovable* (1991), *Jealousy and Passion* (1993), and the series of drawings and collages titled *Rome* (1993) the artist plays with the silhouette-like view of muscular athletes that remind one of sculptures in a Roman stadium during the era of Mussolini. The bodies' heroic poses, depicted as if seen from below, further increasing the monumental effect, seem strangely deformed. The shapes can be seen as hollow bodies – as holes – or as filled spaces, as shadows or interesting forms on a background-foil of ornamental foliage or flowers. And so the oscillating effect of a picture puzzle is created – now the background, now the shapes in the foreground are primarily recognized and perceived. An entire storey of the Kunsthaus in Bregenz [was in 2004] dedicated just to Gary Hume's drawings, to which not enough attention was given previously. Amongst his most beautiful works rank his plant and flower drawings. Here, one could construct a genealogy of elegance and beauty and economy of line, from the arabesques of Henri Matisse to the famous 'plant drawings' of Ellsworth Kelly, straight on to Gary Hume. The human body, often just details – a knee, a hand, a forearm, the place where the thighs meet the crotch or the belly – is extremely simplified by means of a continuous outline, which nevertheless captures a vivid, calm energy. Hume furthermore demands the attention and sensitivity of the beholder's eye by using black charcoal on a dark background. Drawings, or better, the outlines are also instrumental in his paintings. They are the frame, the grid for the paint, which is filled in completely and only restricted by the outline. Gary Hume has developed a unique, unmistakable painting technique to realize his ideas. He uses common household gloss paint in premixed colours, which he brushes onto the horizontal panel. To make the surface as smooth and even as possible, he uses aluminium panels as the basis for his paintings.

The colour planes create substantial bodies of colour of their own. Some keep a distance from the other areas and lines and are so strong that their edges and rims are standing up. Some of them threaten the drawn lines, flow over them, overlay and blur them. Sometimes the artist uses his brush to draw in the paint

while it is still wet, the effect being that the drawing can be seen as a bas-relief in the paint, as an impression. Therefore, it must be emphasized that Gary Hume's paintings can only be seen and perceived to their total effect in the original. The effect of the reflections on the glossy enamel, the colours and shades, that are often so hard to distinguish, the relief-drawing, all this is only visible in accidental light. Hume's paintings elude reproduction by means of photography and print – a strategy to save the art of painting.

When asked about the things he paints, Gary Hume answered 'flora, fauna and portraiture' – plants, animals and people. From our collective iconographic language, worn out by daily use, be it the icons of the pop and fashion culture such as *Michael* (2001) – Michael Jackson – and *Kate* (1996) – Kate Moss – or from our art historical heritage like *After Vermeer* (1995) and *After Petrus Christus* (1995), or childhood picture books like *Bird on a Branch* (1998) and *Bear* (1994), he manages to rescue some new, valid versions and translate them into the present time. He discovers and invents new pictures with a broken, fragile beauty, with lines and shapes of paint that rival each other, that distract from one another and heighten their effects, and with paints in curiously mixed (or muted) colours or compositions full of harmony and tension.

Hume's colours do not originate in nature, but are the artificial, fabricated colours of industrial production that nowadays dominate our environment. Some of Gary Hume's paintings were inspired by the food designer colours found in sweets, fruit drops, etc. Especially during the 1980s, the automobile industry used enamels that were garish in colour 'not to be found in nature', bright signal colours, for example pink, green or orange toned down with white. Colours impress themselves on the mind. [...]

Gary Hume very consciously uses graphic means to achieve certain effects on the picture plane. Just how clever this approach is, becomes apparent when you read Kandinsky's ground-breaking study *Point and Line to Plane*, published in 1926 as volume 9 of the Bauhaus books for basic research, meant for the education of the students. Kandinsky analyses how point and line on the picture plane can create different tones or moods, depending on size, shape, direction, position, be it horizontal, vertical or diagonal, straight or curved, round, square or alternating in thickness. And he found out that the laws of effect within the organism of a picture are as valid for representational as for non-representational art. In his pictures, Gary Hume merges and confronts representational and non-representational shapes and symbols and thereby creates a new tension and harmony within the picture. [...]

Rudolf Sagmeister, extract from 'Endangered Beauty', in *Gary Hume: The Bird Has a Yellow Beak* (Bregenz: Kunsthaus Bregenz, 2004) 75–8; 83.

Christoph Grunenberg
Attraction-Repulsion Machines:
The Art of Jake and Dinos Chapman//2006

[...] The work of Jake and Dinos Chapman, with its copious utilization of sexually explicit and gruesome imagery, seems to privilege the immediacy of the visual as a means of attracting attention and establishing instant engagement. The sensory carpet-bombardment with genitalia and wounds, the vivid evocation of physiological processes and scatological transgressions, and the apocalyptic scenarios of destruction have created a repellent frenzy of the visible beyond which few dare to venture. The visual shock tactics and excesses of representation provide a pleasurable surface in which the viewer may indulge resistingly but which also functions as a distracting tactic, removing true significance by several degrees. As this protective screen of externalized horror collapses, truths are revealed which are far more uncomfortable than instinctive visceral reactions to exposed private parts, mutilated bodies and extreme feasts of torture.

The intense nature of the Chapmans' work is founded on more than just an overdeveloped will to provoke and to shock. Their art is one of ruptures that challenge the homogeneity of the human body and, by extension, the idea of an ordered and enlightened world ruled by logic and reason. [...] Georges Bataille pointed at the sheer boundless capacity of human invention in the evasion of true self and the recognition of erotic urges in particular. Spectacle as a strategy becomes a necessity if art is to produce a level of engagement that goes beyond merely titillating pleasure and mild amusement. It is a means of breaking down the barriers ot civility and reason: 'Fear and horror are not the real and final reaction; on the contrary, they are a temptation to overstep the bounds', Bataille stated, significantly in a chapter on the subject of Beauty'.[1] Degradation, the violation of taboos, perversions and sexual aberrations, incest, defilement and violence are all mechanisms of transgression which are conjured in order to facilitate the traversing of the threshold into the realm of the real. [...]

The most intriguing artworks are generally described as those which manage the perfect coincidence of visual form with expressive intent. The Chapmans have defied this ideal of straightforward symbolic representation and instead fold content into an unsettling visual form. [...]

It is the shifting balance between captivating form and complex iconographic content, resisting facile reading, that distinguishes their art. In formal terms, their creative arsenal revolves around the resurrection of discredited techniques of representation that include polychrome figurative sculpture, a faithful realism bordering on the obsessive, the miniature tableau,

and various forms of the grotesque, frequently imposed onto skilful emulations of children's art.

Theirs is an art that proudly subscribes to an aesthetics of excess, not just in exposing the invisible and that from which we consciously avert our eyes, but also through its insistence on a surplus of entropic disintegration, a superabundance of detail and the scratchy nervousness of their peripatetic drawn and etched lines.

Bataille described the world as 'purely parodic, in other words … each thing seen is the parody of another, or is the same thing in a deceptive form'.[2] The Chapman brothers have created an alternative reality through the radical exaggeration and distortion of familiar forms of figuration that both mimic and mock the illusionary comforts of realism. They play with visual and verbal correspondences, create hilariously vulgar and impenetrably obscure associations, layer images onto existing historical imagery and cyclically reconfigure motifs that reappear in different guises. They employ word games, visual puns, illogical anachronism and time leaps, biological shifts and moral conundrums, unexpected variations in scale and sudden alterations between media to create both amusing and unsettling ambiguities. Obscene laughter, the radical desecration of sanctified ethical principles, extreme horror and graphic representations of violence and sexual activity of all kinds are techniques of transgression employed to challenge received ideas and moral beliefs. Titles are essential and range from the plain silly to the cryptic. Their series of endearing paintings of cats unsubtly plays on the colloquial *double entendre* with the female genitals, as, for example, *Pussy in the Middle* (2001), presenting an anthropomorphic conflation of a saccharine calendar picture of kittens with a vagina. Thanks to their imagination we know what a 'fuck face' might actually look like, and *Two-faced Cunt* (1995) is a rather literal interpretation of the Janus myth with a vagina sandwiched between two faces. […] Some of the shocking content derives from the transfer from one representational medium to another, the translation of motifs from Goya's etchings into three-dimensional miniatures and life-size representations in all their glorious gory detail. The Chapmans' 'improvement on Goya's celebrated (posthumous) print series contains, like all successful parody, elements of reverential homage and mocking ridicule, exaggerating the grotesque and repulsive elements of his visual manifesto against the cruelties of war while simultaneously turning it into a circus sideshow. […]

What is really disturbing in Jake and Dinos Chapman's art are not the outward provocations of nudity, disease and violence but the underlying psychological meanings – the attack on the whole body, the blurring of gender lines, the revulsions of the abject, the insinuations of sadism and the moral

offences. While their sculptures, paintings and prints function perfectly on a visceral level without theoretical superstructure, particular figures, motifs and images can always be traced to specific textual and visual references. At the heart of their work is the creative conversion of psychological processes, symptoms and disorders into convincing material form. They have been called 'official iconographers', producing 'quite *literal* translations – or perhaps 'embodiments' – of a Freudian, pre-conscious, polymorphously perverse, undifferentiated, noumenal "beyond"'.[3] Penis envy, the fear of castration, Oedipal complexes, narcissism, hysteria, paranoia, neuroses, sadism and masochism, scopophilia, the uncanny, the death wish, abjection, totems, taboos and their violation, all make appearances and are variously given sculptural, painterly and graphic form. Nietzsche, Freud, Bataille, Lacan and Deleuze and Guattari are the godfathers of this kindergarten of deviation, perversion and science gone wrong. Bataille's evocation of the 'pineal eye', for example, with its obvious reference to the penis ('a final but deadly erection, which blasts through the top of the human skull and "sees" the overwhelming sun'), is faithfully rendered in a number of works, such as *Seething Id* (1994), evoking male vision of an essentially different kind.[4] The artists not only display an acute historical awareness of psychoanalysis, philosophy and critical theory but continue a productive dialogue with past masters that extends from 'primitive art' and the apocalyptic visions of Goya and Blake via Rodin and the Surrealists to more recent proponents of psychological terror and trauma, such as American West Coast artists Paul McCarthy and Mike Kelley, with whom they share an interest in staging psychological scenarios and unfolding repressed traumas. [...]

'Abjection is above all ambiguity', Julia Kristeva has written, exemplified in the power of Eros to transcend the repellent horrors of the corporeal and base materialism representing Thanatos.[5] [The Chapmans' artwork] *Sex* (2003) is the ultimate 'desiring-machine', with 'repulsion ... the condition of the machine's functioning, but attraction ... the functioning itself'.[6] The state of schizophrenic confusion triggered by horror, disgust and transgression suspends programmed inhibitions and conditioned responses to create a state of moral uncertainty of a force that allows a glimpse into another, more inclusive reality. It is a crisis triggered by the extreme artifice of art, one that attracts us through the sophistication of its workmanship and opulence of its colours and repulses us through its evocation of the real – that is, death and decay brought on by the lowest forms of animal life. *Sex* provides as much pain as it gives pleasure through the beauty of an art which is ecstatic in its intensity.

The dynamics of attraction and repulsion are at the basis of social structures, sacred and civilizing forces interacting in establishing a system of taboos, rituals and values. Attraction and repulsion are not static but 'mobile entities and their

shifting associations are essential 'in the transformation of a depressive content into an object of exaltation'. Art has a mediating function and through horror, disgust and laughter ('the doubling of tragedy by comedy') it can push those powerful unconscious processes which are at the heart of human existence to the surface, 'in a sort of swirling turbulence where death and the most explosive tension of life are simultaneously at play'.[7] Freud once denigrated the impact of art as limited to a 'mild narcosis', which 'can do no more than bring about a transient withdrawal from the pressure of vital needs, and is not strong enough to make us forget real misery'.[8] With their art, the Chapman brothers have abruptly interrupted the artificial sleep of this narcosis, addressing topical, fundamental questions about human existence and identity, challenging orthodox moral parameters and biological truths, while a fantastic and at times vicious sense of humour carefully probes the gravity of this undertaking.

1 [footnote 2 in source] Georges Bataille, *Erotism* (1957); trans. Mary Dalwood (Harmondsworth: Penguin, 2001) 144.

2 [7] Georges Bataille, 'The Solar Anus' (1931); trans. Allan Stoekl, in Stoekl, ed., Georges Bataille, *Visions of Excess: Selected Writings 1927–1959* (Minneapolis: University of Minnesota Press, 1985) 5.

3 [9] David Falconer, 'Doctorin' the Retardis', in *Chapmanworld* (London: Institute of Contemporary Arts, 1996) n.p.

4 [10] Allan Stoekl, Introduction, in Bataille, *Visions of Excess*, op. cit., xii.

5 [46] Julia Kristeva, *Powers of Horror: An Essay on Abjection* (1980); trans. Leon S. Roudiez (New York: Columbia University Press, 1982) 14.

6 [47] Gilles Deleuze and Félix Guatarri, *Capitalism and Schizophrenia, vol. 1. Anti-Oedipus* (1972); trans. Robert Hurley (New York: Viking, 1977) 329–30.

7 [48] Georges Bataille, 'Attraction and Repulsion 1: Tropisms, Sexuality, Laughter and Tears', in *The College of Sociology* (1957–1959), ed. Denis Hollier; trans. Betsy Wing (Minneapolis: University of Minnesota Press, 1988) 111; and 'Attraction and Repulsion II: Social Structures', op. cit., 114; 121; 123–4.

8 [49] Sigmund Freud, 'Civilization and Its Discontents' (1929); in *The Standard Edition of the Complete Psychological Works of Sigmund Freud*, vol. 18 (London: Hogarth Press/Institute of Psychoanalysis, 1961) 8.

Christoph Grunenberg, extract from 'Attraction-Repulsion Machines: The Art of Jake and Dinos Chapman', *Bad Art for Bad People* (Liverpool: Tate Liverpool, 2006) 11–28.

Vito Acconci
Interview with Bryant Rousseau//2007

Bryant Rousseau Vito, with the benefit of hindsight, your remarkable transformation from a conceptual artist to an architect seems almost an obvious move: Your art was always concerned with how bodies relate to each other in a defined space, whether within a gallery's walls or the city at large. Also, your art didn't want viewers, it wanted active participants, and there's no more interactive art than architecture. But I'm guessing this radical shift in your creative practice was arrived at neither quickly nor easily. Can you walk us through how you came to realize that architecture was where you should be focusing your efforts?

Vito Acconci It started when I was doing installations in the mid-1970s. One thing that characterized my work is I wanted to do installations people were a part of. I did an installation at the Sonnabend Gallery in SoHo in 1976 called 'Where We Are Now, Who Are We Anyway'. Basically, a 60-foot table – a wooden plank with stools on either side of it – was propped up on the windowsill of the gallery and then continued out the gallery's window. So what started as a table became a diving board.

As in all of my installations of the 1970s, there was sound, in the case of this work a hanging speaker above the table, with a constant clock ticking, and my voice coming in saying things like, 'Now that we're all here together, what do you think, Bob?' And 'Now that we've gone as far as we can go, what do you think, Barbara?' In other words, what I liked about the project was I found a way to use a gallery as if it was a town square, a plaza, a community meeting place.

At the same time, I started to have this nagging doubt. I thought: I'm kidding myself. A gallery or museum is never going to be a public space. If I really want a public space, I'd better find a way to get there. So even though the work I did for even a long time after that was still in an art context, I was trying to grope my way into architecture. If I thought the artwork needed a public space, I obviously knew there were disciplines that already deal with public space: There's architecture, maybe landscape architecture, maybe industrial design. [...]

Rousseau Talk some more about the primary motivations behind the launch of your own architecture and design studio.

Acconci It started because I thought if I want something that results in a public

reaction, I don't think it can start private. So I needed to have people around me, specifically people from an architecture background. I needed them for two basic reasons. Number one, I wanted to do architecture, but I really didn't know how. Number two, I thought if I'm really going to take this seriously, I can't be a single agent, a single artist, even a single architect. And I made this assumption that the public starts with the number three. One is a solo, two is a mirror image; the third person starts an argument. Once an argument starts, probably public has started.

Rousseau What I find fascinating is that since launching Acconci Studios, you've never looked back. You really entirely ceased being an artist.

Acconci You were very right in what you said in your first question. I never wanted viewers; I always wanted users, participants, inhabitants. I should have realized if I didn't want viewers, I really didn't want art. Because with art, no matter how many nudgings into the traditions are made, the convention is always the viewer is here, the art is there.

So the viewer is always in a position of desire and frustration. Those 'Do Not Touch' signs in museums are there for a reason: The art is more expensive than people are. I hope that is an immoral position, and I wanted things to be in people's hands, people to be inside something. You know architecture by walking through it, by being in the middle of it, not by being in front of it. And I wonder if the real way you learn things is to be in the middle of something.

Rousseau Can you articulate a single aesthetic sensibility that ties all your architecture work together?

Acconci If there's anything I want a work of ours to be, I want it to be secular. I don't want it to have any religiousness in it at all. I don't want it to have belief. I'd like to have commitment as we work, but always commitment knowing that something is going to change. We're not going to be committed to the same thing all the time. We want an outside to come in, so that the commitment is revised. And what we hate about any kind of architecture is if it makes people feel small. [...]

Rousseau What are some of the goals you have set for the studio over the next few years? What excites you about the future?

Acconci We want an architecture that's a biological system; we want a regeneration principle. I don't want it to be just metaphor. I don't know if architecture can ever be as living a thing as all that. Yes, there's a lot of work now

that looks fluid, looks as if it moves. We would love to be able to make something that really does grow, and I'm sure a lot of other architects would say that. But right now I have mixed feelings. I sometimes wonder if architecture is getting caught up in aesthetics. I've seen the word 'elegance' used a lot lately, and it was always a word I had such a horror of.

Rousseau Why?

Acconci For two reasons. It seems to me it's totally about form. But elegance is also a word of the upper class. Now we might want to get at a version of elegance, but I hope it doesn't have the upper-class and all-form connotation. I wonder also if the whole star architecture phenomenon is a sign that architecture as we know it is not really going to exist any longer. I don't think this will happen soon, but I think there will be an architecture developed that starts to develop itself and grow itself. Maybe an architect is there almost like a planter: You plant a seed and then this thing is going to go off in its own direction. I hope architecture becomes just as alive as a tree, just as alive as a biological thing.

Rousseau If not elegance, then what are four or five adjectives you'd like people to associate with your work?

Acconci I want our work to be changeable, portable, multi-functional. I want our work to have a complexity, but not a visual complexity. [...]

Vito Acconci and Bryant Rousseau, extract from interview, *Architectural Record* (June 2007).

Leo Fitzmaurice
Beauty (a list of possibilities)//2007

The index edge of an Argos 'Big One' catalogue … The lump/hump under the badge on a Toyota Avensis … Almost any plastic bottle top … Harlequin packing on ASDA brand light bulbs … A folded photograph … The positions of every 'OWEN 10' shirt at this moment … The spaces between E and S in the Tesco logo … Constructivist influences in pizza box graphics … All the things found on my table this morning … The backs of all the Mister Men … A heap of paint … The thought of following a cloud on a windy day … Clichéd images of tears and flames … The magic wand in Photoshop … Dented words … Church bells with twinkling stars … The word HELL in British Transport Medium … The torso of a motorcycle … Photographing vans all day … Worn sportswear … Invisible graffiti … Handmade warning signs … A full English breakfast as seen from above … Bad goods … Chicken omelette … A dead drawing … The area under a piece of scribble … A tattooed tree … Tudor writing … The indent for a number plate … A city street through a frosted glass door … A collection of identical objects … A TV facing a wall.

Leo Fitzmaurice, 'Beauty (a list of possibilities)', *Garageland*, issue 3: *Beauty* (London: Transition Gallery, 2007).

Biographical Notes

Vito Acconci founded the New York-based architecture practice Acconci Studio in 1988. Formerly he was internationally known as a conceptual artist since the 1960s. Retrospectives include Museum of Contemporary Art, Chicago (1980); Museu d'Art Contemporani de Barcelona (2004).

Theodor Adorno (1903–69) was a philosopher, musicologist and cultural critic of the Frankfurt School. His major works include *Negative Dialektik* (1966; *Negative Dialectics*, 1973) and the posthumously published *Ästhetische Theorie* (1970; *Aesthetic Theory*, 1984).

Alexander Alberro is Associate Professor of Art History at Barnard College, Columbia University, New York. He is the author of *The Best Dishwashing Liquid Around: Conceptual Art and the Politics of Publicity* (2002), and co-editor with Blake Stimson of *Conceptual Art: A Critical Anthology* (1999).

Rasheed Araeen is a Pakistan-born artist, curator and writer, based in London since 1964. A key figure in postcolonial critique, he was Founding Editor of the journal *Third Text*. Retrospectives include Ikon Gallery, Birmingham (1987). His writings are collected in *Making Myself Visible* (1984).

Art & Language (since 1977 comprising Michael Baldwin and Mel Ramsden, in association with Charles Harrison) is a collaborative art practice founded, with other former members, in 1968. Drawing on philosophy they investigate conceptual and ideological presuppositions underlying art's institutionalization. Retrospectives include Fundació Antoni Tàpies, Barcelona (1999).

Benjamin H.D. Buchloh is the Franklin D. and Florence Rosenblatt Professor of Modern Art, Harvard University, an editor of *October* and a contributor to *Artforum*. His books include a first volume of collected writings, *Neo-Avantgarde and Culture Industry: Essays on European and American Art from 1955 to 1975* (2001).

T.J. Clark is Professor of Modern Art, University of California at Berkeley. His books include *Image of the People: Gustave Courbet and the 1848 Revolution* (1973), *The Painting of Modern Life: Paris in the Art of Manet and his Followers* (1985) and *Farewell to an Idea: Episodes from a History of Modernism* (1999).

Mark Cousins is Director of General Studies and Head of the Graduate Programme in Histories and Theories at the Architectural Association, London. He is also Visiting Professor of Architecture at Columbia University. Journals to which he has contributed include *Harvard Design Magazine*, *m/f*, *October*, *Economy and Society* and *Art History*.

Diarmuid Costello is a philosopher of aesthetics based at Warwick University, England, and Vice-President/Chair of the British Society of Aesthetics. He has co-edited and contributed to numerous publications on contemporary art and aesthetic theory and to journals such as *October* and the *The Journal of Aesthetics and Art Criticism*.

John Currin is an American painter whose figurative pastiches draw on a wide range of sources from the Renaissance nude to the 1960s pin-up magazine. Retrospectives include Museum of Contemporary Art, Chicago (2003) and Whitney Museum of American Art, New York (2004).

Arthur C. Danto is Johnsonian Professor Emeritus of Philosophy at Columbia University and art critic for *The Nation*. His books include *Beyond the Brillo Box: The Visual Arts in Post-Historical Perspective* (1992), and *The Madonna of the Future: Essays in a Pluralistic Art World* (2000).

Jacques Derrida (1930–2004) was among the most influential of post-war French philosophers and literary theorists. His central works include *Of Grammatology* and *Writing and Difference* (both 1967), and *Spectres of Marx* (1993).

Anna Dezeuze is a Postdoctoral Research Fellow in Art History and Visual Studies at the University of Manchester, England. Her research interests include spectator participation and the dematerialization of the art object. Journals to which she has contributed include *Art Monthly* and *Papers of Surrealism*.

Thierry de Duve is a Belgian art historian, critic and curator whose work focuses on the philosophical and pedagogical implications of developments in art and visual discourse from Duchamp onwards. His books include *Pictorial Nominalism: On Duchamp's Passage from Painting to the Readymade* (1991) and *Kant after Duchamp* (1998).

James Elkins is E.C. Chadbourne Chair in the Department of Art History, Theory and Criticism at the Art Institute of Chicago. He is the editor of the *Art Seminar* series; his books include *On Pictures and the Words That Fail Them* (1998) and *The Domain of Images* (1999).

Leo Fitzmaurice is a British artist based in Liverpool who reassembles discarded materials such as advertising graphics and commercial packaging to make sculptural installations in both indoor and outdoor locations. His commissioned projects include *Detourist*, a series of public realm interventions whilst visiting London, Liverpool, Shanghai, Stavanger, Berlin and Zurich in 2006.

Fredric Jameson is Professor of Comparative Literature and Romance Studies at Duke University, Durham, North Carolina. His books include *Signatures of the Visible* (1990), *Postmodernism, or, The Cultural Logic of Late Capitalism* (1991) and *The Cultural Turn* (1998).

Jason Gaiger is a Lecturer, and Deputy Chair of the Art History and Art of the Twentieth Century courses, at the Open University, England. With Charles Harrison and Paul Wood he has co-edited two volumes of *Art in Theory*, covering the periods 1648 to 1815 and 1815 to 1900.

Leon Golub (1922–2004) was one of America's leading postwar figurative painters and political activists, and partner of the painter Nancy Spero. Retrospectives include Irish Museum of Modern Art, Dublin (touring, 2000–1) and Ronald Feldman Fine Arts, New York (2008).

Christoph Grunenberg is Director of Tate Liverpool. Exhibitions he has curated include 'Gothic: Transmutations of Horror in Late Twentieth-Century Art', Institute of Contemporary Art, Boston (1996), 'Summer of Love: Art of the Psychedelic Era', Tate Liverpool (2006) and 'Jake and Dinos Chapman: Bad Art for Bad People', Tate Liverpool (2007).

Dave Hickey is an American writer on art and curator. In 2001 he curated the SITE Santa Fe Biennial. His books include *Prior Convictions: Stories from the Sixties* (1989), *The Invisible Dragon: Four Essays on Beauty* (1994) and *Air Guitar: Essays on Democracy* (1997).

Kathleen Marie Higgins is Associate Professor of Philosophy, University of Texas at Austin. Her main areas of research are continental philosophy, aesthetics and the philosophy of music. Her books include *Nietzsche's Zarathustra* (1987) and *Comic Relief: Nietzsche's Gay Science* (2000).

Suzanne Perling Hudson is Assistant Professor of Art History, University of Illinois at Urbana-Champaign, and a scholar of the work of Robert Ryman, on whom she is preparing a monograph. Journals to which she has contributed include *Artforum*, *Art Journal* and *October*.

Mark Hutchinson is a British artist. Group exhibitions he has organized include, with Dave Beech, 'There is Always an Alternative: possibilities for art in the early nineties', temporary contemporary, London (2005). Writings include contributions to *the first condition*. http://www.thefirstcondition.com

Caroline A. Jones is Professor of Art History at Massachusetts Institute of Technology. She is the author of *Machine in the Studio: Constructing the Postwar American Artist* (1998).

Alex Katz is an American figurative painter whose work since the 1950s has been associated with a Pop art aesthetic and who became internationally influential during the 1990s. Retrospectives include Whitney Museum of American Art, New York (1986) and IVAM, Valencia (1996).

Rosalind Krauss is University Professor of Twentieth-Century Art and Theory, Columbia University, New York. Her books include *The Originality of the Avant-Garde and Other Modernist Myths* (1986), *The Optical Unconscious* (1994) and *Bachelors* (2000).

Agnes Martin (1912–2004) was a Canadian-born American painter, at first associated with Minimalism, who worked in New York from 1957 until 1967 when she moved to New Mexico to pursue a reclusive, spiritually-based life and method of painting. Retrospectives include Stedelijk Museum, Amsterdam (1991), Whitney Museum of American Art, New York (1992) and a series of installations at Dia: Beacon, Hudson Valley, New York (2004–7).

Saul Ostrow is Chair of the Visual Arts and Technologies Environment and Associate Professor of Painting at the Cleveland Institute of Art, Ohio. He has curated over 70 exhibitions and is a regular contributor to *Art in America*. He is editor of the series *Critical Voices in Art, Theory and Culture*.

Simon O'Sullivan is a Senior Lecturer in Art History and Visual Culture in the Department of Visual Cultures, Goldsmiths College, University of London. He collaborates with Dave Burrows in the art practice Plastique Fantastique. His books include *Art Encounters Deleuze and Guattari: Thought Beyond Representation* (2006).

Griselda Pollock is Professor of the Social and Critical Histories of Art at the University of Leeds, England. Her books include *Framing Feminism: Art & the Women's Movement 1970–85* (with Rozsika Parker, 1987; revised 1992) and *Old Mistresses; Women, Art and Ideology* (1981; 1996).

David Raskin is Associate Professor, Department of Art History, Theory and Criticism, School of the Art Institute of Chicago. Journals to which he has contributed include *Art History*, *Art Criticism*, *Art Journal* and *Art in America*.

Gerhard Richter is among the most influential German artists of the post-1945 period; he has been described as a conceptual painter. Retrospectives include The Museum of Modern Art, New York (2004). His work is extensively documented at http://www.gerhard-richter.com

John Roberts is a British art critic and theorist, and contributor to *New Left Review*. His books include *Postmodernism, Politics and Art* (1990), *The Art of Interruption: Realism, Photography and the Everyday* (1998) and *Philosophizing the Everyday: Revolutionary Praxis and the Fate of Cultural Theory* (2006).

Rudolf Sagmeister is Curator at the Kunsthaus Bregenz, Austria. Exhibitions for which he has contributed catalogue essays include those of Jake and Dinos Chapman (2005), Gary Hume (2004) and Franz West (2003).

Elaine Scarry is the Walter M. Cabot Professor of Aesthetics and the General Theory of Value at Harvard University. Her books include *The Body in Pain: The Making and Unmaking of the World* (1985), *Resisting Representation* (1994) and *On Beauty and Being Just* (1999).

Robert Smithson (1938–73) was an American artist whose work intersected with conceptual art, Land art and Minimalism, and whose wide-ranging writings made a significant contribution to art discourse in the late 1960s and early 1970s. Retrospectives include Musée d'art moderne de la Ville de Paris (1982) and Centro Julio González, Valencia (1993).

Nancy Spero is a New York-based American artist, feminist and activist whose work, alongside that of her late partner Leon Golub, has been internationally influential on generations of politically motivated artists. Retrospectives include Institute of Contemporary Arts, London (1987) and Museu d'Art Contemporani de Barcelona (2008).

Wendy Steiner is Richard L. Fisher Professor of English, University of Pennsylvania. Her books include *The Scandal of Pleasure: Art in an Age of Fundamentalism* (1996) and *Venus in Exile: The Rejection of Beauty in Twentieth-Century Art* (2001).

Andy Warhol (1928–87), among the most influential artists of the Pop, Minimal and Conceptual era in the 1960s and 1970s, used serial repetition of appropriated images in his work from 1962 onwards. Retrospectives include The Museum of Contemporary Art, Los Angeles (2002). The most extensive collection and archive of his work is at the Warhol Museum (www.warhol.org).

Dominic Willsdon is the Leanne and George Roberts Curator of Education and Public Programs at San Francisco Museum of Modern Art. From 2000 to 2005 he was Curator of Public Programmes at Tate Modern and a Senior Tutor in Critical Theory at the Royal College of Art, London.

Paul Wood is a British writer on art and theory who has published widely in exhibition catalogues and journals. He is the co-editor, with Charles Harrison, of *Art in Theory 1900–2000: An Anthology of Changing Ideas* (2001).

Richard Woodfield is Emeritus Professor of Aesthetics and Art Theory at Nottingham Trent University, England. He has edited a number of texts by the art historian Ernst Gombrich and constructed the Gombrich Archive (www.gombrich.co.uk). His books include *Art History as Cultural History: Warburg's Projects* and *Framing Formalism: Riegl's Work* (both 2001).

Acconci, Vito, and Rousseau, Bryant, Interview, *Architectural Record* (June 2007)

Adorno, Theodor, *Ästhetische Theorie* (1970) (Frankfurt am Main: Suhrkamp, 1973); trans. C. Lenhardt, *Aesthetic Theory* (London: Routledge and Kegan Paul, 1984)

Alberro, Alexander, 'Beauty Knows No Pain', *Art Journal*, vol. 63, no. 2 (Summer 2004)

Araeen, Rasheed, *Making Myself Visible* (London: Kala Press, 1984)

Armstrong, John, *The Secret Power of Beauty* (London: Penguin, 2006)

Art & Language, 'On Painting', *Tate Papers* (London: Tate, 2004)

Beckley, Bill, and Shapiro, David, eds, *Uncontrollable Beauty: Toward a New Aesthetics* (New York: Allworth Press, 1998)

Beech, Dave, 'The Politics of Beauty', *Art Monthly*, 306 (May 2007)

Bernstein, Jay M., *The Fate of Art: Aesthetic Alienation from Kant to Derrida and Adorno* (Pennsylvania: Penn State Press/Cambridge: Polity Press, 1992)

Buchloh, Benjamin H.D., 'Conceptual Art 1962–1969: From the Aesthetic of Administration to the Critique of Institutions', *October* (Winter 1990)

Cheng, Anne Anlin 'Wounded Beauty: An Exploratory Essay on Race, Feminism and the Aesthetic', *Tulsa Studies in Women's Literature* (Autumn 2000)

Clark, T.J., *Farewell to an Idea: Episodes from a History of Modernism* (New Haven: Yale University Press, 1999)

Cousins, Mark, 'The Ugly' (Parts I and II), *AA Files*, no. 28 and no. 29 (London: Architectural Association, 1994)

Currin, John, and Rosenblum, Robert, Interview, *Bomb* magazine, issue 71 (Spring 2000)

Danto, Arthur C., *The Abuse of Beauty: Aesthetics and the Concept of Art* (Chicago: Open Court, 2003)

Donoghue, Denis, *Speaking of Beauty* (New Haven: Yale University Press, 2003)

de Duve, Thierry, *Kant after Duchamp* (Cambridge, Massachusetts: The MIT Press, 1996)

Derrida, Jacques, *La Verité en peinture* (Paris: Flammarion, 1978); trans. Geoff Bennington and Ian McLeod, *The Truth in Painting* (Chicago: The University of Chicago Press, 1987)

Eagleton, Terry, *The Ideology of the Aesthetic* (Oxford: Basil Blackwell, 1990)

Eco, Umberto, *Storia della bellezza* (Milan: Bompiani, 2004); trans. Alastair McEwan, *On Beauty: A History of a Western Idea* (London: Secker & Warburg, 2004)

Elkins, James, ed., *Art History versus Aesthetics* (London and New York: Routledge, 2006)

Gaiger, Jason, 'Incidental and Integral Beauty: Duchamp, Danto and the Intractable Avant-Garde', lecture (London: Tate Modern, Saturday 8 March 2008); first published in this volume.

Garageland, issue 3: *Beauty* (London: Transition Gallery, 2007)

Golub, Leon, and Spero, Nancy, Interview with Adrian Searle, in Searle, ed., *Talking Art* (London: Institute of Contemporary Arts, 1993)

Grunenberg, Christoph, 'Attraction-Repulsion Machines: The Art of Jake and Dinos Chapman', in *Bad Art for Bad People* (Liverpool: Tate Liverpool, 2006)

Higgins, Kathleen Marie, 'Whatever Happened to Beauty? A Response to Danto', *The Journal of*

Aesthetics and Art Criticism, vol. 54, no. 3 (Summer 1996)

Hickey, Dave, 'Enter the Dragon: On the Vernacular of Beauty', in *The Invisible Dragon: Four Essays on Beauty* (Los Angeles: Art Issues Press, 1993)

Hutchinson, Mark, catalogue essay, *Nausea: Encounters with Ugliness*, ed. Hutchinson and Nicola Cotton (Nottingham, England: Djanogly Gallery, March 2002)

Jameson, Fredric, *The Cultural Turn: Selected Writings on the Postmodern 1983–1998* (London and New York: Verso, 1998)

Jones, Amelia, *Aesthetics in a Multicultural Age* (Oxford: Oxford University Press, 2002)

Jones, Caroline A., *Machine in the Studio* (Chicago: University of Chicago Press, 1996)

Katz, Alex, and Sylvester, David, Interview in *Alex Katz: Twenty-Five Years of Painting*, ed. David Sylvester (London: Saatchi Gallery, 1997)

Krauss, Rosalind, *The Originality of the Avant-Garde and Other Modernist Myths* (Cambridge, Massachusetts: The MIT Press, 1986)

Leslie, Esther, *Synthetic Worlds: Nature, Art and the Chemical Industry* (London: Reaktion, 2005)

Martin, Agnes, and Sandler, Irving, Interview, *Talking Art: Interviews with Artists since 1976* (London: Art Monthly and Ridinghouse Editions, 2007)

Ostrow, Saul, 'The Eternal Problem of Beauty's Return', *Art Journal*, vol. 62, no. 3 (Fall 2003)

Perling Hudson, Suzanne, 'Beauty and the Status of Contemporary Criticism', *October*, no. 104 (Spring 2003)

Pollock, Griselda, *Vision and Difference* (London and New York: Routledge, 1988)

Prettejohn, Elizabeth, *Beauty and Art 1750–2000* (Oxford: Oxford University Press, 2005)

Psomiades, Kathy Alexis, Beauty's Body: Femininity and Representation in British Aestheticism (Stanford: Stanford University Press, 1997)

Richter, Gerhard, *The Daily Practice of Painting: Writings 1962–1993*, ed. Hans-Ulrich Obrist (Cambridge, Massachusetts: The MIT Press, 1995)

Roberts, John, *The Intangibilities of Form: Skill and Deskilling in Art After the Readymade* (London and New York: Verso, 2007)

Sagmeister, Rudolf, 'Endangered Beauty', in *Gary Hume: The Bird Has a Yellow Beak* (Bregenz: Kunsthauz Bregenz, 2004)

Sartwell, Crispin, *Six Names of Beauty* (London and New York: Routledge, 2004)

Scarry, Elaine, *On Beauty and Being Just* (Princeton, New Jersey: Princeton University Press, 1999)

Smithson, Robert, *The Collected Writings*, ed. Jack Flam (Berkeley and Los Angeles: University of California Press, 1996)

Steiner, Wendy, *Venus in Exile: The Rejection of Beauty in Twentieth-Century Art* (Chicago: The University of Chicago Press, 2001)

Warhol, Andy, *The Philosophy of Andy Warhol: From A to B and Back Again* (New York: Harcourt, Inc., 1975)

Wood, Paul, *Art Has No History! The Making and Unmaking of Modern Art* (London and New York: Verso, 1994)

Index

ACKNOWLEDGEMENTS

Editor's acknowledgements

I'd like to thank Iwona Blazwick, Hannah Vaughan and Ian Farr not only for making this book happen but for improving it. Thanks also to Caraline Douglas and Katrina Schwarz.

Publisher's acknowledgements

Whitechapel Gallery is grateful to all those who gave their generous permission to reproduce the listed material. Every effort has been made to secure all permissions and we apologize for any inadvertent errors or ommissions. If notified, we will endeavour to correct these at the earliest opportunity.

We would like to express our thanks to all who contributed to the making of this volume, especially: Vito Acconci, Alexander Alberro, Rasheed Araeen, Art & Language, Jay M. Bernstein, Benjamin H.D. Buchloh, T.J. Clark, Diarmuid Costello, Mark Cousins, John Currin, Arthur C. Danto, Anna Dezeuze, Martin Donougho, Thierry de Duve, James Elkins, Leo Fitzmaurice, Jason Gaiger, Christoph Grunenberg, Dave Hickey, Kathleen Marie Higgins, Suzanne Perling Hudson, Mark Hutchinson, Fredric Jameson, Caroline A. Jones, Alex Katz, Rosalind Krauss, Estate of Agnes Martin, Saul Ostrow, Simon O'Sullivan, Griselda Pollock, David Raskin, Gerhard Richter, John Roberts, Rudolf Sagmeister, Elaine Scarry, The Estate of Robert Smithson, Nancy Spero, Wendy Steiner, Dominic Willsdon, Paul Wood, Richard Woodfield, Adrian Searle. We also gratefully acknowledge the cooperation of: Acconci Studio; *Art Monthly*; Artists Rights Society; *BOMB Magazine*; University of Chicago Press; Gagosian Gallery; Houghton Mifflin Harcourt Publishing; Institute of Contemporary Arts, London; Anthony d'Offay Gallery; Open Court Publishing Company; Ridinghouse Editions; Saatchi Gallery; Suhrkamp Verlag; Transition Gallery, Glasgow; Verso; Visual Artists and Galleries Association, Inc.; Yale University Press.

Whitechapel Gallery is supported by
Arts Council England

Whitechapel Gallery

whitechapelgallery.org

Whitechapel Gallery is supported by